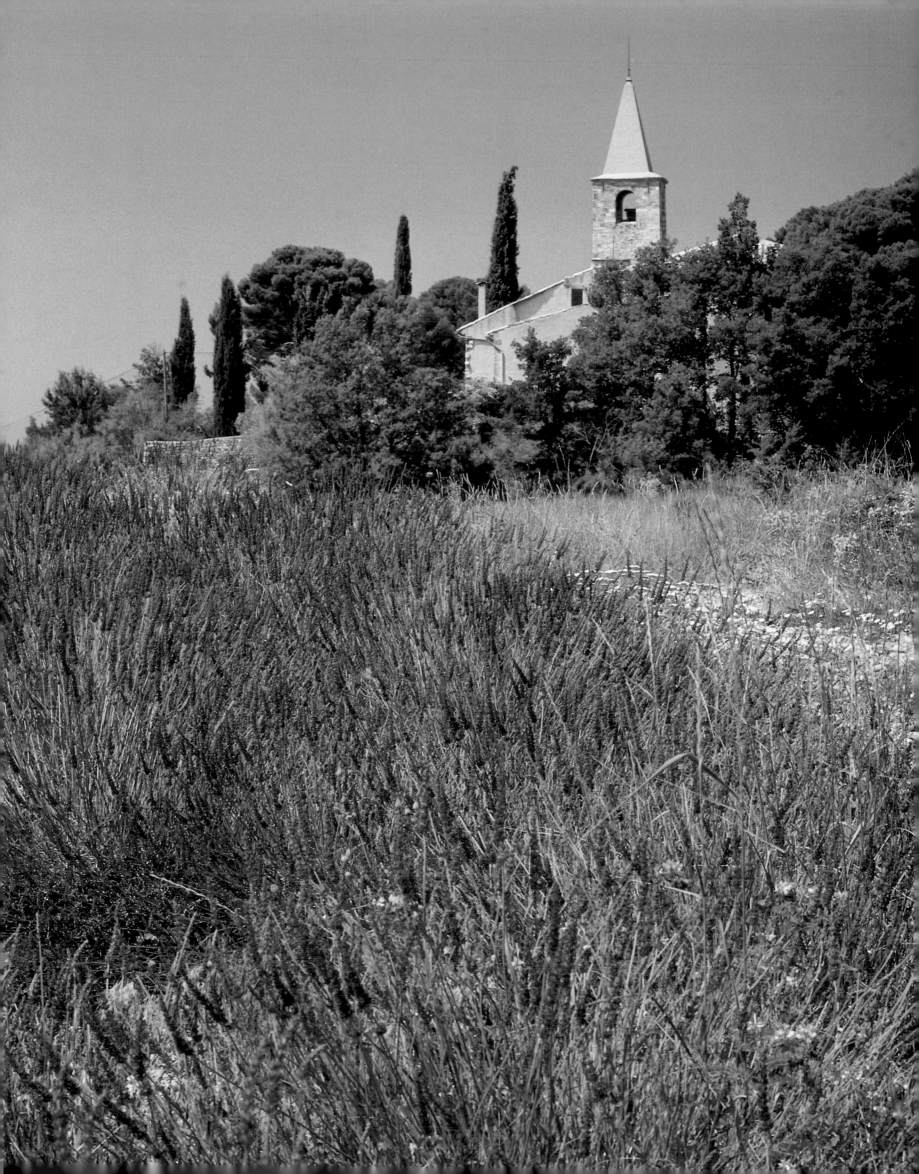

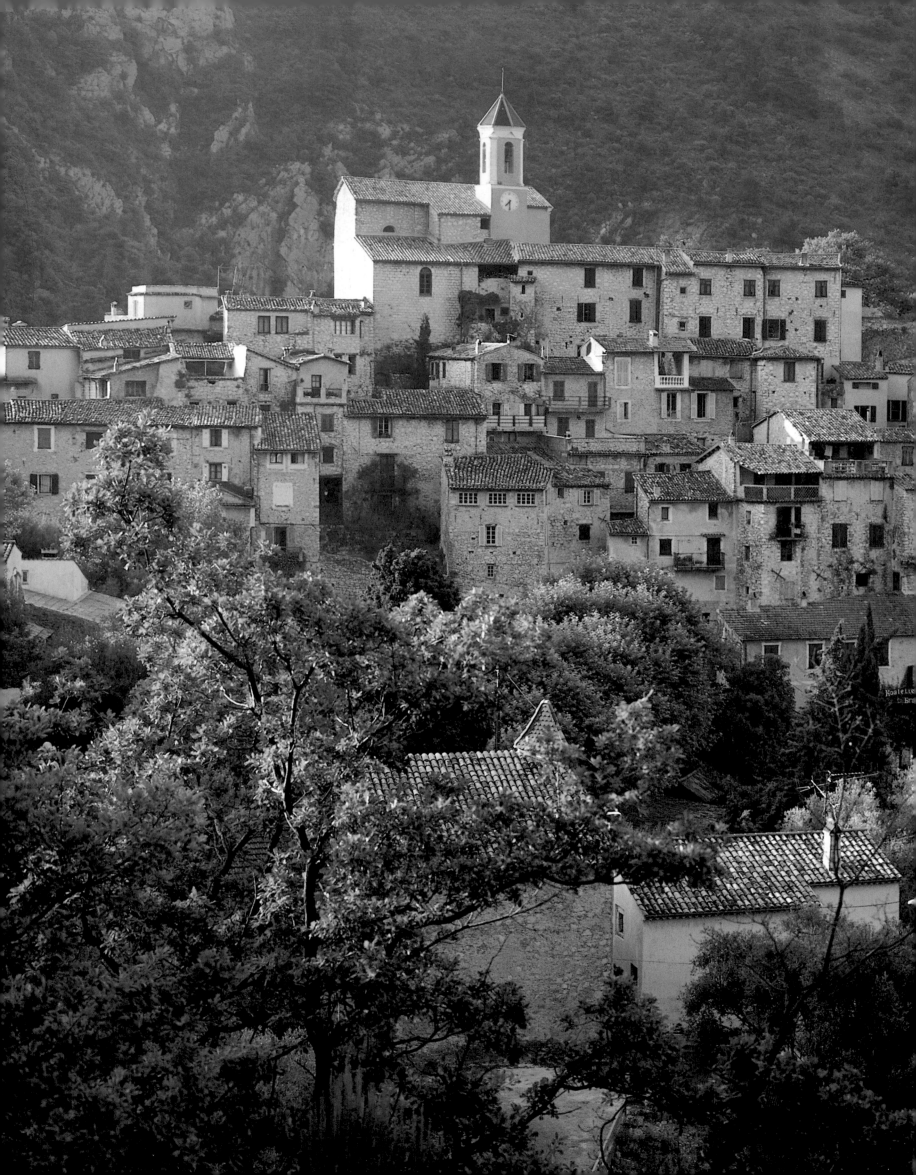

The
Most Beautiful Villages
of Provence

MICHAEL JACOBS

PHOTOGRAPHS BY HUGH PALMER

With 304 illustrations in color

THAMES AND HUDSON

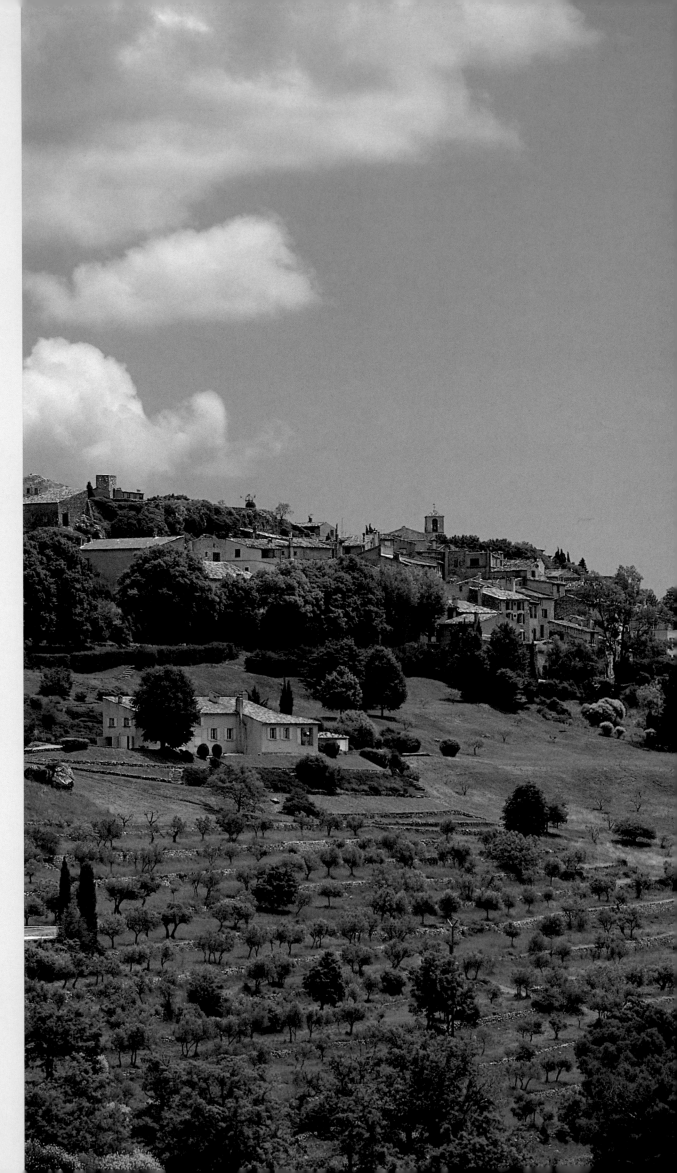

HALF TITLE
Lavender fields on the outskirts of Riez, Alpes-de-Haute-Provence.

TITLE PAGE
The tightly grouped dwellings of Peillon (Alpes-Maritimes): one of the most dramatic of the perched villages of Provence.

RIGHT
Tourtour occupies a commanding position over the upper valley of theVar.

© 1994 Thames and Hudson Ltd, London
Text © 1994 Michael Jacobs
Photographs © 1994 Hugh Palmer

First published in the United States of America in 1994 by Thames and Hudson Inc., 500 Fifth Avenue, New York, New York 10110

Library of Congress Catalog Card Number 94–60276

ISBN 0–500–54187–6

Printed and bound in Singapore

Contents

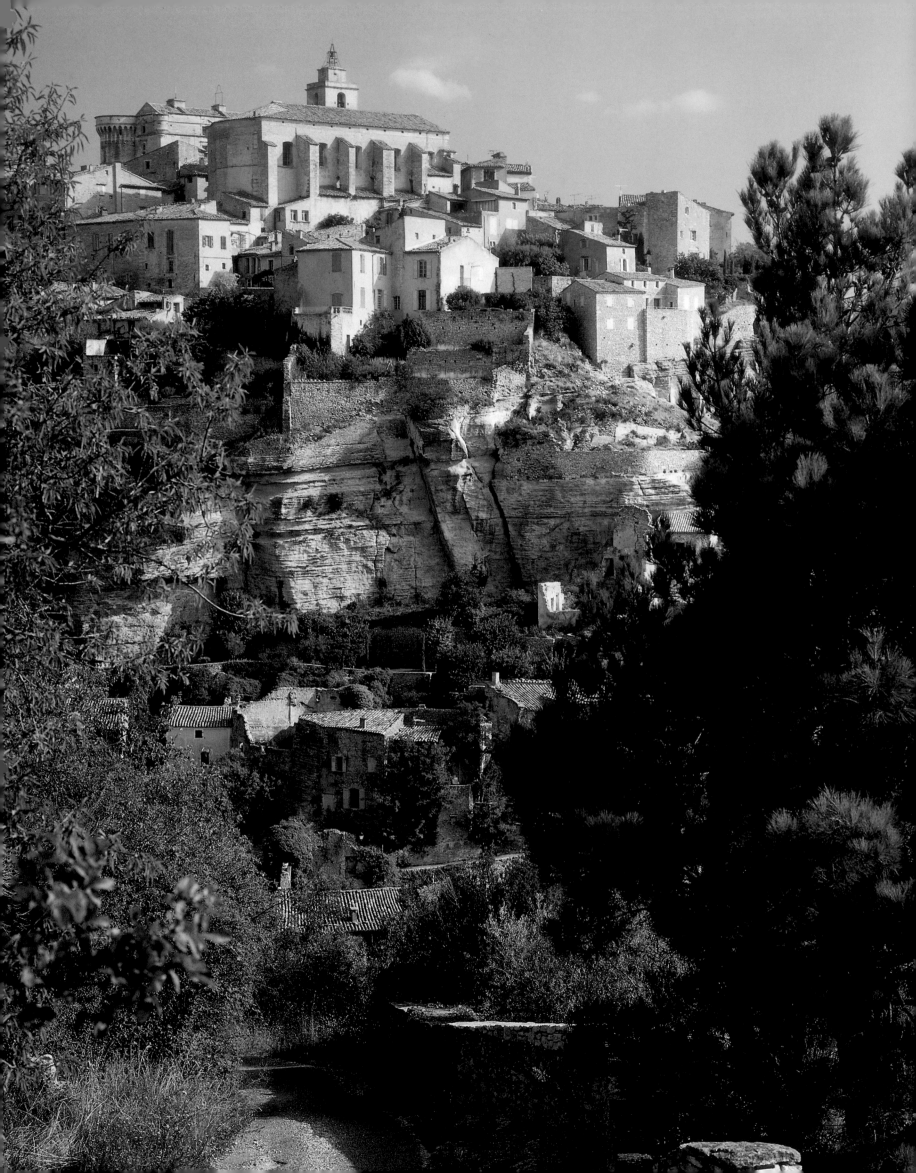

Introduction

THERE IS NOT ONLY ONE PROVENCE, as the novelist Colette noted, but several. The exceptional variety of the region's landscapes is matched by the complexity of its cultural make-up and the wealth of myths that surround it. Celebrated as the 'Gateway to the South', Provence is not only a key area of the Mediterranean world, it is also a vital cultural and commercial link between northern and southern Europe by virtue of its position at the foot of the great thoroughfare of the Rhône valley.

The Greeks colonized Provence, and planted its olives; Celts and other northern tribes came next, and were followed by the Romans, who made it their first 'Province' outside Italy, and left there an incomparable architectural legacy. Between the sixth and ninth centuries the Moors formed a stronghold in the wooded, mountainous district known to this day as 'les Maures'. The Papacy acquired a district corresponding roughly to modern Vaucluse in 1277 and turned the court at Avignon into a showpiece of Italian culture. They were to keep this territory right up to the time of the Revolution, almost three centuries after the rest of Provence had been incorporated into the kingdom of France. In the early nineteenth century Italian ties were strengthened when the *comté* of Nice was annexed, briefly, to the kingdom of Savoy.

The official boundaries of present-day Provence were more or less established by the end of the last century, at a time when the region was acquiring an increasingly mythical dimension. Frédéric Mistral and his fellow poets associated with the Provençal revival had evolved a vision of the region based heavily on glamorous notions of the medieval kingdom and its amorous troubadours. Successive generations have developed their own myths of the region and have constantly disputed the boundaries of the 'true' Provence. Many purists, for instance, exclude the lands to the east of the river Var, including the Côte d'Azur and its hinterland, claiming that 'real' Provence is synonymous with the heartland of the Roman province, an area extending west of the Rhône and into Languedoc. Others have discarded

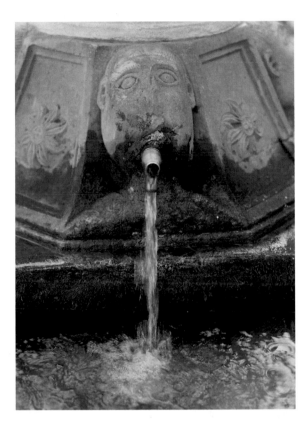

The austere and sturdily buttressed church of Gordes (opposite) *forms the apex of a composition characteristic of the finest and best preserved of the Provençal villages. The relatively severe architecture of many of them is offset by the abundance of playful fountains, such as this delightful example in Bargemon* (above), *an eighteenth-century work combining classical rosettes with naïve heads.*

7

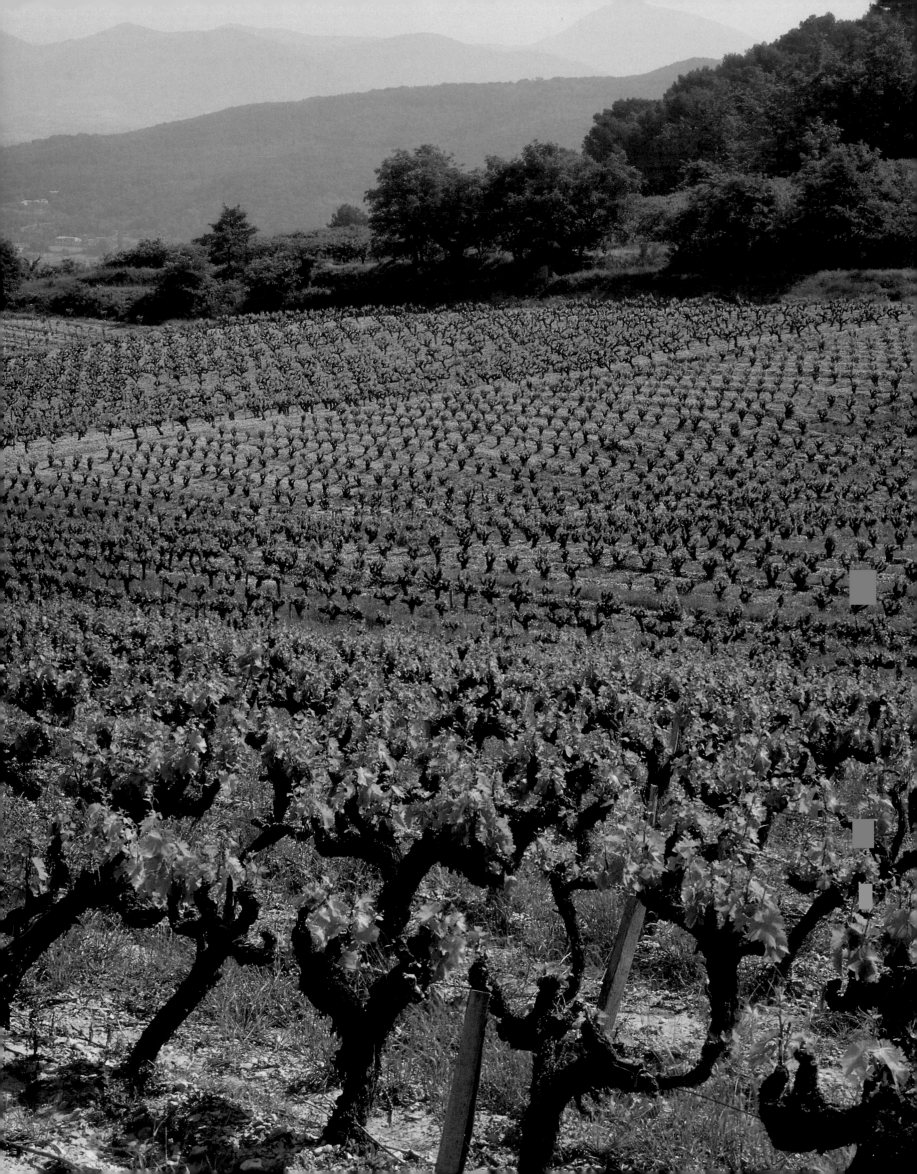

from their vision the entire Provençal coast, though only the novelist Jean Giono was brave enough to claim that the one true Provence lay to the north of the Durance – a largely desolate area totally at odds with the popular image of the region as a sensual playground.

Whatever their definition of Provence, most people prefer to think of the region in terms less of its huge cities, such as Marseilles and Nice, than of its villages, which have been seen, since the time of Mistral, as the embodiment of the true Provençal spirit.

Unsurprisingly, the remarkable variety of Provence is reflected in these villages, which differ markedly in their character and architecture from one district to another. While many villages of the mountainous areas of Alpes-de-Haute-Provence are of granite and slate, those of Alpes-Maritimes have a colourful and dramatic Italianate look, with east-west settings, cheerful Baroque churches and tall, brightly-coloured houses. Nonetheless, there is a type of village which is generally thought of today as unmistakably Provençal and is principally associated with the *départements* of the Var and the Vaucluse. Among its common characteristics are a dramatic, hill-top site, and an architecture of russet-tiled roofs, olive-green shutters and rough-hewn, ivy-covered masonry. More specific features include austerely simple and darkly-lit churches, with belfries crowned with light and playful ironwork. Typical, too, are the seventeenth- and eighteenth-century fountains, shaded squares and promenades, and the deserted cobbled lanes. Ironically, though, the Provençal villages now so widely admired tend to be those where the traditional sources of local economy were damaged irreversibly by dramatic change from the late nineteenth century onwards.

The Provence of Mistral's childhood in the eighteen-fifties and sixties was a region at the height of its economic fortunes, a place to which the poet could look back in later life as a rural paradise. However, in the eighteen-seventies and eighties, a series of disasters befell the region, including the collapse of the silk and dye industries, and the destruction, by phyloxera and frost respectively, of vines and

V ines, introduced to Provence by the Greeks and extensively cultivated by the Romans and the Avignon popes, form a backdrop to many of the region's villages and are an important source of income; those shown opposite *belong to a district where the recently planted vineyards of the Côtes-du-Ventoux give way to the celebrated, time-honoured ones of the lower Rhône valley. Elegant, ironwork belfries and elaborate church portals* (above) *feature prominently in visitors' impressions of Provence and are indeed among the region's most distinctive features.*

Provençal colour: the traditional blues of the shutters vie with the Tricolour at Cotignac (Var) (top): curved tiling, as in this roof-top scene at Ampus, Var, (above), gives a russet-red warmth to the skyline of many of the region's sun-blessed villages. Meanwhile, in the quiet corners of places such as Crestet, Vaucluse (opposite), the main sounds are provided by water pouring out from the many Renaissance and Baroque fountains of Provence, installed when the villages were at the height of their commercial prosperity.

olive trees. Furthermore, the advent of the railway, far from bringing new wealth to the interior, encouraged numerous country folk to leave their threatened lands and try to find employment in the burgeoning urban centres along the Provençal coast. Villages were radically altered both by severe depopulation and by the movement of the remaining inhabitants down to the village's lower slopes to be nearer the main lines of communication. Unable to sell the houses that they had abandoned, and unwilling to pay taxes on them, these villagers often destroyed the roofs of their former homes. By the early years of the present century, many Provençal villages had the appearance of ghost towns.

A number of evocatively ruined villages can still be seen in Provence, including such spectacularly situated ones as the Fort de Buoux and Oppède-le-Vieux. There are also a handful of villages, such as the Alpine community of Lurs, which still have the somewhat moribund character which must have been so prevalent in Provence right up to the nineteen-fifties. All these places have a powerful, haunting appeal, and it is easy to see how they were such an important source of inspiration early this century to such a writer as Jean Giono, in whose work the cheerful, arcadian Provence of Mistral is replaced by an equally romanticized view of the Provençal village as sinister and cruel.

A more balanced view of Provence is provided by the work of the writer and film director Marcel Pagnol, who has recently enjoyed a revival of popularity following the filming of two of his late novels, *Jean de Florette* and *Manon des Sources*. Although the darker side to Provençal village life is present in his novels, Pagnol was essentially an optimist whose works helped to popularize a sunnier and more humorous Provence, a world of arcadian beauty centred on wine, pastis, cafés, fêtes, local markets and village personalities.

The transformation this century of the Provençal villages and the exceptional popularity they enjoy today among foreigners are due very much to artists, who were among the first to appreciate their

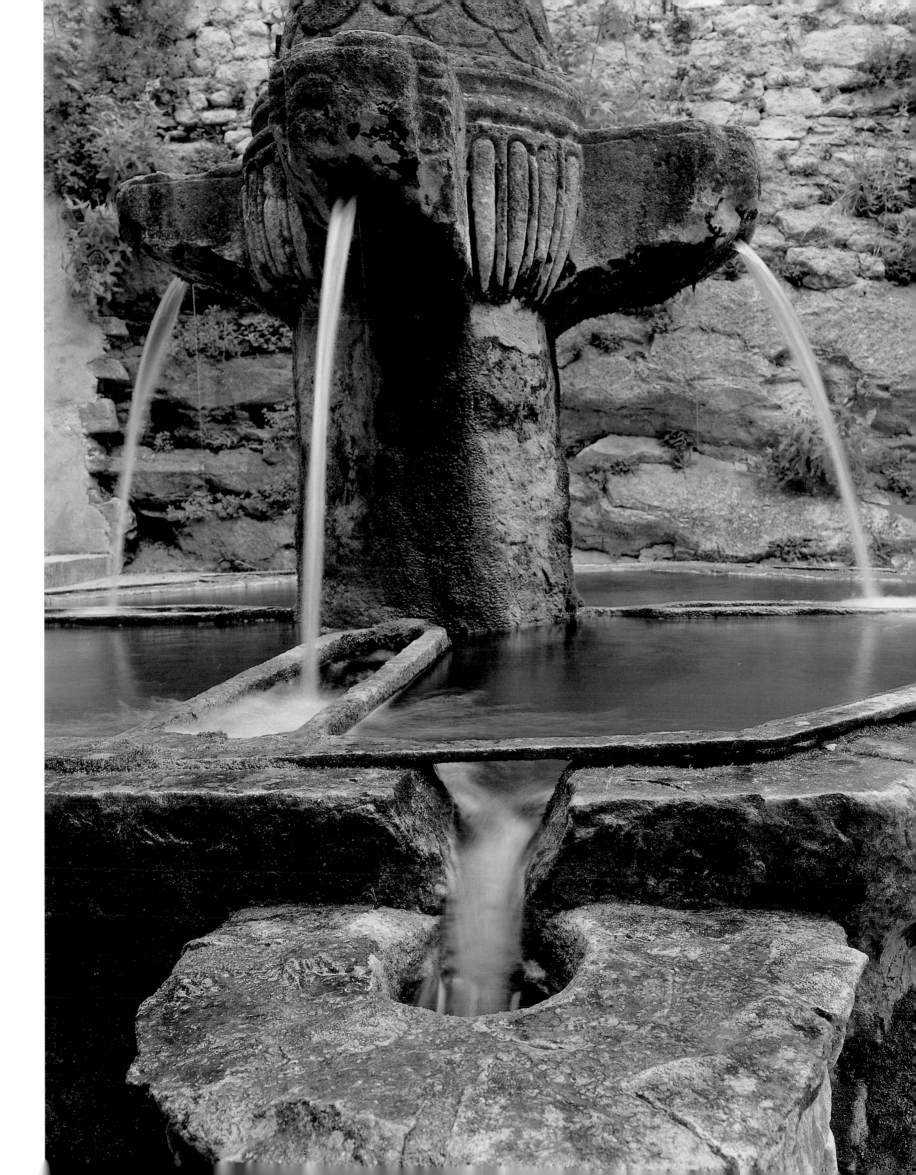

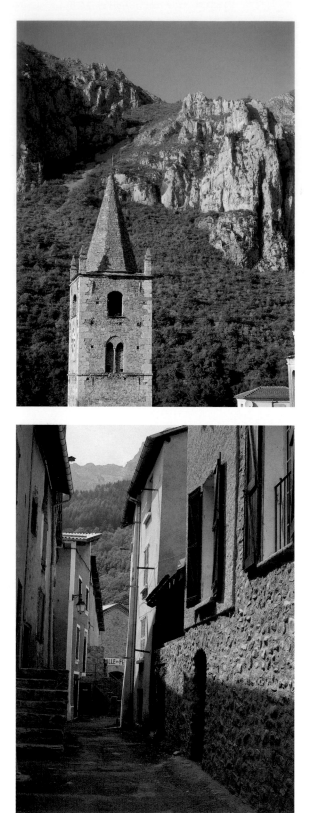

*T*he ironwork belfries of lower Provence are succeeded in the Alpine villages, such as La Brigue (top *and* above), *by heavy, rough-hewn structures that echo the dramatic, rocky surroundings. Though only a short distance to the south of La Brigue in Alpes-Maritimes, the village of Saorge* (opposite) *recalls in its pastel-coloured architecture the Baroque campaniles and mountainous setting of the neighbouring Italian region of Liguria.*

charm and to move into the remarkably cheap properties left by the departing villagers.

Although Provence is often referred to now as 'the cradle of modern art', the region was only 'discovered' by artists in comparatively recent times. One of the pioneers was Vincent van Gogh who, however, showed no apparent interest in the traditional rural world vaunted by the regional writers. It says much for his inherently perverse outlook that one of his most famous rural scenes should be of a modern drawbridge forming part of a new irrigation scheme.

It was left to van Gogh's equally eccentric contemporary, Cézanne, one of the few important painters actually native to Provence, to record the serene, classical beauty of the Provençal countryside. Though little appreciated in his day, Cézanne was the main inspiration behind the thousands of artists from all over Europe and America who came to Provence after the First World War and attempted to render its villages and landscapes in terms of solid, simplified forms radiant with colour. 'From Marseilles to Vintimille', wrote one critic of the time, 'on the coast and inland, there is scarcely a village but someone, dreaming of Cézanne, has come and set up an easel there.'

Artist communities, which had earlier proliferated in rural areas of central and northern France, came to be established in the villages of Provence. The first to be 'settled' were those on or behind the Côte d'Azur, an area which has long been favoured by foreigners as a winter resort. They included Èze, Mougins, Le Cannet, Tourette, Seillans and Cagnes (the model of the so-called 'Montparnasse-sur-Mer' in Cyril Connolly's bitter, fictional exposé of artist life in the south of France of 1936, *The Rock Pool*). But the most thriving of all the original artist villages was Saint-Paul-de-Vence, which eventually came to be one of France's livelier centres of contemporary art.

As the coastal strip and immediate hinterland became more crowded, a growing number of artists began moving to the remote parts of the interior, especially to the villages of the hilly district

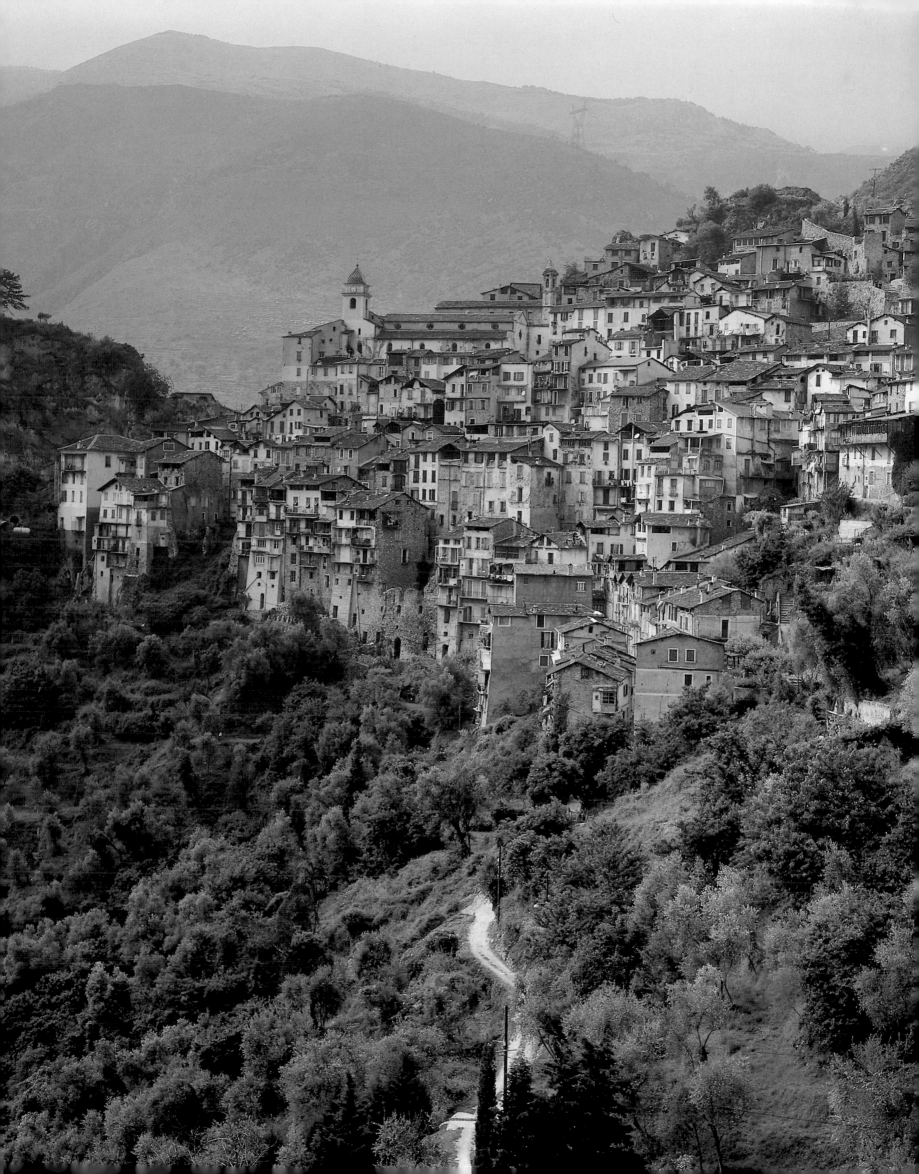

A contrast to the simplicity of so much Provençal architecture is the local taste for Rococo, which is often expressed in ironwork (top). *Strong colours, the fig tree* (above) *and natural abundance* (opposite) *are all major ingredients in the traditional image of the region.*

of the Lubéron in the Vaucluse. During the Second World War, for instance, an experimental community of architects, writers and artists was set up in the ruins of Oppède-le-Vieux. Shortly afterwards, a group of abstractionists, headed by the academic Cubist André Lhote and the Op artist Vasarely, came to be associated with the village of Gordes. By the nineteen-seventies the district town of Apt had acquired the nickname of 'Saint-Germain-du-Lubéron', in reference to the number of fashionable Parisians of artistic and literary leaning who had taken up part- or full-time residence there.

Tourists and 'foreign' settlers have followed in the footsteps of the artists and, in recent years, have turned their attention increasingly to the Provençal interior. Village life there has come to be widely seen as a civilized ideal, inspiring, for instance, a taste for a simple, informal style of daily existence. An interesting aspect of this phenomenon has been the current fashion for the once despised oil and garlic based simplicity of Provençal village cooking, much admired by such writers on the subject as Elizabeth David and M.F.K. Fisher.

The new settlers in Provence have helped to revive the most beautiful villages of the region, while often promoting a rural ideal no less mythical than that of writers such as Frédéric Mistral and Marcel Pagnol. The image of Provence as a 'blessed land' has made over the past few years a greater impact than ever, and continues to detract from the true complexity and cultural riches of the region's villages. Yet, as the photographs in this book amply convey, the sheer beauty of these villages and their settings is such as to make one understand how myths are formed and sustained.

VAUCLUSE AND BOUCHES-DU-RHÔNE

The département *of Vaucluse corresponds almost exactly to the papal territory of Comtat-Venaissin, which derived its name from the former bishopric of Venasque, today one of the richest architecturally of the many outstanding villages that make up this district. The Vaucluse, though including a vine-covered section of the Rhône Valley, is dominated by its mountains, most notably the white-capped profile of Mont Ventoux, the highest French peak between the Alps and the Pyrenees. The southern and traditionally more isolated half of the district is taken up by the long range of the Lubéron, which was once a place of refuge to members of the heretical Vaudois faith.*

Bouches-du-Rhône represents not only the historic heart of Provence but also what many would call its spiritual heart. This is the land where the Romans left some of their finest buildings outside Italy, where the troubadours reputedly held their courts of love and where Provence was ruled by its Counts; it is also the land of Mistral, Van Gogh, Cézanne and Pagnol.

A paved path on the lower outskirts of Gordes (opposite) takes the visitor into the heart of this geometrically arranged Vaucluse village, from which there are panoramic views south towards the range of the Petit Lubéron.

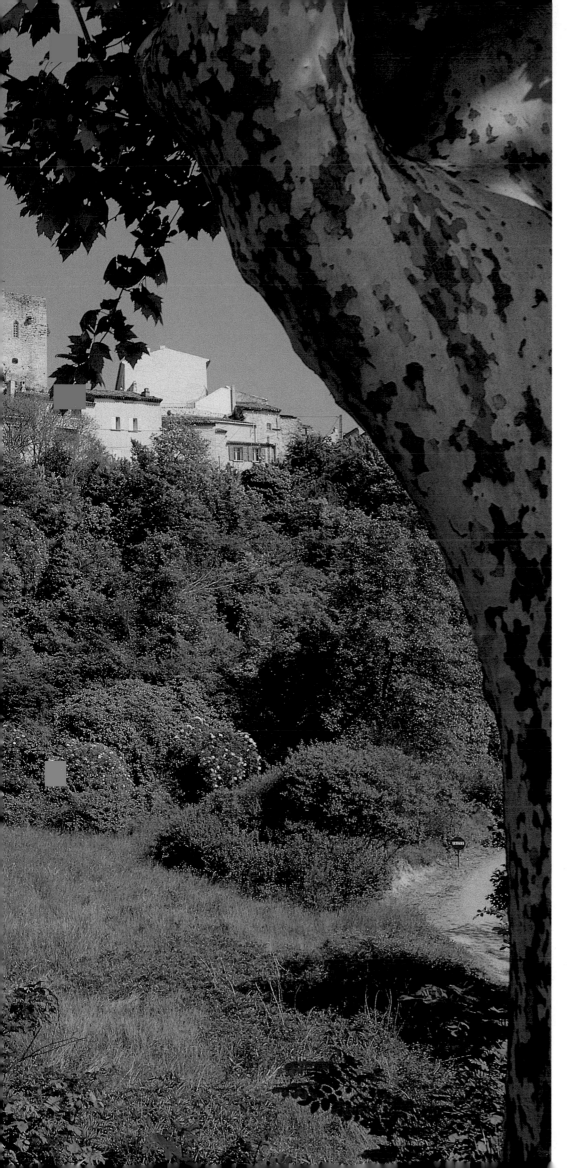

Ansouis
VAUCLUSE

THE TINY VILLAGE of Ansouis rises up magically on a wave of rock above the fertile, open countryside facing the southern slopes of the Lubéron. Its immediate appeal is due very much to the dramatic siting of its castle, which stands on the crest, looming over a wooded drop on its northern side.

The castle, one of the most enchanting in Provence, has an intimate, lived-in character, the result of having remained in the same family, the Sabrans, for over eight centuries. A large shaded terrace, with giant urns and wonderful views, is laid out in front of the building's elegant late Renaissance wing, behind which is the original twelfth-/fourteenth-century fortress. Two of Provence's most popular saints, Elzéar de Sabran and Delphine de Puy-Michel lived there. They were a married couple who achieved dubious sanctity through living together without ever consummating their union.

The impressively austere Romanesque parish church of Saint-Martin is attached to the castle walls and was originally the castle's Court of Justice.

At the very foot of the village, embellished with modern ceramic sculptures of fish, is the aptly named Musée Extraordinaire. This is the brain-child of Georges Mazoyer, an artist, deep-sea diver, and collector of fossils and Provençal furniture. He has united his many interests in the museum, which has an upper floor filled with the characteristically dark Rococo wooden furniture of rural Provence, and a lower suite of rooms recreating the underwater world. The fossils on display testify to the days when the Lubéron range was an island.

The village of Ansouis is dominated by its castle, which rises on its northern side directly above the surrounding countryside. Here we see the long Renaissance wing, which contrasts with the simple sturdiness of the medieval castle behind.

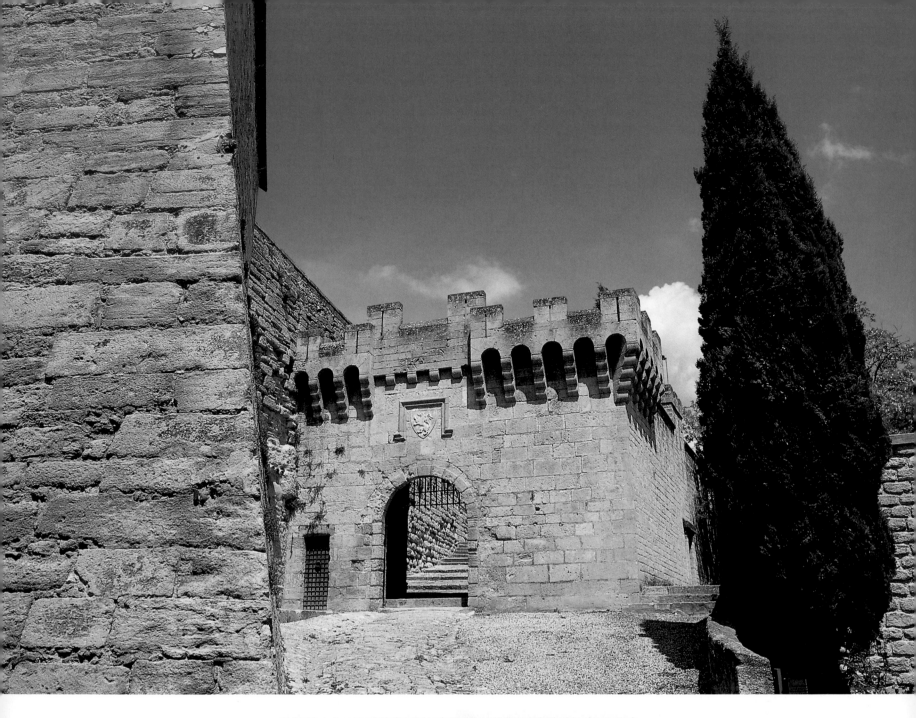

*A*n imposing medieval gateway (above) *marks the exciting final stage of the climb up to the castle of Ansouis, and leads directly to the castle's elegant forecourt. At the opposite end of the village is the* Musée Extraordinaire (right *and* far right)*, the creation of Georges Mazoyer, here seen among the strange sculptures of marine life which decorate the museum.*

*T*he quiet streets and alleys of
Ansouis reflect the simplicity
and secretiveness of the archetypal
Provençal village: closed shutters; a
table tastefully covered in a white
cloth on a hidden veranda; and walls
adorned only with ivy and the
patchwork created by brilliant
sunlight through shady trees.

Bonnieux

VAUCLUSE

A statue of the Virgin rises high above Bonnieux on the crowning spire of the Old Church, a building of characteristically Provençal simplicity set amid giant cypresses (above). *At the very foot of the village, dating from the time when community life came to be concentrated on the lower streets, is the New Church, a neo-Romanesque structure profiled here against the orchards and vine-growing fields below* (opposite).

LOOKING OUT over fields towards the hill-village of Lacoste, Bonnieux lies seemingly suspended between the range of the Lubéron and the long fertile valley which spreads west towards Avignon. The liveliest of the beautiful but sombre villages on the northern side of the Lubéron, Bonnieux has had a prosperous past which is reflected in the Renaissance and Baroque detailing found in many of the old stone houses lining the narrow, steeply ascending streets of the upper village.

Here, steps lead up to the old church which stands among ancient cedars at the very top of the village. Still retaining extensive fragments of the original Romanesque structure, the church was elegantly enlarged in the fifteenth century and given shortly

afterwards an elaborate altarpiece in gilded wood. The new church, at the foot of the village, is an undistinguished neo-Gothic structure, but is worth a visit for its four primitive panels of the Passion, which are said to be German works of the sixteenth century. Two kilometres away, to the west of the winding, panoramic road which leads towards Apt was a Gallo-Roman settlement, guarded by a citadel on the site of present-day Bonnieux; of this nothing now survives apart from the remarkable Pont-Julien (see pp. 28–9), a three-arched bridge standing isolated among fields. Another curious survival near the village is the old railway station, now converted into an art gallery, complete with tracks of the line which connected the villages of the Lubéron with towns to the west.

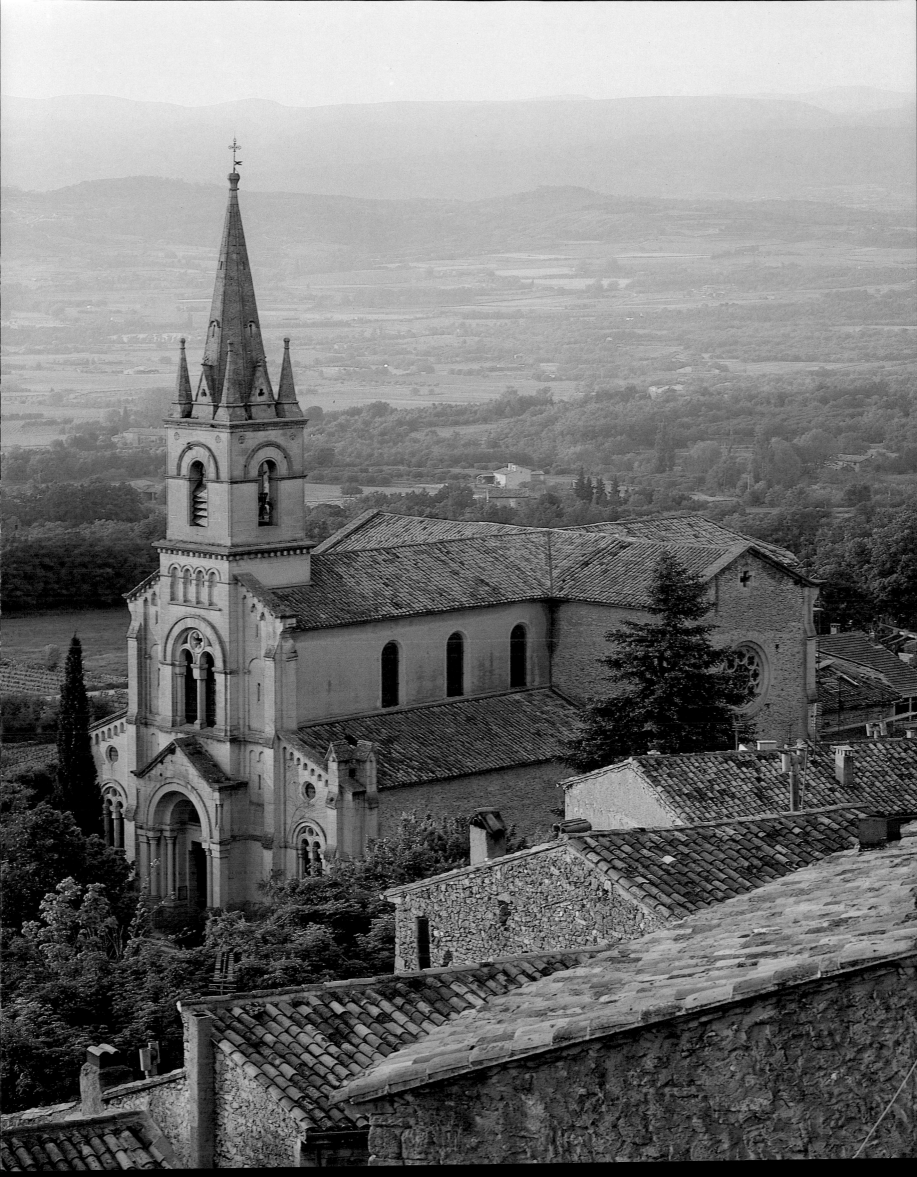

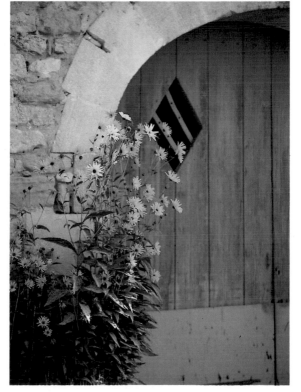

A simple fountain (opposite) *forms a focal point along the village's main thoroughfare. Touches of colour in the lower part of Bonnieux: in front of the César hotel and restaurant is a dark yet attractive alley* (above) *which climbs towards the parish church through an arch joining two sixteenth-century houses.*

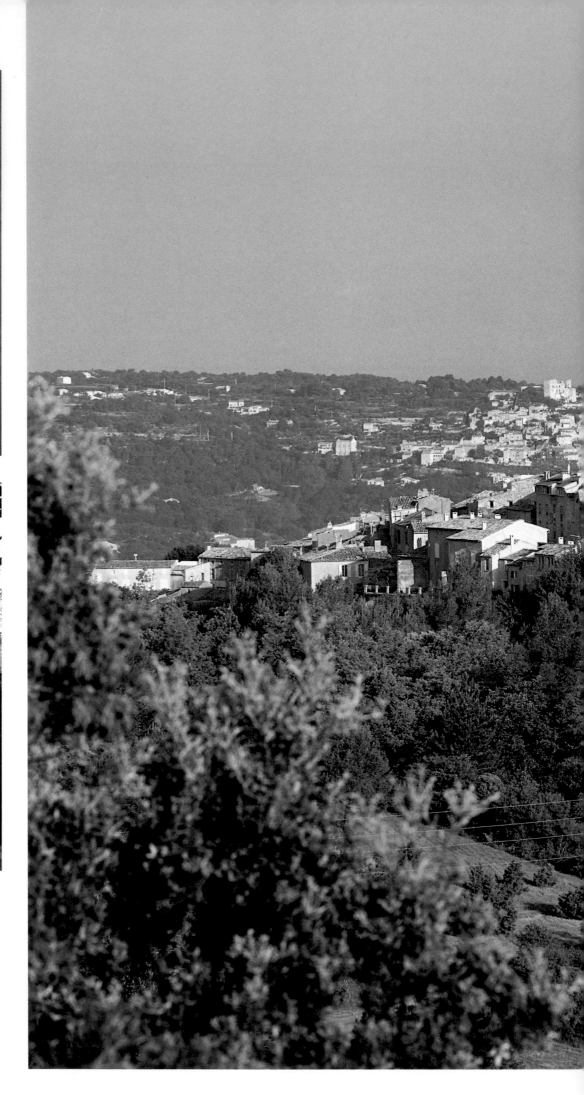

A deserted alley leads to the eighty-six steps which climb up to the shaded Old Church of Bonnieux; traditional Provençal houses shelter behind trees and shrubs in the upper part of the village (top). In the background to the tightly grouped roofs and walls of Bonnieux (right) can be seen the village of Lacoste; its prominent castle, associated with the notorious Marquis de Sade, offers a secular riposte to Bonnieux's spire.

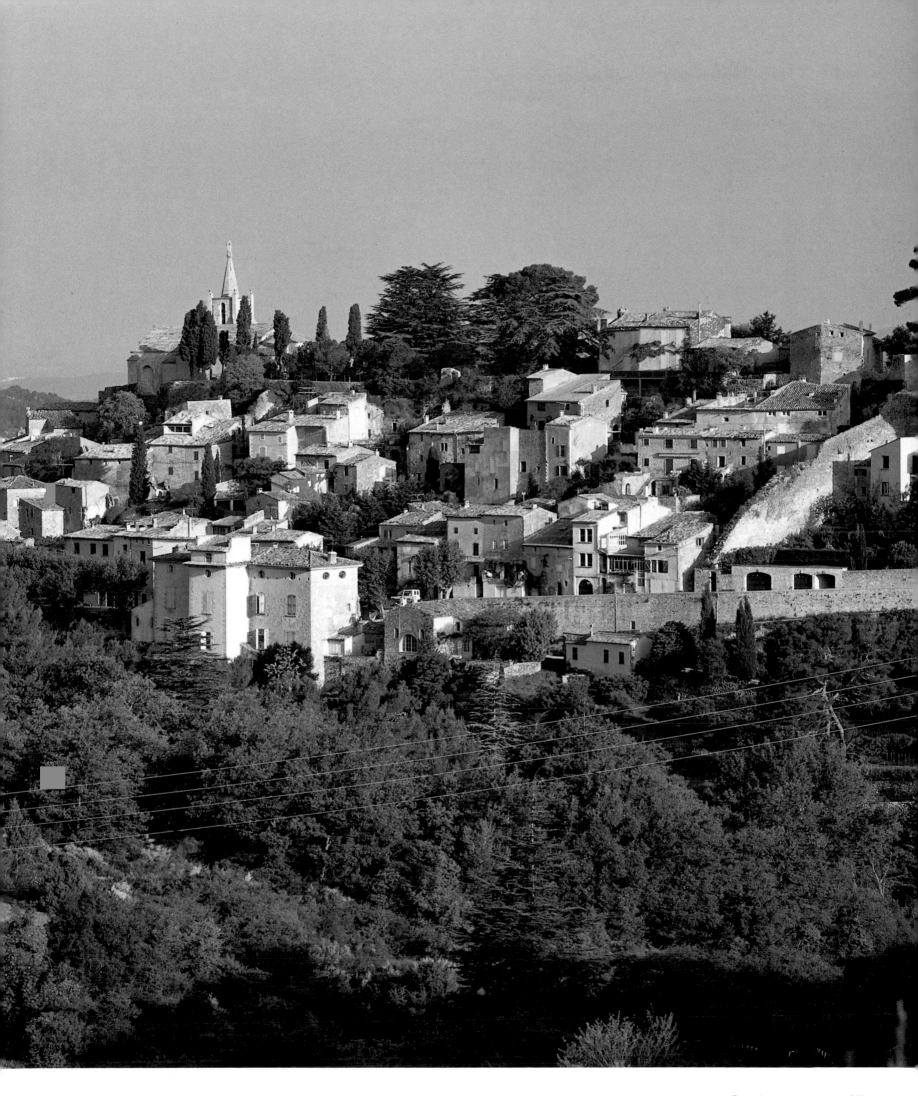

A broad fertile valley (above) *separates the ranges of the Lubéron and the Ventoux. It was here that the original Gallo-Roman settlement of Bonnieux was founded. The sole survival of this is the three-arched Pont Julien* (right), *a magnificently preserved bridge of the third century A.D.; the openings between the arches, as well as giving a remarkable lightness to the structure, had the practical function of allowing the water to pass through it more freely in times of flooding.*

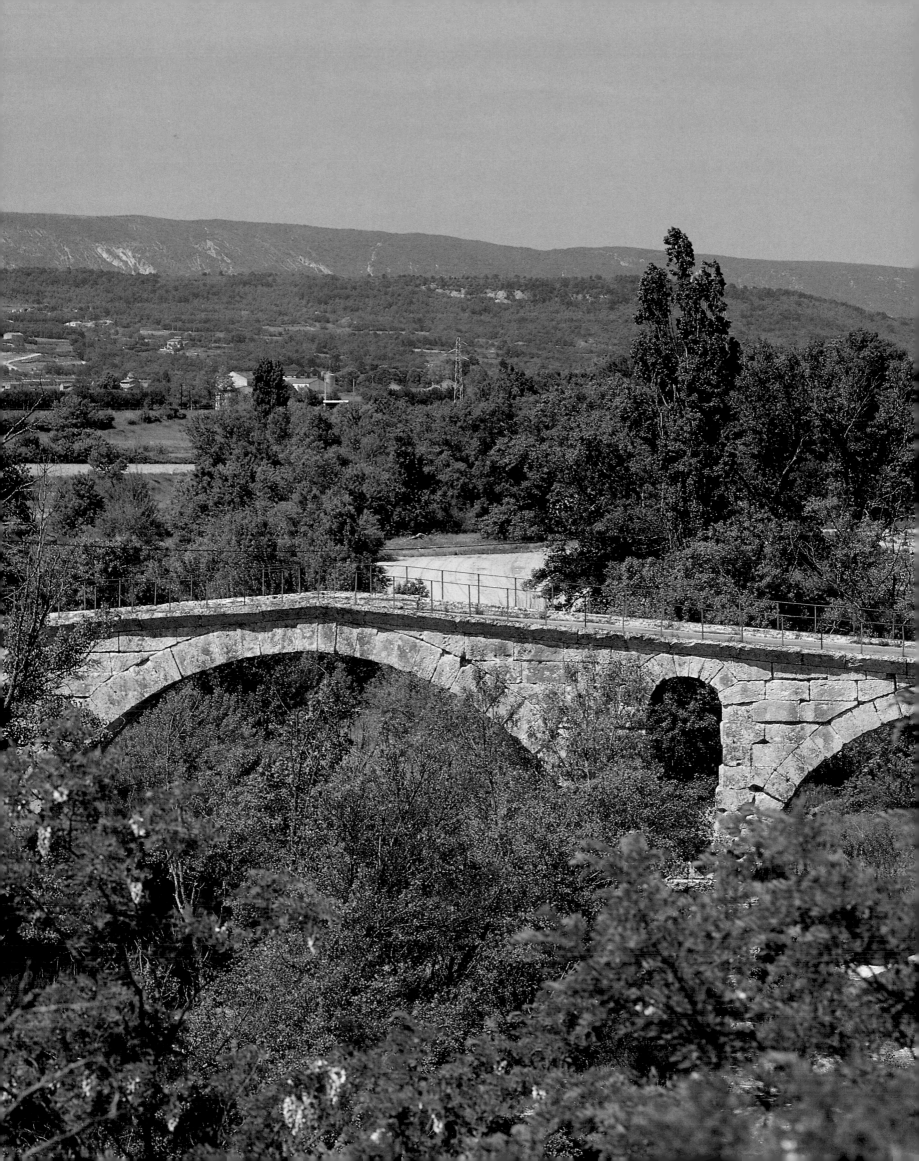

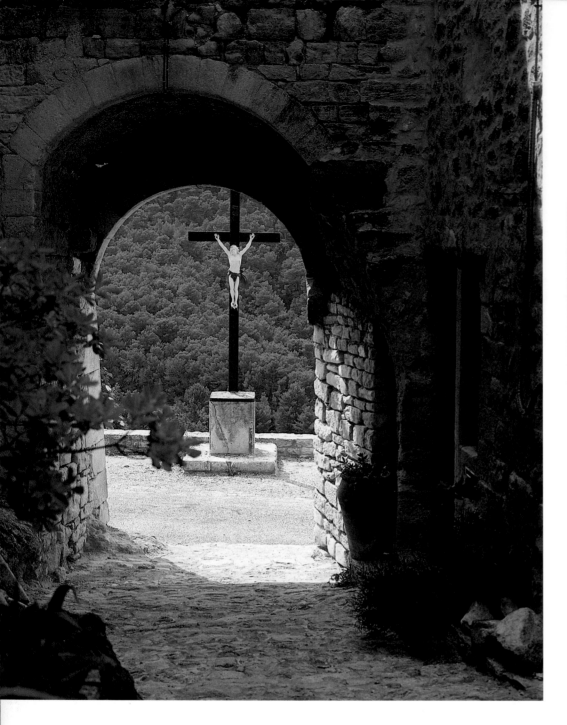

Crestet

VAUCLUSE

THE VERY NAME of this village seems to suggest its dramatic position high up in the range of rocky hills known as the Dentelles de Montmirail. This tiny and exceptionally quiet place, which seems almost abandoned from afar, reveals itself at close quarters to be a medieval miniature stretched out along a single street which ascends towards the extensive ruins of a Romanesque castle. The castle had remained intact right up to the Revolution. Now in the process of restoration, it has superb views over the countryside.

At the lower end of the village street is a jewel of a square which includes a picturesquely arched old house, a Renaissance fountain with four jets of water, and an eleventh-century church dominated by a tall bell-tower in dark stone.

A track from the village leads down to the wooded gorge of the Trignon, where you will find the ruined convent of Prebayon, a seventh-century foundation destroyed in 1563 by the Huguenots, who also massacred the inhabitants of Crestet. The ruins of this isolated site include an overgrown and perilous-looking bridge spanning the narrow Trignon. Other curiosities include a nineteenth-century oratory, a statue of 1897 to the Virgin, and a miraculous source, the waters of which are said to cure eye diseases. Every year, on 15 August and 8 September, large numbers of pilgrims gather here.

A crucifixion glimpsed through an arch at the lower end of the hamlet; a neglected chapel niche attached to one of the buildings around the tiny square: such details give Crestet an almost other-worldly appearance. The Renaissance fountain (opposite) in the centre of the square was made operable again in 1949 and is now supplied with fresh water from the Font-d'Oyers, a source two kilometres from Crestet.

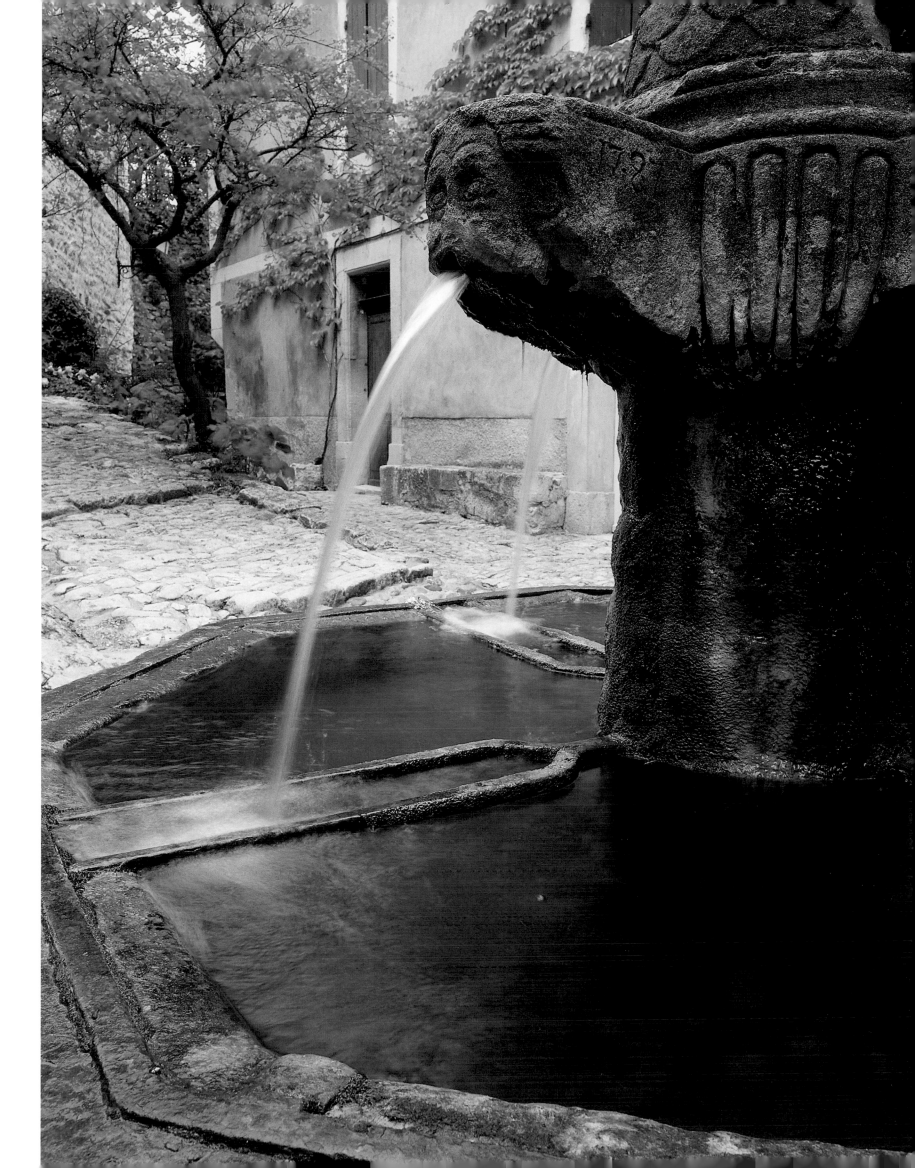

A crude stone carving of Bacchus (top), a reminder of Crestet's proximity to the vineyards of the Côtes-du-Rhône and Ventoux, adds a mysterious, pagan note to one of the cobbled paths (this page) that gently climb from the church to the outlying castle. These paths have recently been brought back to life through the restoration of adjoining houses.

The lower hamlet is dominated by the dark-stone, Romanesque tower of the church (opposite), which commands extensive views of the fertile, vine-covered valley below.

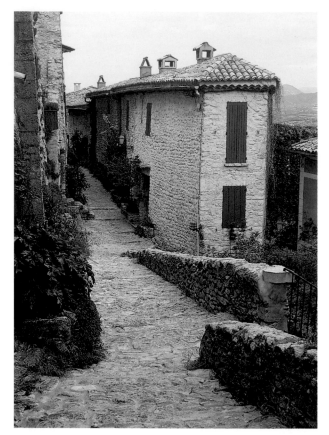

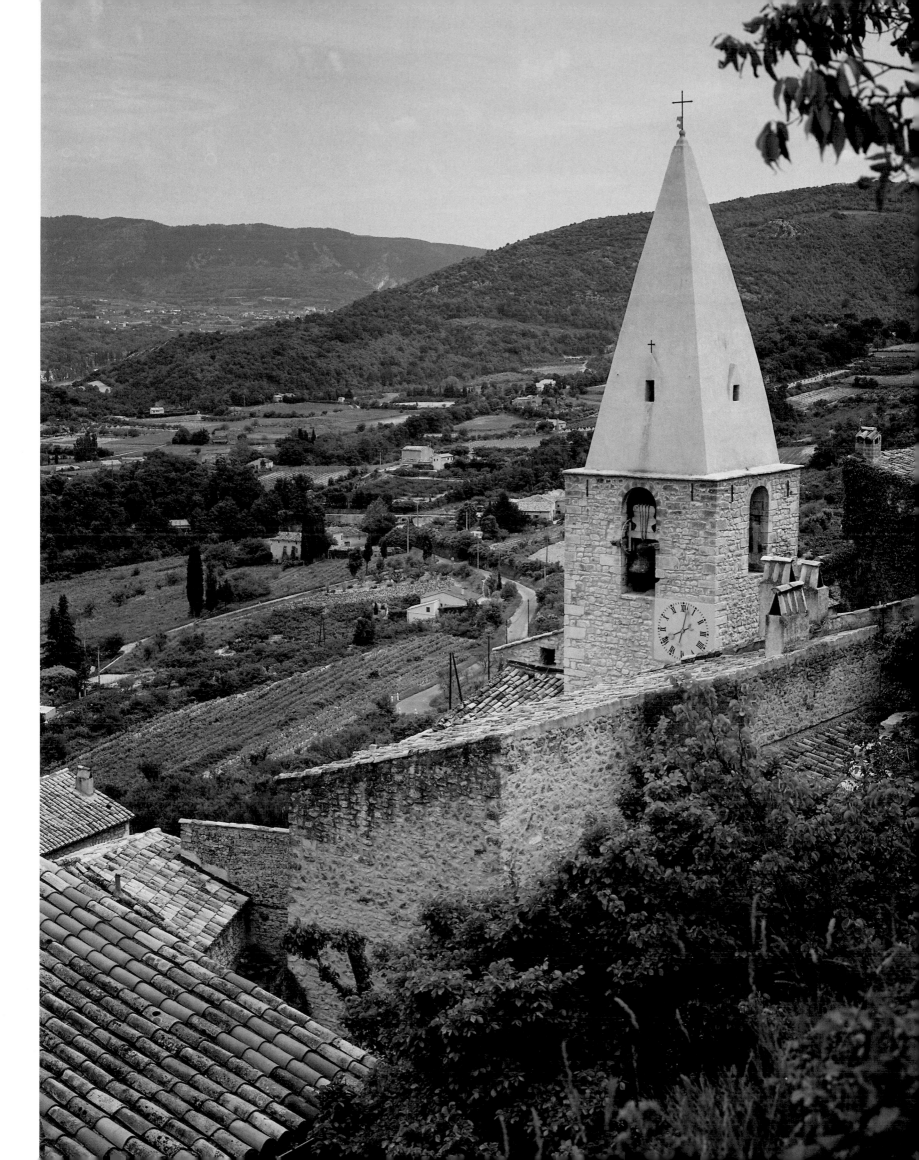

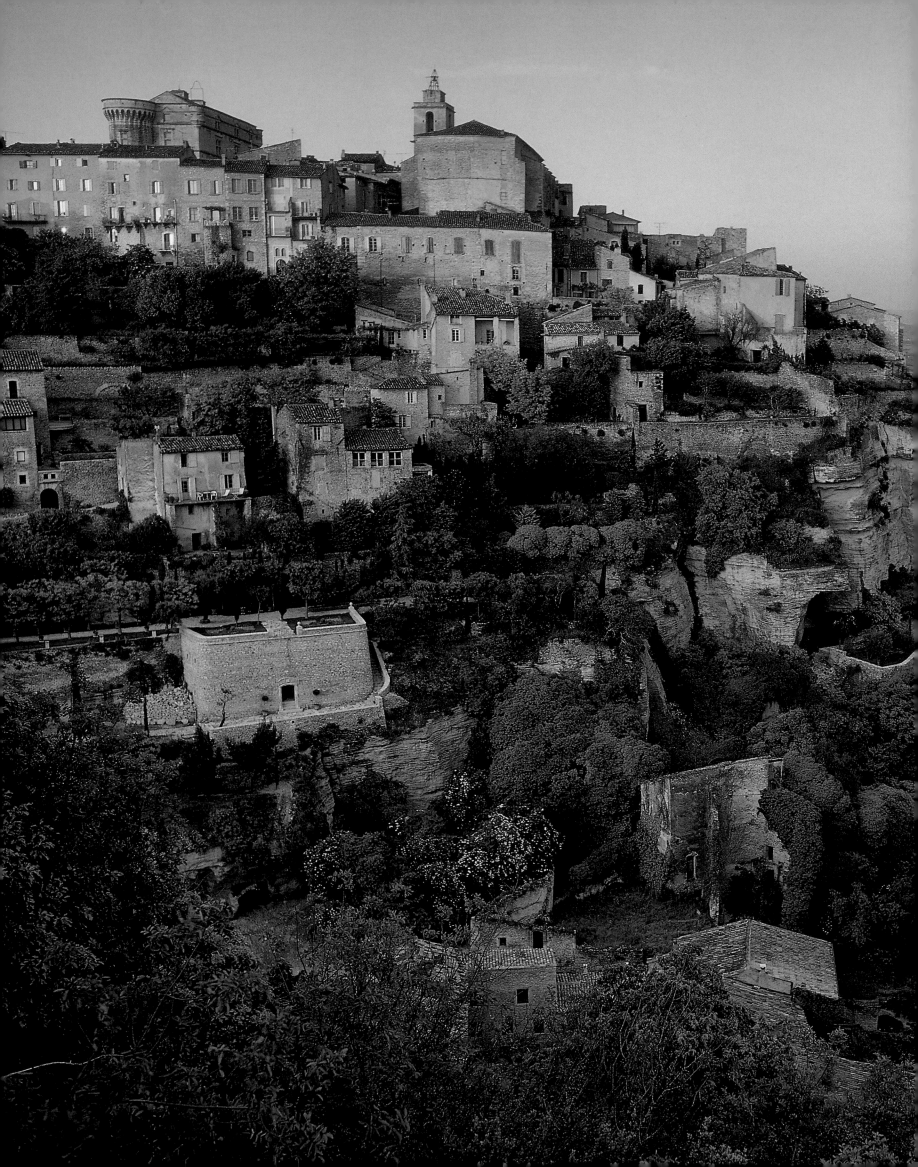

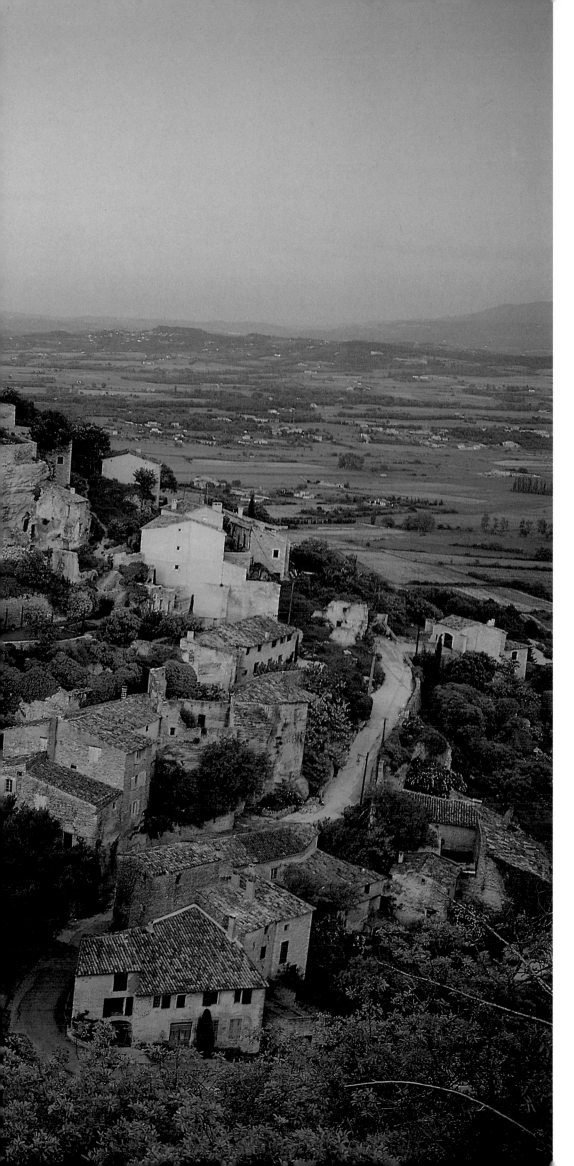

Gordes *VAUCLUSE*

GORDES makes a particular impact when viewed from a distance, where it appears as a monumental Cubist composition rising in tiers up to an imposing Renaissance castle. Much of what you see, though apparently unchanged since the sixteenth century, is in fact due to modern reconstruction. The whole village was virtually razed to the ground by the Germans as an act of retaliation for the killing of one of their soldiers in 1944.

The geometrical look of the village may partly explain its appeal to a particular kind of artist, beginning with the academic Cubist painter, André Lhote, who came to Gordes in 1938 and is often said to be its 'discoverer'. Of greater consequence for the village's popularity was the later arrival of the Hungarian-born Op artist Victor Vasarely. He restored the ruined castle in the course of the nineteen-sixties and transformed it into the first of the four museums devoted to him. The one at Gordes has the attractions of a magnificent roof terrace and an enormous, intricately carved fireplace, the main survival of the original Renaissance interior.

A twilight view of Gordes (left) *from the road leading to the upper part of the village; sitting firmly on the skyline are monuments respectively to God and the Op artist Vasarely: the severe church of Saint-Fermin and the magnificent castle now housing one of Europe's four Vasarely museums. The bulk of the present château was built during the Renaissance, but the machicolated corner tower* (above), *which gives the building so much of its geometrical power, dates from the twelfth century.*

*O*ne of the alleys or 'calades'
climbing up to a characteristic
Provençal clock-tower (opposite)
with an ironwork superstructure;
high stone walls shielding luxuriant
gardens (opposite *and* above) *are a
special feature of Gordes. Vasarely is
inescapable here; one of his rigidly
geometrical sculptures* (far left)
*stands outside the museum devoted to
his work. A simple nineteenth-
century fountain* (left) *adorns a
neighbouring square.*

*The annual Gordes fête in
September is one of the last in
the Lubéron summer season. It is also
one of the liveliest, spreading to
neighbouring villages and attracting
people from miles around, who come
to take part in cycling competitions
and donkey races, to play in the
improvised fairground, to eat and
drink, and above all to dance to the
early hours of the morning.*

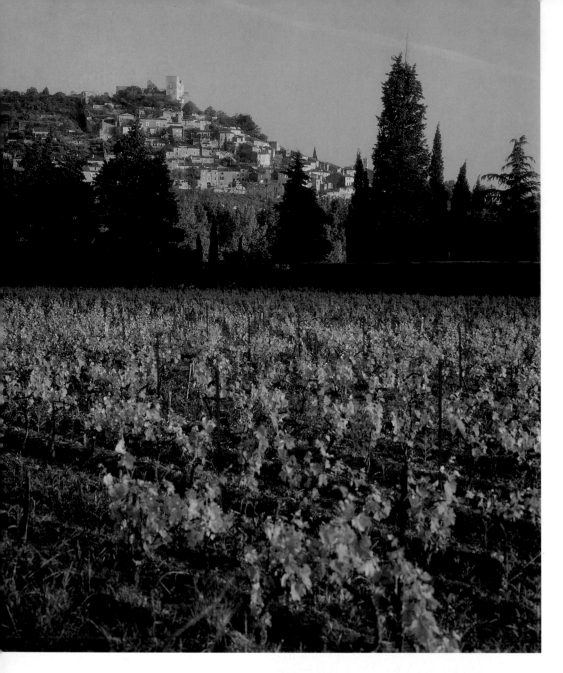

Lacoste

VAUCLUSE

BORDERED on one side by the dark sweep of the Petit Lubéron and on the other by the fertile valley beneath the massive, distant profile of Mont Ventoux, Lacoste is a hill-village built below the ruined castle which once belonged to the infamous Marquis de Sade, whose presence seems to have left a permanent, sinister shadow.

The life of this hauntingly beautiful village is concentrated on its lower street, on which can be found the Café de Sade as well as a gallery named Les Studios de Justine. The remainder of the village, which rises steeply above the street, had been largely abandoned by the nineteen-fifties. At that point, however, many of the properties were purchased by an American artist for conversion into an art school. Other artists and foreigners moved into the village, and the former unpaved alleys of its upper part were cobbled and the houses renovated.

The enormous castle, isolated among shrubs and aromatics, dates back to the eleventh century, and first achieved notoriety in 1545 when the Baron of Oppède imprisoned over three hundred members of the heretical sect of the Vaudois there and had them raped, tortured and killed. The building was greatly enlarged and altered in the late eighteenth century by the Marquis de Sade, with money provided by his wealthy wife. The Marquis had little interest in Provence, disliked the villagers of Lacoste, and abhorred rural life. But he did develop a great passion for his castle and made it the setting for the two fantasies written in his later years in prison, *Justine* and the *One Hundred and Twenty Days of Sodom*. The castle, left in ruins after the Revolution, became a place of pilgrimage this century for Surrealist artists and writers, such as André Breton.

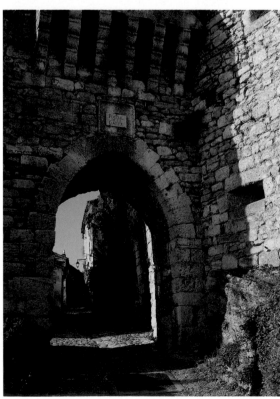

The former Protestant bastion of Lacoste is seen (above) *rising over the cultivated fields that separate the village from the fervent Catholic stronghold of Bonnieux. The crowning ruins of the castle of the Marquis de Sade are the main survival of a medieval defensive system which includes the impressive gateway* (right), *defensive walls* (opposite) *and fortified houses* (overleaf).

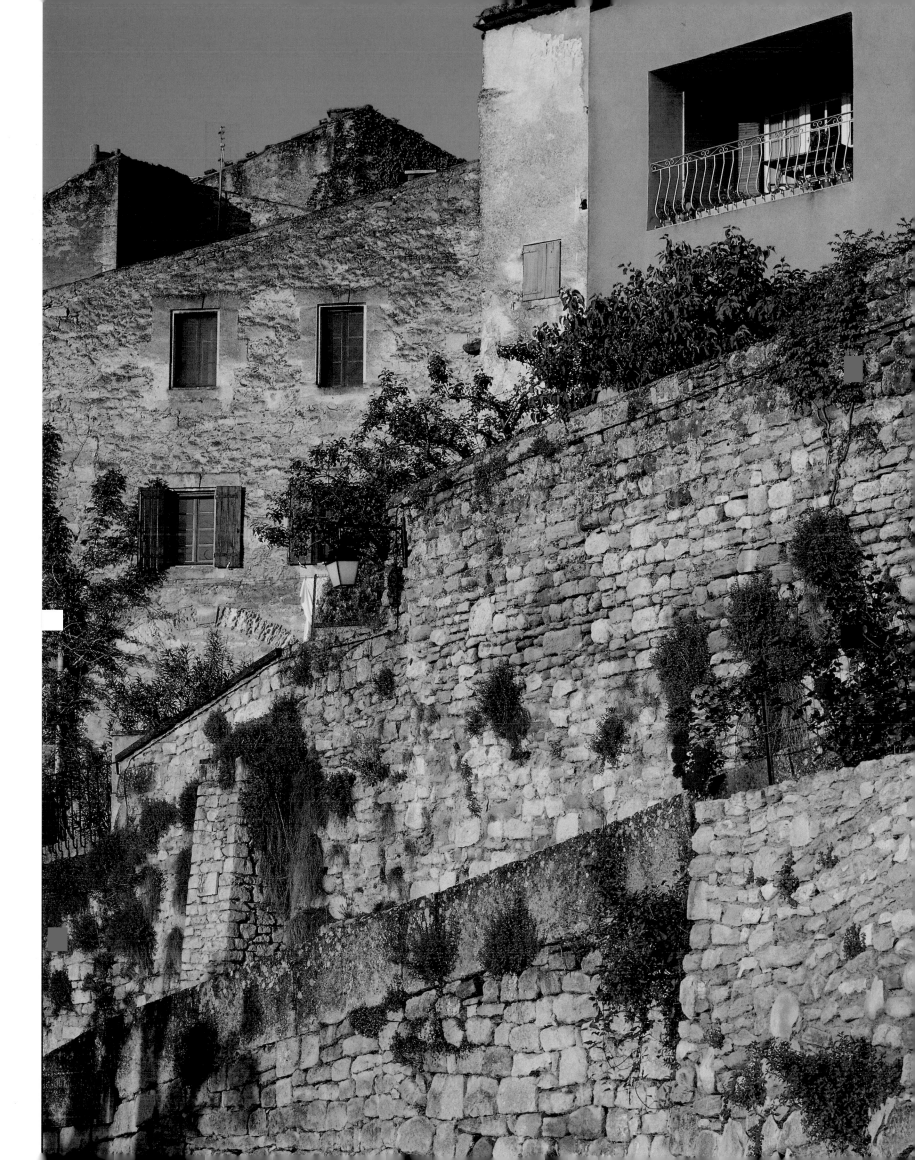

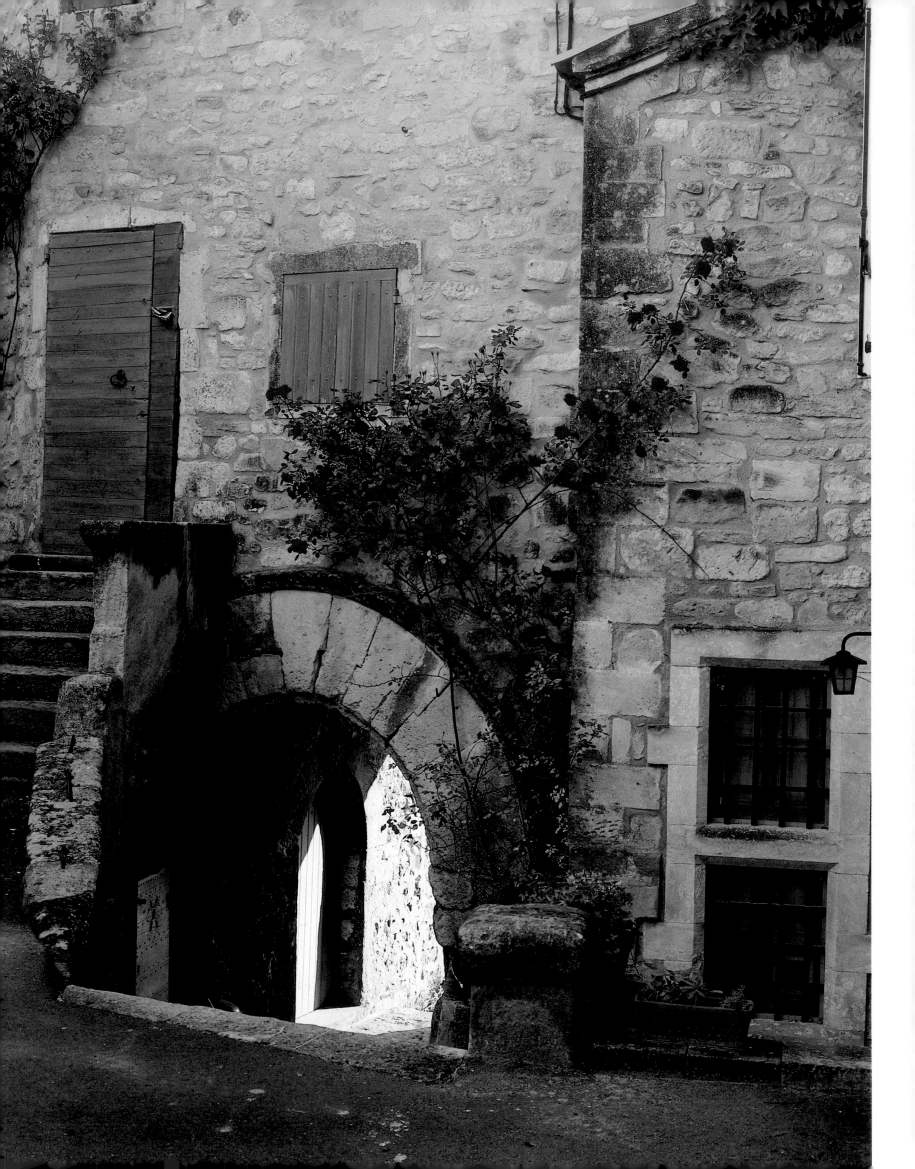

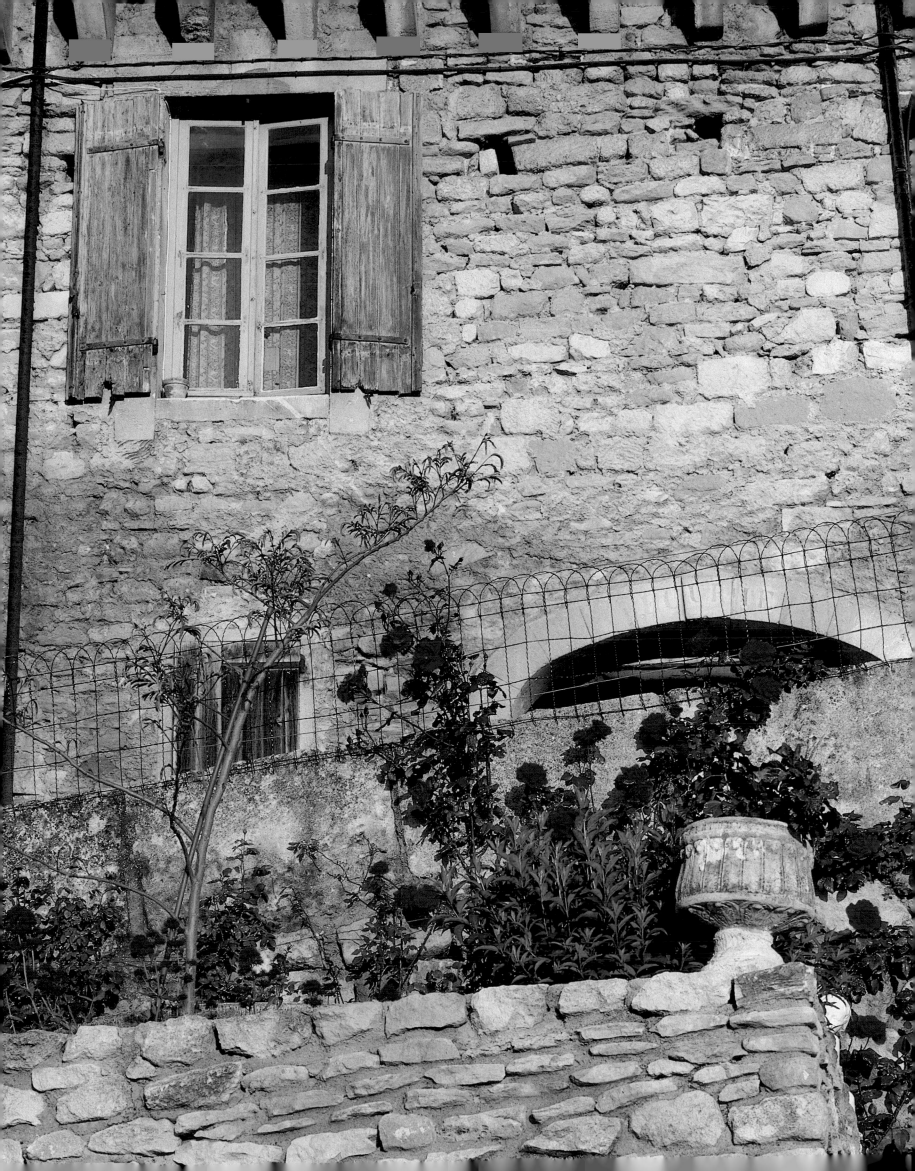

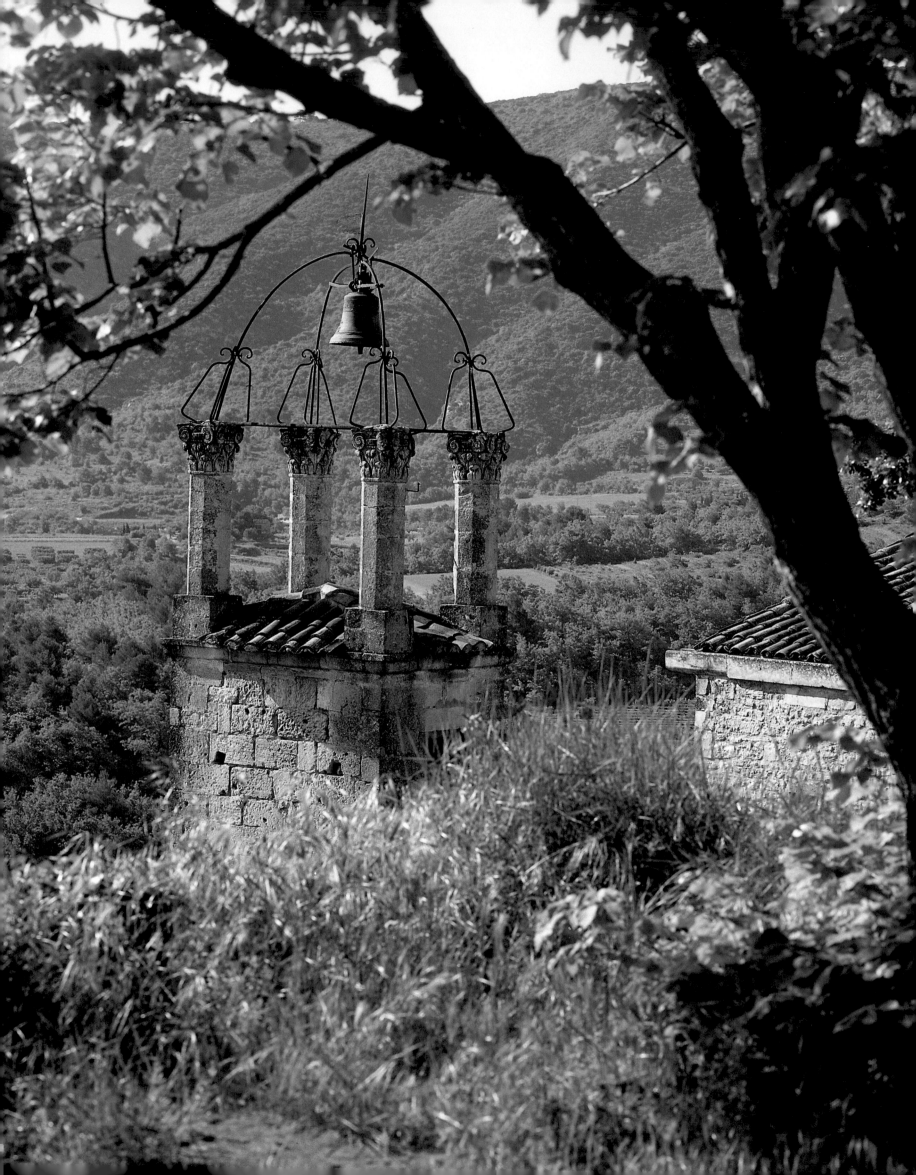

The charming village bell-tower (opposite), *its ironwork superstructure resting on Corinthian columns, stands at the entrance to the grounds of the ruined castle; the wooded range of the Lubéron looms in the background* (above). *The Mairie* (left) *was moved in the nineteenth century from the upper village to its present position on the small square overlooking the delightful Hôtel de France.*

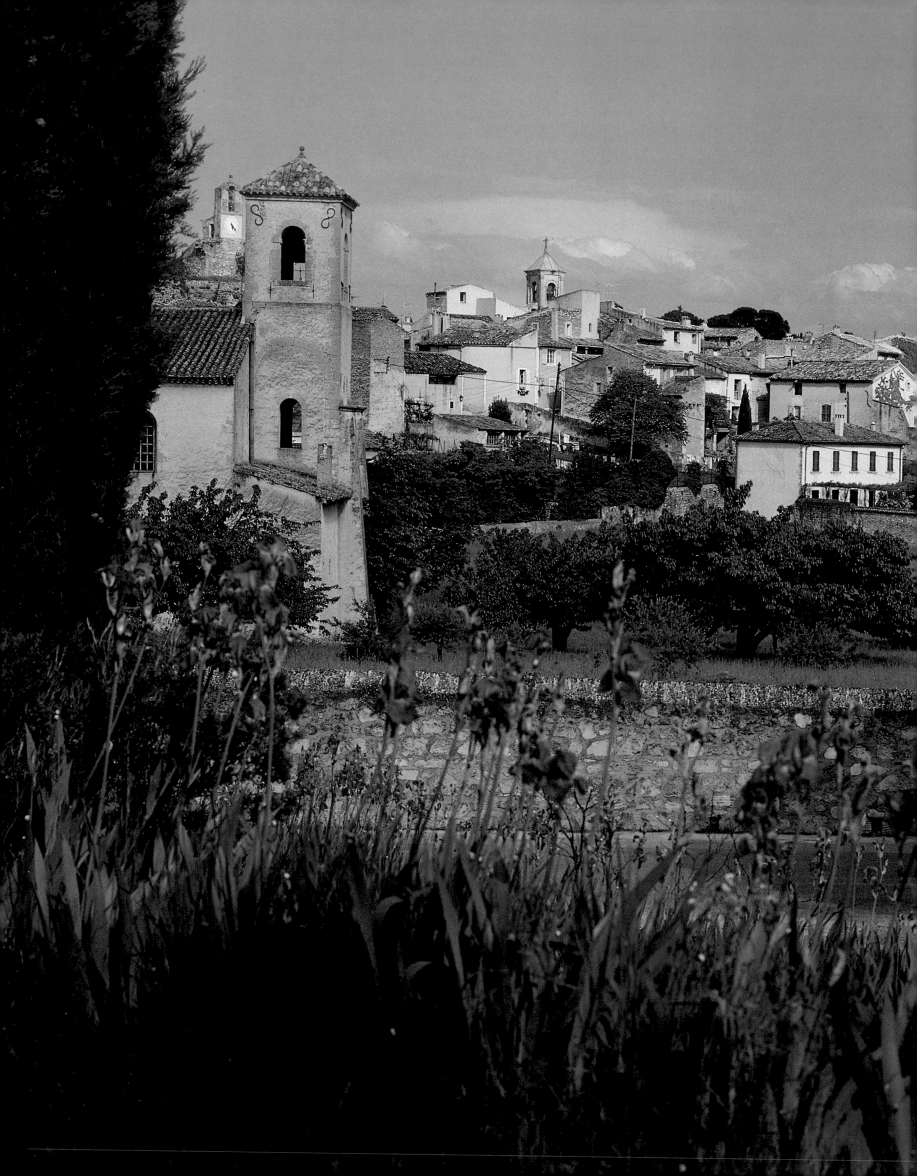

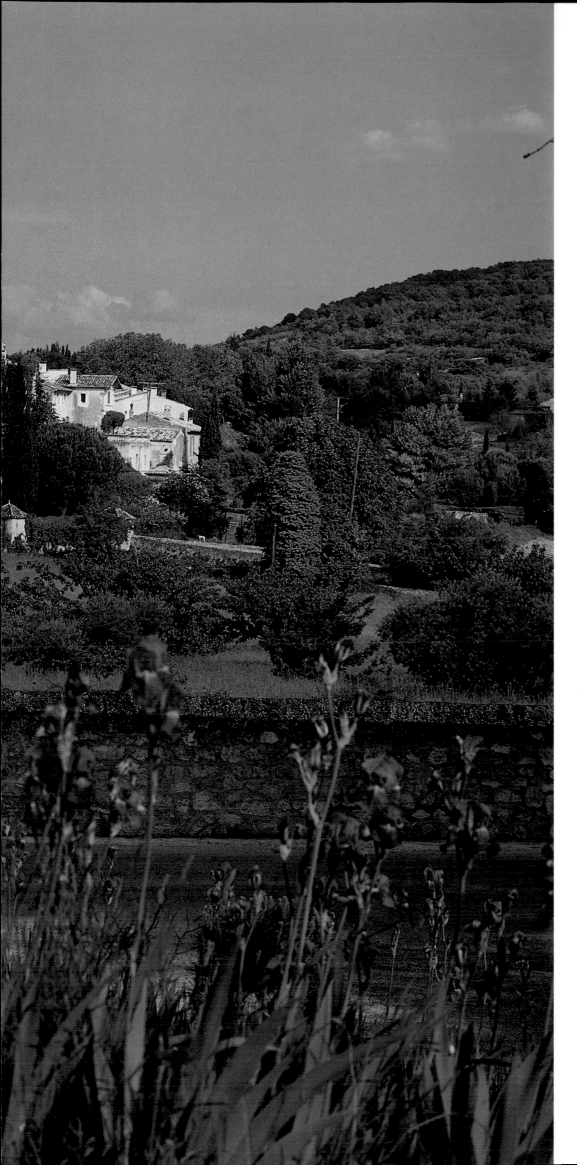

Lourmarin

VAUCLUSE

DRIVING FROM Bonnieux along the spectacular small road which winds its way down the ravine separating the Grand and the Petit Lubéron, you emerge into an open, scented countryside of orchards, vines and lavender fields. In contrast to the enclosed, isolated world on the northern slopes of the Lubéron, this is a more obviously Mediterranean landscape, and there is even a strong hint of Italy in the Renaissance bulk of Lourmarin's castle, a building which stands among fields, a short distance away from the mound on which the village itself is built. Dating mainly from the fifteen-forties and containing inside some magnificent Renaissance fireplaces, the château was abandoned in the nineteenth century, then later used by gipsies taking part in the pilgrimage to Les Saintes-Maries-de-la-Mer. A local tradition has it that the gipsies were responsible for the strange graffiti on one of the inner walls, and that they put a curse on the place shortly after being evicted prior to the thorough restoration undertaken in the nineteen-twenties.

Between the château and the village is an isolated small church which was built for Protestants, who made up the majority of the population during Lourmarin's heyday in the fifteenth and sixteenth centuries. A young Englishman, Henry Dundas Shore, is buried in the nearby cemetery, in a tomb which points towards England and has an inscription recording that he had died in Lourmarin 'on his return from Nice, whither he had gone for the restoration of his health'. Another tomb, of great simplicity, is that of the novelist, essayist and playwright Albert Camus, who purchased a small house in Lourmarin shortly after winning the Nobel prize for Literature in 1957. However, his period spent in the village was a short one, for he died tragically in a car crash near the village while being driven to Paris in 1960.

The village is seen here from a point on its outskirts. Lourmarin's former Protestant community, despite being in a majority, were only allowed to build their temple outside the village, where its tower rises over cultivated fields. At the top of the village behind can be seen the tower of the church of Saint-André-et-Saint-Trophime, a Gothic structure of the fifteenth century.

The many fountains of Lourmarin (this page) *testify to the village's enduring prosperity, as does its general air of neatness. Lourmarin's large and splendid château* (opposite) *has substantial fifteenth-century fortifications adjoining an elegant Renaissance centre-piece.*

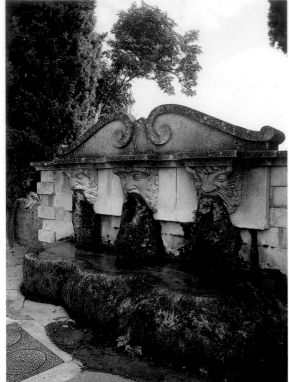

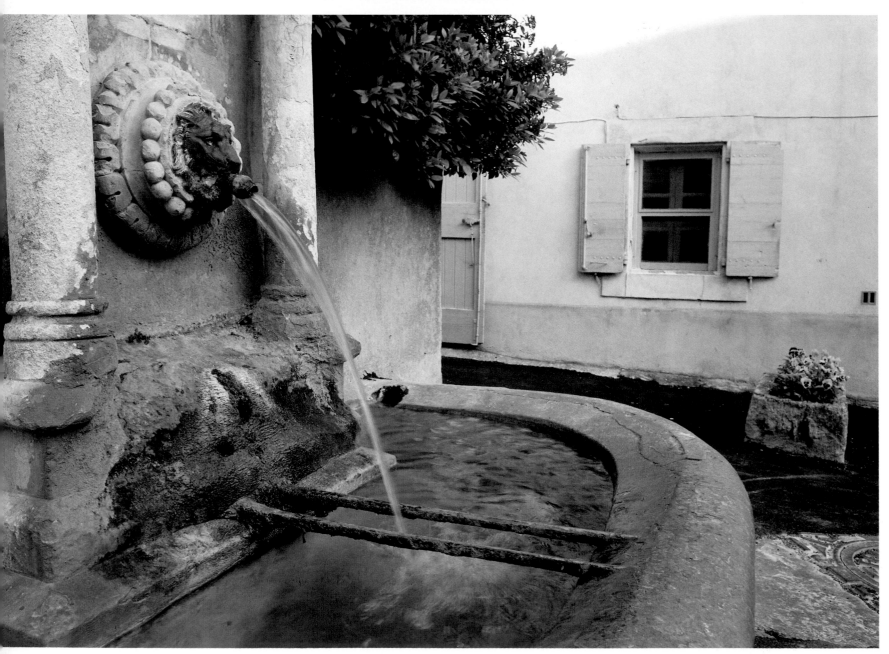

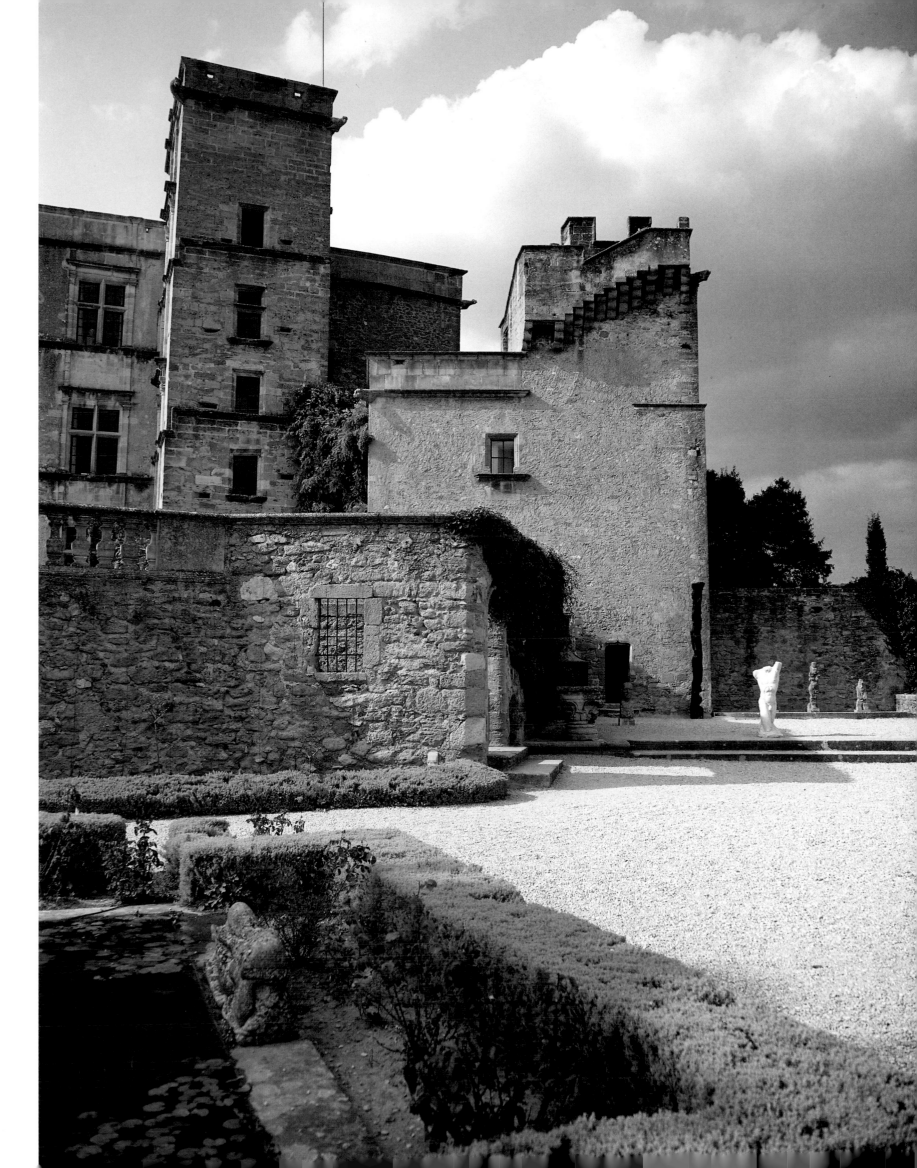

Ménerbes

VAUCLUSE

MÉNERBES lies along the top of a narrow, wooded hill below the northern slopes of the Lubéron. It was a Protestant stronghold in the sixteenth century, then later a refuge to a debauched contemporary of the Marquis de Sade, Count Rantzau, who fled there from his native Denmark in 1766. He had been implicated in a plot against the Danish queen; at Ménerbes he lived with a beautiful young dancer, Sophie Livernet, whom he passed off as his daughter. In more recent times the village has played host to a number of distinguished artists: Picasso left his Yugoslav mistress Dora Maar with a house in the village, while Nicolas de Staël purchased an old property there before abandoning his wife and leaving for Antibes. The only famous person commemorated today in Ménerbes is the turn-of-the-century poet Clovis Hugues, a friend of Mistral and a fellow member of the group of Provençal revivalists known as the Félibrige.

Whereas other Provençal hill-villages differ in character between their lower and upper halves, Ménerbes is an elongated community, where the principle division is between its western and eastern sides. The former side is the livelier of the two, and contains the village's café and a handful of shops, including the butcher's made famous by Peter Mayle's *A Year in Provence*. The most interesting monuments, however, are to be found in its quiet, eastern side, where extensive remains of fortifications can be seen. Half-hidden among trees on the hill's ledge is a small but sturdy fortress built in 1584 after the ousting of the Huguenots. This was completely restored in the nineteen-seventies by the pioneering historian of the Impressionists, John Rewald.

Beyond the fortress is the fourteenth-century parish church of the Assumption, which houses primitive painted panels from the nearby former monastery of Saint-Hilaire. The church stands at the edge of an atmospheric and ruined cemetery, which occupies an excellent vantage-point at the westernmost end of the fortifications. From its walls the citadel can be seen below, standing in isolation on a rock. Originally built in the thirteenth century but rebuilt after 1577, this structure contains within its defensive walls a residence used by both Count Rantzau and Nicolas de Staël.

Ménerbes, seen here from the lower slopes of the Petit Lubéron, stands proudly on a ridge at one end of which is a thirteenth-century citadel; a short distance behind this can be seen the tower of the village's fourteenth-century church.

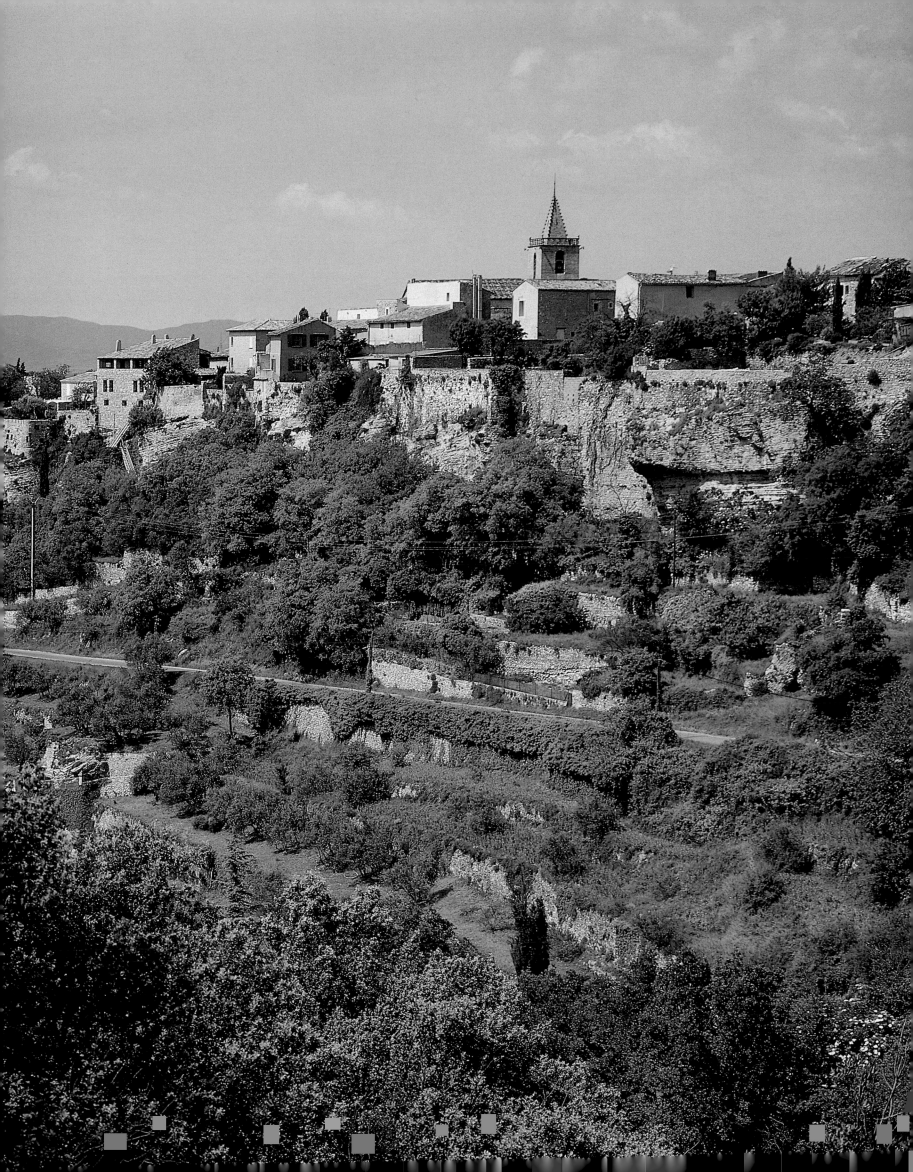

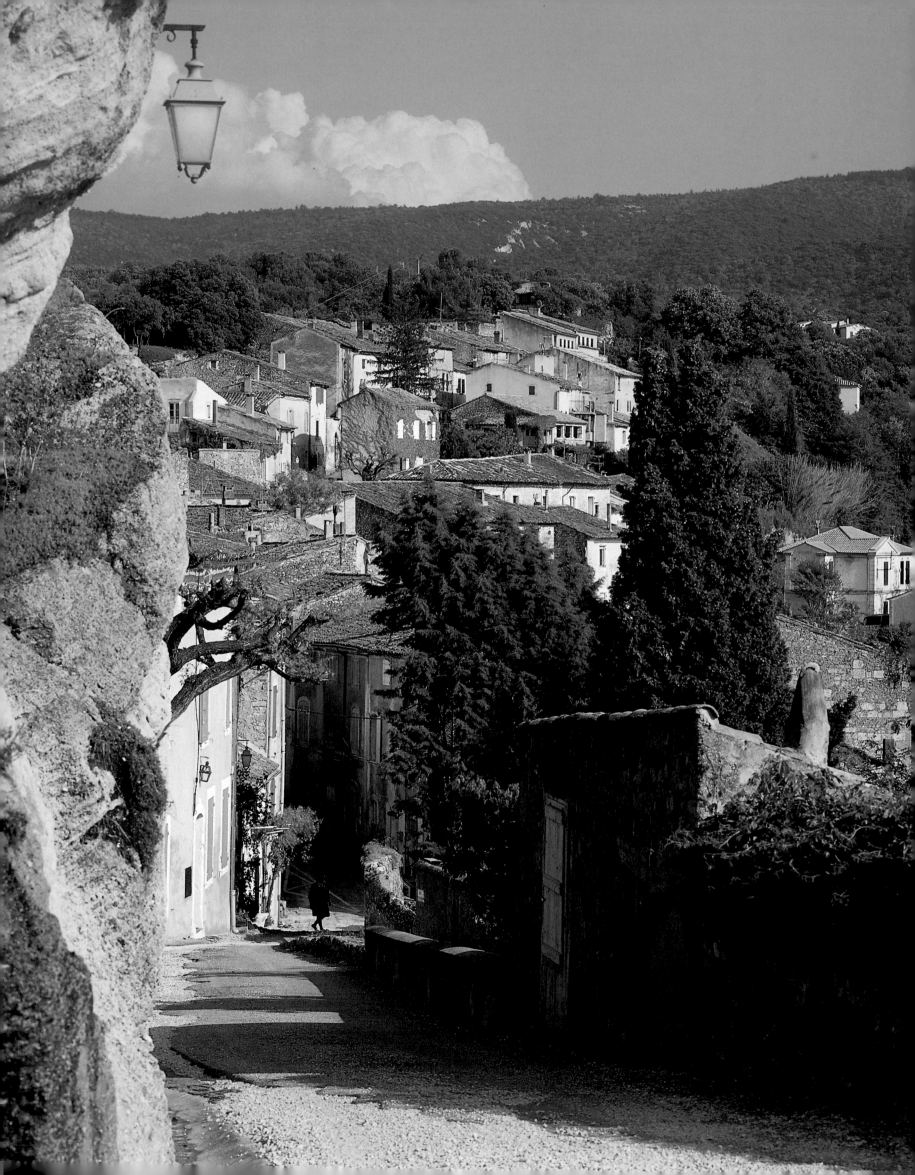

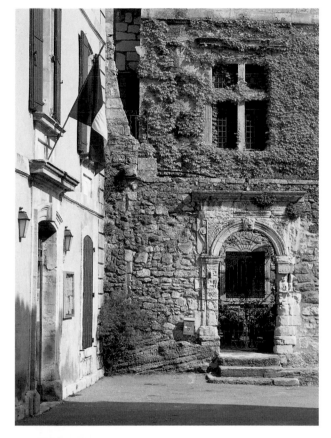

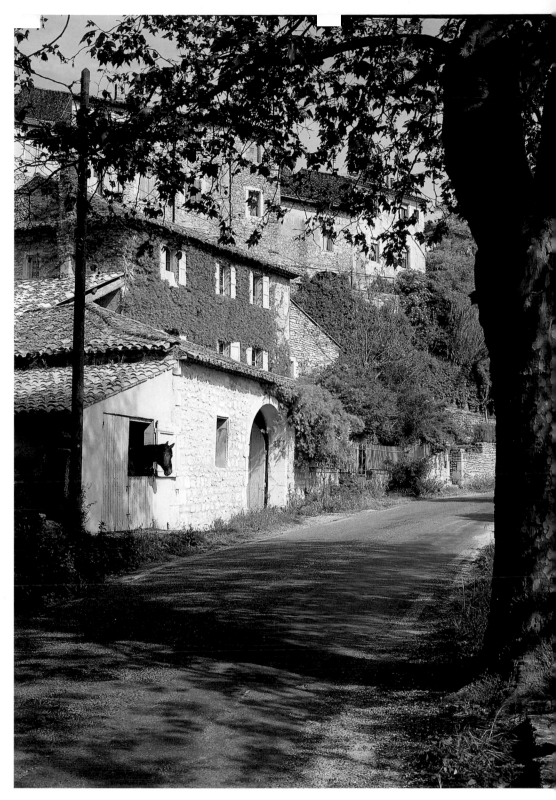

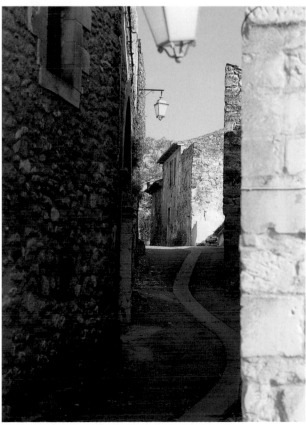

*L*ooking east from the street leading to Ménerbes'
privately owned castle (opposite); the wooded slopes
of the Petit Lubéron rise up in the background. A palace
overlooking a tiny late-Renaissance square (above left)
on the southern side of the village serves today as the
Town Hall. This deserted alley (left) joins the castle of
Ménerbes with the parish church. The road behind
Ménerbes (above) leads immediately to the enchanting
wooded valley separating the village from the Petit
Lubéron; the stables in the foreground mark the sharp
transition between the village and countryside.

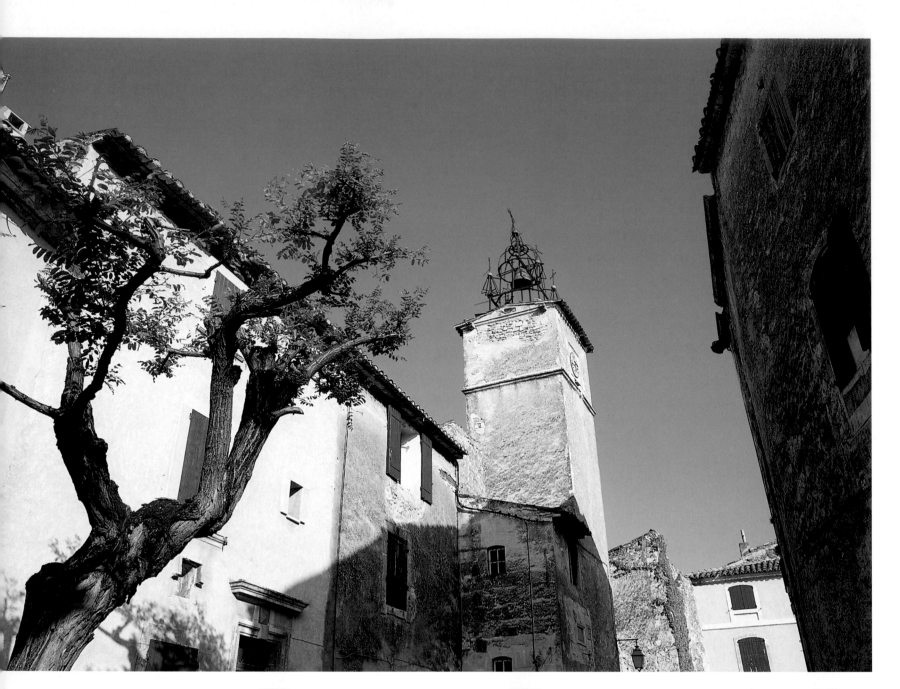

*T*he village of Ménerbes boasts
many evocative features on its
eastern side, such as this old fountain
(right) *in a deserted square seemingly
suspended in timelessness. The parish
church* (above) *is set back slightly
from the village on a rocky mound.
The cemetery beyond* (opposite) *forms a quiet and barely disturbed
panoramic terrace with magnificent
views of the citadel* (far right), *the
wooded slopes of the Lubéron and the
valley of the Coulon.*

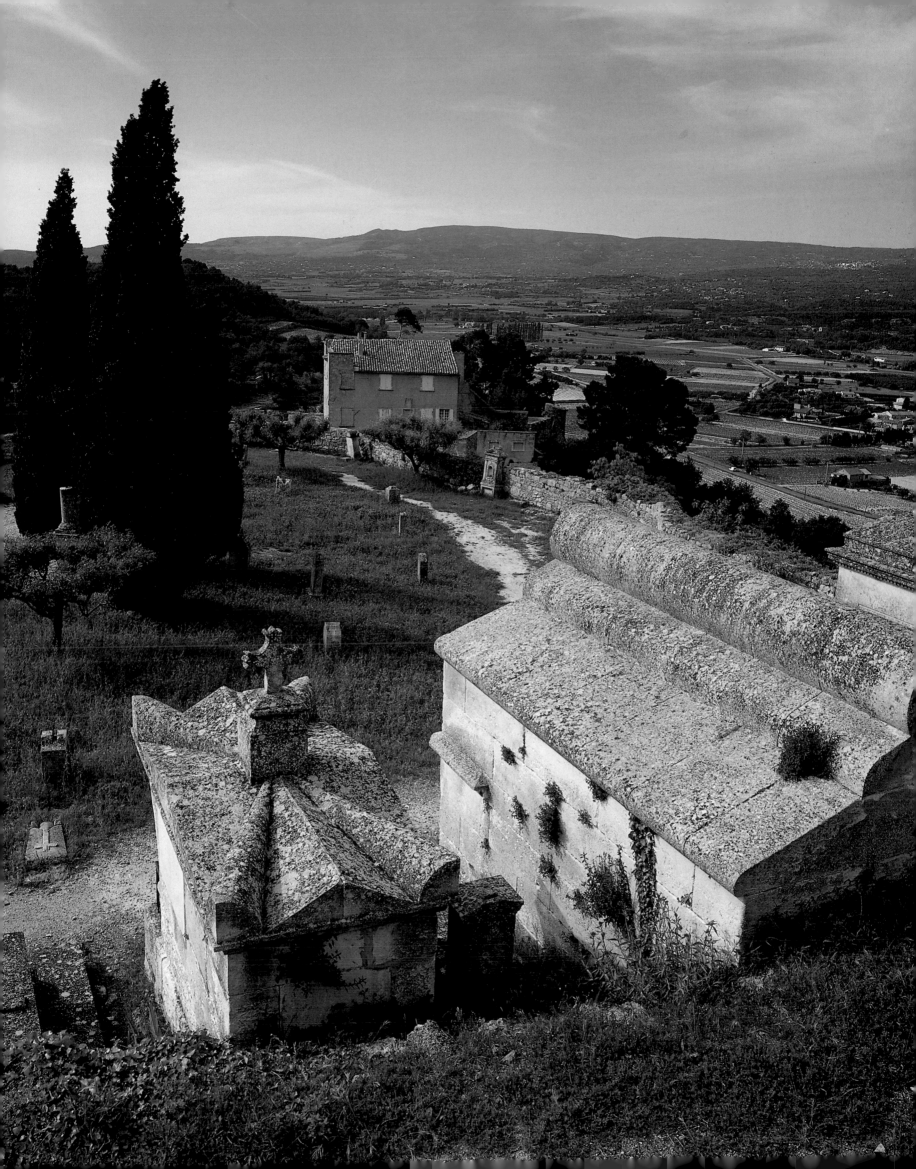

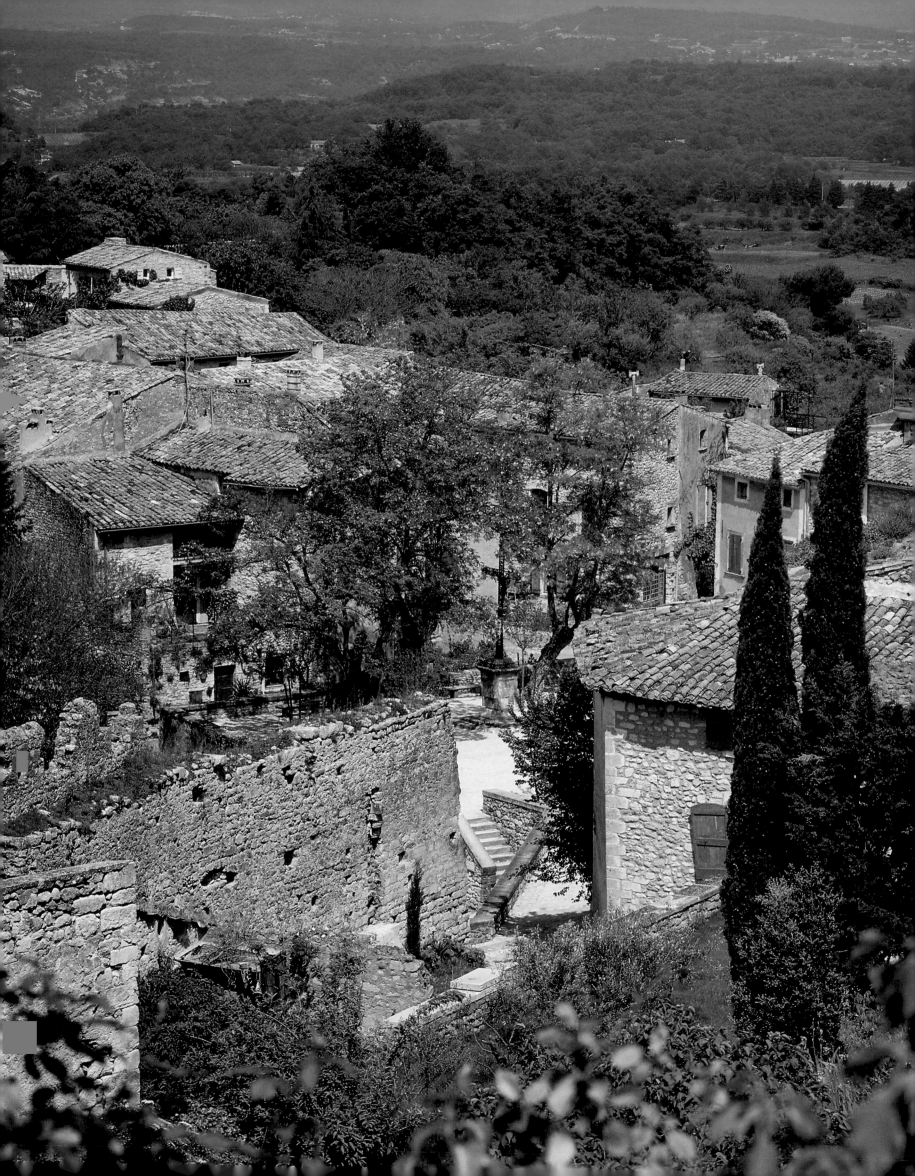

Oppède-le-Vieux

VAUCLUSE

ONE OF THE MOST atmospheric of Provence's ruined villages, Oppède-le-Vieux clings to an overgrown limestone crag on the northern slopes of the Petit Lubéron. When approached on foot, either from the wooded path leading to Bonnieux or from the one steeply descending from the Lubéron's crest, the place could easily be imagined as some Romantic illustration of the idea of the Sublime.

Developed by the Counts of Toulouse in the thirteenth century, then sacked by the Aragonese in 1409, Oppède was made a baronetcy in 1501 and entrusted by Pope Alexander VI to the Maynier family. The cruel first Baron of Oppède, Jean de Maynier, seems never to have lived in his fiefdom, but nonetheless brought notoriety to its name after his involvement in 1545 in the massacre of the heretical sect known as the Vaudois.

Deprived of its military importance, Oppède lived on as a modest agricultural community until 1912, when its rapidly declining fortunes led its remaining villagers to be rehoused in the new settlement of Oppède-les-Polivets, lower down the valley. At the outbreak of the Second World War a group of young artists and architects, including the wife of the novelist Saint-Exupéry, took refuge among the ruins, and briefly established here an idealistic, self-sufficient community. More recently a growing number of buildings grouped around the well-preserved lower defensive walls of the village have been converted into holiday homes, cafés and antique shops.

Fortunately, however, the greater part of the site retains its unspoilt, ruinous charm, and you might well think that you are entering some untended classical site as you walk up the fragrant, herb-choked path towards the main surviving structure in the village's upper half: the dramatically exposed church of Notre-Dame-d'Alydon. Higher still, and half-hidden among trees and thicket, are the remains of the twelfth-century castle, where vertiginous views can be had of a wooded ravine and limestone scars, a truly sublime experience.

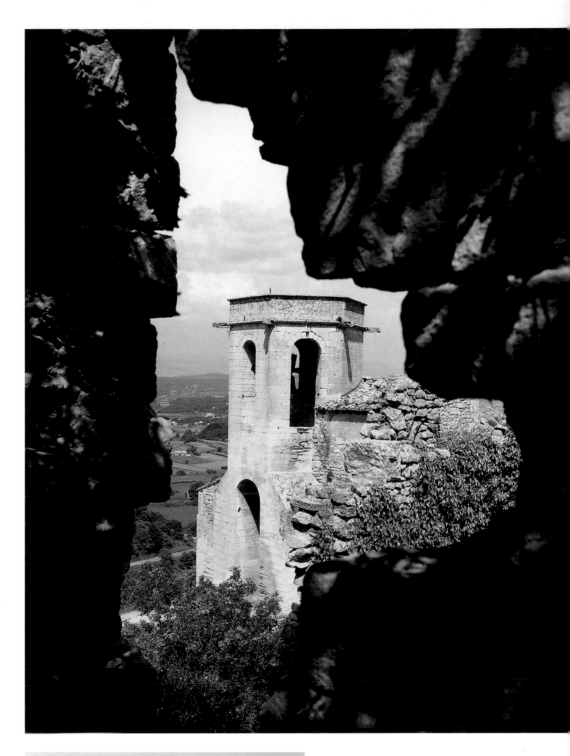

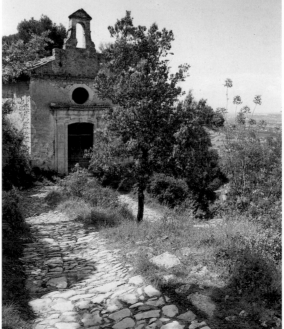

The lower part of Oppède-le-Vieux (opposite) has become inhabited once again in recent years. Through this gap (above) in the bramble-covered ruins of Oppède's castle there is a fine view of the octagonal bell-tower of the isolated church of Notre-Dame-d'Alydon, a Romanesque structure rebuilt in the sixteenth century and extensively restored in the nineteenth; in the distance the fertile fields of the valley of the Coulon roll down towards the modern settlement of Oppède-les-Polivets. The nineteenth-century chapel of Saint-Antonin (left) is built alongside the rocky path leading to the top of the village.

57

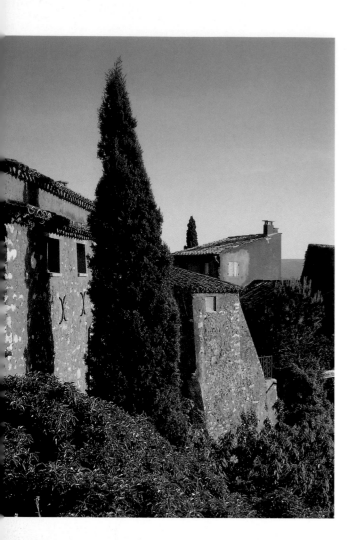

Roussillon
VAUCLUSE

THE RUSSET RED colouring, which tints every surface in Roussillon and gave the village its Latin name of Viscus Russulus (the red hill), is caused by the dust from the extraordinary ochre cliffs on which it stands.

With its surviving medieval walls, surrounding pines, and impressive location between the Lubéron and Mont Ventoux, Roussillon is beautiful enough. But it is given a wholly memorable, and indeed hauntingly surreal quality, by the strange, ochre landscape below it. The vivid greens of the pines highlight the lurid reds, yellows and oranges of fantastical rock forms shaped both by erosion and by recent quarrying. The whole setting amounts to perhaps the closest European equivalent to the canyons of Colorado and Arizona.

Roussillon is also famous for having inspired the American sociologist Laurence Wylie to write one of the finest recent studies of French rural life, *Village in the Vaucluse* (1957). Wylie describes a primitive but essentially friendly community which is somewhat different from the Roussillon of today and the hostile, oppressive Roussillon which the author Samuel Beckett encountered while taking refuge there during the Second World War. The boredom of village life drove Beckett to a nervous breakdown, though at least the environment was memorable enough for him to mention it in his play *Waiting for Godot*.

This panorama of Roussillon from the Apt road (right) gives a marvellous impression of the village as a medieval stronghold, while the rock of its ancient fort rises in the background above the church. Just out of sight is the extraordinary Chaussée des Géants (left), an abandoned ochre quarry described by the actor Jean Vilar as 'the ultimate of tragic stage sets, a red Delphos'. The ochre colours virtually every building (above left).

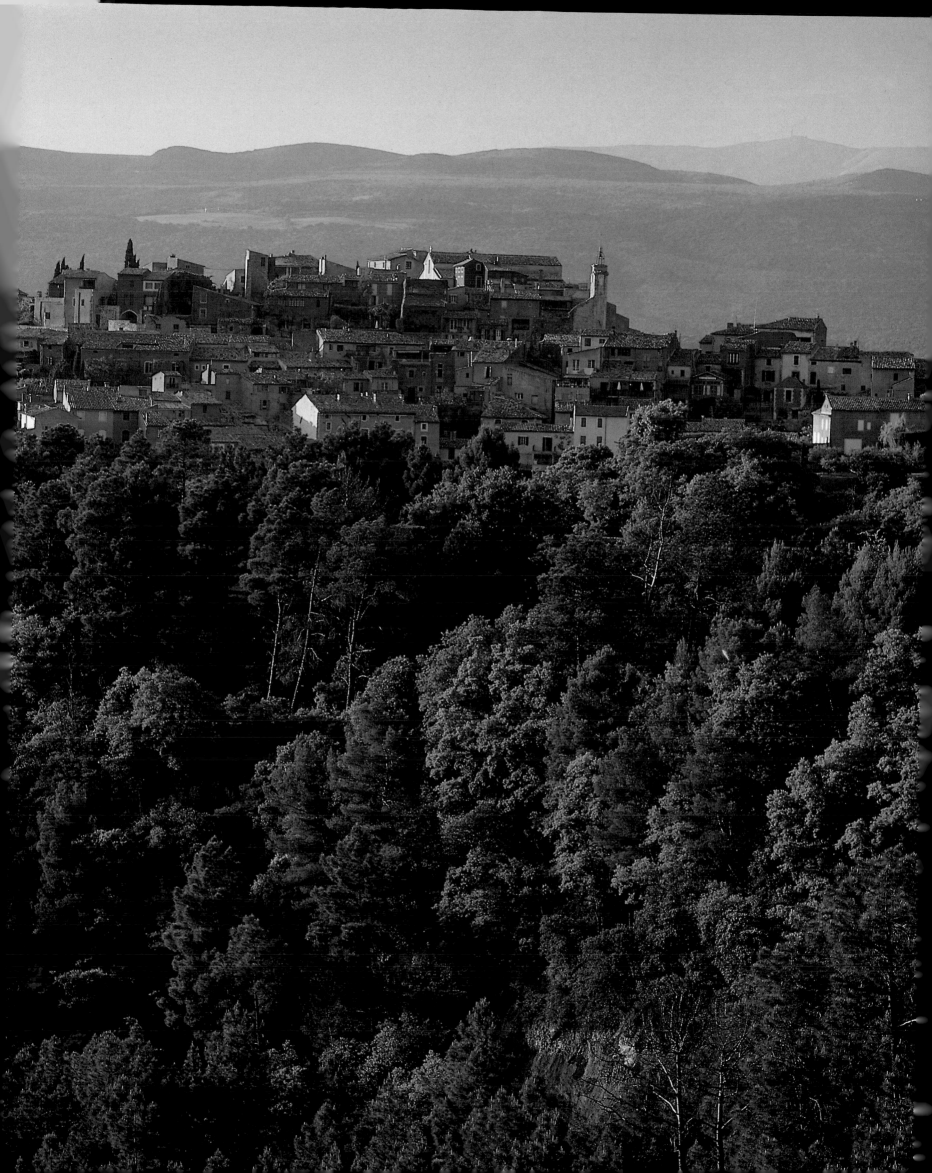

Roussillon's primary attraction is its setting, but arched alleys, eighteenth-century portals and ruined masonry around the fort give the village a certain haunting appeal. A pigeonnier or dovecot, a traditional feature of Provençal houses, forms a near-abstract composition in the ochre colours of the village (opposite).

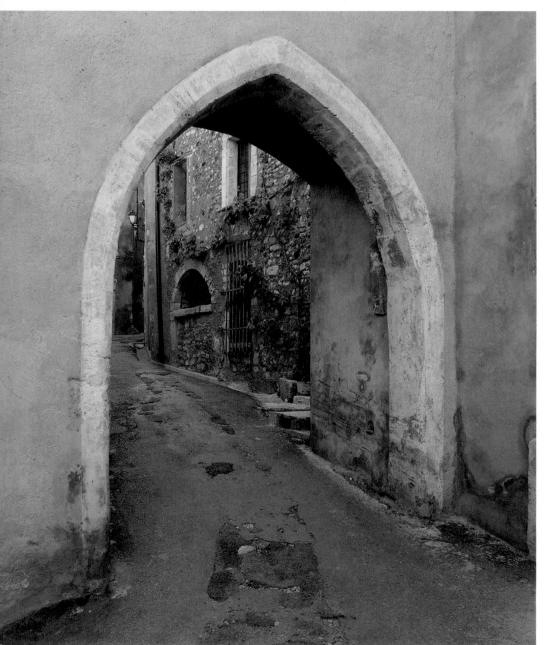

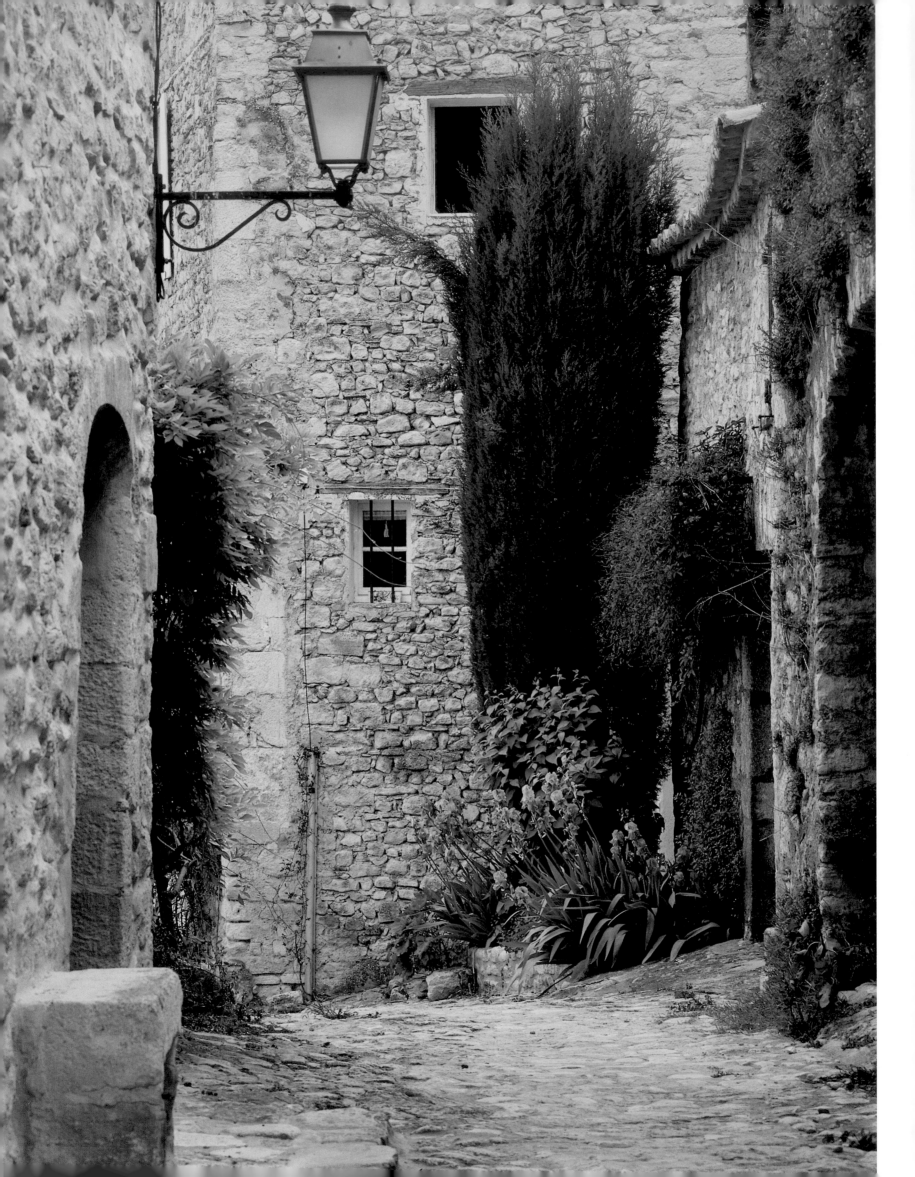

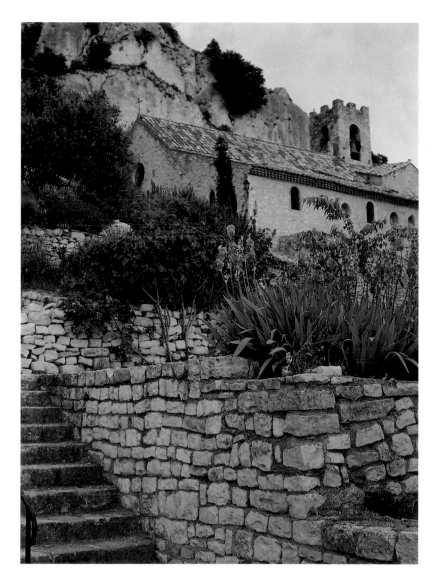

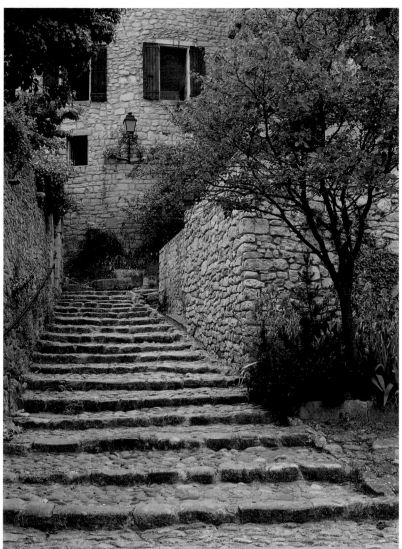

Séguret
VAUCLUSE

LYING ALONG the scorched, lower slopes of the jagged peaks of the Dentelles de Montmirail, Séguret is a wine-growing village enjoying a magnificent view over the Rhône valley vineyards, including those of Gigondas and Châteauneuf-du-Pape. Their products could well be the greatest legacy of the papal stay at Avignon.

The castle at Séguret, which stands today in ruins above the village, was commissioned by Pope Clement V in 1274, the year the papacy took over the territory from the Counts of Toulouse, who in turn had acquired it from the Princes of Orange. The line of the fourteenth-century ramparts can clearly be seen descending from the castle down to the village, where further medieval fortifications are to be found.

Séguret has been taken over by artists and crafts-men and, in the summer months, the more obviously picturesque corners of this self-consciously pretty vil-lage become the subject of many an amateur painting. The whole village has the look of an outdoor medieval museum, with a tour beginning at a tall twelfth-centu-ry gate, then proceeding along a narrow street to a charming Baroque fountain, finally reaching a Romanesque parish church, which stands in isolation on a panoramic terrace.

The quaint paved alleys of Séguret (opposite *and* above right) *lead eventually to the parish church* (above left), *a much restored Romanesque building set below the first of the spectacular rocky crags of the Dentelles de Montmirail.*

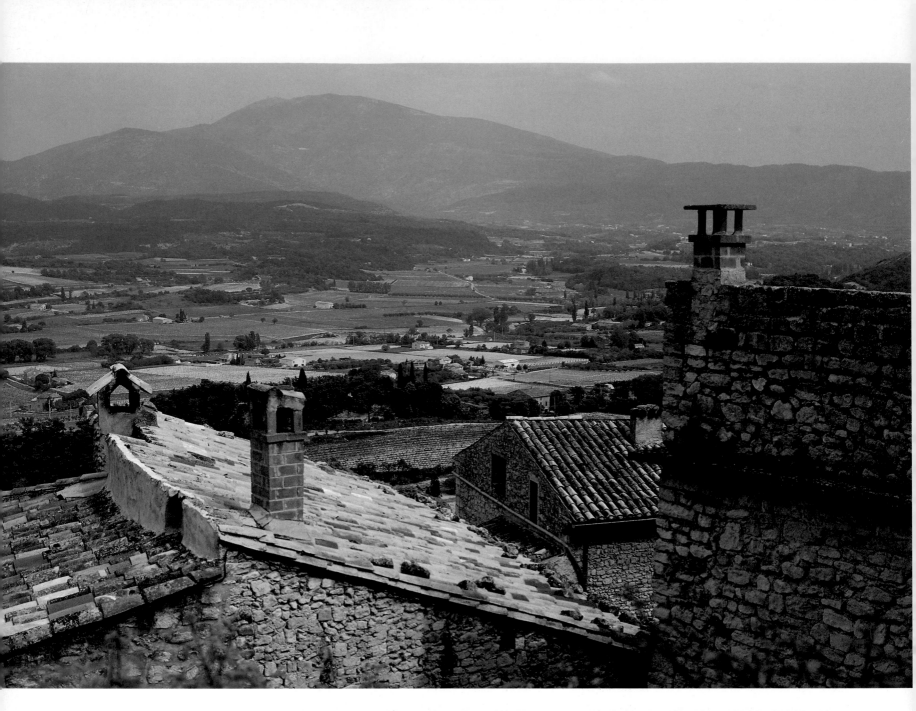

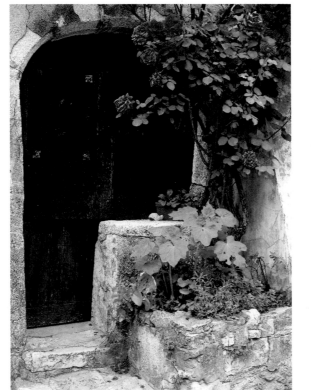

*H*idden corners and secret fountains in the heart of Séguret give way to spectacular views of fertile plains and mountains on its outskirts (these pages).

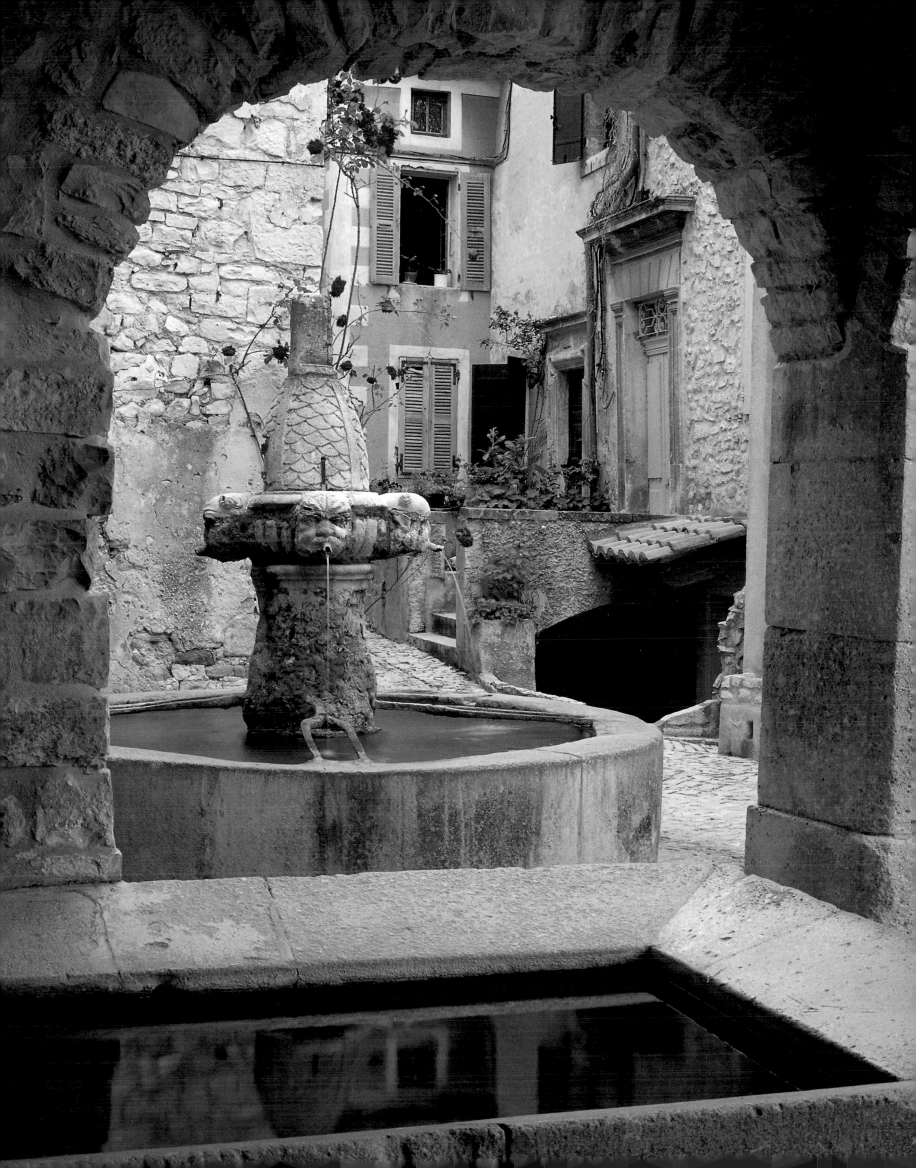

Vaison-la-Romaine *VAUCLUSE*

The narrow river of the Ouvèze (opposite), which is spanned at this point by a one-arched Roman bridge, flows between the low-lying new town of Vaison and the rocky spur on which the medieval settlement, characterized by its fortress-like houses, is built (above).

A PLACE of vital significance in the early history of Provence, Vaison-la-Romaine extends on both sides of the river Ouvèze, under the pyramidical bulk of Mont Ventoux. Though a fair-sized community with light industries and an extensive modern town, Vaison has an upper, self-contained medieval quarter with the look and character of a hill-village.

Vaison has its origins in a fortified Celtic settlement founded on the rocky outcrop supporting what is now the upper town. The place served as capital to the tribe of the Vocontii up to the second century B.C., when the tribe was defeated by the Romans, who decided to abandon the rock and to move down to the low-lying land on the other side of the Ouvèze. Here they created one of Gaul's wealthiest towns, the extensive and evocative ruins of which have earned Vaison the name of 'the Pompeii of France'. With the arrival of Christianity, the Roman town was further developed and a splendid cathedral (later rebuilt in a Romanesque style) was founded here. In the twelfth century, a con-

flict between the Counts of Toulouse and the Bishops of Vaison led the former to build a castle on the site of the former Celtic settlement. The townspeople eventually joined the Counts in their hill-top citadel, and only moved back again across the river in the eighteenth century, when they began developing the present modern town on what had been Roman Vaison.

The medieval upper town fell into ruins from the eighteenth century onwards, and its narrow streets and imposing houses in exposed masonry were only restored in recent times. Encircled by fragments of its medieval walls, its many cedars giving it a certain Tuscan character, this is a place of tranquil and slightly decayed charm which contrasts heavily with the bustle of the lower town. Standing exposed on its bare rock summit is the imposing shell of the castle of the Counts of Toulouse, from the terrace of which you can appreciate to the full the beauty of Mont Ventoux, capped by its white limestone crest which creates an impression of perpetual snows.

66

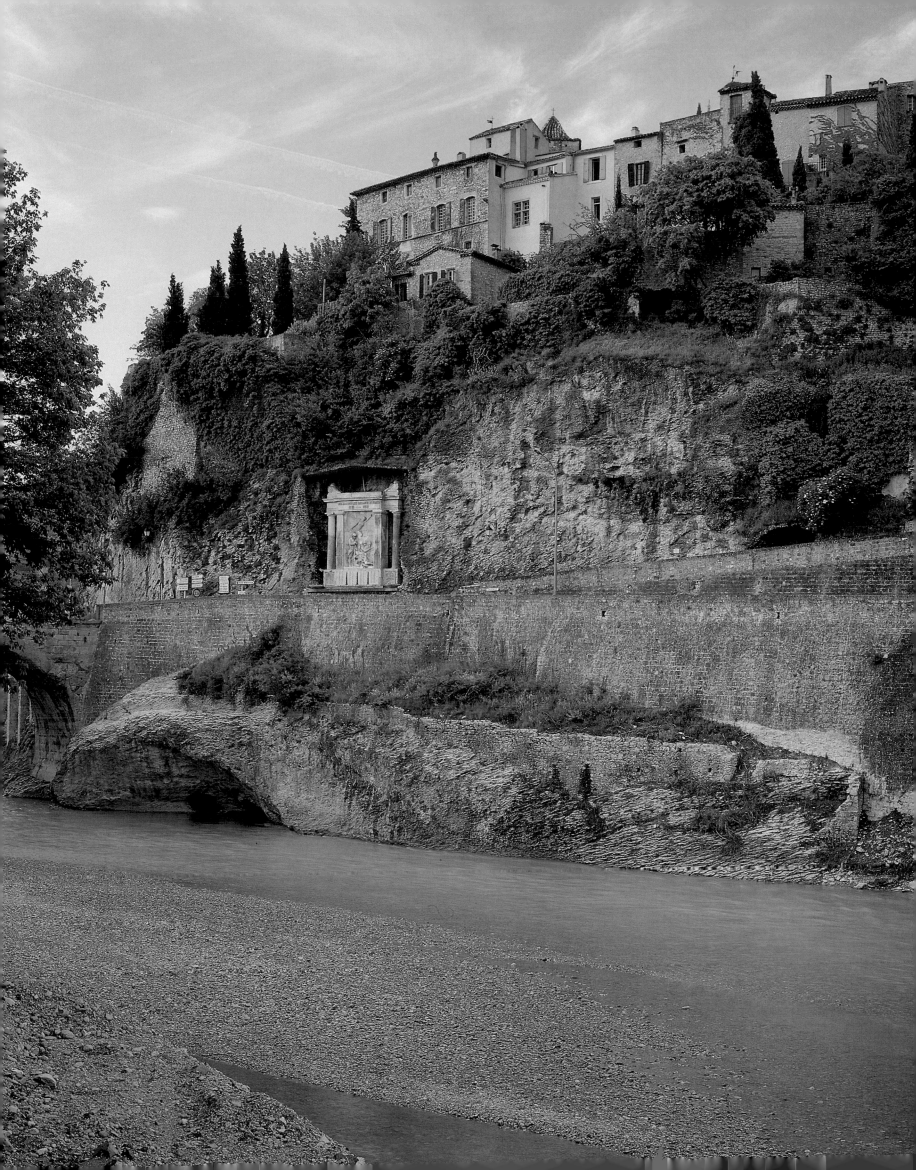

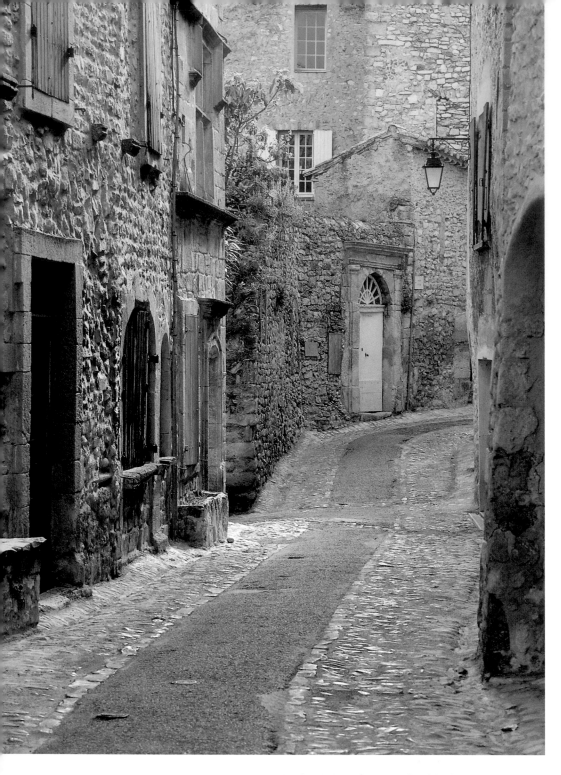

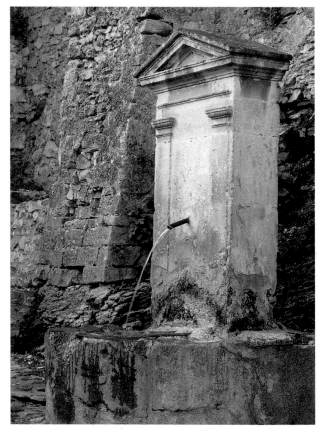

Cedars, a pedimented fountain, gardens, and trefoil Gothic windows like those of a Venetian palace, conjure up visions of grandeur unusual in a village setting, as the visitor walks through the quiet traffic-free streets of Vaison's medieval upper town (these pages).

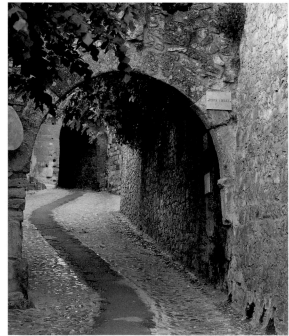

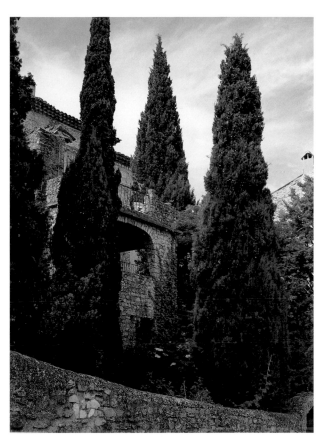

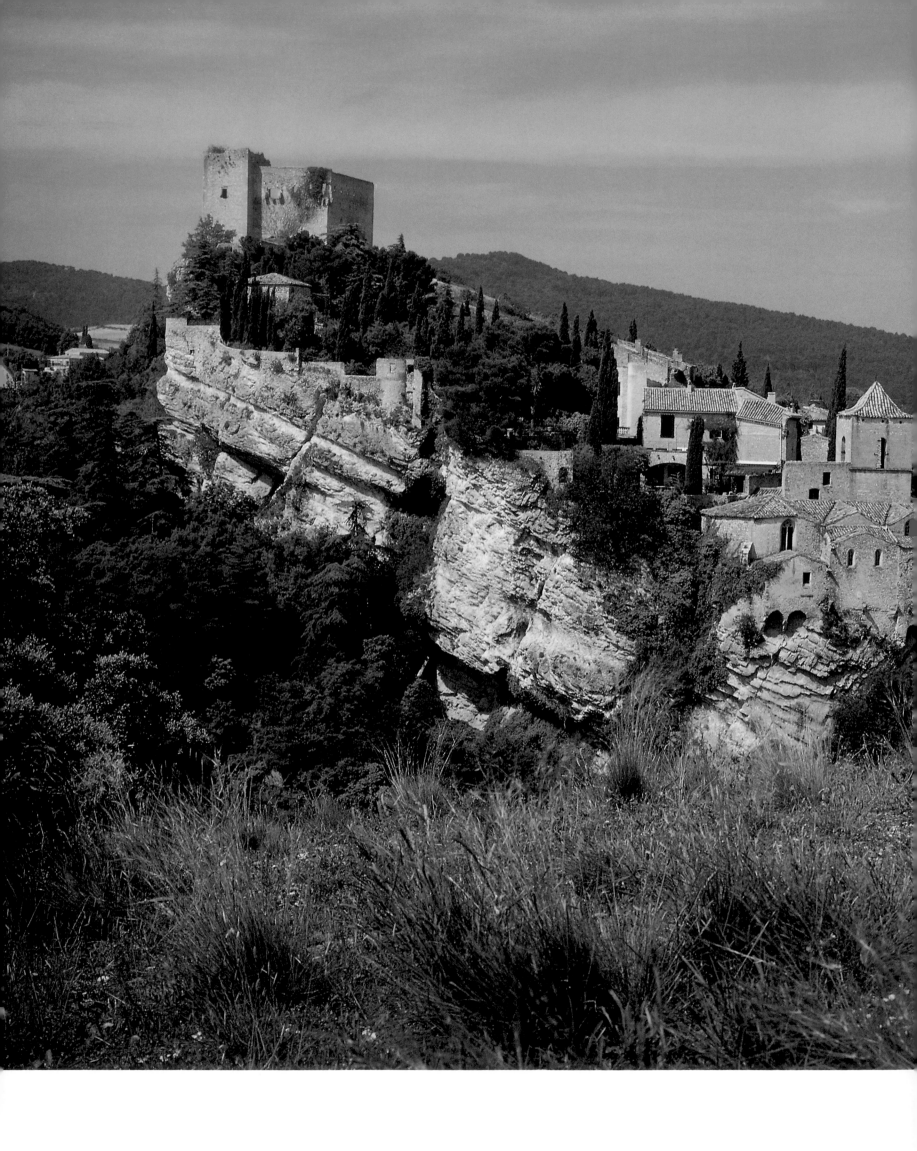

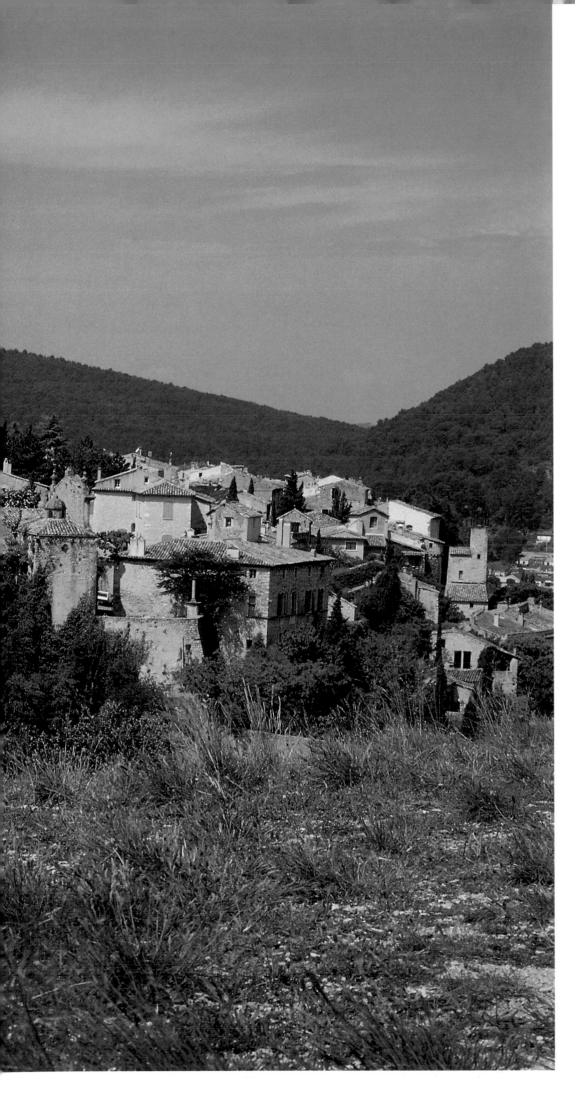

*T*he parish church (above), *a fifteenth-century structure enlarged in the eighteenth, stands half-way up the old town, the crest of which (left) is crowned by the castle of the Counts of Toulouse, now a hotel; extensive fragments of the medieval fortifications are visible in the foreground.*

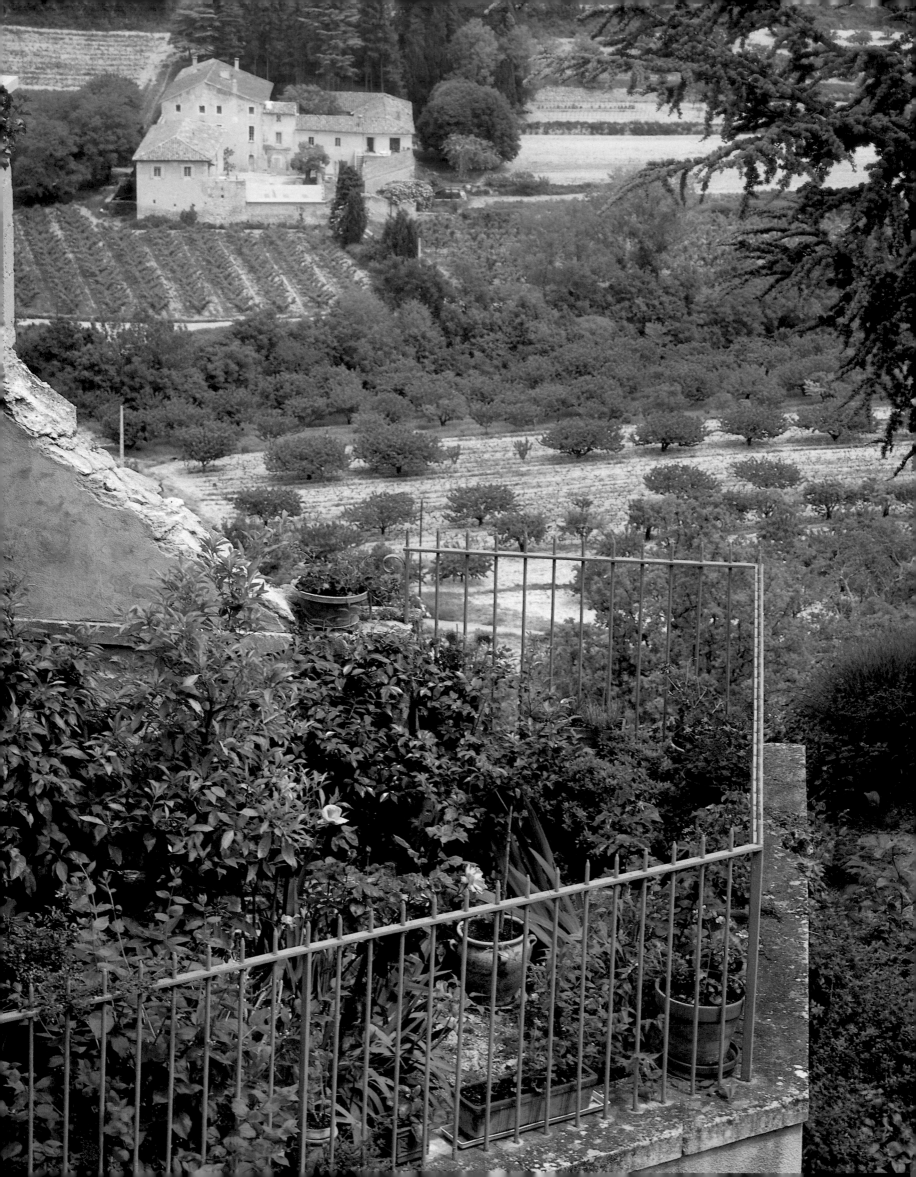

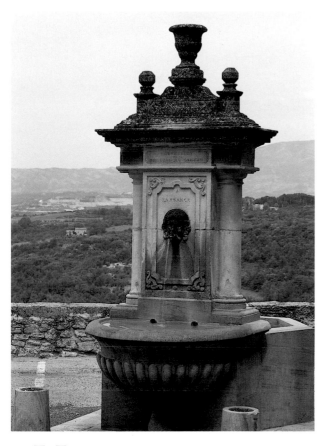

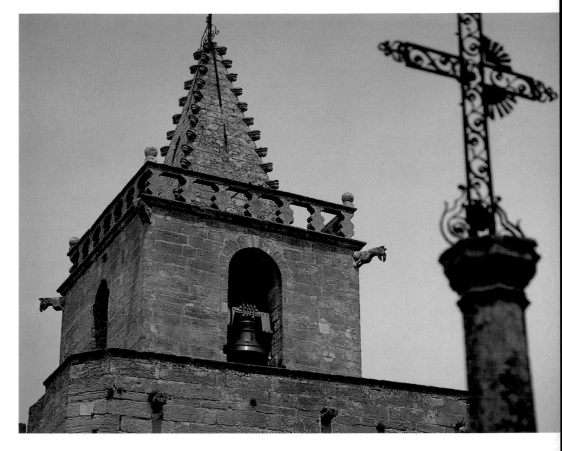

Venasque VAUCLUSE

IT IS DIFFICULT to believe that this small, remote village, perched high above the wild landscape of wooded ravines stretching between the valleys of Apt and Carpentras, was once a major bishopric which gave its name to the vast papal territory of the Comtat-Venaissin.

Though both a Celtic settlement and a Roman sanctuary, Venasque only rose to importance in the sixth century, when the Bishop of Carpentras, Saint Siffrein, took refuge here to escape from barbarian invasions. His successors remained in Venasque up to the tenth century, when they finally moved their seat back to the low-lying town of Carpentras. Carpentras went on to become the capital of the Comtat and the thriving commercial centre of today, while Venasque declined to such an extent that only twenty families remained by the nineteen-fifties. Recent restoration and growing tourism have brought new life and sophistication to the place without wholly ridding it of its solitary character.

Apart from its sensational cliff-edge position and charming small streets, Venasque offers two of the finest architectural treasures of Provence, both on a terrace directly above the cliff. One is the large Romanesque church of Notre-Dame, which was built in the eleventh century to replace a cathedral founded by Saint Siffrein; within its movingly austere interior is a powerful *Crucifixion.* The other building is a circular Early Christian baptistery.

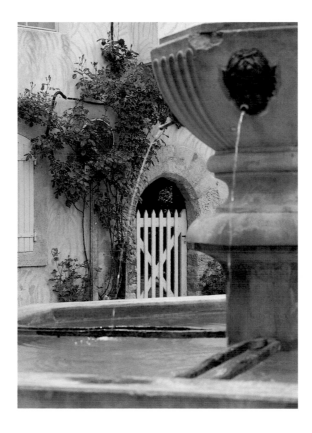

A magnificently sited modern roof garden (opposite) *on the northern side of Venasque looks over the valley which stretches towards Carpentras. Eighteenth-century fountains* (left *and* above left) *are among the many attractive details of the village. The architectural masterpieces, however, are the parish church of Notre-Dame* (above) *and its adjoining baptistery, respectively in the Romanesque and early Christian styles; the Romanesque tower is crowned by an eighteenth-century balustrade and spire.*

73

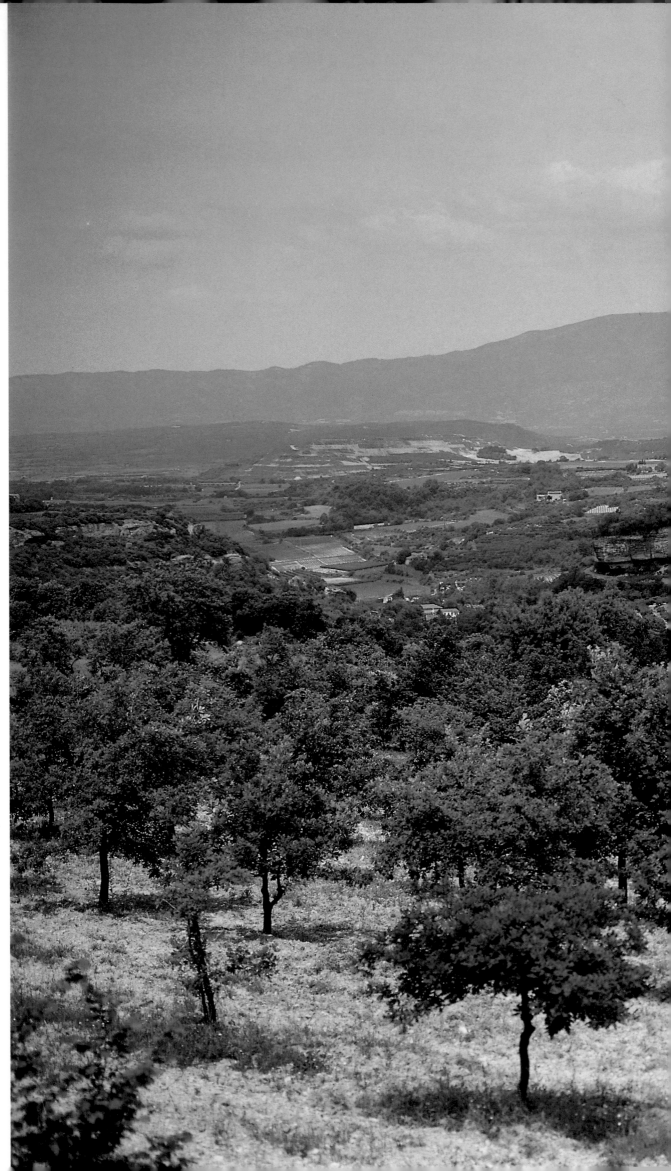

*T*he suitability of Venasque as a
place of refuge for the bishops
of Carpentras is apparent from this
panoramic view (opposite) taken
from the valley below and showing
the limestone cliffs so characteristic of
this hidden corner of the Comtat-
Venaissin; the mountain in the
background is the Mourre Nègre.

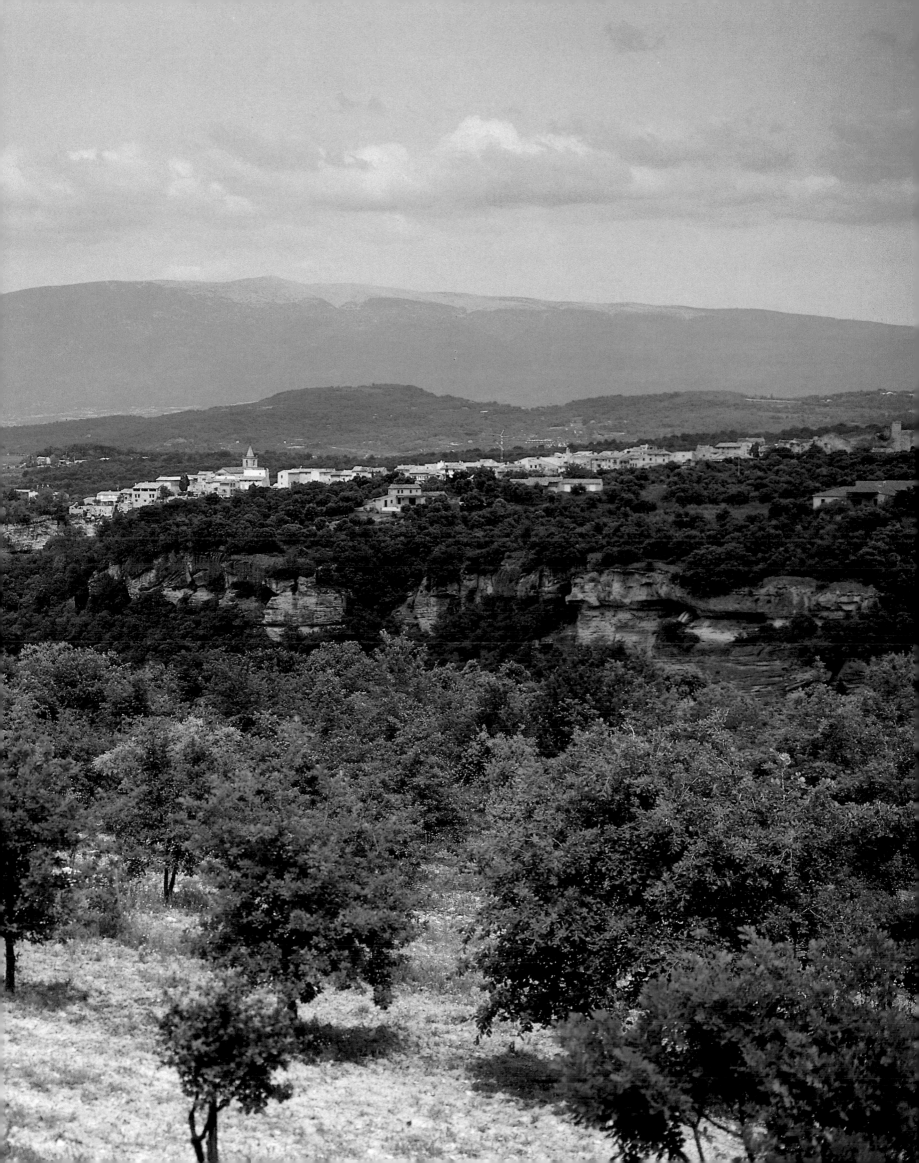

Eygalières
BOUCHES-DU-RHÔNE

EYGALIÈRES sits below the bleached pinnacles of the Alpilles, whose distinctive, ragged profile will be familiar to many through the canvases of van Gogh. This is also a landscape recalling imagined scenes from classical antiquity, a dusty scene of dazzling light, clusters of cypresses, and rocky fields criss-crossed with rows of ancient olive trees.

The Roman Sixth Legion founded Eygalières after discovering among these arid surroundings a spring which would later feed an aqueduct leading to Arles. They named the place 'Aquileria' or 'the gatherer of waters', and erected a temple dedicated to the water gods. The site of this temple is marked today by the isolated outlying hermitage of Saint-Sixtus, a place of affecting simplicity, framed by cypresses, and evocative of some shrine in the Roman Campagna.

Eygalières has never been a sizeable or historically important community, and yet it has been known since antiquity for the manufacture of millstones which, right up to the end of the nineteenth century, were exported to places as far apart as the United States, Turkey and Russia. In recent years the fame of Eygalières has been spread by the many artists and writers associated with the village.

The main part of the village extends leisurely up a long spur of rock, and features the imposing Renaissance mansion of the Bruno-Isnards. The ruins of a castle, with its keep crowned by a modern statue of the Virgin, stand at the top of the village.

A view of the upper part of Eygalières (above), behind which rise the ragged peaks of the Alpilles. The spur of rock, crowned by what was once Eygalières' citadel, is framed here by cypresses and parched fields, reminders of the paintings of van Gogh (opposite).

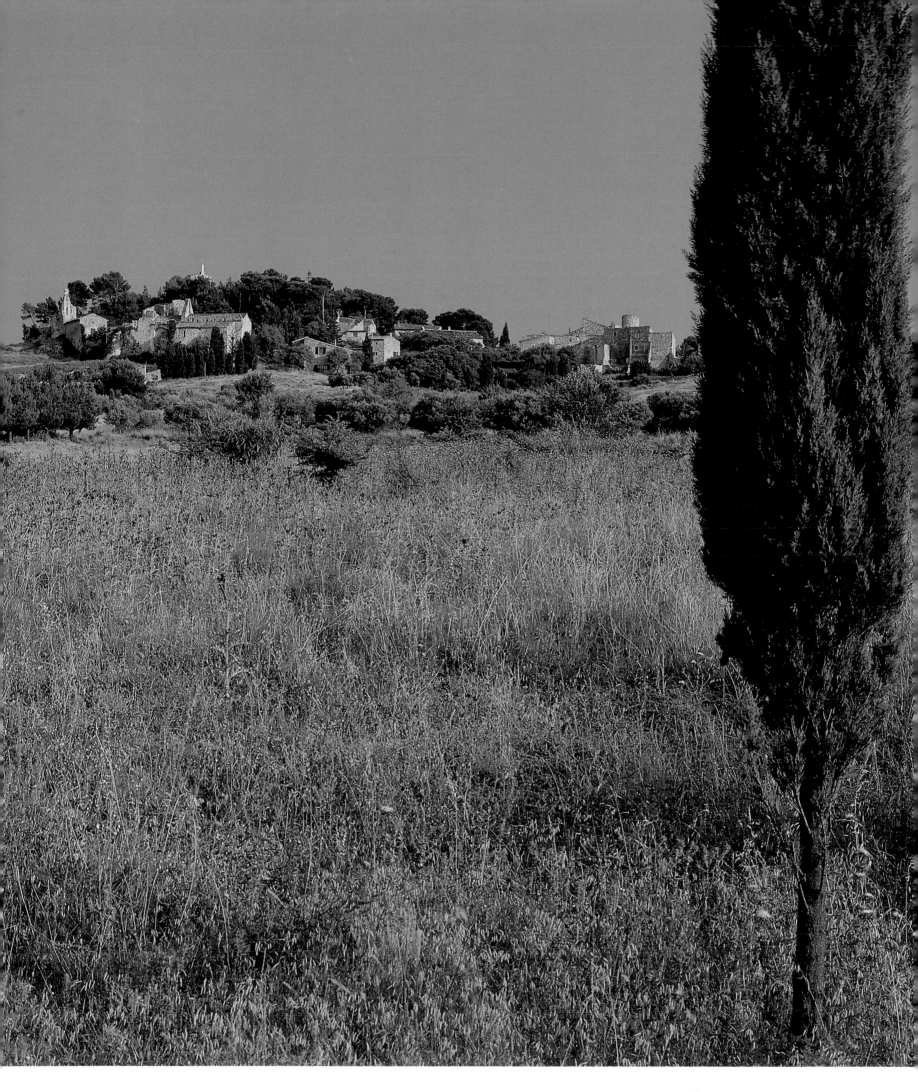

*G*reenery, masonry and ironwork, essential ingredients of Provence, here seen in Eygalières (above *and* left); *the Chapelle des Pénitents Blancs* (far left) *stands inside the former citadel and contains a small archaeological museum with objects from ancient and medieval times. At the top of the citadel is a bell-tower* (opposite), *which was built in 1672 to celebrate the liberation of the villagers from the fiefdom of the Guise family; stones taken from the ruined castle were used in its construction.*

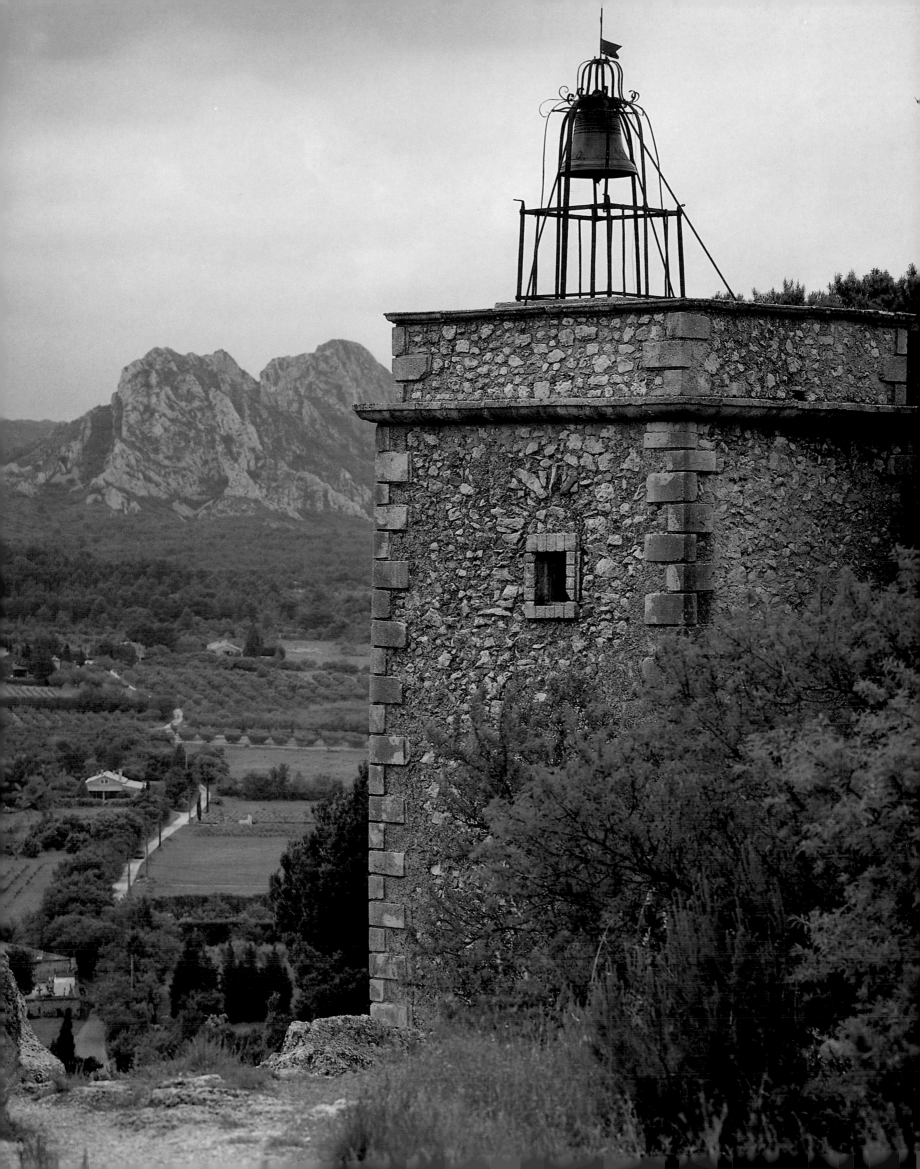

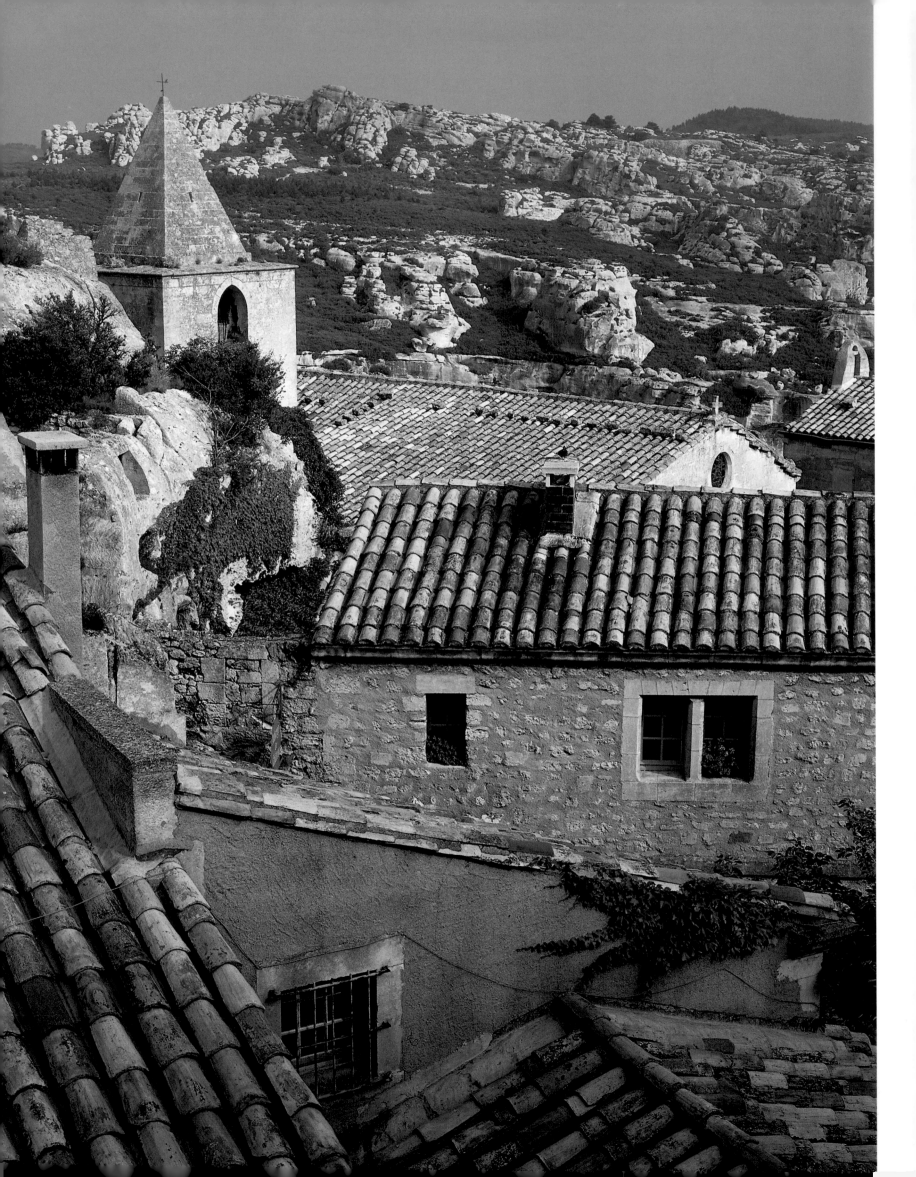

Les Baux-de-Provence

BOUCHES-DU-RHÔNE

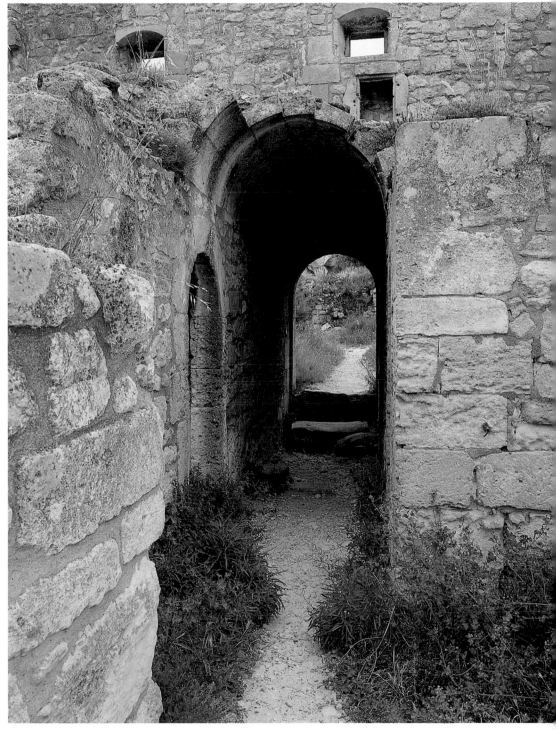

In the lower, inhabited part of Les Baux (opposite), the squat spire of the parish church of Saint-Vincent stands outlined against the dramatic limestone boulders of the Alpilles. This splendid lintel (left) dates from the seventeenth century, just before the destruction of Les Baux's prosperous Protestant community. These ruins (below) in the medieval citadel extend like the vestiges of some ancient site.

ONE OF THE MOST visited tourist sites in France, Les Baux is also a place which has contributed more than any other to the romantic image of Provence.

Though today a half-ruined village with a population of barely five hundred, in the Middle Ages it was a community of at least six thousand inhabitants ruled by a family famously described by the poet Mistral as 'a race of eagles, never vassals'. Provençal nationalists such as Mistral not only thought of the lords of Les Baux as the epitome of the powerful, independent spirit of Provence, but also envisaged their court as a centre of poetry and love. Legends grew up about the 'courts of love' that were held in Les Baux, and about the troubadours who took part in these by wooing with their verse the most beautiful women of the day. Romantics and tourists alike have also been inspired by tales of the more bloodthirsty deeds of the lords of Les Baux, in particular those of the last of their number, the fifteenth-century Raymond of Turenne, who lived in his fiefdom almost as a brigand and reputedly entertained himself by throwing his prisoners over the cliffs at the village limits.

Even those who come to Les Baux with their minds free of tales of love and brigandry are likely to have their imaginations fired by a first sight of the village. Built on top of a gaunt, dramatic 'bau' or escarpment, it is set against the craggy limestone range of Les Alpilles, here split in two by a valley said to have inspired a passage in Dante's *Inferno*.

The small village below the enormous ruins of the castle is made up of no more than two narrow streets lined with a number of severe but elegant Renaissance mansions dating from the period when Les Baux was rebuilt as a wealthy Protestant stronghold. The village was razed in the seventeenth century and languished in ruins until it was discovered by artists and writers two centuries later. The southern extremity of the citadel, marked by a memorial to a poet contemporary of Mistral, has a sheer drop down to the fertile plains of Arles, so frequently painted by van Gogh.

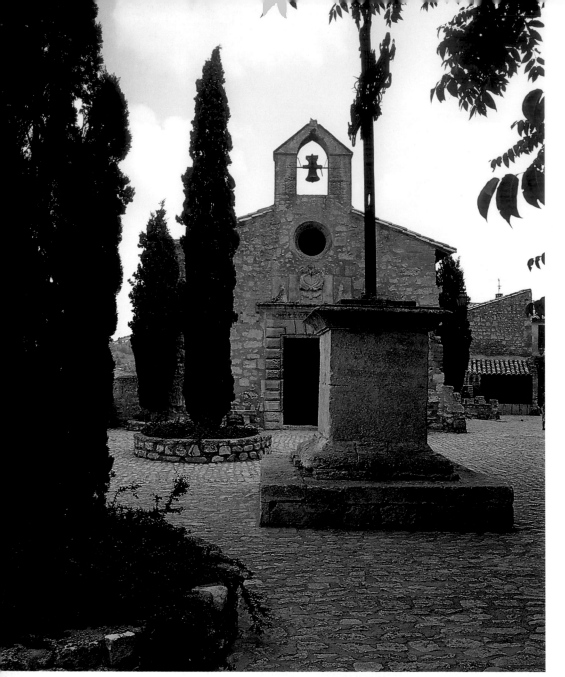

*I*n the heart of the lower village is the simple seventeenth-century Chapelle des Pénitents Blancs (above). Numerous survivals from the Renaissance enhance Les Baux (upper *and* lower right), *including this tiny summer pavilion* (right) *in the valley. Known misleadingly after the medieval queen of Provence, 'La Reine Jeanne', it was in fact commissioned in 1581 by Jeanne de Quiqueran, wife of the Baron of Les Baux. Frédéric Mistral had a copy of it made for his tomb in Maillane. The windswept plateau offers quite spectacular views in every direction* (opposite).

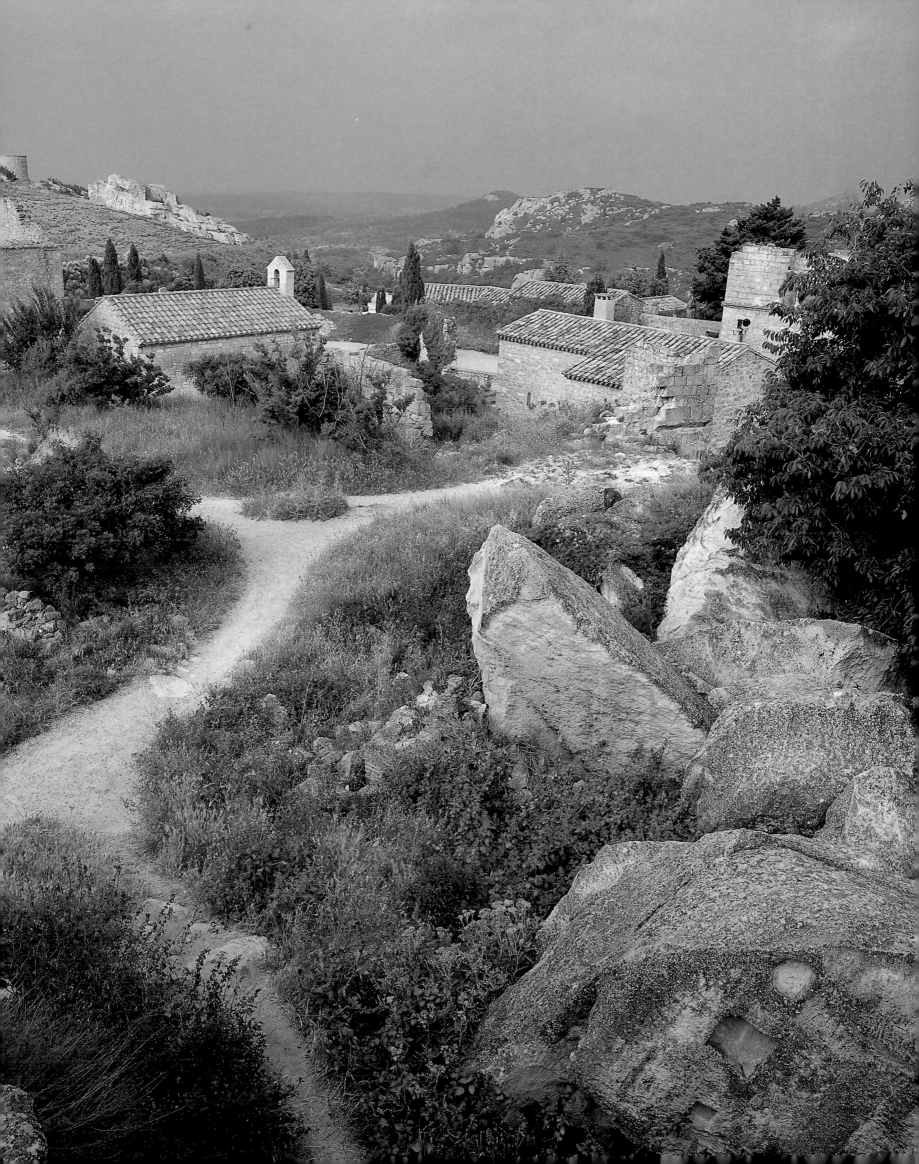

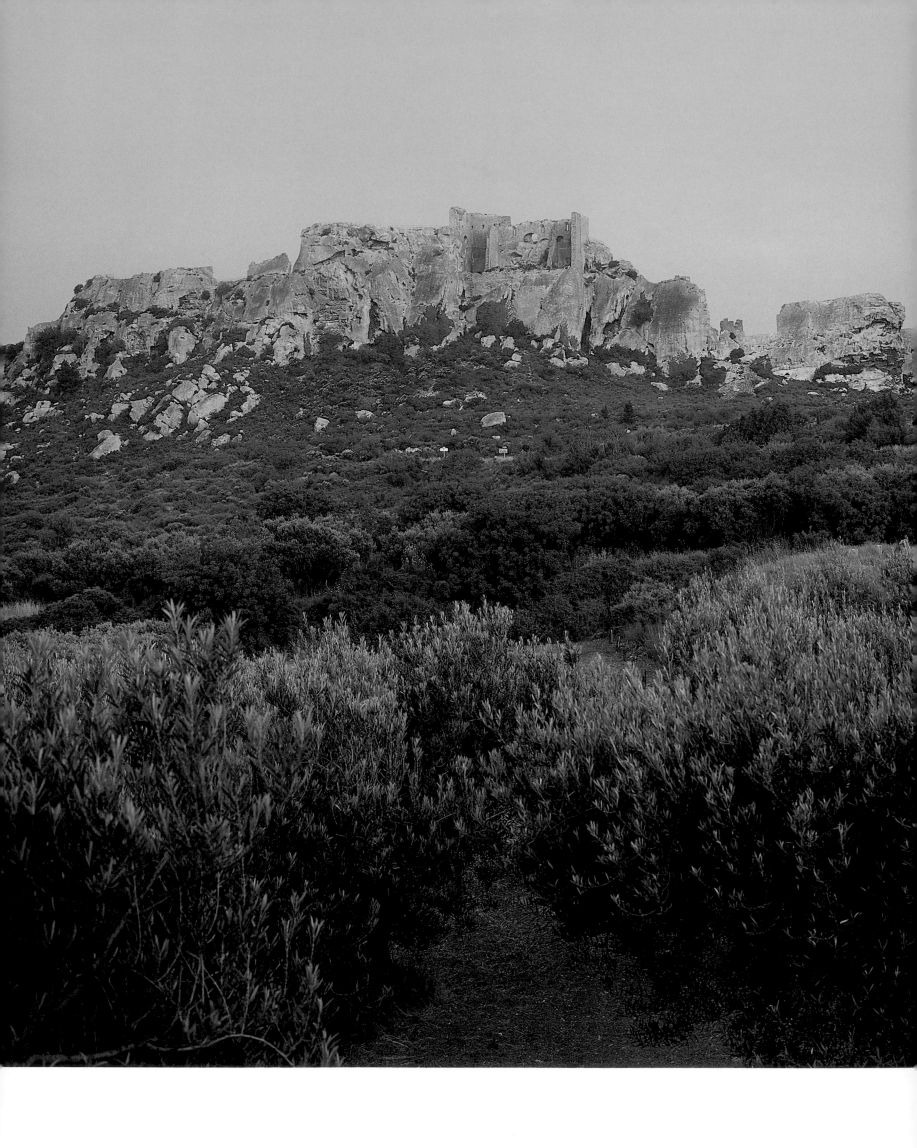

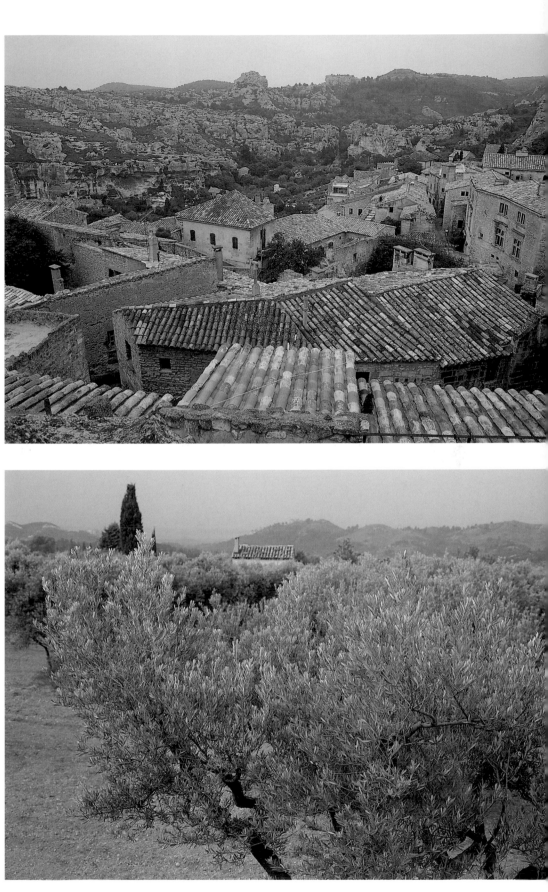

*F*rom a distance, Les Baux (left) *appears as some
fantastic apparition thrown up in a parched*
landscape of white rock and olive trees (top *and* above).

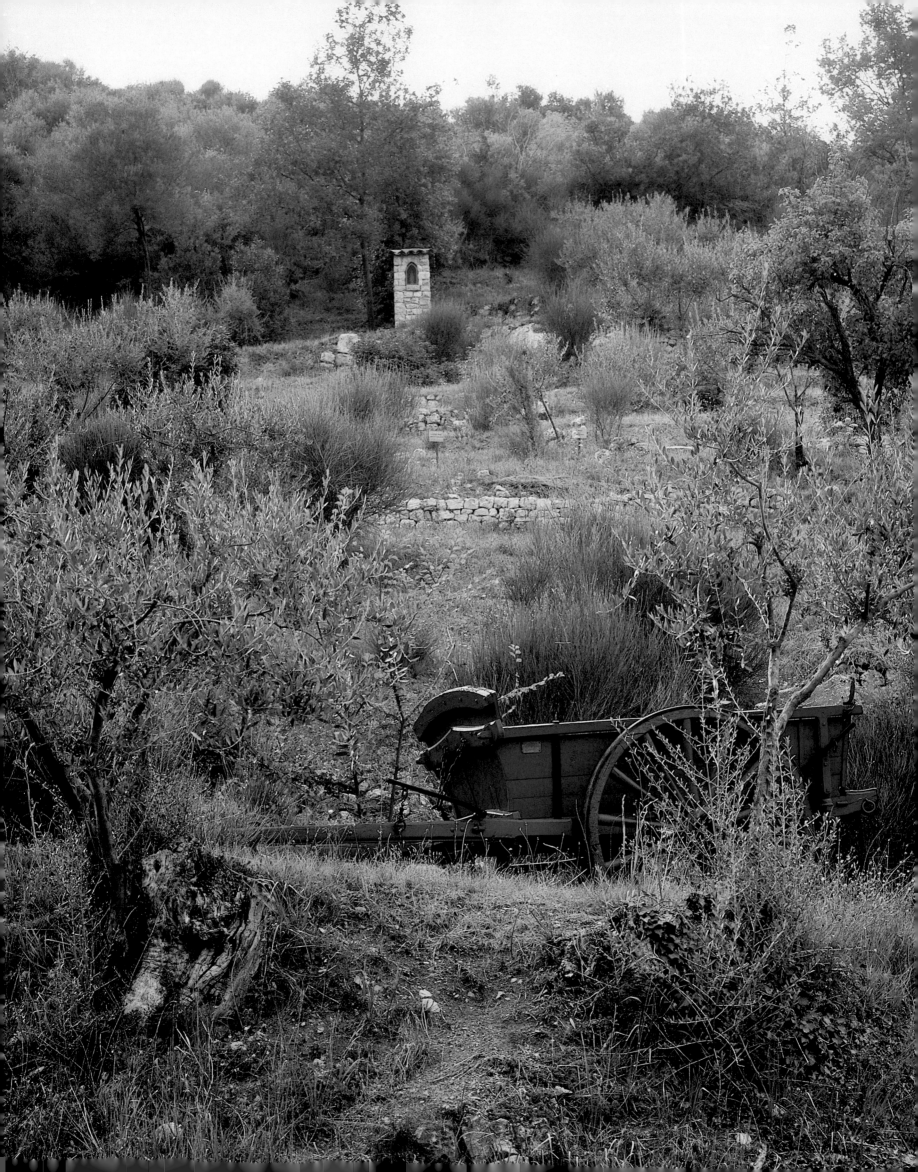

VAR AND ALPES-MARITIMES

The Var is one of the most forested regions of France and, away from the wine-growing valley separating the upper from the lower Var, is extensively covered in a dense, rolling carpet of oaks, pines and cork trees. The region's mountains and forests gave it an inhospitable reputation until the late nineteenth century when tourism finally arrived. By then, the adjoining Alpes-Maritimes was emerging as one of the playgrounds of Europe, though resorts such as Saint-Tropez were still unspoilt fishing villages right up to the nineteen-fifties.

The Alpes-Maritimes is the newest of the Provençal départements; *it was created in 1860 out of the former* comté *of Nice and an area to the west between the river Var and the Esterel. Famous for its mild climate and the lush vegetation of the coast, the region also includes wild and lonely Alpine valleys in its northern half. The villages close to the area's eastern border are characterized by their strong Italianate features and traditions; pasta dishes are widely popular, Italian dialect is often spoken, and churches are generally in an Italian Baroque or Lombard Romanesque style.*

Near the village of Seillans in the Var (opposite).

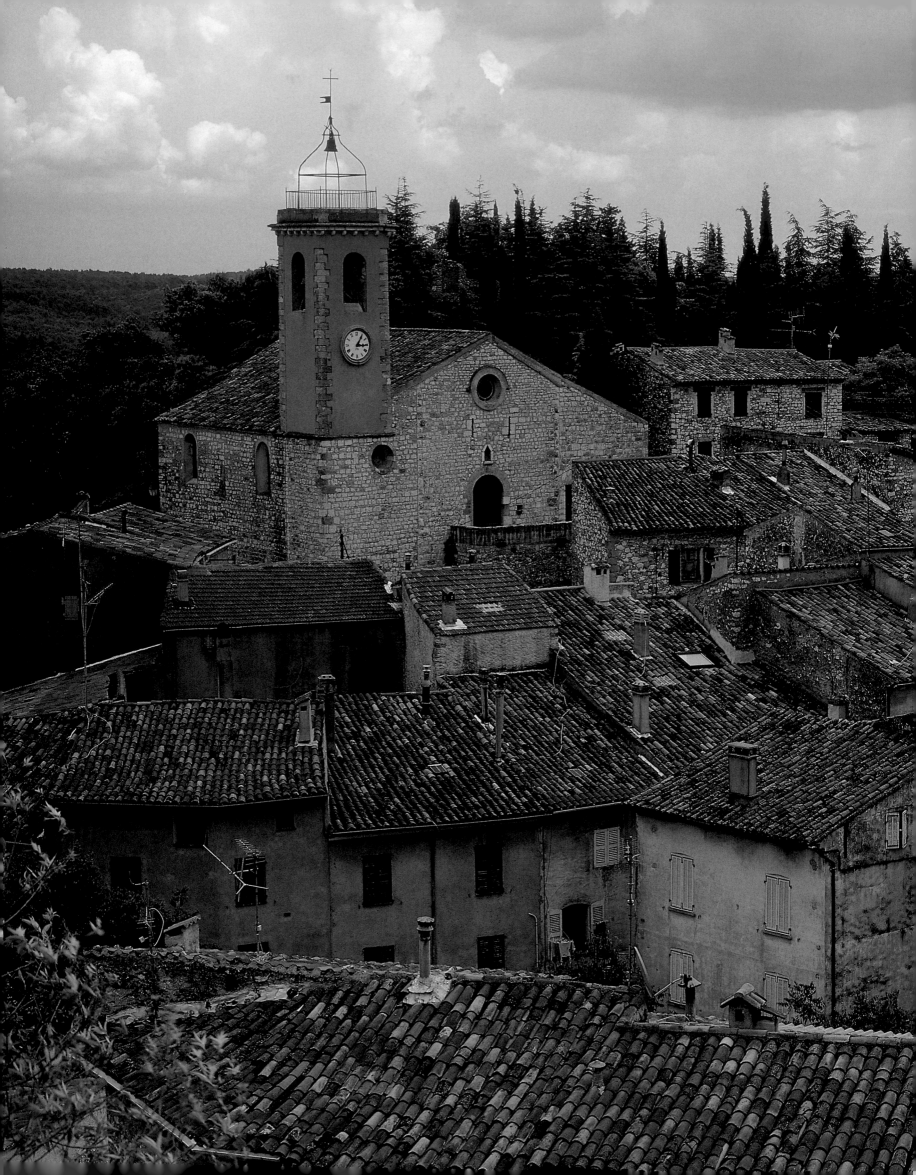

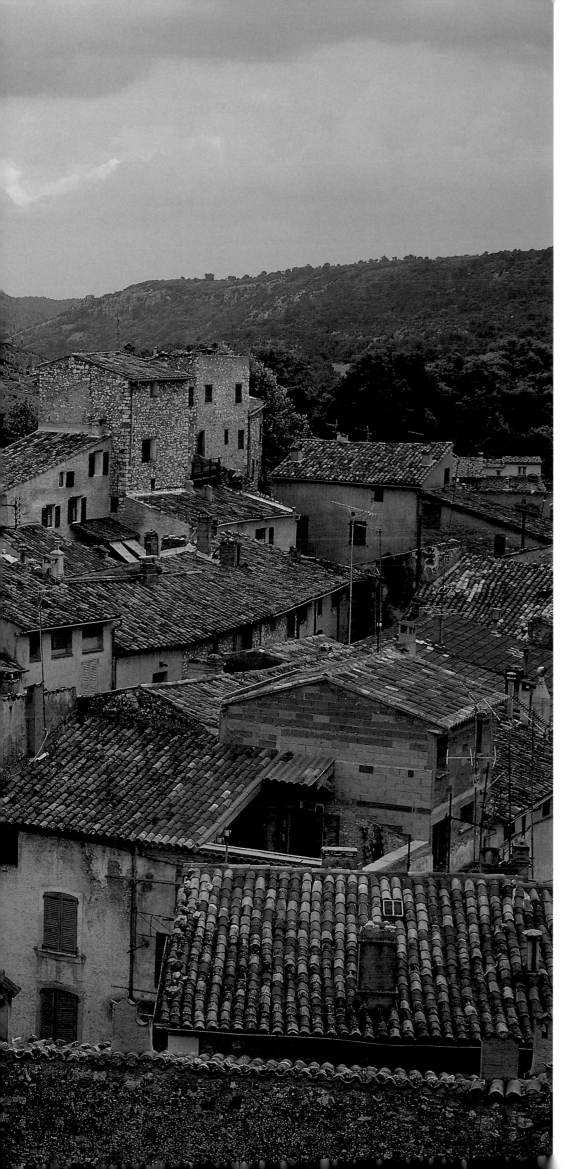

Ampus

VAR

BUILT ABOVE the modest gorge of the river Nartuby, Ampus overlooks a homely landscape of fields, streams and wooded hills. It is a small and little-known village, though it was a place of considerable importance in Roman times. Its name is probably derived from *emporium* (public market) of which traces have been found in the village.

Ampus is still a village living primarily off agriculture, in particular the cultivation of vines and olives, and the raising of sheep. The generally simple architecture of the village's upper half includes rustic monuments dating back to the eleventh century, when the villagers distinguished themselves by the unusual feat of defeating the Saracens rather than being defeated by them. An eleventh-century gate porch can be seen on the gentle climb from the peaceful main square up to the crowning Romanesque church of Saint-Michel, the barrel-vaulted simplicity of which makes a fine setting for a colourful sixteenth-century statue of the archangel. Beyond the church are the ruins of the village's ancient castle.

The compact group of houses (left) *making up the village of Ampus cluster around a parish church of unadorned simplicity;* (above) *aloe and other exotics contrast with the pines at the top of the village.*

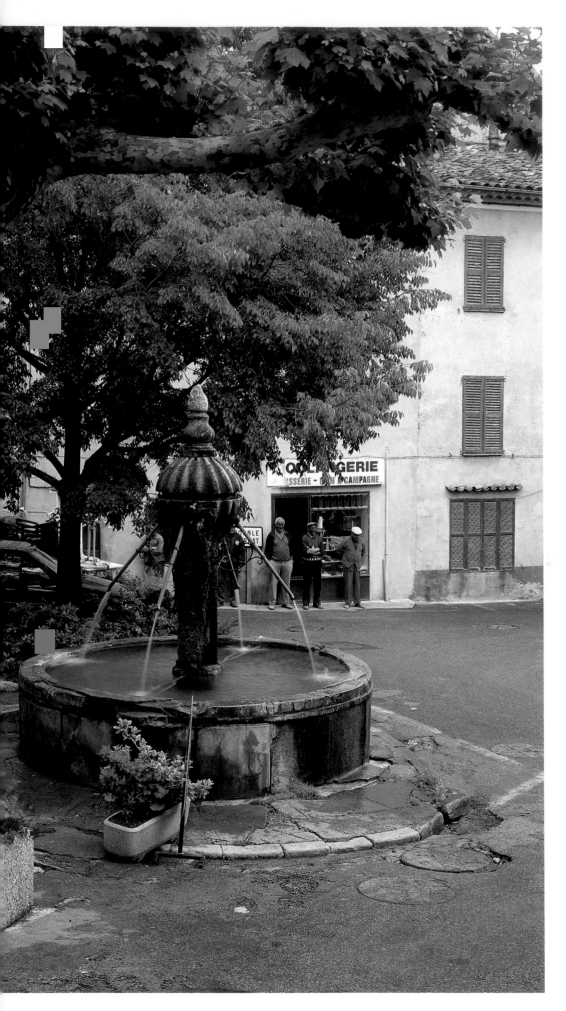

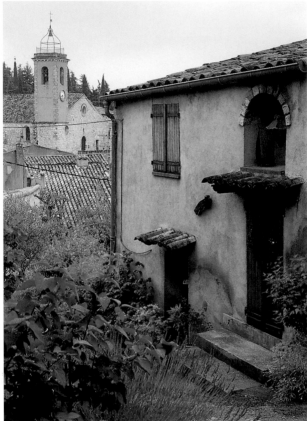

A modest nineteenth-century fountain and a simple boulangerie (left) are the liveliest features of the quiet main square of Ampus. Narrow arched streets (opposite) lead eventually to the parish church of Saint-Michel (below), which retains many of its Romanesque features. Traditional ironwork and terracotta provide interesting shapes and textures in the village (bottom).

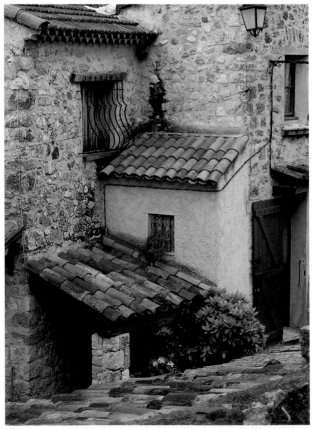

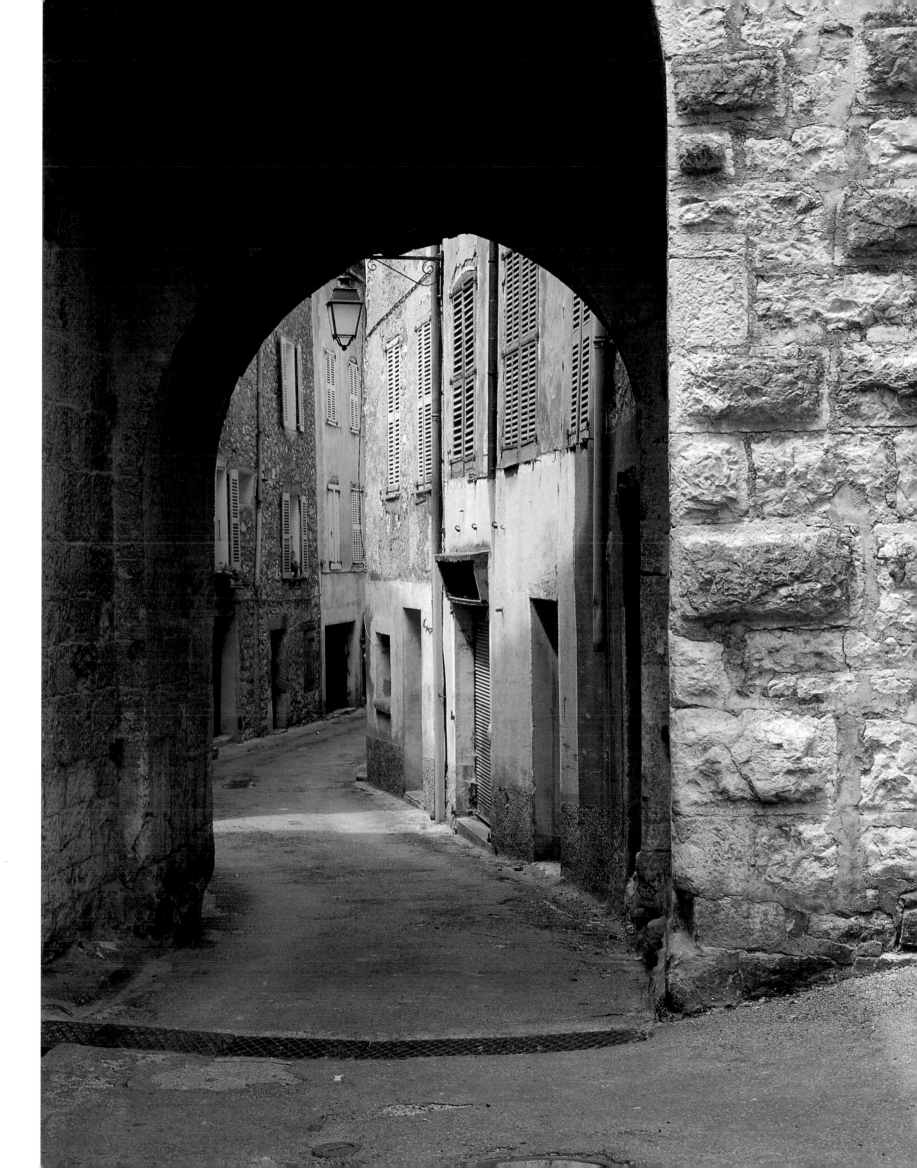

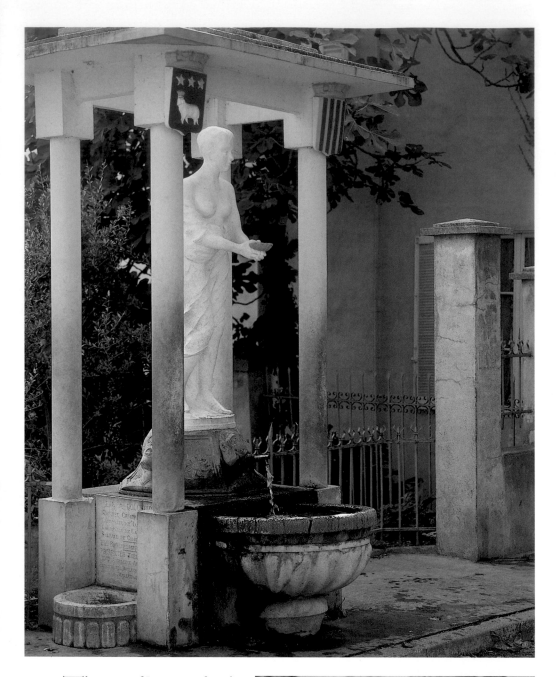

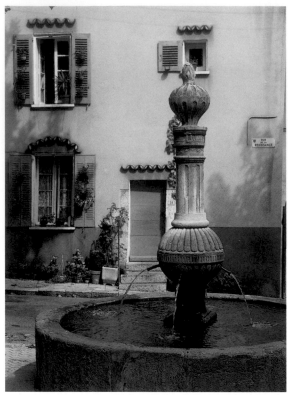

Bargemon

VAR

IDYLLICALLY SET in hilly, wooded countryside, carpeted with orange trees and mimosas, Bargemon is a large and lively village which was apparently greatly favoured by the Romans, perhaps on account of its mild climate and famed spring waters.

Razed by the Saracens, the village was consequently rebuilt around 950 with a sturdy ring of fortifications. After being a dependency of the abbey of Saint-Victor in Marseilles, Bargemon became the original fiefdom of the Villeneuves, a family which would play a leading role in Provençal history. The village prospered through its strong commercial links with both the lower and upper Var, and through its leatherwork and weaving industries, which were still thriving in the nineteenth century.

Bargemon has retained an extensive section of its medieval ramparts and numerous medieval stone houses with narrow openings serving a defensive rather than decorative purpose. But what makes the village so special – and so wonderful to visit at the height of summer – are its many shaded streets and small, fountain-adorned squares. Enormous elms and a Renaissance fountain stand in front of the most endearing square of them all – the one overlooked by the flamboyant Gothic portal of the church of Saint-Étienne. The church itself, a fifteenth-century structure, is actually attached to the ramparts; one of the original look-out towers houses the bells of the church.

The waters of Bargemon, famed since Roman times, are fed into a number of fountains that greatly contribute to the village's charm. A modern statue of classical inspiration marks the Fontaine de Couchoire (above), which is built above a thermal spring; a more engaging design is the eighteenth-century fountain (below) crowned by an artichoke, a reference to Bargemon as a market town.

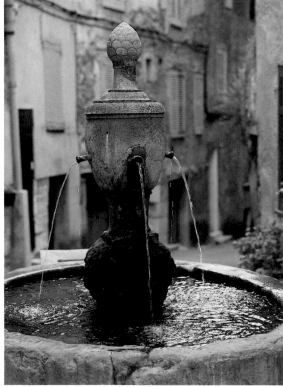

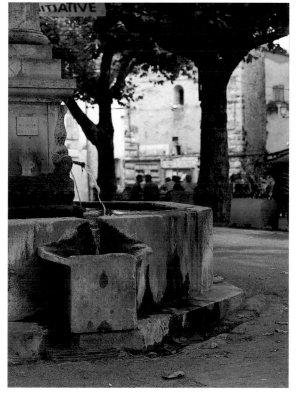

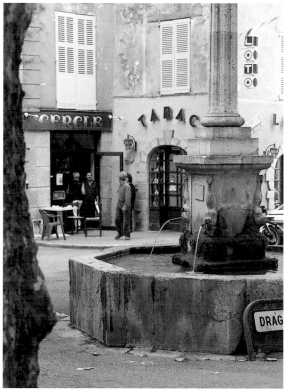

The grandest of the fountains (this page) forms the centre-piece of the elm-shaded main square.

The pleasing climate and therapeutic waters of Bargemon have led to the construction here of a number of fine houses and villas, many with delightful gardens (left, below and opposite). Bargemon is at its most beautiful when viewed from the Draguignan road (overleaf), from where it appears as a compact hill-village dominated by the seventeenth-century tower of Saint-Étienne.

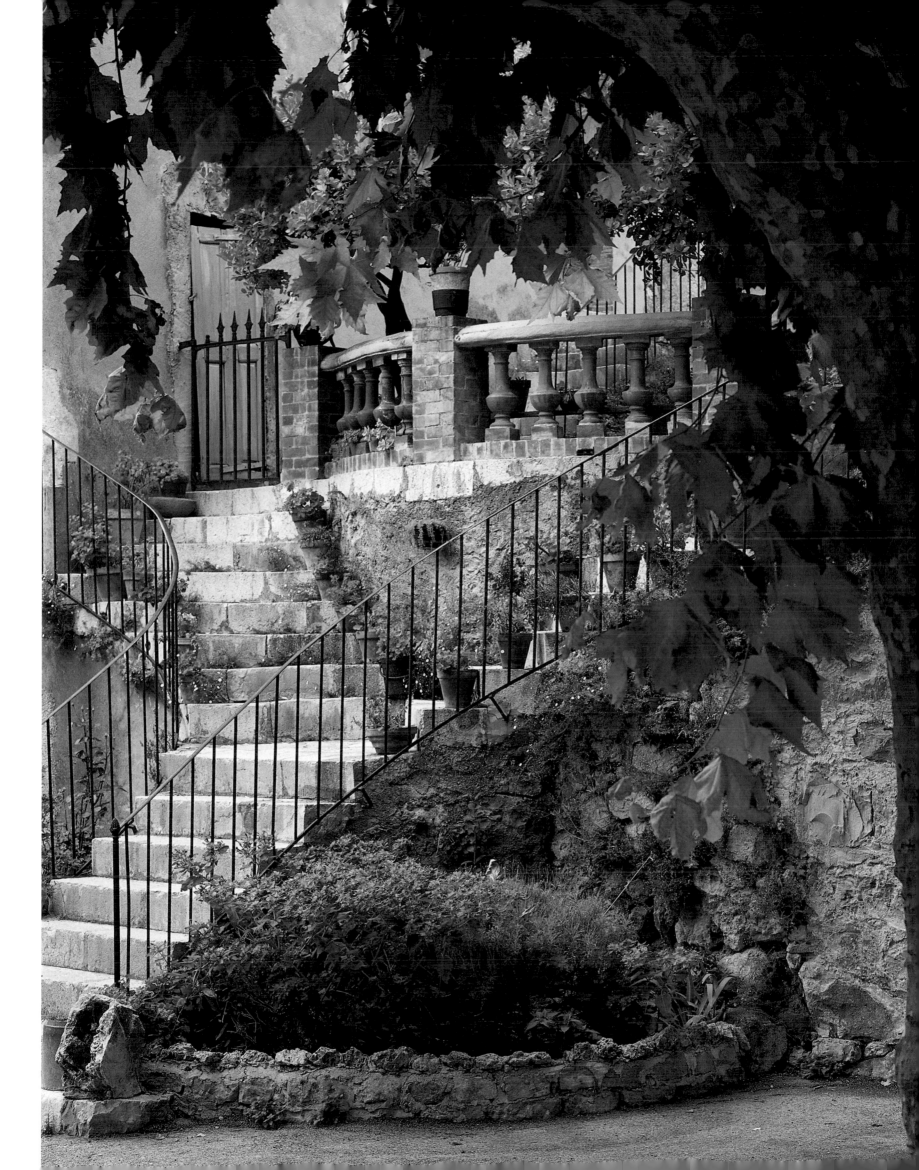

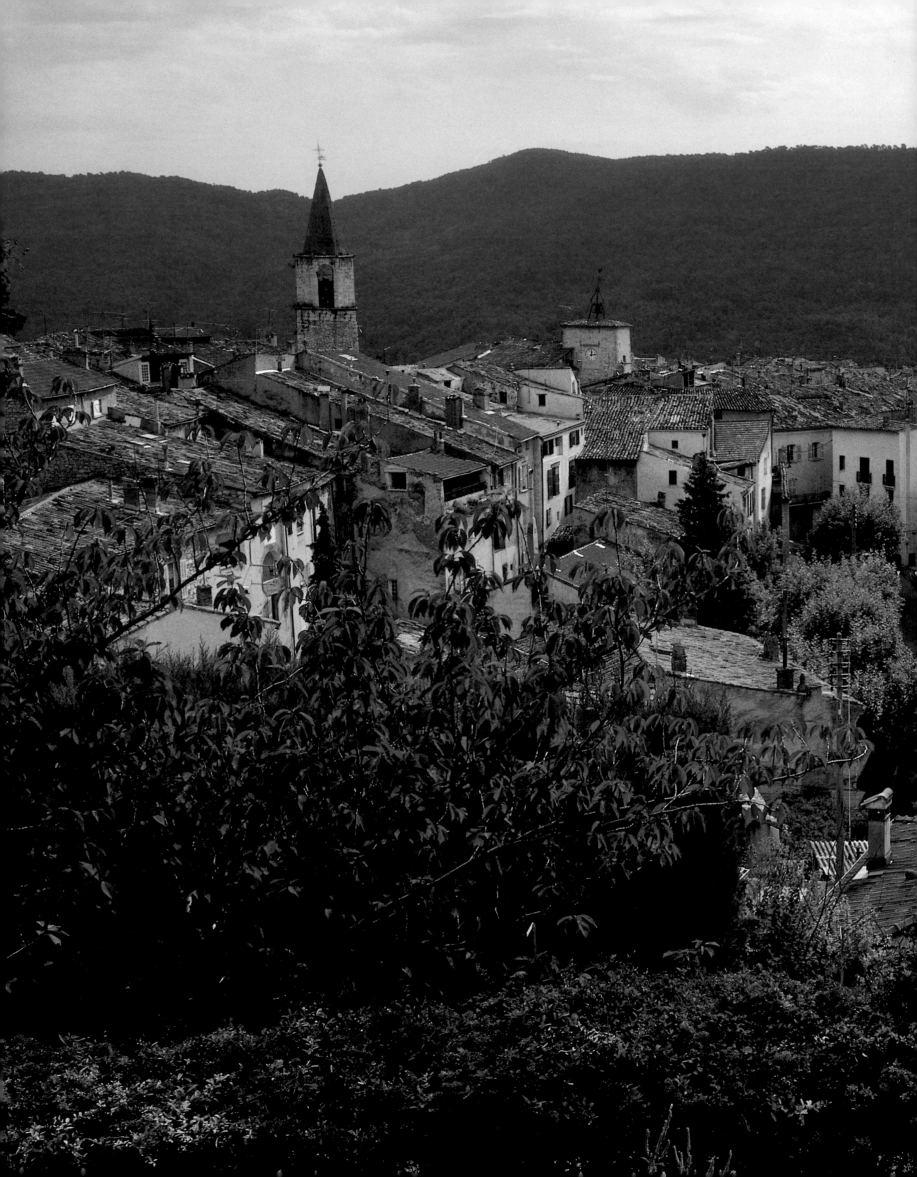

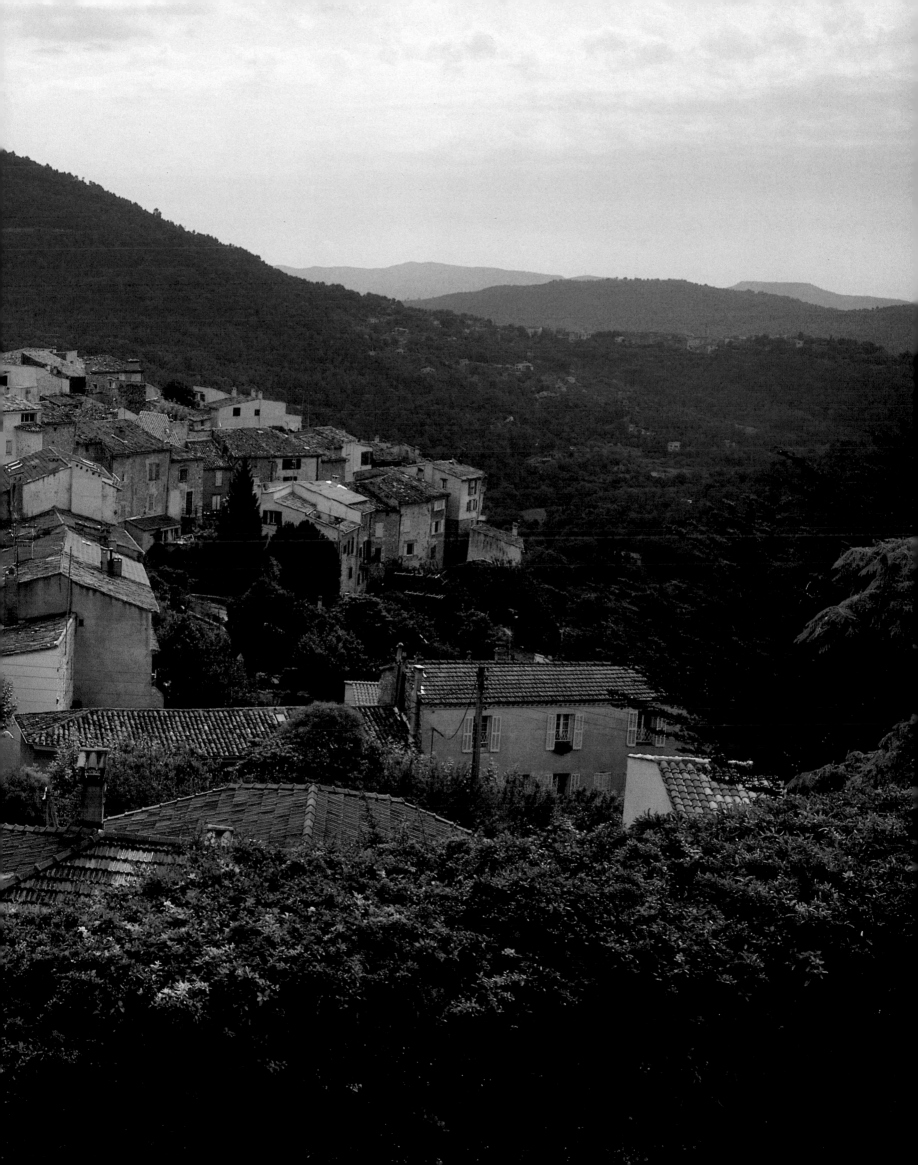

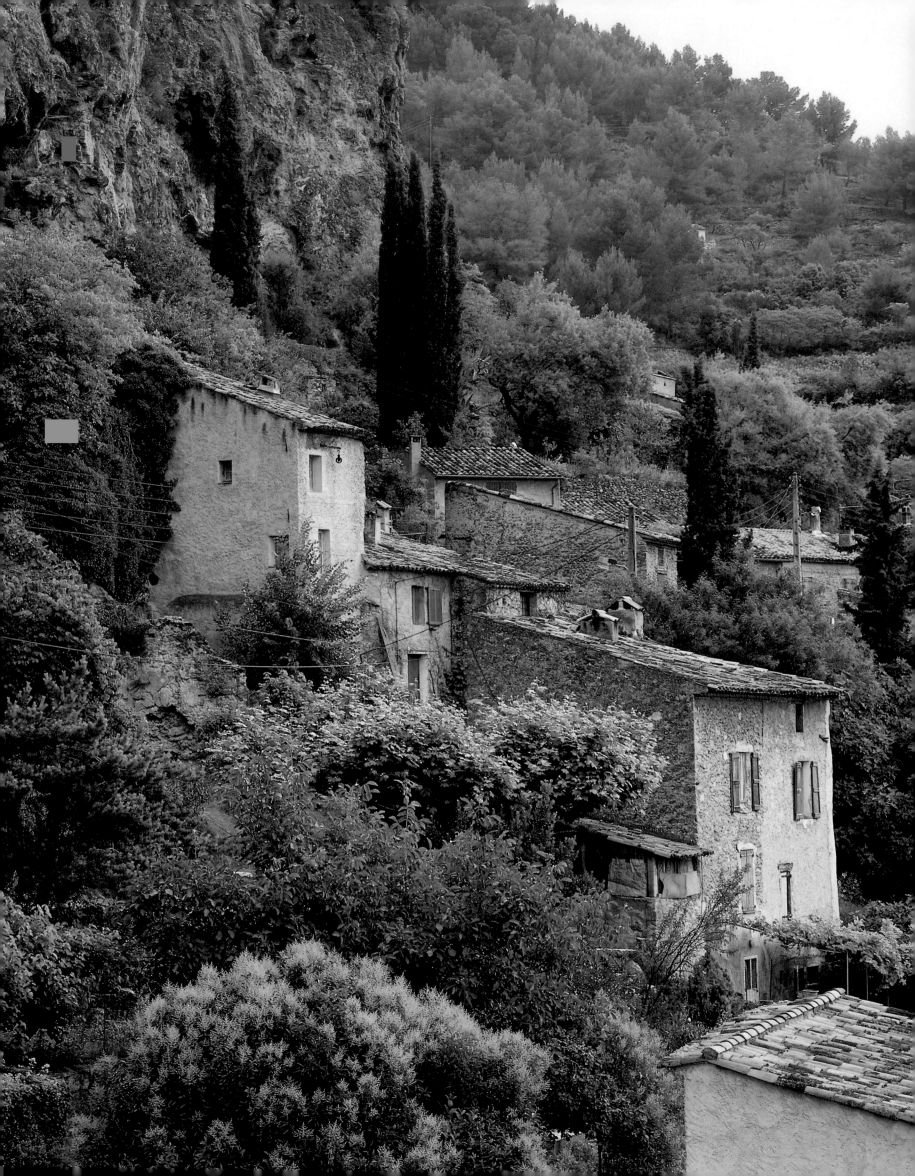

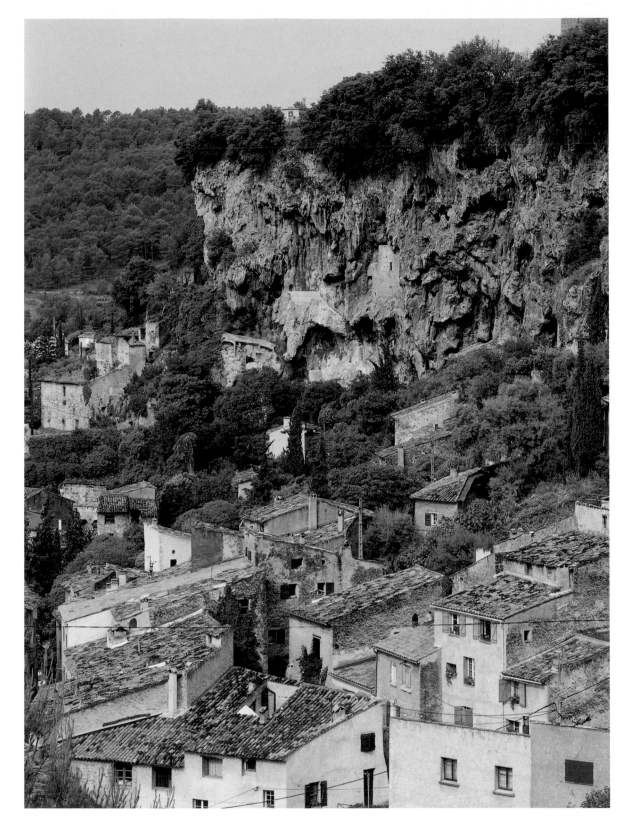

The closely-knit ensemble of seventeenth-century Cotignac's weathered masonry and russet-coloured roofs blends perfectly with the pitted cliff behind (opposite and *right); the rocky face is broken by a number of fortified troglodytic dwellings which have been used as refuges in times of war.*

Cotignac

VAR

COTIGNAC occupies a striking position at the foot of a tall cliff pockmarked with caves that were once inhabited. Little is known about the village's early history, though it is generally thought to have been populated originally by Celto-Ligurian tribes, who named it after the Celtic word for rock. Abandoned in Roman times, Cotignac seems to have been resettled after the fifth century A.D. by Jews, whose stay here is attested by the existence of a 'Rue de Jérusalem' and the presence until recently of a synagogue. Cotignac's heyday really came in the seventeenth century, when the combined effect

of apparitions made by the Virgin and Saint Joseph led to much money and favour being bestowed on the place by both church and royalty. Additional prosperity resulted from thriving tanning and silk industries, which continued to be active right up to the end of the nineteenth century, when the village's population rose to over three and a half thousand.

The visitor to Cotignac is immediately confronted by one of the finest of Provence's shaded promenades, inspired by the Cours Mirabeau in Aix-en-Provence. Cafés, towering plane trees, a weekly market and, as the

centre-piece, a fine eighteenth-century fountain representing the Four Seasons, make this a delightful place to linger before progressing further into a village which becomes increasingly quiet and decayed the closer it gets to the cliff-face which rises so dramatically above it. All the streets lead to a long, narrow and near-deserted square dominated by a clock-tower pierced by a gateway and an eighteenth-century Mairie resembling an abandoned dolls' house which has been propped up against the cliff. The overwhelming sense of mystery is enhanced by the ancient olive mill which lies abandoned and neglected on the steep footpath behind.

The village centre of Cotignac still retains an endearingly lively character, with a number of small shops (above and above right) seemingly unchanged since the early years of this century. Particularly splendid is the wooden Art Nouveau frontage of the hardware shop overlooking the village's central shaded avenue, where markets are held on Tuesday mornings (right and opposite).

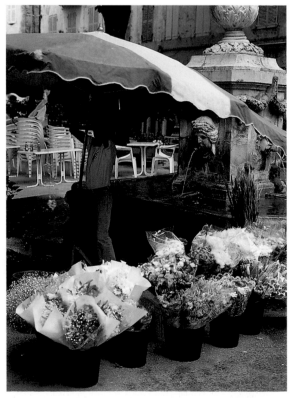

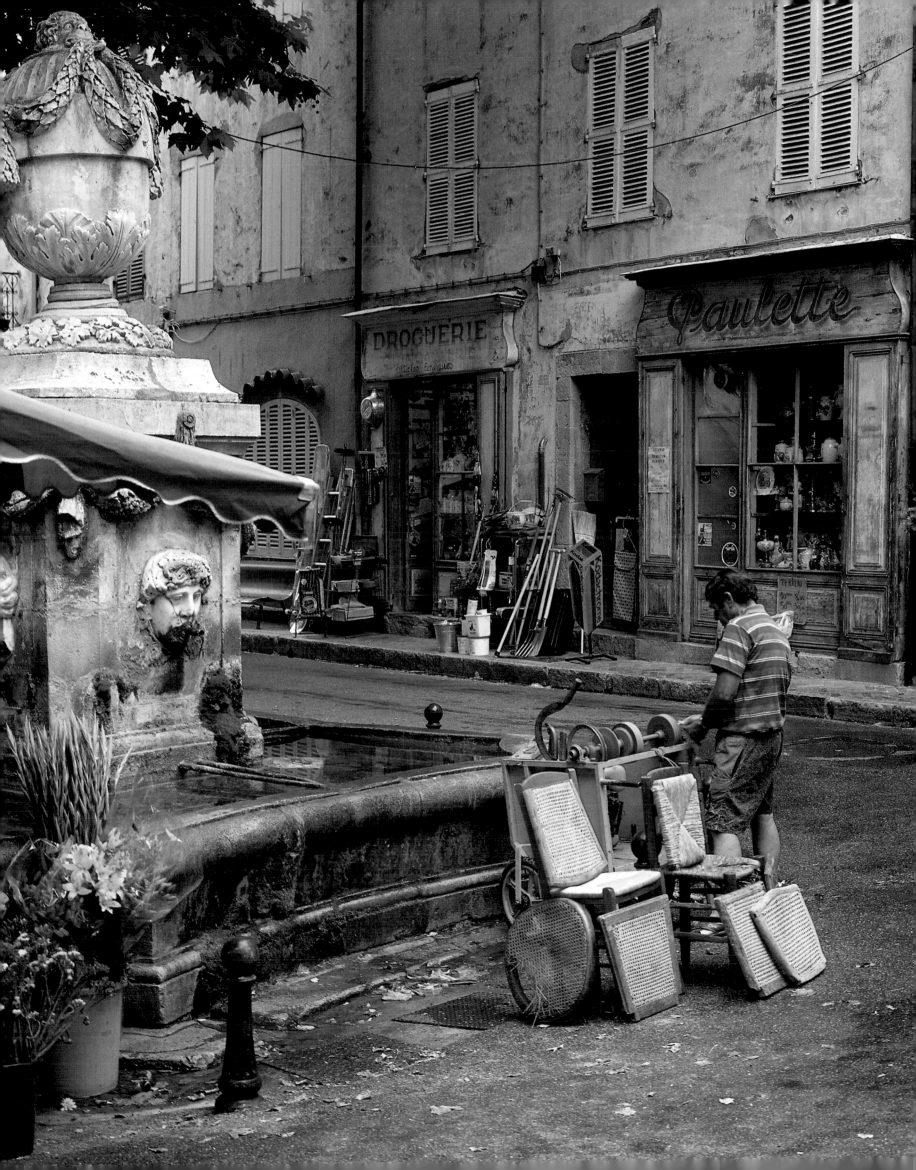

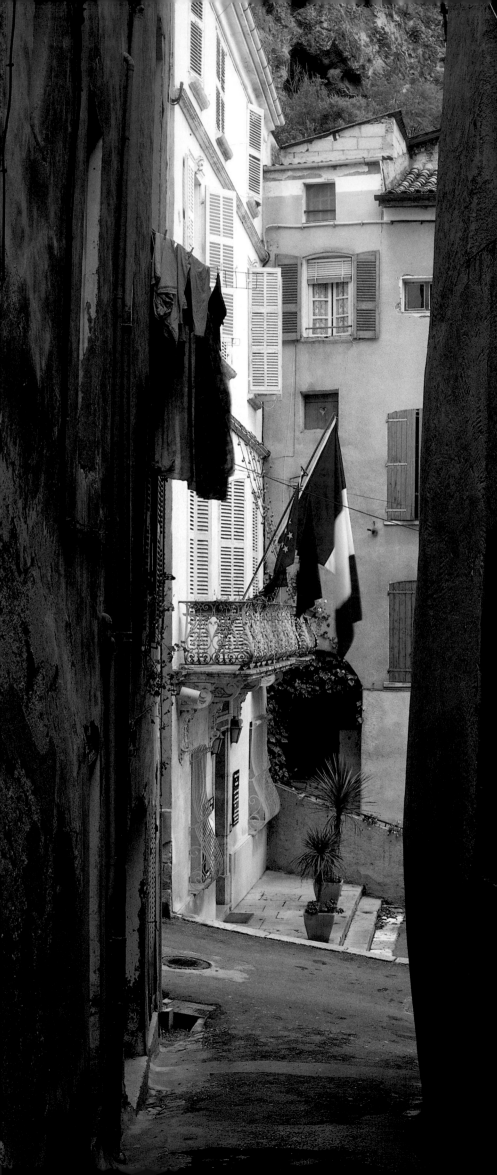

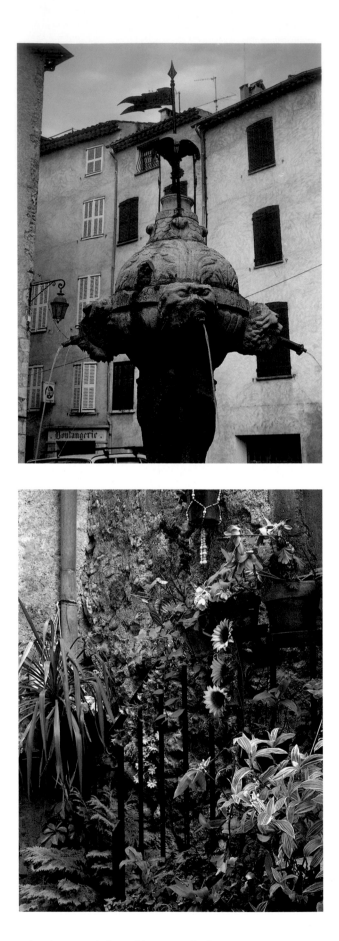

*T*he French flag adds a note of colour to Cotignac's toy-town-like Mairie (left), seen here through one of the side entrances to the tiny, fountain-adorned square (top) in which it stands. Luxuriant vegetation enhances the feeling of close harmony between the village and its natural setting (above *and* opposite).

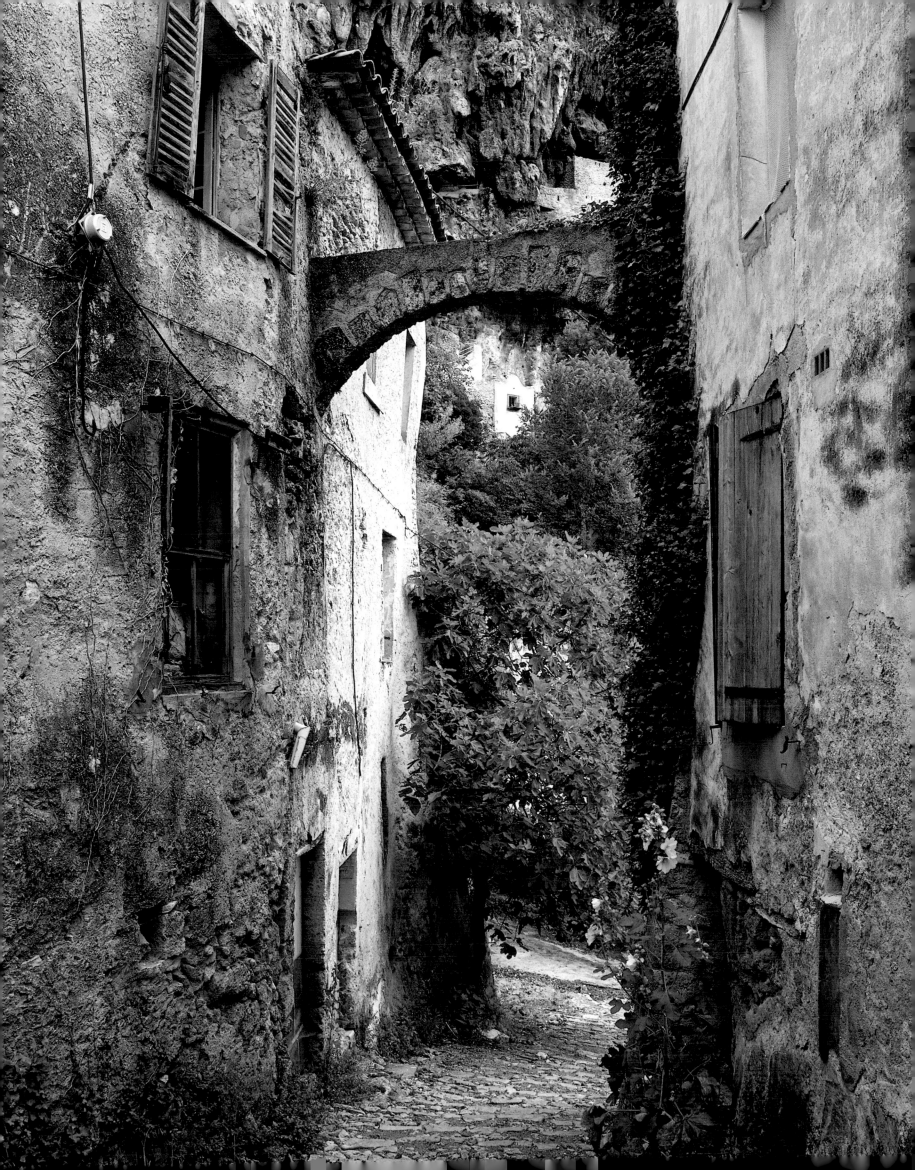

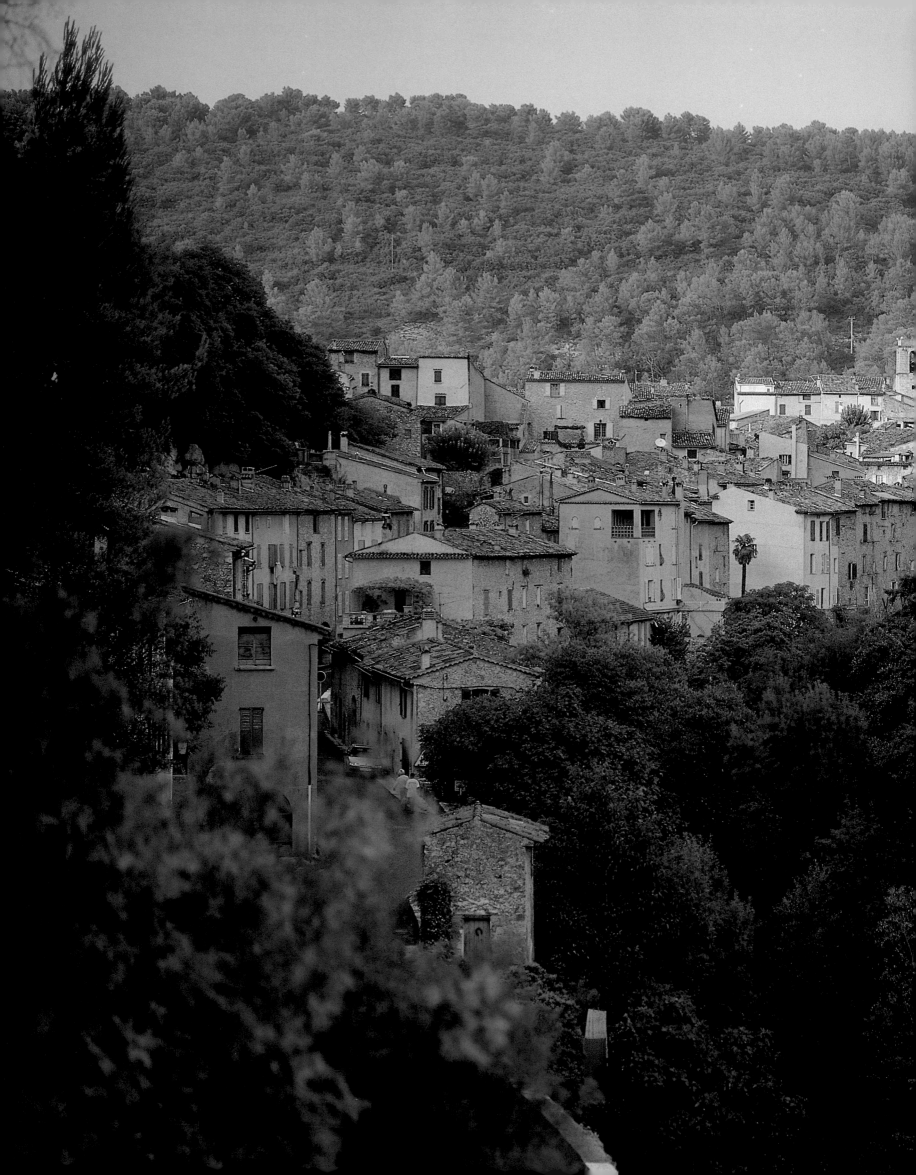

Entrecasteaux

VAR

THE JEWEL-LIKE village of Entrecasteaux, the place 'between two hills', is spread out over two sides of a small and densely wooded valley. Unlike most other Provençal villages, which command extensive views of their surroundings, Entrecasteaux is a wholly inward-looking place.

The whole history of Entrecasteaux is centred on some of the colourful grandees, most notably the Grignans and the Brunys, who have been its lords. It was during the sixteenth century, under the Counts of Grignan, that the place began to acquire some distinction. In the following century, under François de Grignan – the son-in-law of the celebrated woman of letters, Madame de Sévigné – the village acquired an added grandeur appropriate to its patron's status as the first Marquis of Entrecasteaux and Lieutenant-General of Provence. But such was the Marquis's extravagant life-style that the family château had to be sold in 1714 to the wealthy upstarts, the Brunys.

The haughty Brunys – whose members included a Treasurer-General of France and a famous admiral – were also responsible for heaping shame on the village after Jean-Baptiste Bruny, the president of the Provençal Parliament, murdered his wife and fled to Lisbon, where he languished in prison until his death in 1785. By that time the great days of Entrecasteaux were over, though a certain amount of colour was brought back to the village after 1974, when the château was acquired by a Scottish eccentric called Ian MacGarvie-Munn, who worked as a painter and as a diplomat, and counted among his achievements a brief spell as commander-in-chief of the Guatemalan navy.

Entrecasteaux has changed little in appearance since the eighteenth century. Certain of its cobbled streets, with their restrained sixteenth- and seventeenth-century dwellings, have the quality of a stage-set. Particularly endearing is the shaded, café-lined promenade, which looks directly across the tiny river Bresque to the château, below which is a formal French garden traditionally attributed to the great Le Nôtre.

The parish church of Saint-Sauveur guards one of the sides of the wooded fold in which the village of Entrecasteaux is built.

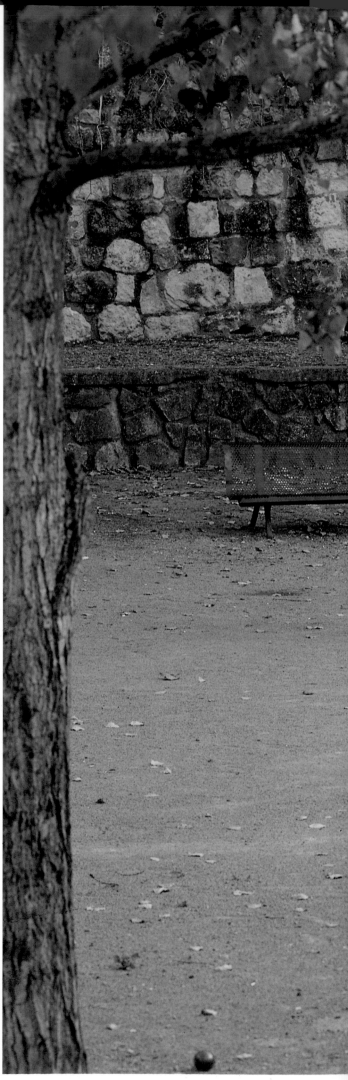

*Le Nôtre's designs and sketches for the Orangery
gardens at Versailles were reputedly given by him to
the Marquise de Sévigné with the intention that they
should be used by her son-in-law at Entrecasteaux; the
formal gardens (above) were in any case not completed
until 1781. The gardens are now a public park, while
the shaded promenade which overlooks them (right)
provides an excellent space for the ubiquitous Provençal
game of* boules.

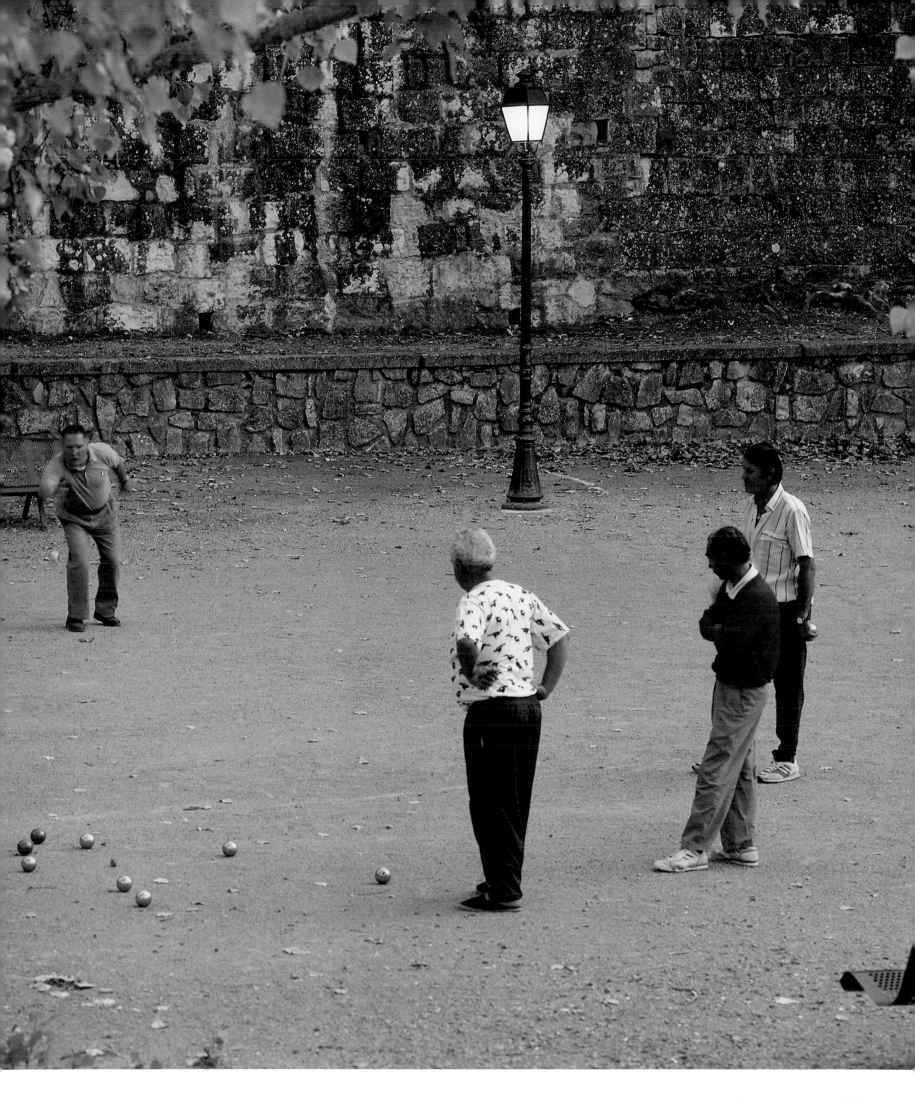

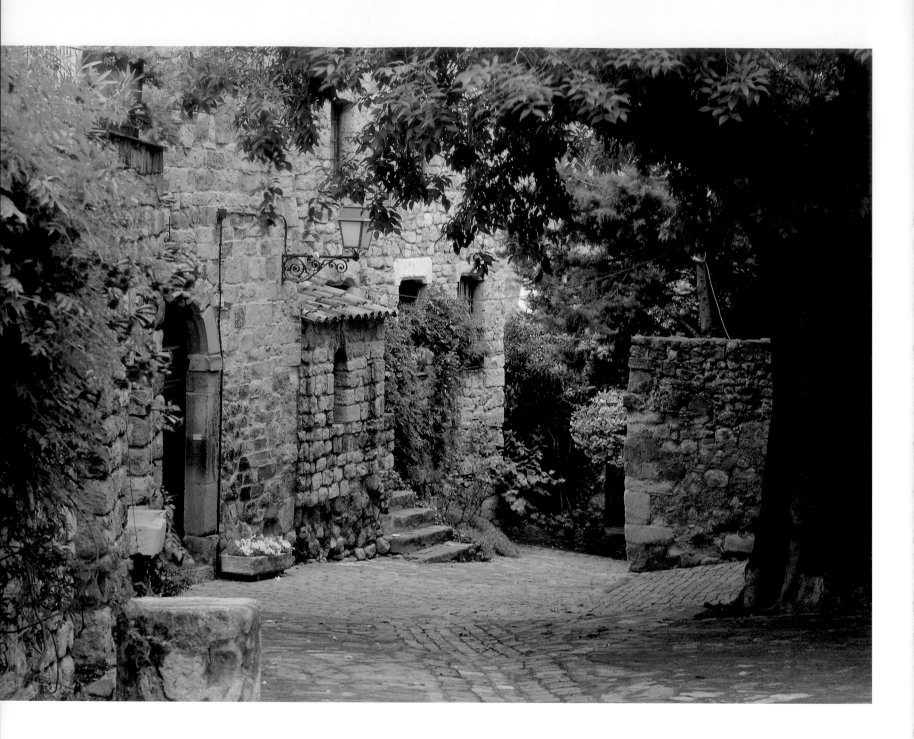

Les Arcs-sur-Argens

VAR

The older medieval houses in the upper part of Les Arcs (above) are built in the local stone, notable for its pinkish colouring; behind the houses (opposite) nestles a kitchen garden, the potager *so important to French country cuisine.*

ONE OF THE BEST preserved of the Var's medieval villages, Les Arcs stands among the vineyards of the prosperous Argens valley, a busy trade route since Roman times. The arches of its name might refer to those either of any outlying ruined aqueduct or of an important Roman bridge which once spanned the local river. The greatest of its surviving monuments date from the Middle Ages, when the village was ruled by the powerful Villeneuve family, whose history was closely linked to that of the Catalan Counts of Provence. Among its members was Romée de Villeneuve, who not only became an influential minister to Raymond Berenger IV, but was also distinguished enough to earn a mention in Dante's *Paradiso*. A later family member, Arnaud de Villeneuve, fathered the popular local heroine, Sainte Roseline, who repudiated her family wealth while still a teenager,

and whose mummified corpse is still an object of veneration at the nearby former convent of La Celle.

The skyline of Les Arcs is dominated by the tall and sturdy tower of the twelfth-century keep of the Villeneuve castle, where Sainte Roseline was born in 1263. The lower parts of the castle, once one of the most important in Provence, have been transformed into a luxury hotel overlooking the village roof-tops and vineyards.

Stepped alleys lead steeply from here into the 'Parage', a small *quartier* within the original medieval walls. This quarter, the oldest in the village, was radically restored between 1945 and 1971, and combines quiet charm with a slightly self-conscious medieval look. A small arch below an elegant ironwork belfry marks the lower end of the medieval quarter, beyond which the village acquires a more animated character.

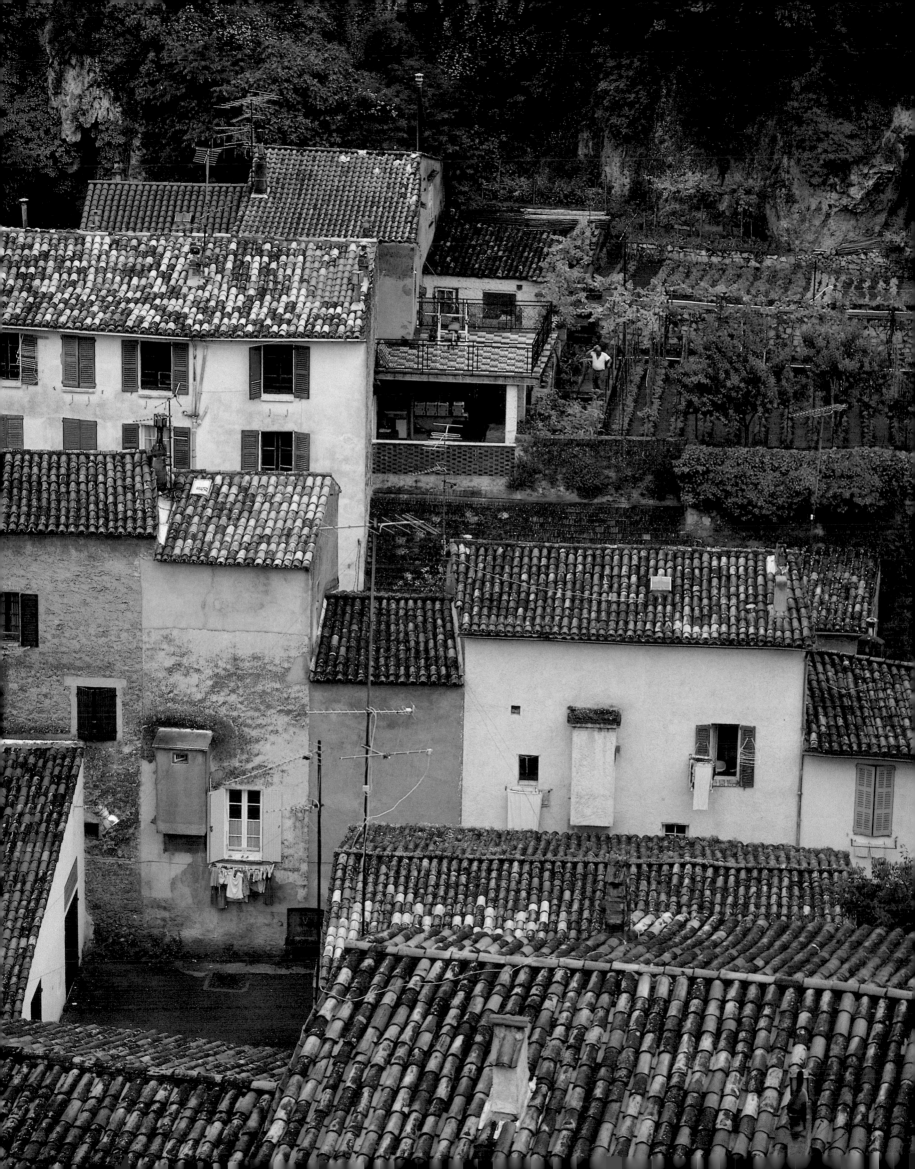

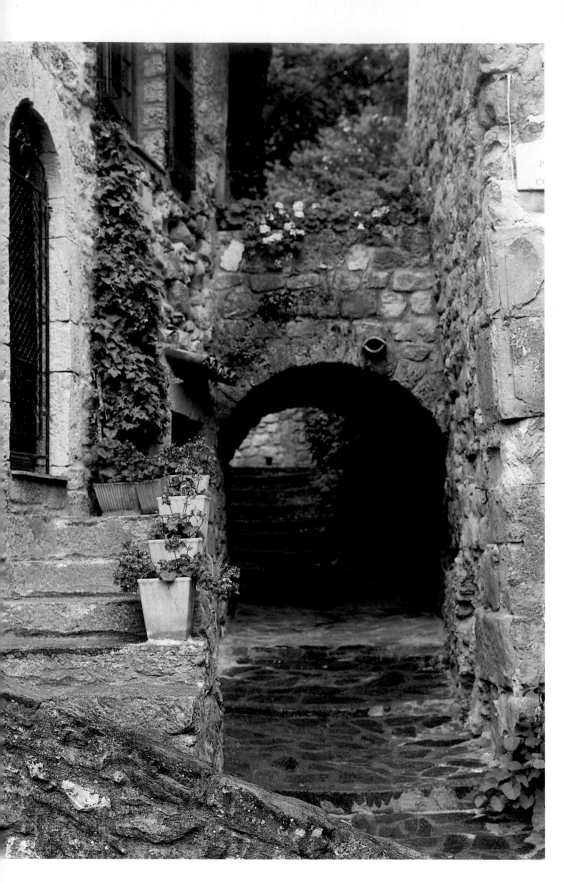

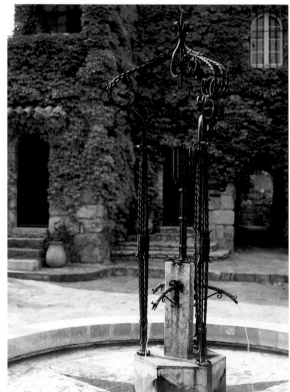

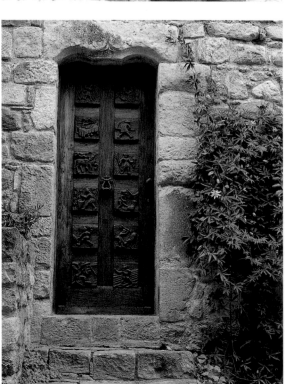

*F*urther medieval details (this page) *from the walled, upper district of Les Arcs known as the 'Parage'; the imposing twelfth-century keep which rises above the village* (opposite) *not only sheltered the great hall of the castle but also all the archives and official documents relating to the community. It now forms a decorative adjunct to a luxury hotel.*

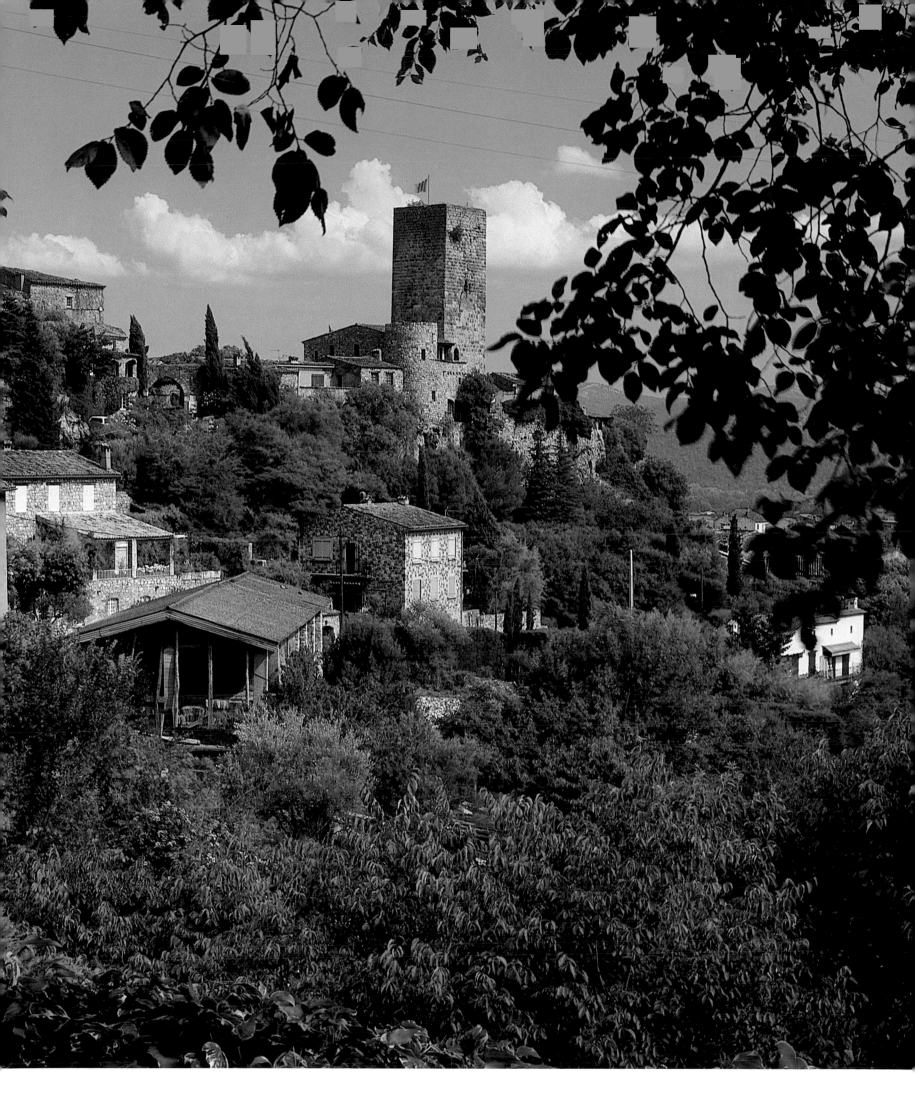

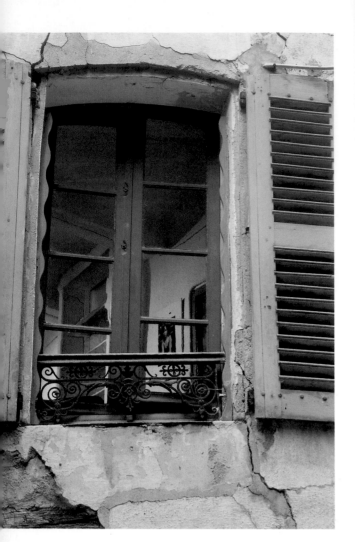

Seillans VAR

THE OLDEST of the fortified hill-villages of the upper Var, Seillans is a harmonious ensemble of pinkish-ochre houses looking over fertile fields from wooded heights which sparkle with broom and olive trees.

Situated in an area full of neolithic and Celto-Ligurian vestiges, Seillans was occupied from the second century B.C. by the Romans, who created a large settlement in the fields below the village. Repeatedly sacked during the Dark Ages, the village was reputedly named 'Seillans' after the Provençal word for the pot used for boiling the oil with which the inhabitants vainly tried to repel the invaders. The village's subsequent history was rather more peaceful and marked principally by disputes over the ownership of its seigniorial rights. By the late nineteenth century, when Seillans had become a quiet backwater, the Vicomtesse Savigny

A reproduction of a work by the photographer Robert Doisneau is glimpsed through a window of the house once occupied by the painter Max Ernst (above). An evocatively lit outdoor café (right), perched on a terrace, brings a touch of fantasy to the upper village.

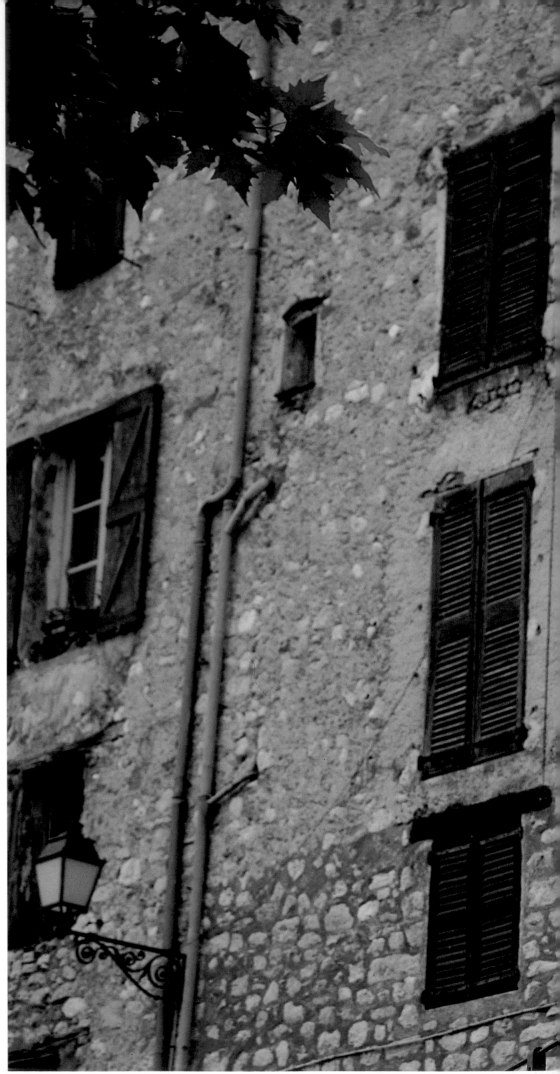

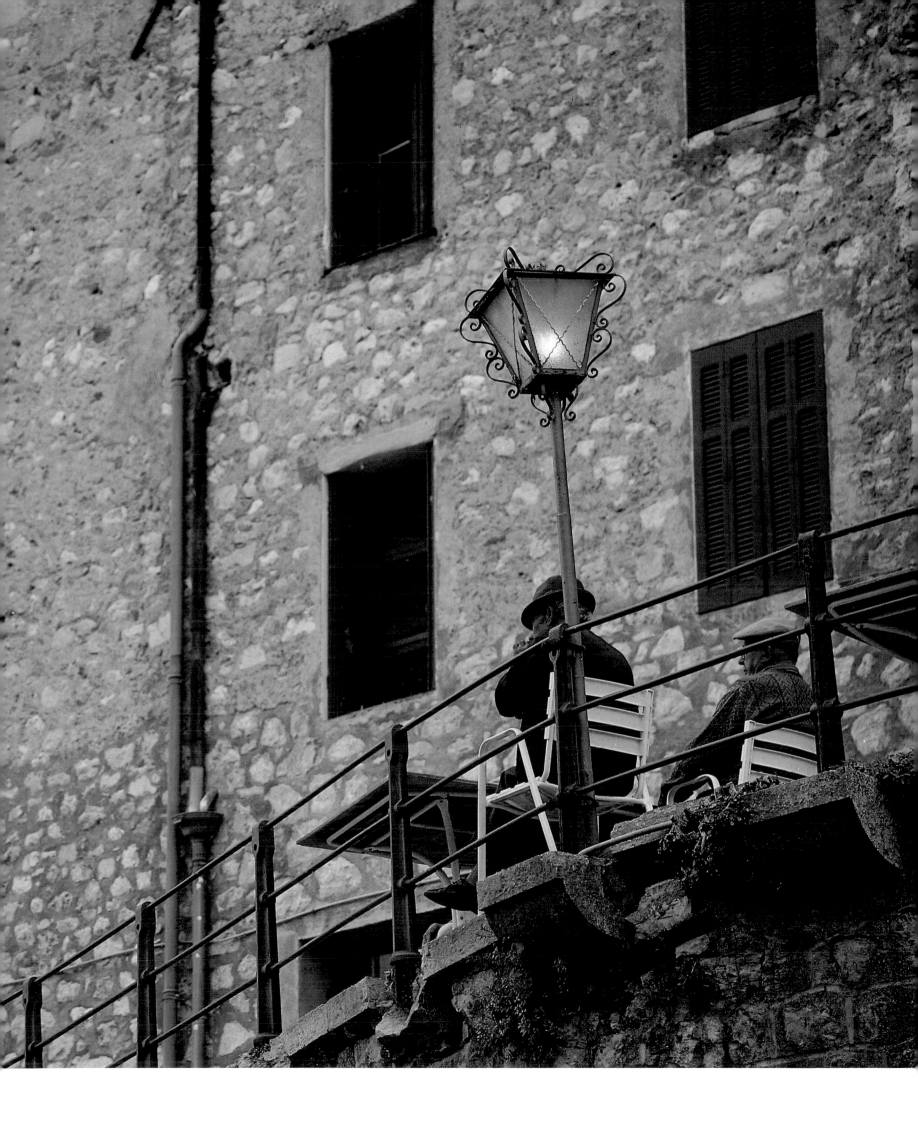

de Moncorps decided to provide new employment for the inhabitants by expanding the local horticulture industry and founding a perfume factory. At the same time the village began to attract a number of distinguished people from the world of the arts, including the composer Gounod and the writers Jean Aicard and Alphonse Kerr. The Surrealist artist Max Ernst moved there in 1962 and remained until his death in 1976.

It is difficult, though, to relate Ernst's erotic and often violent exploration of the unconscious to this extremely pretty village, a place exuding such refined good taste that hardly a shop has been allowed to intrude on its ancient centre.

The old village is entered through three gates built into the tall, compressed row of houses converted from the original outer fortifications. Cobbled alleys climb up from here to a small square, where a fountain plays in front of a seventeenth-century chapel. At the very top of the hill is the privately owned castle, which is in fact a picturesque assemblage of structures dating from the eleventh to the seventeenth centuries.

The fountain (left) *in the Place du Thouron is one of many restful distractions on the climb up the steep cobbled alleys of the village* (left top, centre *and* opposite). *The blacksmith* (above) *valiantly upholds a traditional and vanishing way of life, more perhaps for pleasure than profit.*

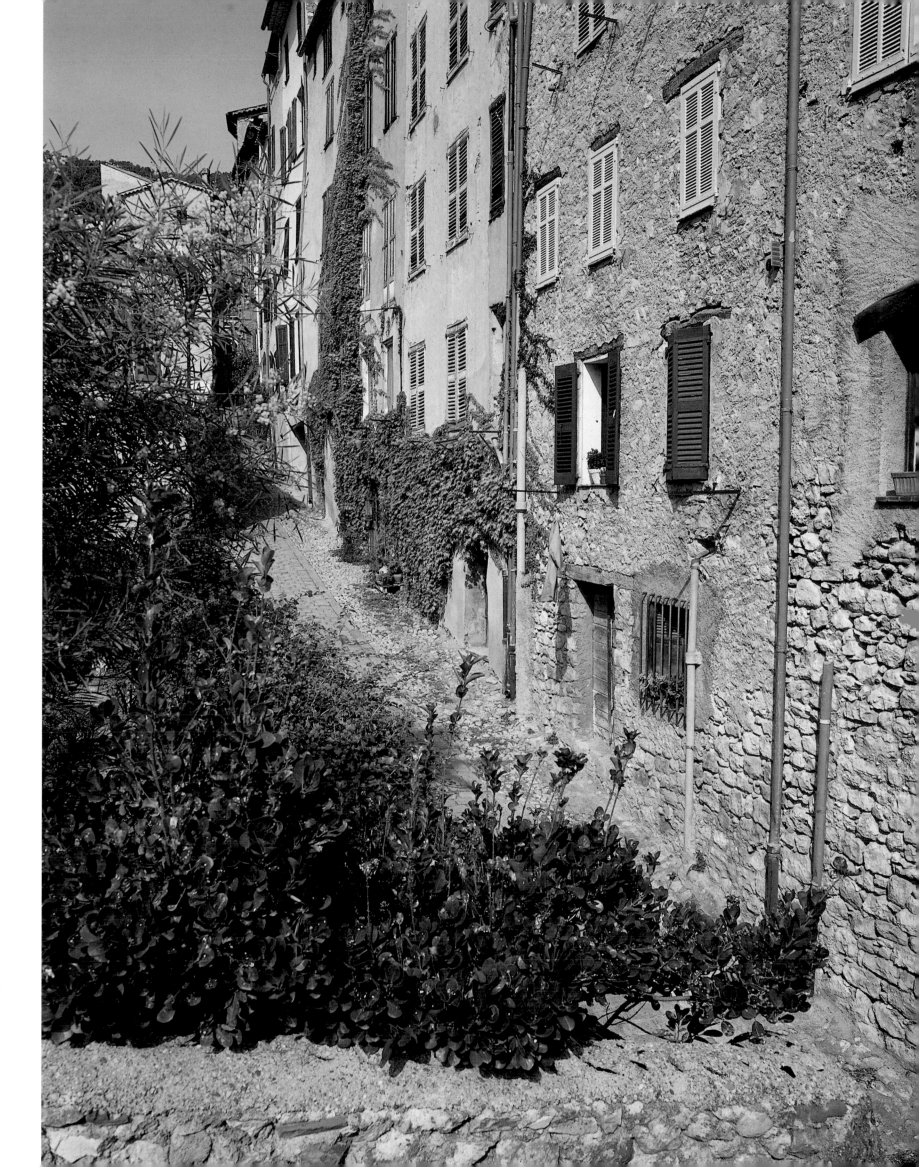

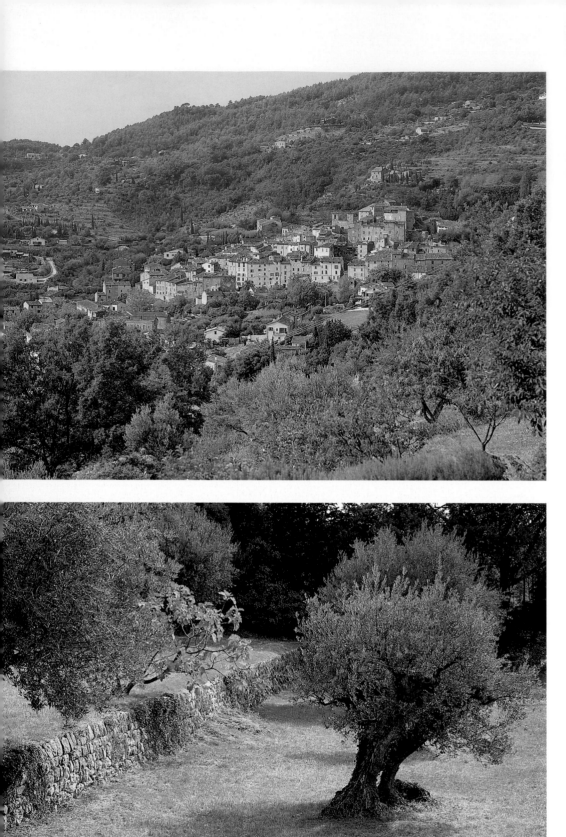

*U*nder the shadow of its pleasantly ramshackle castle,
the village of Seillans luxuriates amid terraced
groves of olive trees (top *and* above). *From the village
there is a magnificent view* (right) *over a
characteristically Provençal landscape of terracotta roofs,
cypresses and olive trees.*

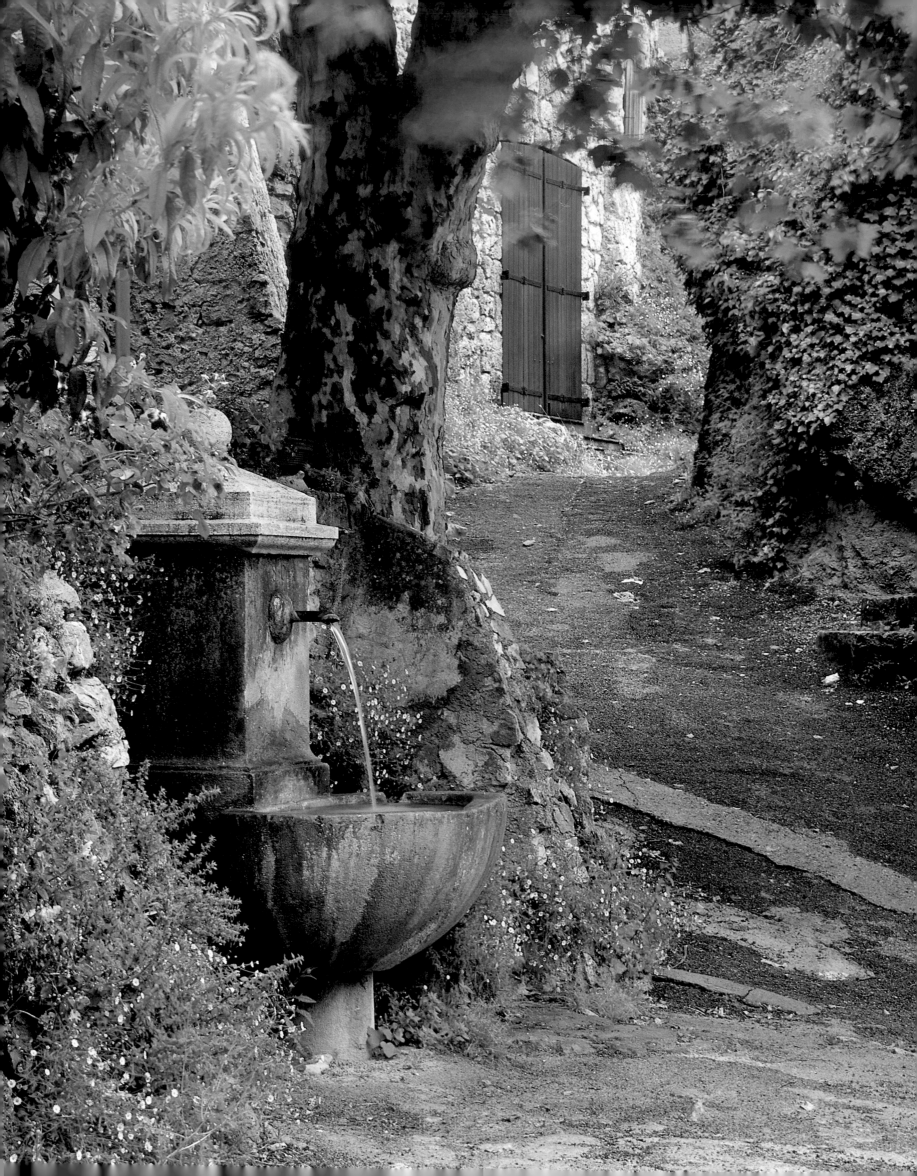

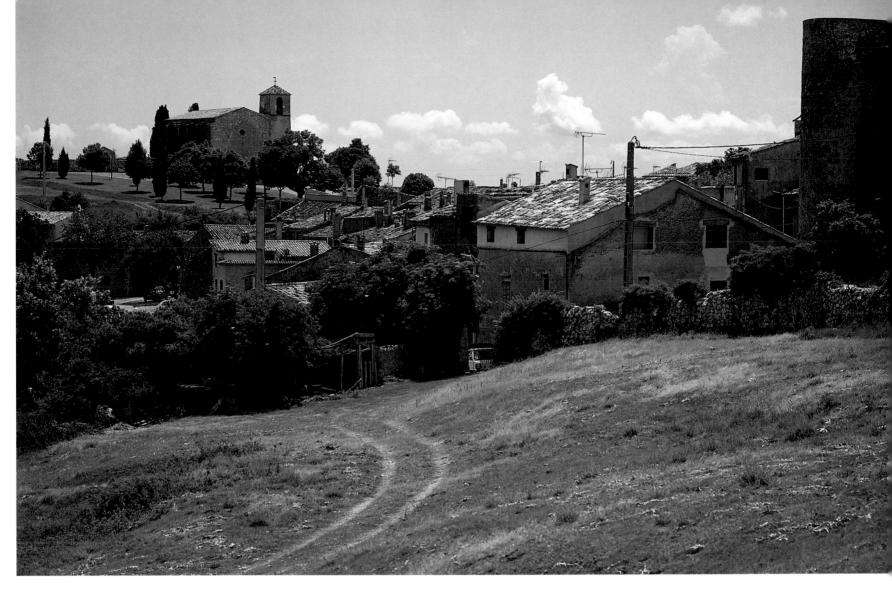

Tourtour VAR

BYPASSED both by the Wars of Religion and the Revolution, Tourtour has achieved later renown as a tourist centre, and was indeed one of the first villages in this scantily populated part of the Var to attract large numbers of foreign visitors. Those driving here from the neighbouring and comparatively peaceful village of Villecroze might well be surprised on reaching the central square of Tourtour, which is lined for much of the year with crowded café tables.

There is much in Tourtour of picturesque appeal – vaulted passageways, medieval houses and arches, three small castles, and several cascades gushing over ivy-covered rocks. But the village's most memorable characteristic is its situation at the very top of a wooded, gently rounded mountain commanding a vast panorama stretching all the way from the Bay of Saint-Raphaël to Mont Ventoux. This situation has earned Tourtour the nickname of 'the village in the sky', but it also helps to explain why the place was spared the skirmishes and bandit attacks which ravaged nearby communities such as Aups.

The panorama is best appreciated from the church of Saint-Digne, a much restored twelfth-century structure standing in isolation above the hill's edge.

The sound of rushing water from streams and fountains (opposite), permeates the byways of Tourtour. Arched alleys and paths lead from the main part of the village up to the twelfth-century parish church, which has famous views over the surrounding countryside (above).

Trees, plants and fountains abound in Tourtour (overleaf), encouraged by the special local soil and the abundance of water. The village is notable for its large number of private gardens.

119

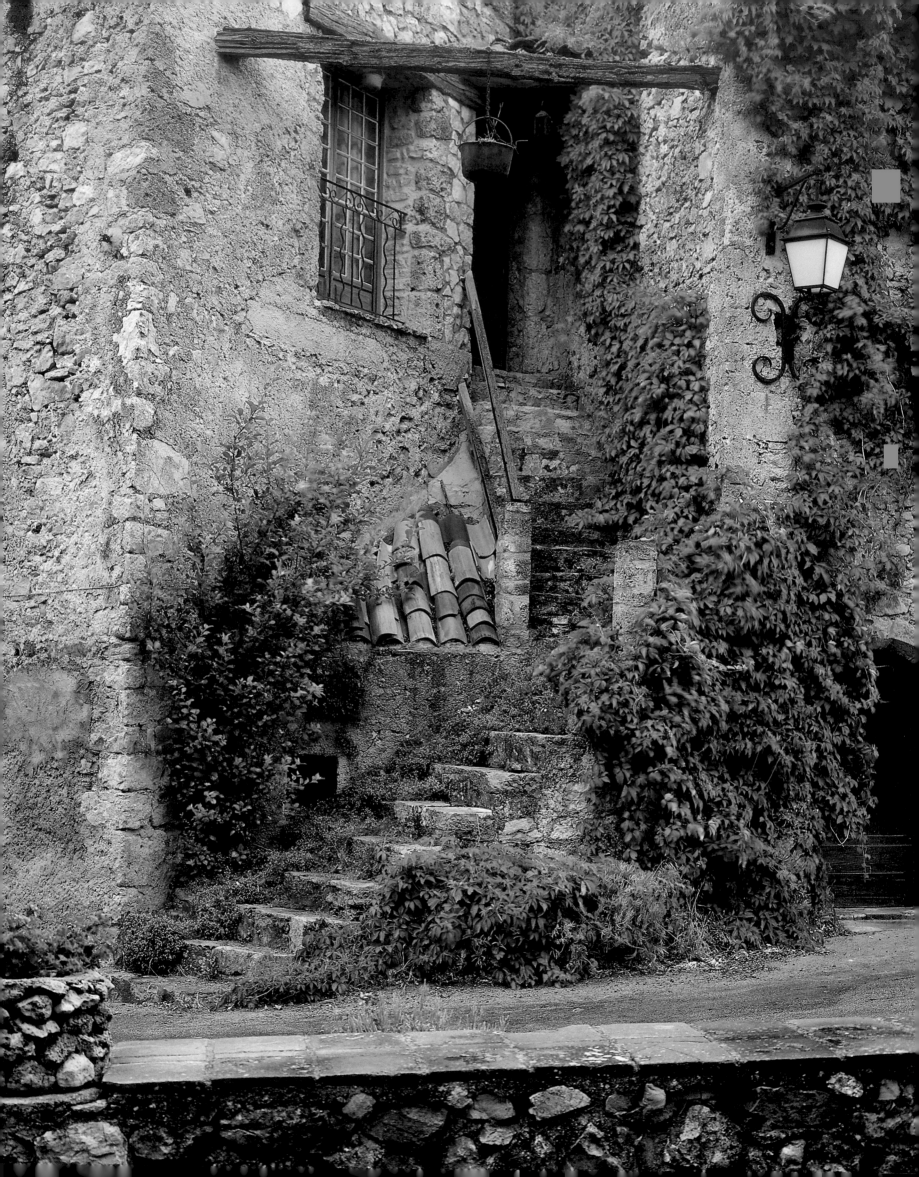

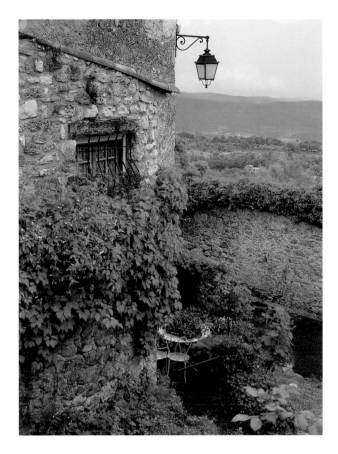

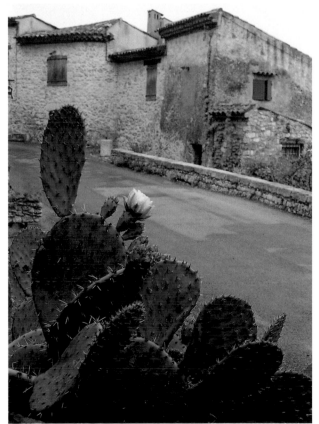

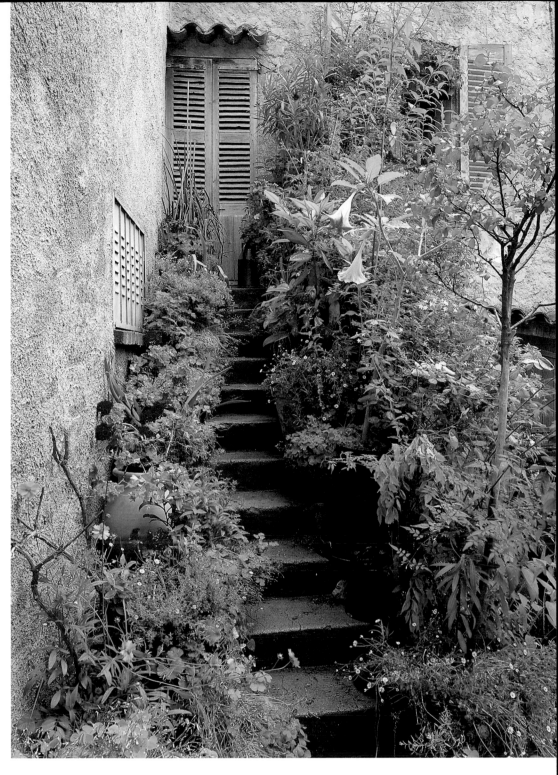

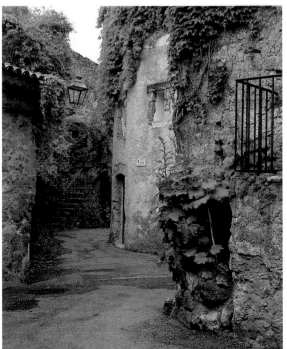

*P*articularly characteristic of
*Tourtour are the rows of pots on
the steep entrance-ways to houses,
and the great cascades of ivy all but
covering the village's narrow, stepped
alleys* (this page *and* opposite).

Trigance

VAR

Lavender-flavoured honey, the famous Miel de Provence, provides a steady employment for Monsieur Bernard (below), whose family has been producing it in Trigance for generations. A well-head stands next to a medieval house (opposite) at the entrance to one of the rough-hewn streets leading up to the castle.

SITUATED in one of the bleakest corners of Provence, Trigance dominates a wild plateau marking the entrance to the spectacular Gorges of the Verdon. Encircled by a ring of barren mountains, this tiny village lies below the crenellated towers and battlements of an eleventh-century castle, which was largely rebuilt in the nineteen-sixties and converted into a hotel.

Trigance was originally a small Roman settlement, then in the early Middle Ages it became a dependency of the abbey of Saint-Victor in Marseilles. The 'castle' was built by the monks less as a castle than as a fortified monastery, which helps to explain why one of its four sides – the one facing the mountains – was left unprotected.

After the departure of the monks in the fourteenth century, Trigance was ruled by a succession of feudal lords who, following a devastating plague in 1630, were forced to repopulate the village with settlers from outside the region. At the time of the Revolution the castle was destroyed by the villagers, who pillaged its masonry to rebuild their own homes.

Five hundred inhabitants were left in the village by the outbreak of the First World War, but this number rapidly dwindled in later years. A chapel dedicated to the plague saint, Saint Roch, stands at the entrance of the village, while on the miniature main square is a monument to the war dead. Bleached stone houses, restored by more recent arrivals, line stepped and cobbled alleys that peter out amidst the rocky, herb-scented terrain.

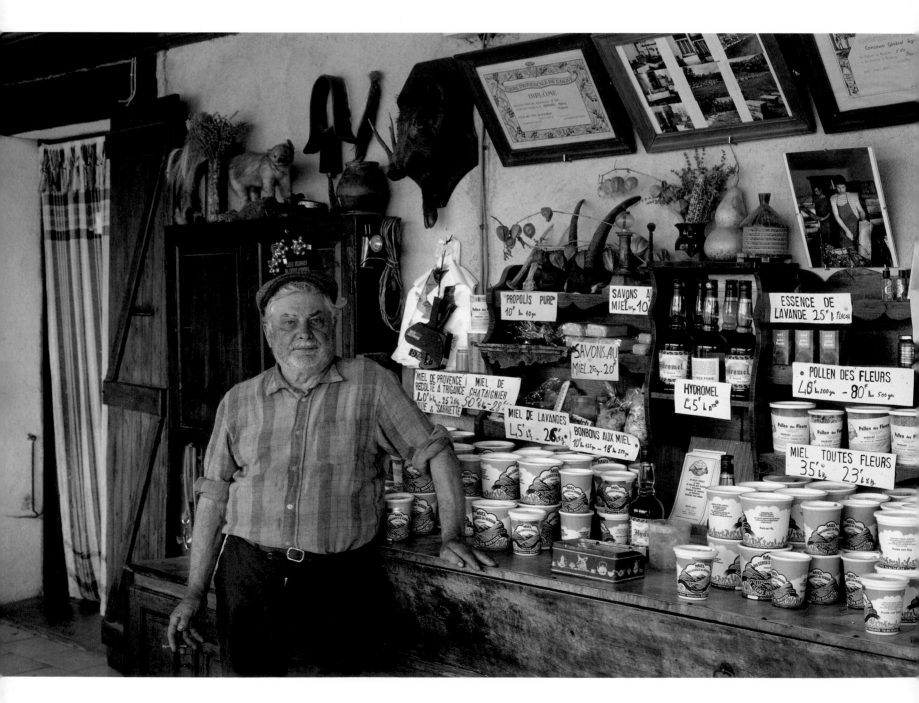

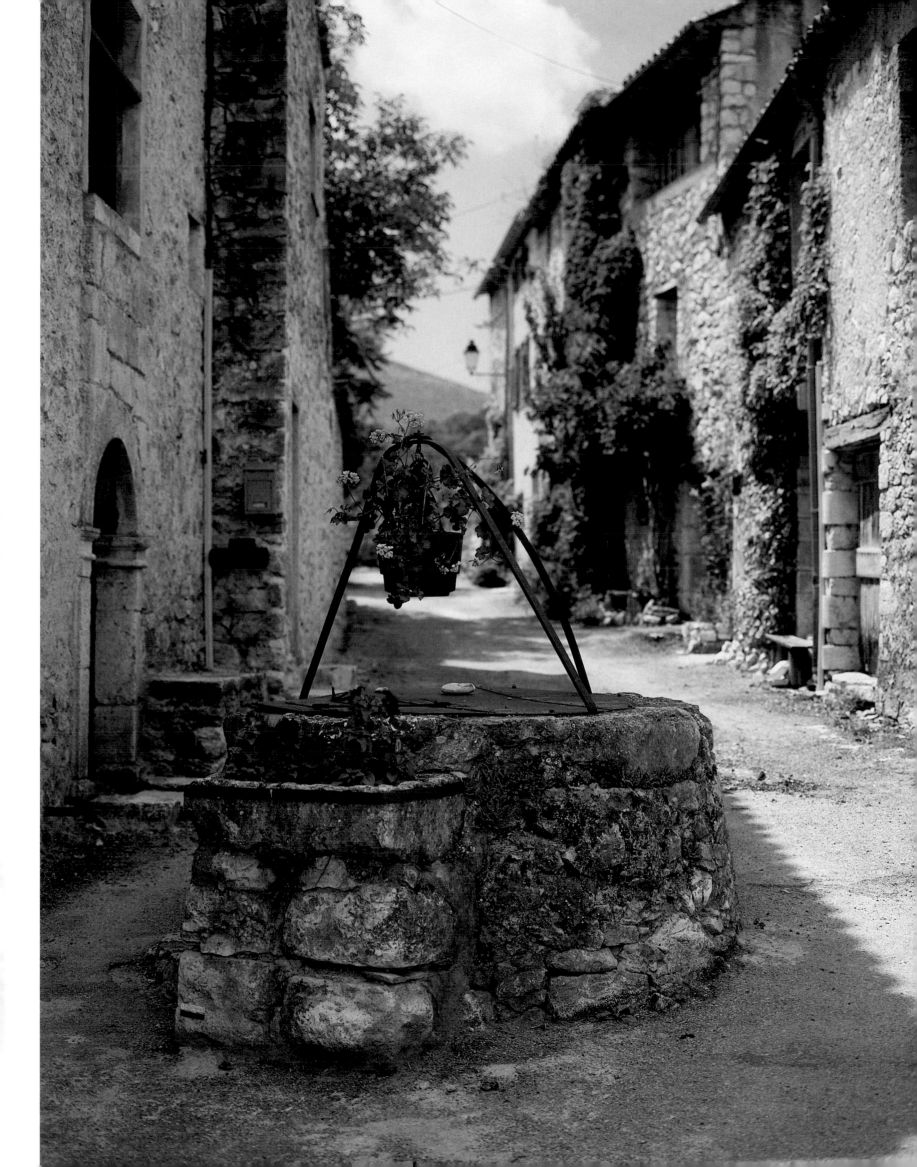

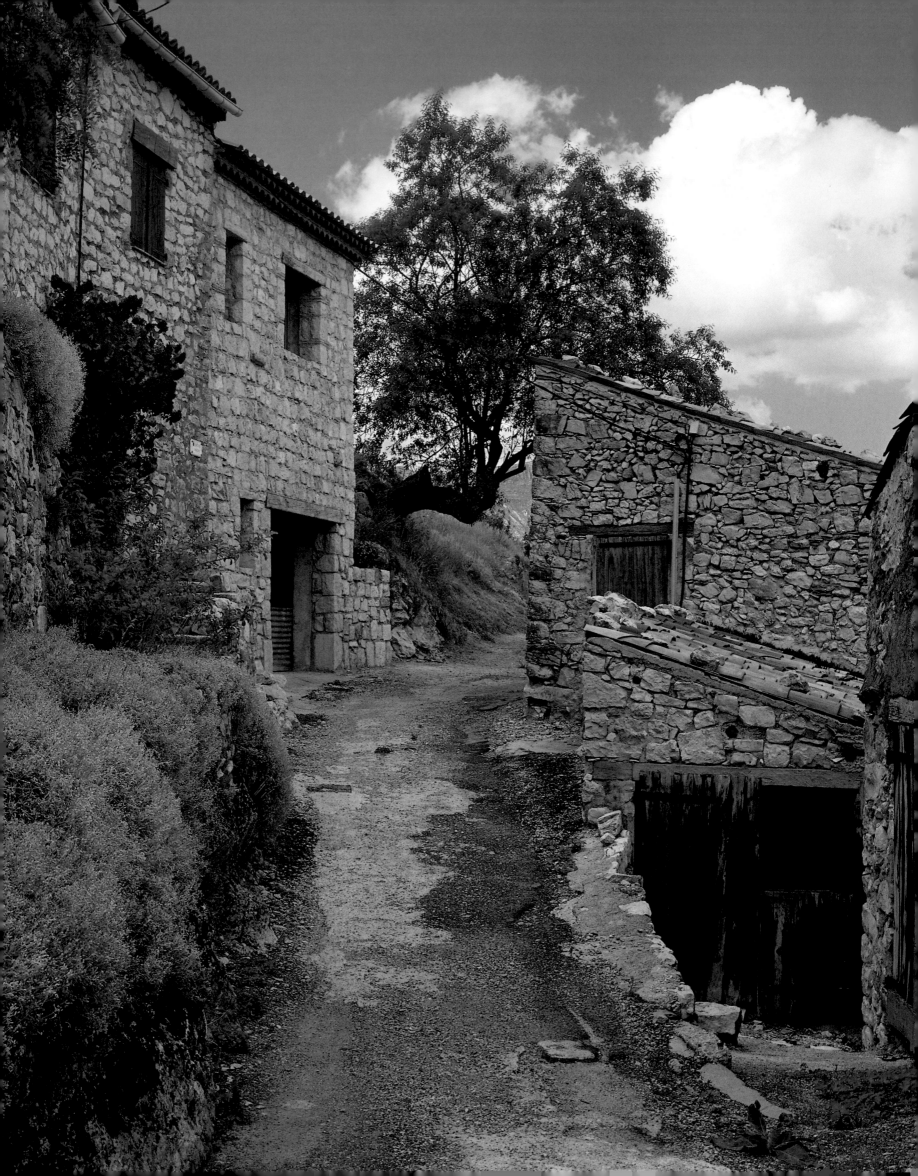

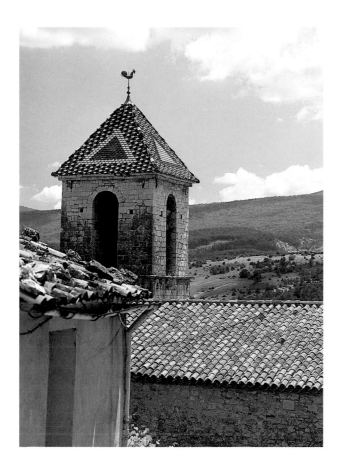

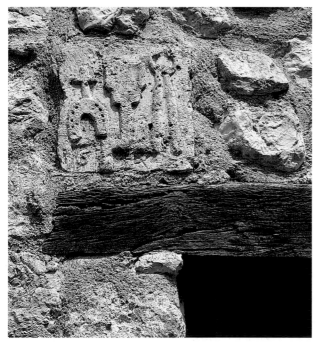

*N*ew homes in traditional style have risen from the
ruins of the upper part of the village (opposite). A
simple medieval arch (right) and the unadorned tower
(top) of Saint-Michel emphasize the village's essential
austerity; the carvings above a lintel (above) record the
former presence of a smithy. The sparsely covered summit
of the Colle de Bries makes an impressive backcloth to the
village and the Château de Trigance, now a luxury
hotel (overleaf).

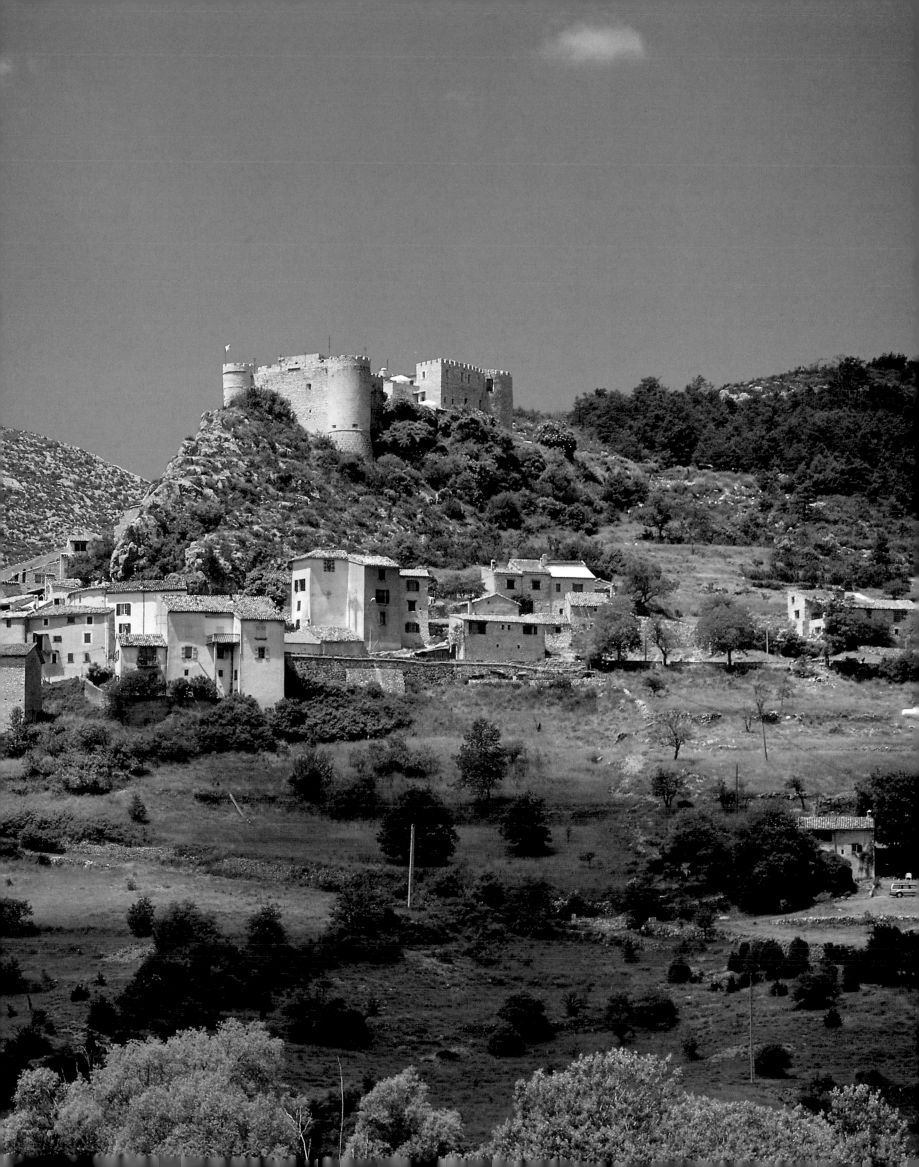

Villecroze *VAR*

KNOWN ONCE as 'la ville creusée' or 'the hollowed town', Villecroze grew out of a neolithic community sheltered within the caves of a now densely overgrown tufa cliff. A spacious cave dwelling, with steps hewn from the rock and sixteenth-century windows, can be seen in the village's enchanting and surprisingly large park, where a waterfall over one hundred feet high cascades into a stream which meanders through a peaceful setting of hedgerows, lawns and an elegant pavilion used for art exhibitions.

Settled first by the Romans and then by monks from the abbey of Saint-Victor in Marseilles, Villecroze experienced its heyday after 1150, when the Templars established here the important Commanderie de Ruou. The order declined in power at the end of the thirteenth century, after which the Commanderie was used by the Hospitallers, who let it decline before eventually

Squat arches and masonry of remarkable thickness characterize the secretive streets of the tiny old quarter of Villecroze (right); a sunnier aspect of the village is presented by its well-planted park (above).

130

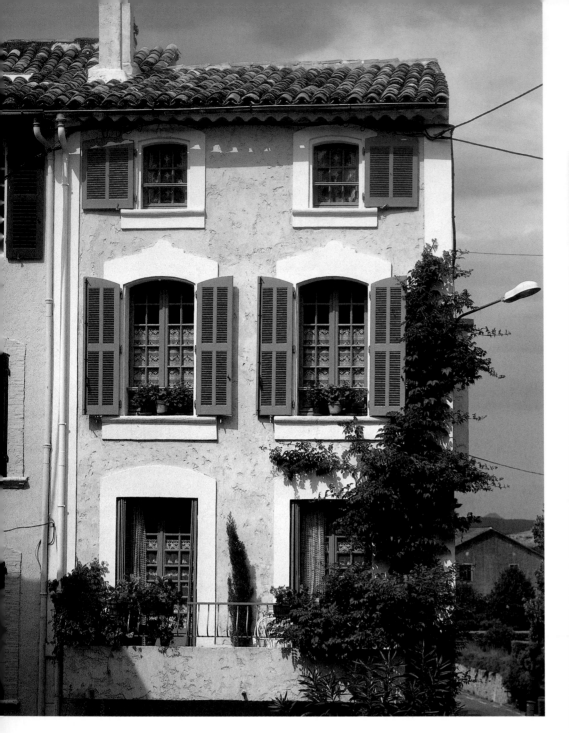

There is an overall elegance about the heart of the village, expressed equally well in its dwellings (above and above right) and in such features as a simple drinking trough (right). The loveliest feature of the village's great park is a stream which cascades down the overgrown cliff-face (opposite).

transferring it elsewhere. The village never recovered. Its main claim to fame in later years was to have been the birthplace in 1887 to Jean Pain, who became known unglamorously as the 'Pope of Compost'. Thought of in his time as a crank, Jean Pain was one of the earliest scientists to have realized the energy potential of compost made from brushwood.

The early importance of the village is barely hinted at in the Villecroze of today, a small and quiet community, with a friendly café, a well-stocked Maison de la Presse, and extensive views over a rolling landscape of oaks and pines. Hidden from the main road and entered through the arch of a modest clock-tower, is a tiny old quarter, hemmed in by severe houses marking the line of the medieval fortifications. A ring of narrow pedestrian valleys, with occasional views of the green landscape below, darts in and out of arches, the silence disturbed only by the hammerings of a solitary furniture-maker.

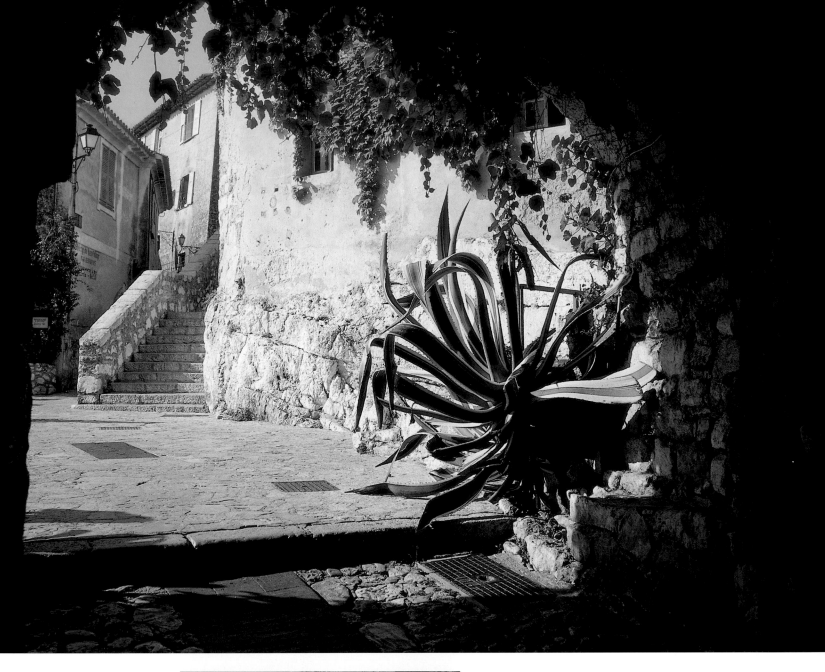

Èze

ALPES-MARITIMES

Aloe (above) *guards the entrance to Èze's citadel, largely occupied by the famous Exotic Garden* (right)*, where numerous rare plants used in the making of perfumes vie with a rich collection of cacti. Thread agave at the top of the garden* (opposite) *provides the foreground to the dramatic view over Cap Ferrat.*

THE GERMAN PHILOSOPHER Nietzsche, staying at Èze during the eighteen-eighties, conceived much of the third part of *And Thus Spoke Zarathustra* while contemplating the village's vertiginous views over the luxuriant sparkling coastline which extends along wooded bays towards Monaco and Italy.

The original settlement of Èze, situated slightly to the west of the present village, was a Ligurian trading post with strong commercial ties with Greece after the fourth century B.C. Fear of coastal attack led, in the Middle Ages, to the village being transferred to its present eagle-nest position above the Middle Corniche. Elevated to *comté* in 1592, Èze then entered a long decline during the reign of Louis XIV, who ordered the destruction of its walls. Towards the end of the nineteenth century, when the surrounding Côte d'Azur was at the height of its fashion as a winter resort, Èze became one of the first Provençal villages to be 'discovered' by artists and writers. By the nineteen-seventies

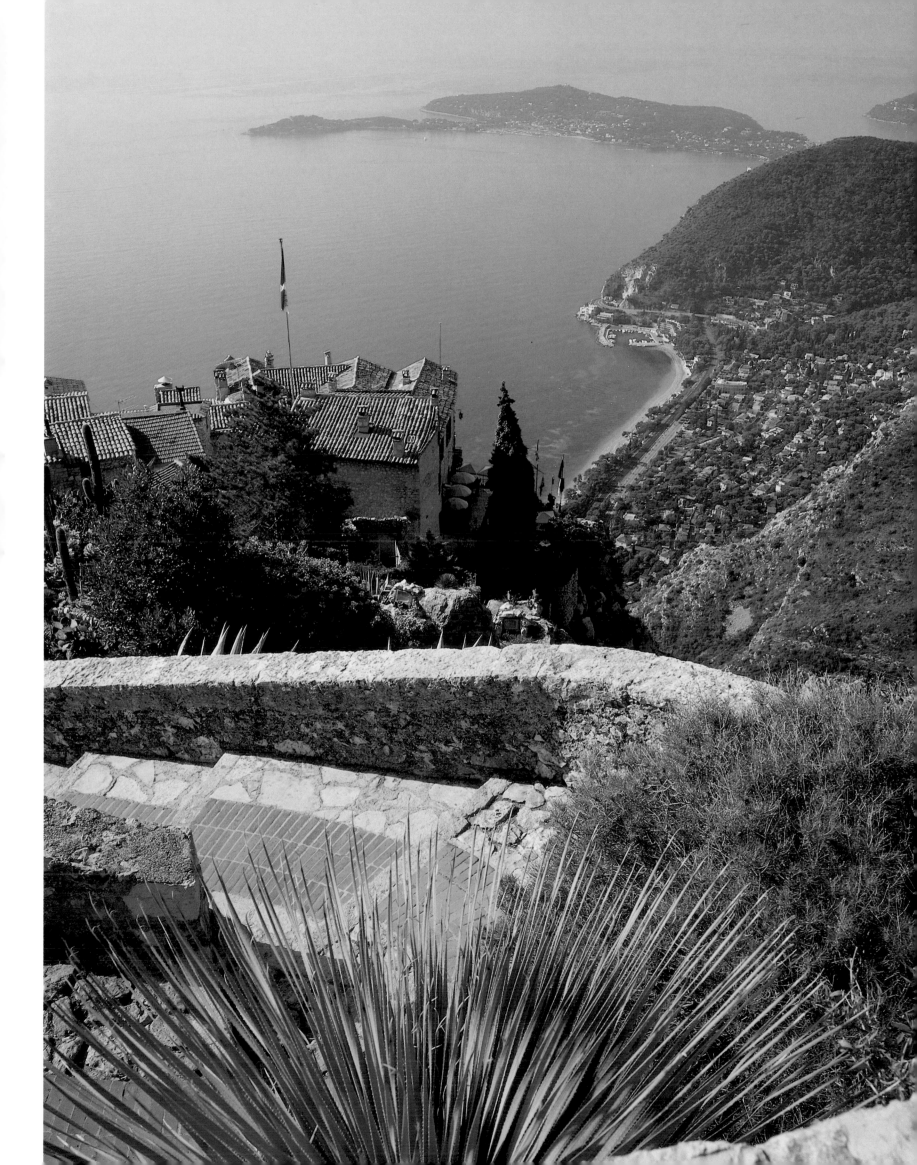

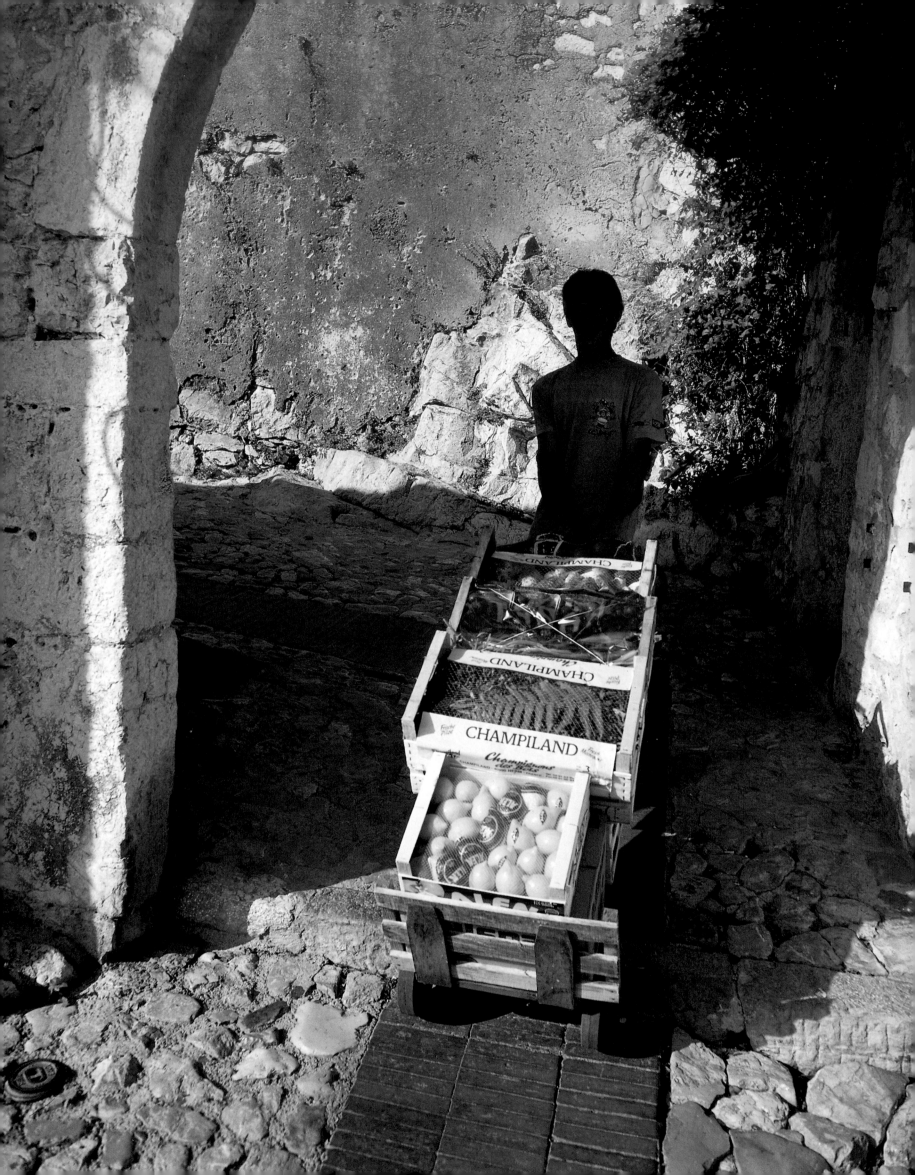

the village economy had come to depend very heavily on income from visitors, as traditional activities, such as the cultivation of flowers and mandarin oranges, began to decline.

The medieval village of Èze, entered by a fourteenth-century gate, has narrow, car-free streets which ascend steeply to the crowning ruins of the village's citadel, within which is a sensationally sited 'exotic garden', planted during the nineteen-fifties with a wealth of cacti and rare plants.

The narrowness of Èze's streets and its many levels have ensured that market produce is still transported by trolleys (opposite and right). A less traditional sight are the many colourful displays of postcards (below), an inevitable feature of a village which has been the scene of thriving tourism since the end of the last century.

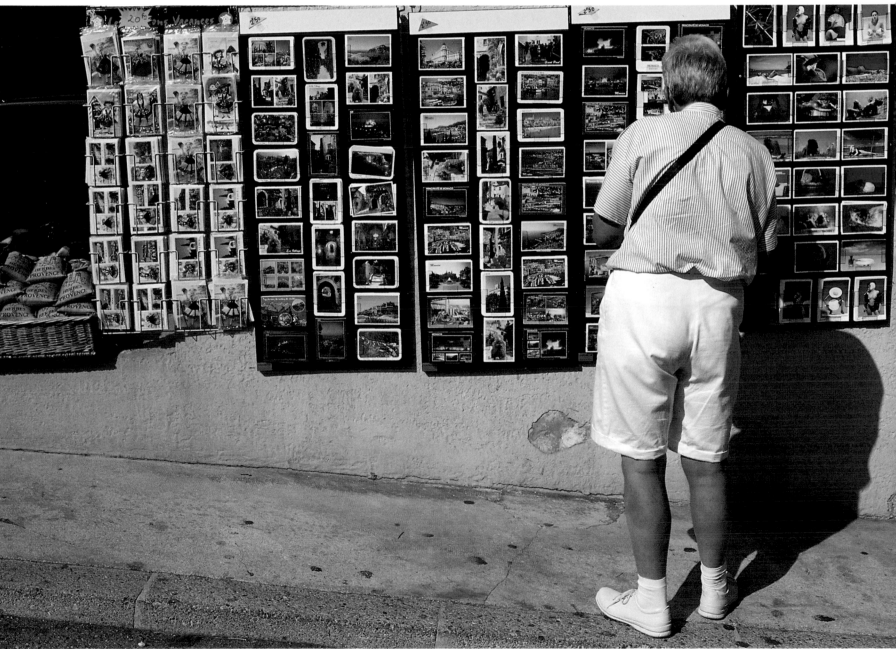

The crowds of the coast soon disappear in the hinterland north-east of Èze, where green vegetation alternates with bleached, limestone crags; this view is towards the hill-village of Piene-Haute.

138

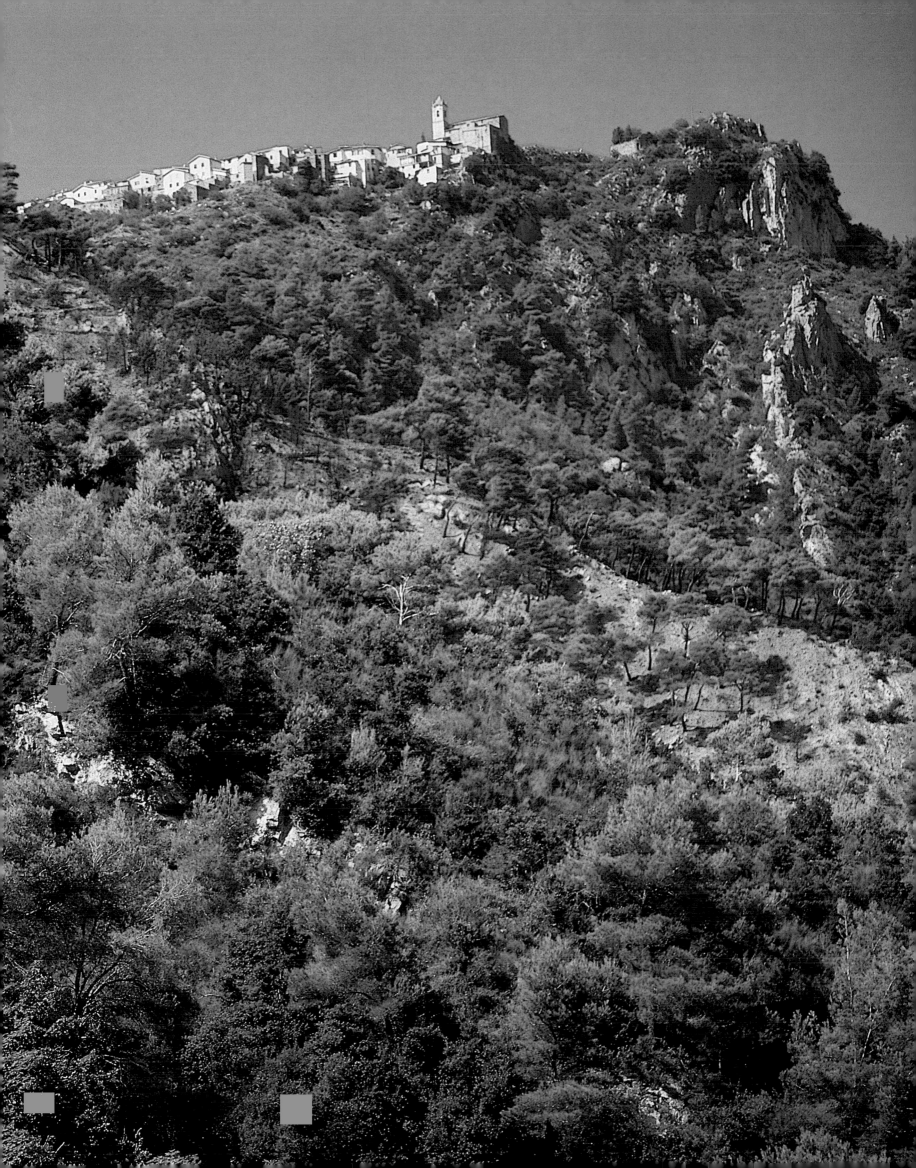

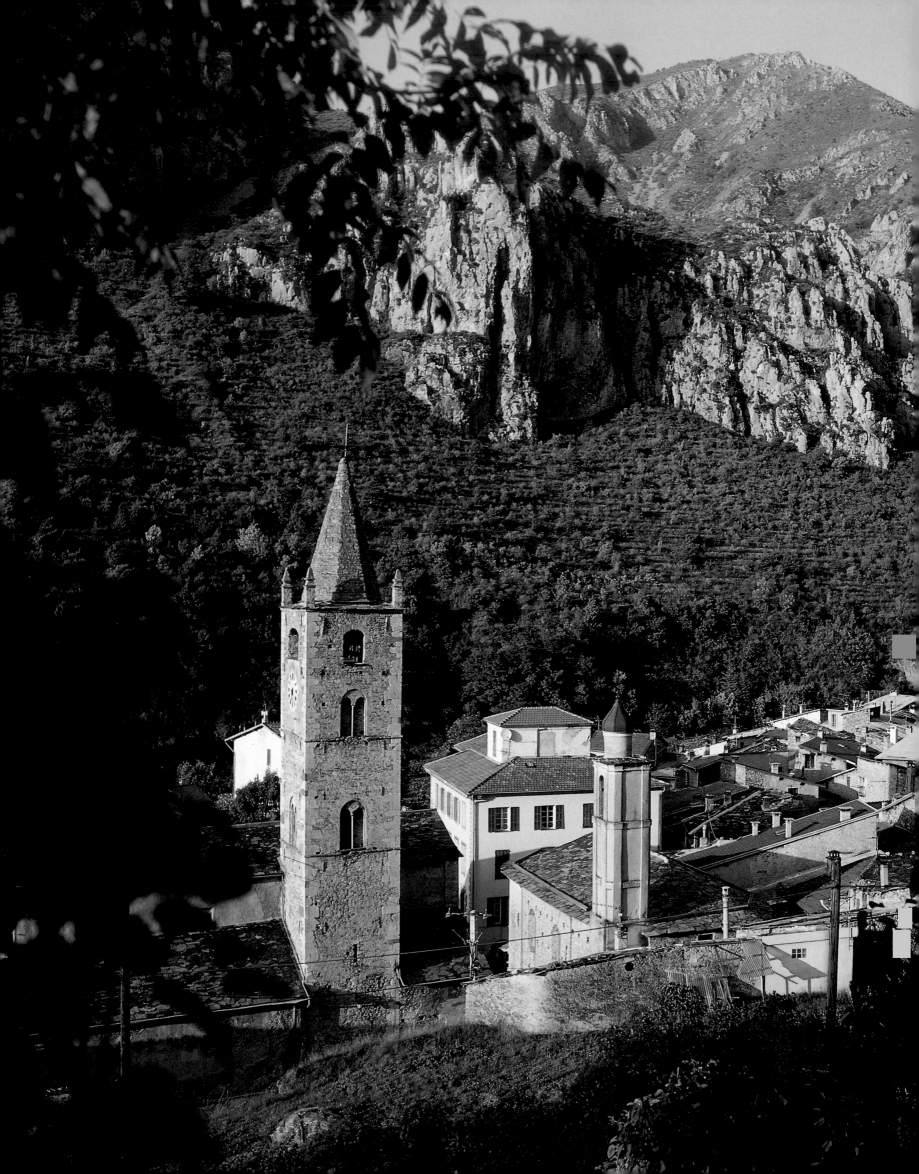

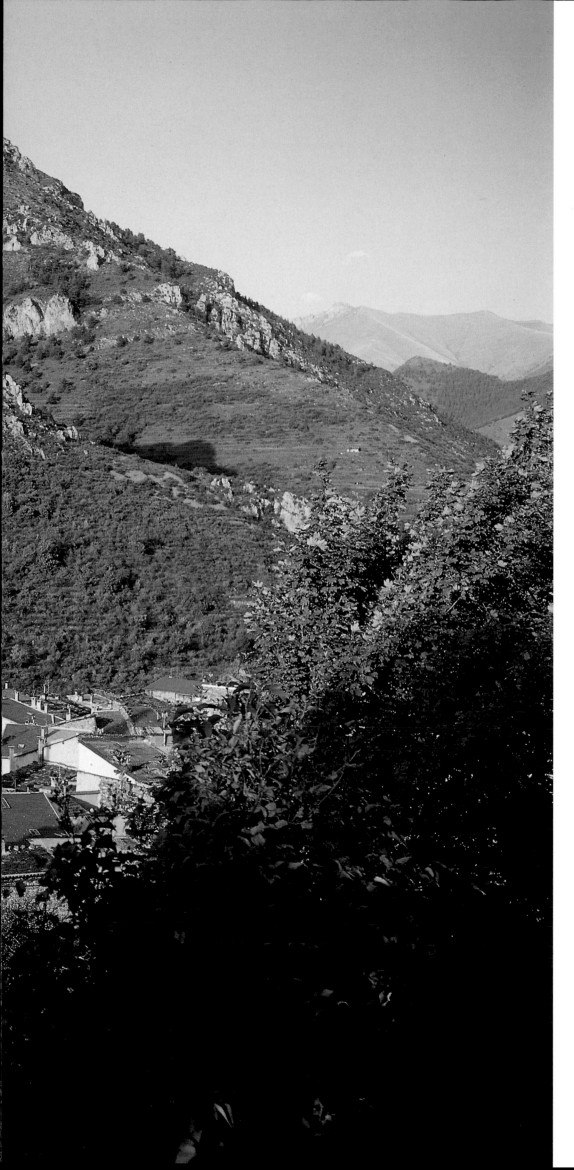

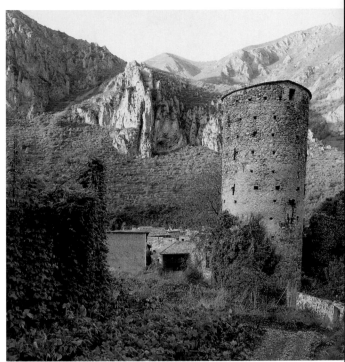

La Brigue
ALPES-MARITIMES

ONE OF SEVERAL little unspoilt villages right on the Italian border, La Brigue rests along the banks of an insignificant Alpine river off the great valley of the Roya. Surrounded by peach trees and emerald-green fields, the village looks towards the distant gaunt peak of Mont Bégo, a mountain regarded with great awe and reverence in ancient times.

La Brigue conveys a sense of remoteness, which is reflected in the village's history. It is tucked away in a tiny corner of Provence which remained part of Italy until 1947, nearly a century after the rest of the *comté* of Nice had been united with France. This half-forgotten area was retained by the house of Savoy essentially as a hunting-ground.

Italian is still the main language of the more elderly inhabitants of this quiet village of arcaded streets lying at the foot of a ruined castle. The buildings, constructed out of the greenish local stone, have fine portals and lintels and are unmistakably Italian in their detailing. A Romanesque bell-tower, striped with Lombard bands, is attached to the parish church, while on the small main square are two chapels enlivened with characteristically Italian *trompe-l'oeil* decoration.

The cliffs of the Cime de Durasca (left) *loom dramatically behind the elegant, Romanesque bell-tower of Saint-Martin: a watch-tower on the outskirts of the village recalls troubled times* (above).

141

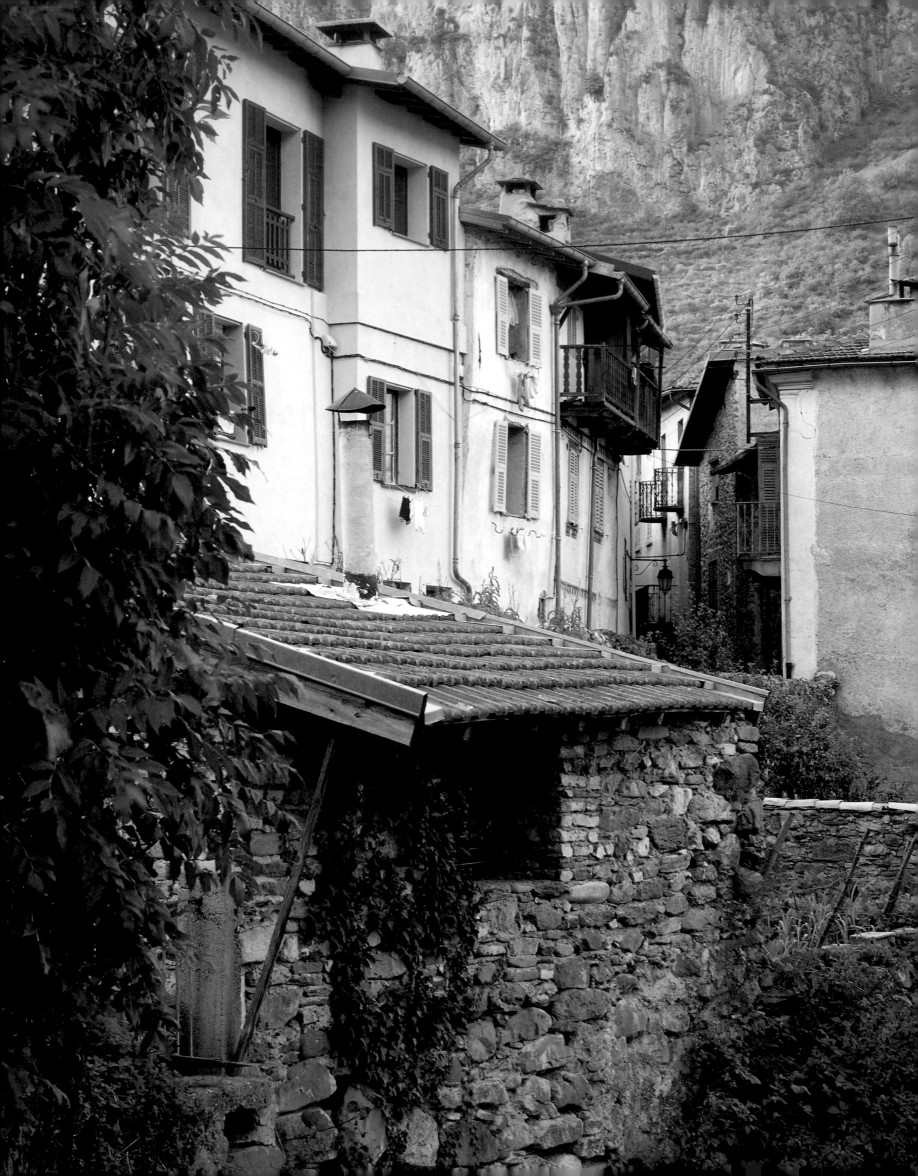

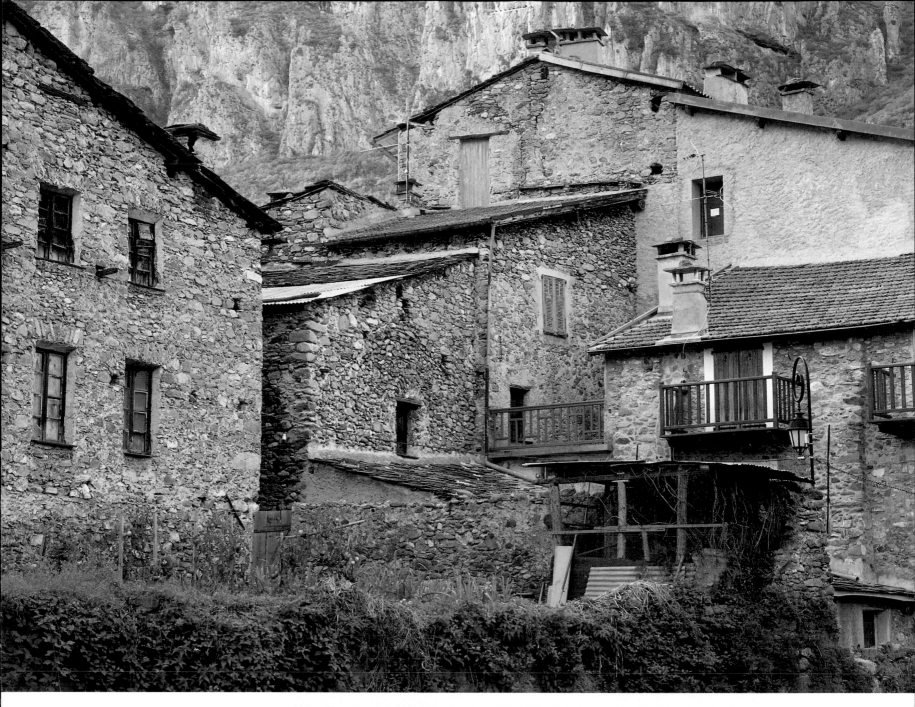

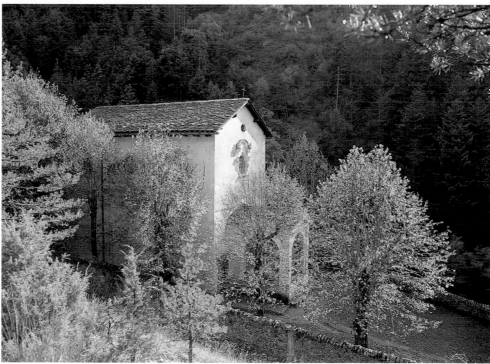

L ong, sloping roofs in slate, wide eaves and wooden balconies are characteristics of the Alpine architecture of this part of Provence (opposite *and* above). *The isolated chapel of Notre-Dame-des-Fontaines* (right) *lies to the east of La Brigue; its simple fifteenth-century exterior gives no hint of the decorative profusion within* (overleaf).

ap · x · Q̄r petrus pꝰsso voce ancille hostarie negauir xp̄m

Judas scariotes

*F*rescoes by the fifteenth-century
Italian artists Jean Baleisoni
and Jean Canavesio cover all the
walls of the chapel of Notre-Dame-
des-Fontaines; the most powerful are
those of the Last Judgement and the
Passion of Christ by Canavesio, an
artist of strong Germanic tendencies
who worked also at Lucéram and
Peillon: detail from the base of the
Crucifixion scene (right); *Christ
before Pilate* (above); *the Denial of
St. Peter* (above right); *the Suicide
of Judas, with a devil removing his
soul* (below right).

The Crowning of Thorns (above); a detail from the Last Judgement on the west wall (left).

The crumbling plaster of Lucéram's houses offsets the brilliant pastel colours of the church of Saint-Jean (opposite). Sainte-Marguerite, another church, has fifteenth-century treasures, including Jean Canavesio's altarpiece of Saint Antoine of Padua (below) and splendid wall paintings. The panoramic view of Lucéram (overleaf) gives no hint of the ravine separating the village from the slopes behind, which still bear the scars of the disastrous fire of 1986.

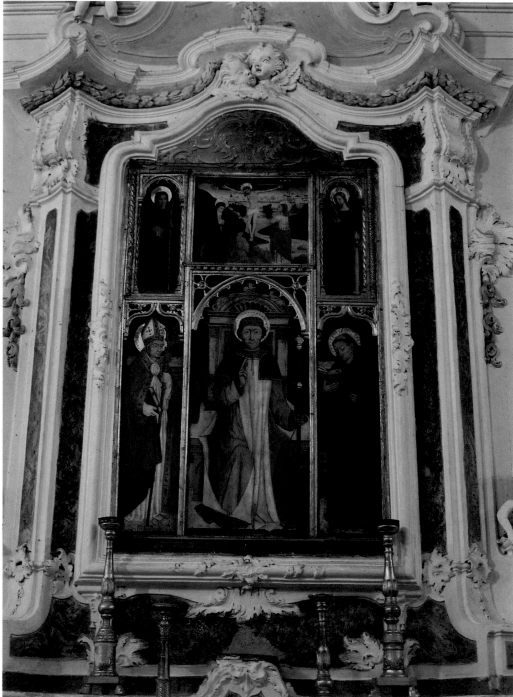

Lucéram
ALPES-MARITIMES

TIGHTLY BUILT on a steep rocky ledge, Lucéram enjoys an immense panorama over a mountainous landscape once densely carpeted with Mediterranean pines and shrubs. A disastrous fire in the summer of 1986 devastated the surrounding landscape but fortunately spared the village, which remains one of the most beautiful in the Nice hinterland and remarkably unspoilt.

Probably Roman in origin, and with a name apparently derived from the Latin 'lucus eram' ('I was the sacred wood'), Lucéram occupies an important position at the junction of three ancient roads, including the Salt Road to Piedmont. In the Middle Ages the villagers were granted special privileges which freed them from subservience to any feudal lord and allowed them to extract dues from passing merchants. This helped greatly to supplement a local economy based heavily on olive-growing and wood-cutting.

The medieval heart of Lucéram lies above the main road and is dominated by a crenellated watch-tower, the main survival of the original encircling fortifications. Narrow, stepped alleys climb up between tall, overlapping houses, many with Gothic doors. Near the top, and enjoying the most magnificent views, is a balustraded terrace supporting the parish church of Sainte-Marguerite. Wholly Italianate in character, like the village itself, the church is an eighteenth-century remodelling of a modest Gothic structure and has a Rococo, pastel-coloured interior which contrasts markedly with the sombre austerity of most other Provençal churches. Also remarkable are the building's many works of art, including an extensive series of fifteenth-century altarpieces. The church also houses the relics of Sainte Rosalia of Palermo, a saint whose name is often invoked as a remedy against the plague. In times of plague hundreds of pilgrims would make their way to Lucéram to see the relics. Today the village's main religious event is a Christmas procession of shepherds bearing gifts of lambs and fruit.

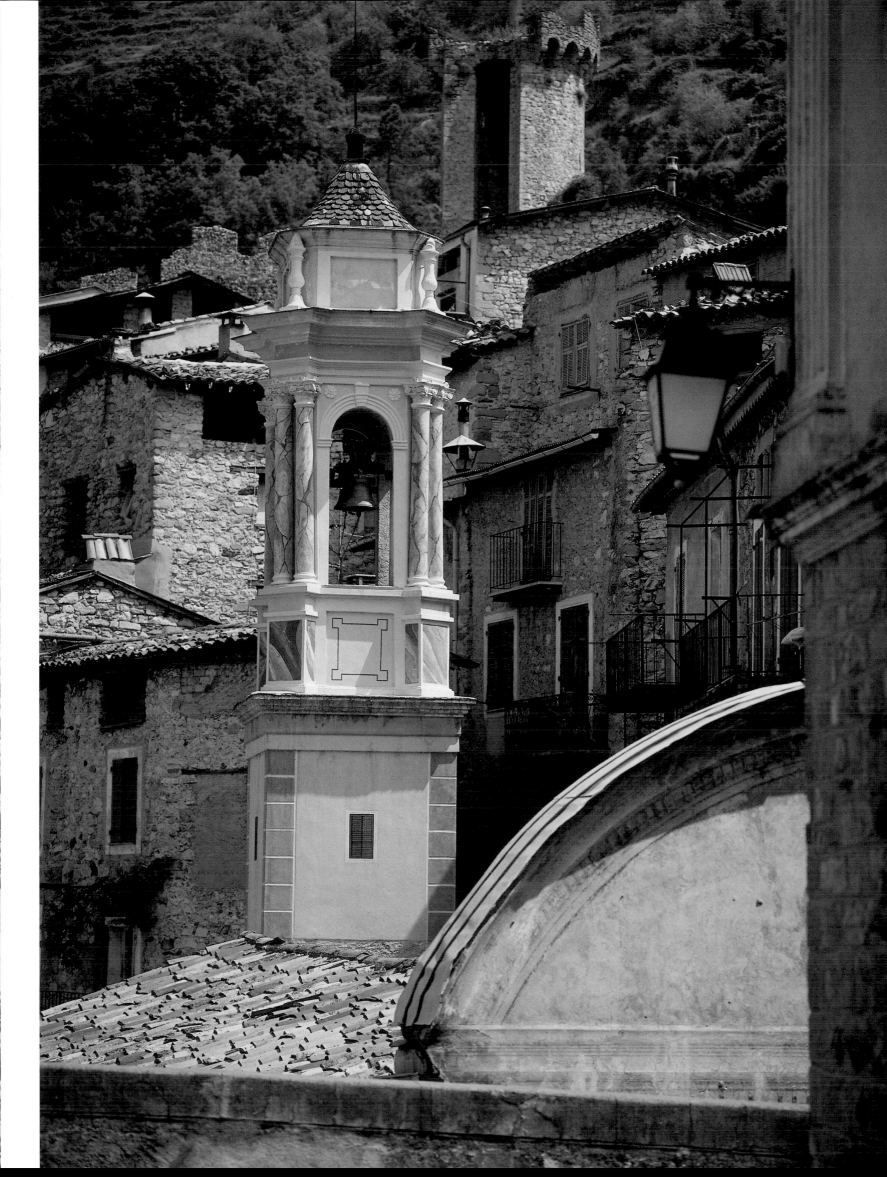

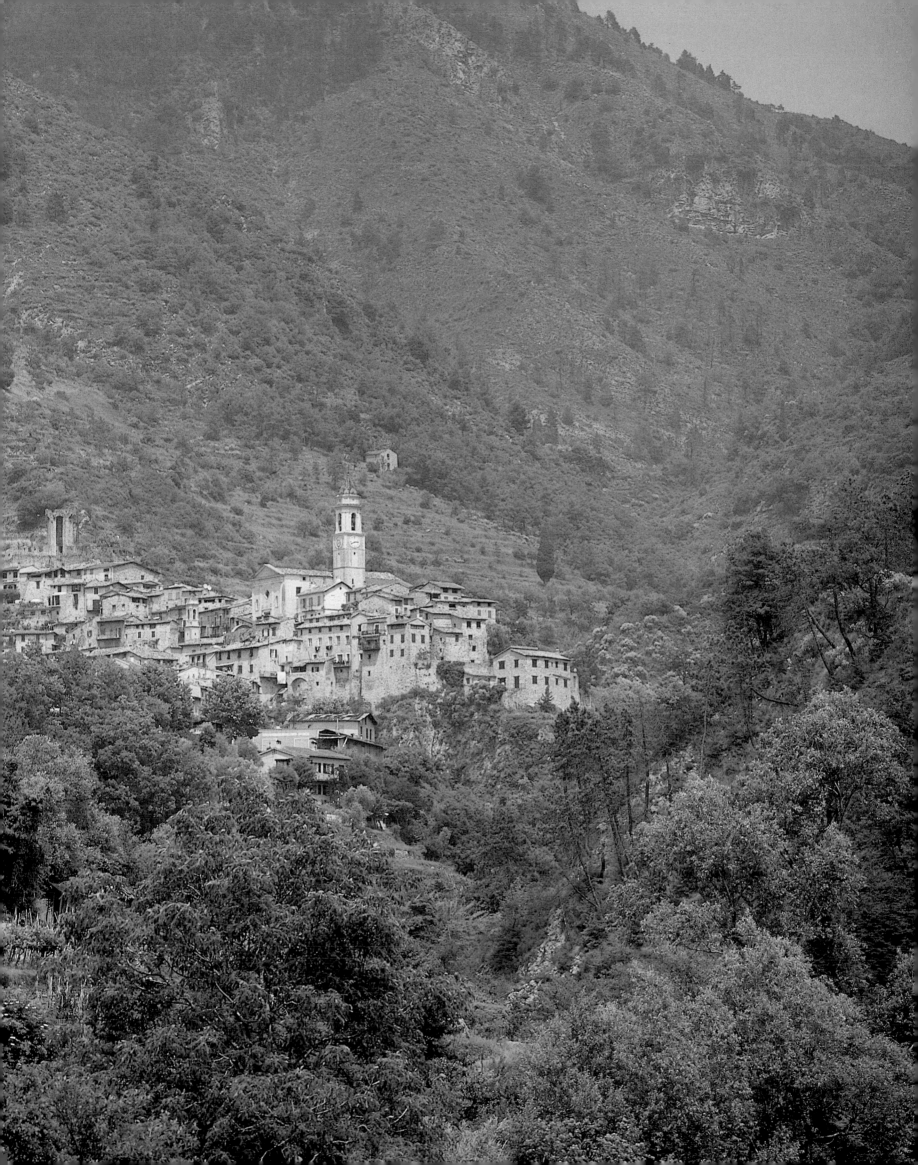

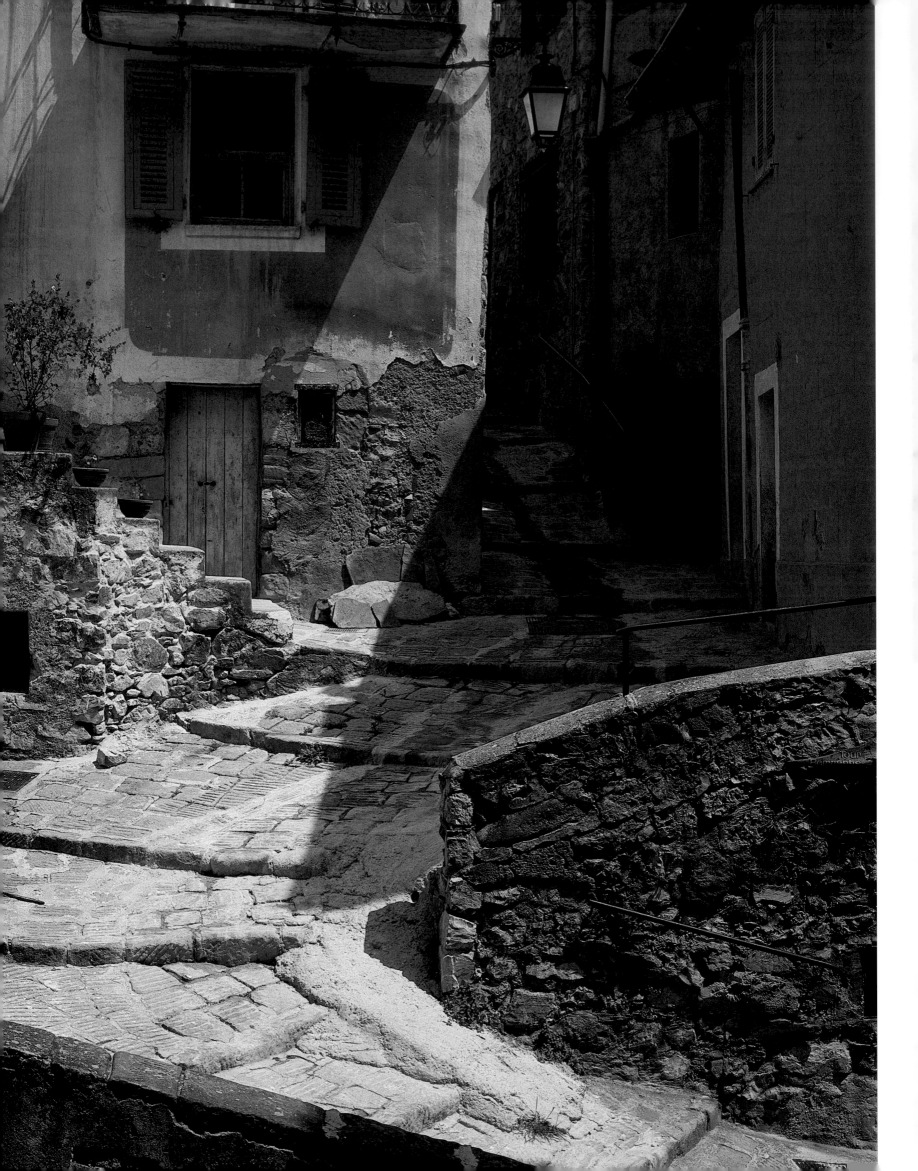

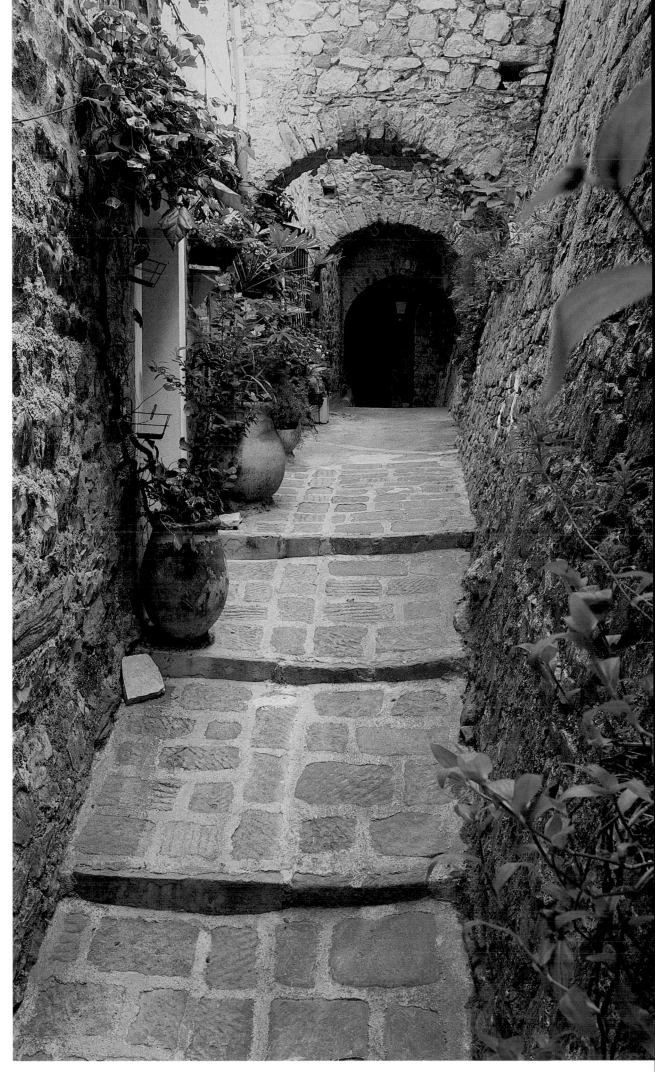

*T*he labyrinth of stepped,
curving alleys in the old heart
of Lucéram (opposite *and* this page)
lends this village a peculiarly secretive
air, which is integral to its charm.
Narrow, late-medieval houses ensure
high contrasts of dark shadow and
warm Provençal light.

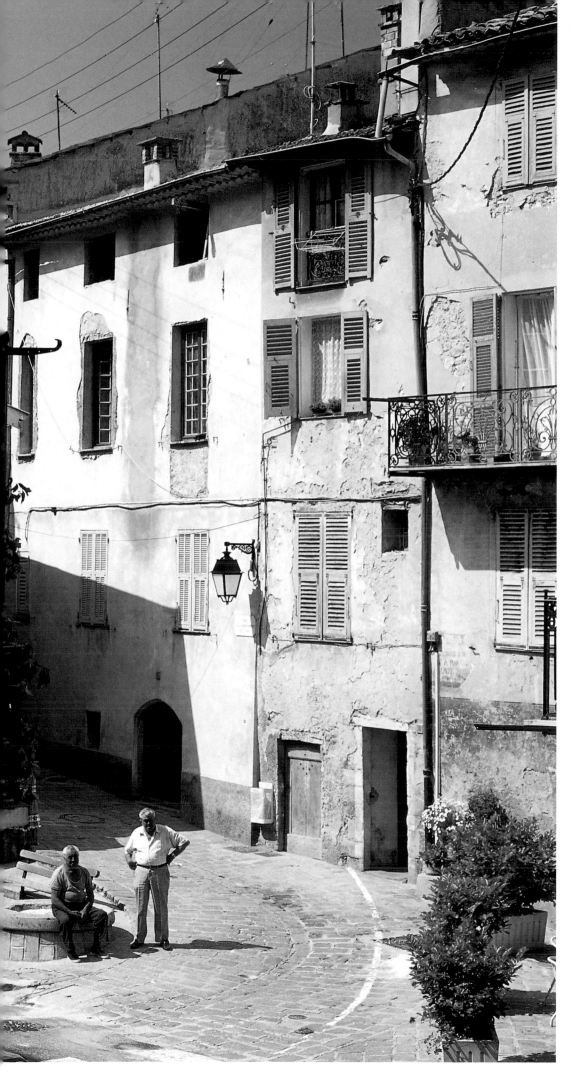

Repose on the sunlit square in front of the church of Sainte-Marguerite (left); from here there is a view over the roofs and terraces of the village (above). The Virgin in Glory is painted on the rounded pediment crowning the façade of the Baroque chapel of Saint-Jean (top), which features also a delightful example of a Provençal wrought-iron weather-vane.

Peillon
ALPES-MARITIMES

FOR THE SHEER AUDACITY of its eagle-nest position, no other village in Provence, and few in Europe, can compare with Peillon. After taking the small and winding road which climbs up to it you might wonder at first where the village could possibly be situated, until suddenly, turning a bend, a sheer limestone pinnacle appears, pushing itself high above the lush Mediterranean vegetation and supporting on its peak a cluster of houses with ochre colouring indistinguishable from that of the rock face. Can a car, you might well ask, really reach there?

The sprawling coastal development of the Côte d'Azur lies, hidden from sight, a few miles away; but already you feel in a different and very remote world. Any thoughts, however, that you might be visiting some savage bandit's lair are soon dispelled on arrival in the village, at the entrance to which is a group of discreet restaurants and hotels popular with the Niçois on summer weekends.

If you have suffered from vertigo and agoraphobia while driving up to the village, you might well experience claustrophobia within the rabbit's warren of dark, arched and impossibly beautiful alleys that climb up to the crowning glory of the Church of the Transfiguration. The church, standing exposed on a small panoramic terrace, brings a welcome note of Italian light and colour after the relative gloom of the village below. Its interior has a rustic, Baroque charm and cheerfulness, but does not live up artistically to that of the Chapel of the Black Penitents at the foot of the village, where you can see a superlative cycle of frescoes by the fifteenth-century artist, Jean Canavesio.

Peillon, crowned with the Church of the Transfiguration, is viewed here from near the top of the narrow, winding road which climbs up to the village.

154

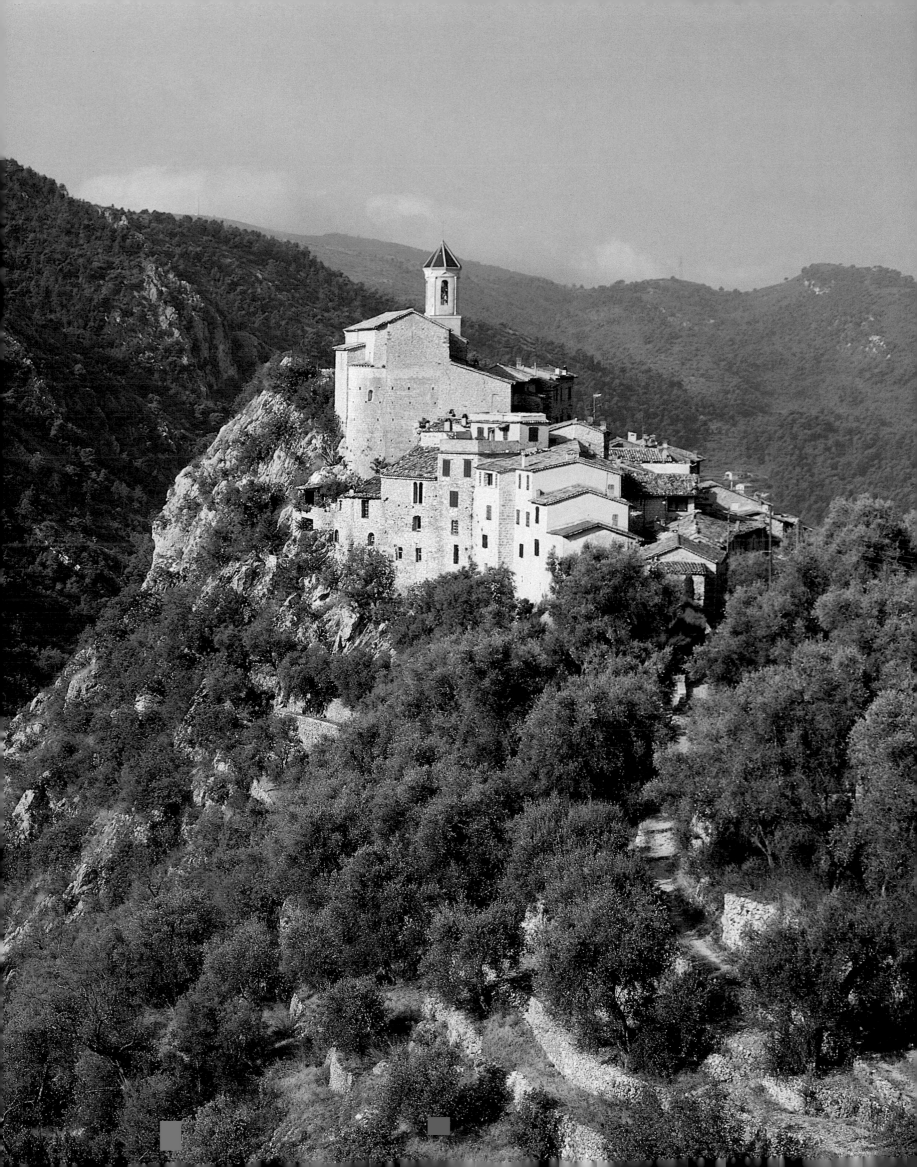

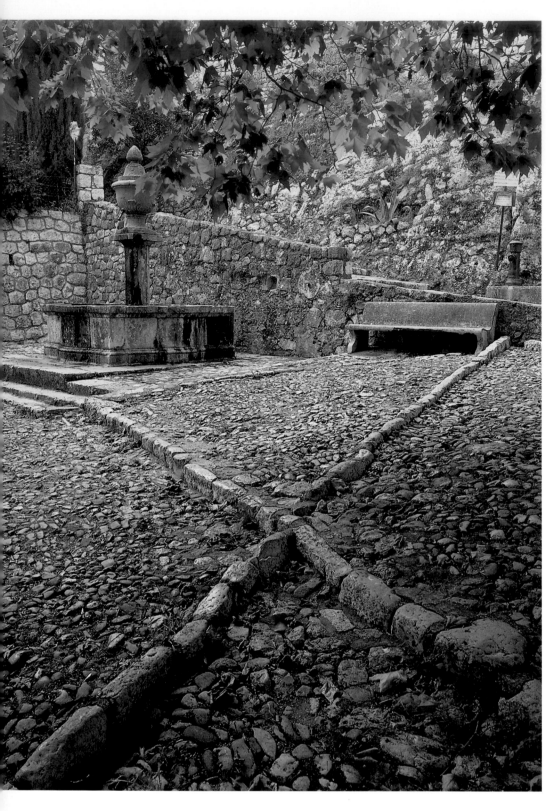

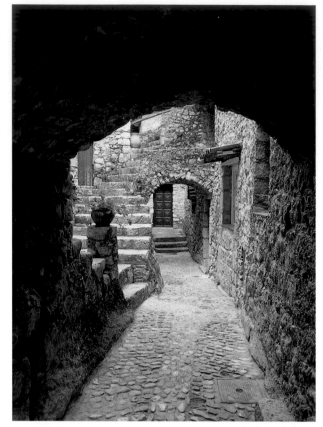

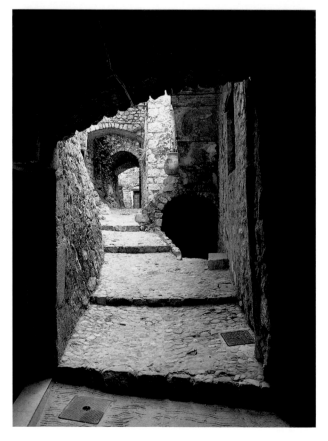

*A*n elegant fountain welcomes the visitor at the
entrance to the walled village of Peillon (above);
the dark, stepped alleys within the walls (right *and*
above right) *tunnel their way through medieval houses
before climbing up above the roof-line to give glimpses of
the village's dramatic surroundings* (opposite).

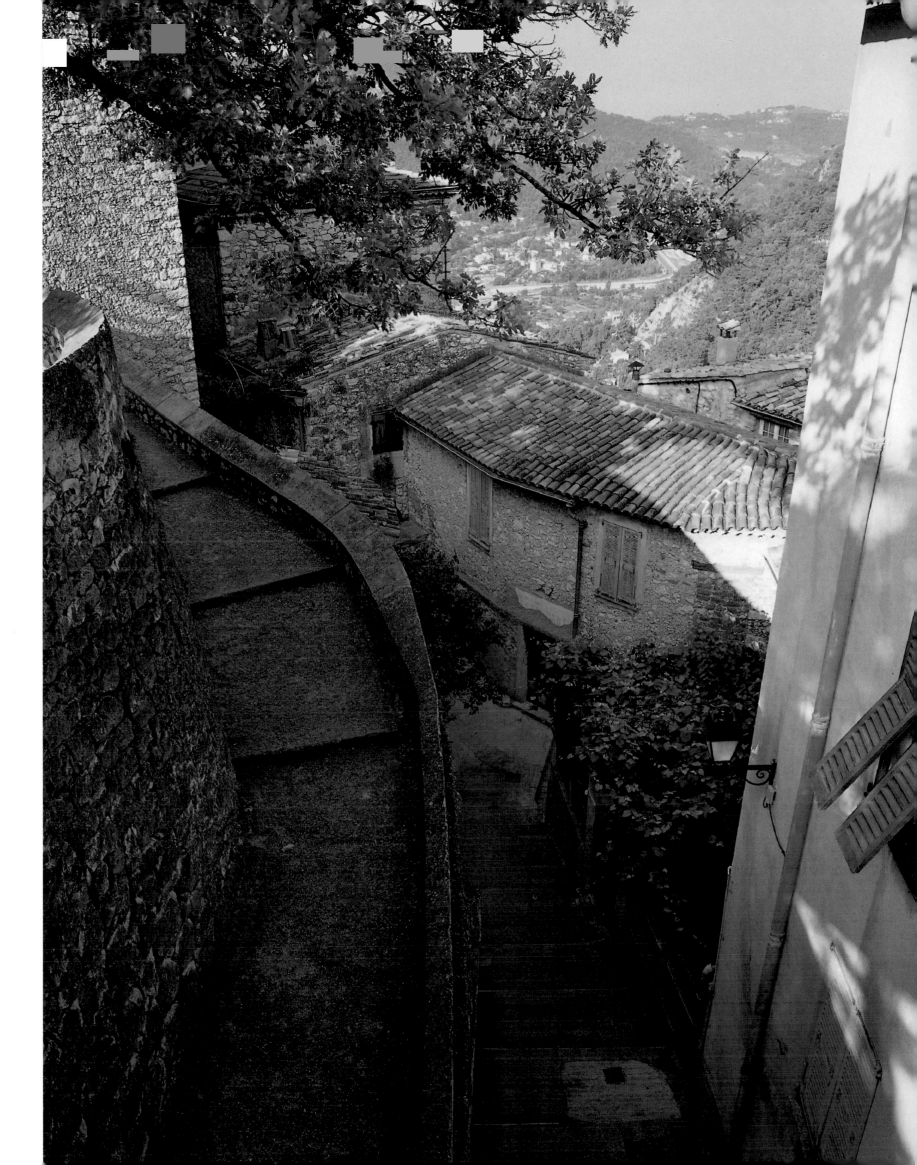

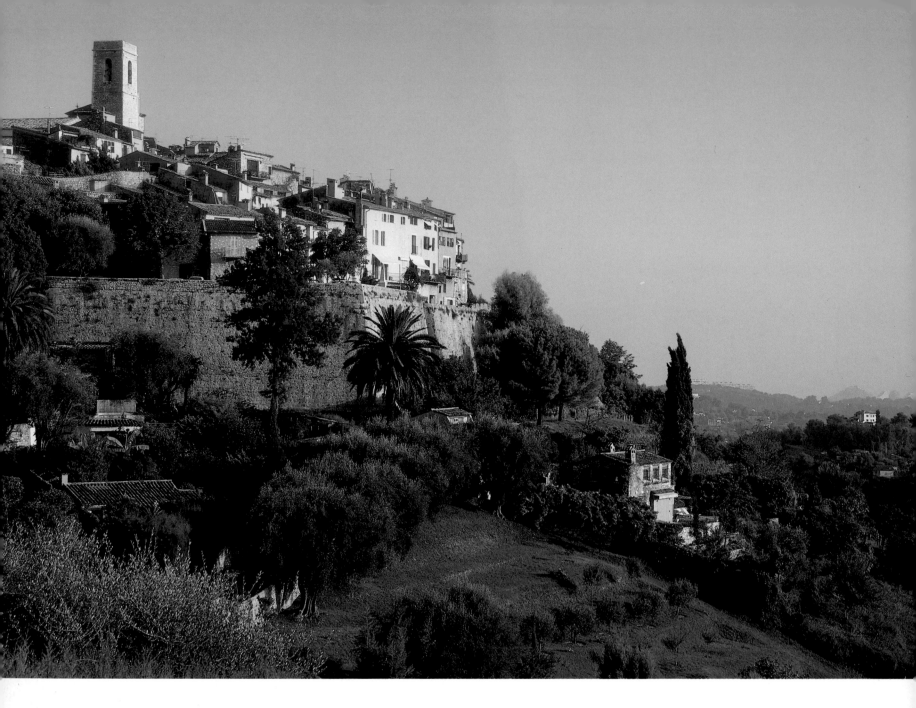

Saint-Paul-de-Vence

ALPES-MARITIMES

Sixteenth-century defensive walls in the foreground and, at the top of the village, the eighteenth-century clock-tower of the church of the Conversion of Saint Paul; a summer haze hangs over the near-tropical surroundings of the village, dotted with elegant villas (opposite).

THE ARCHETYPE of the beautiful Provençal hill-village, Saint-Paul-de-Vence sits snugly above a lush and rolling landscape of cypresses, citrus trees and villa-strewn hillsides. Crowned by the fine tower of its main church, this well-preserved village is entirely surrounded by its sixteenth-century defensive walls, which were erected by François I to reward the villagers for having successfully resisted the troops of Charles V in 1536.

Enormously prosperous up to the eighteenth century, Saint-Paul then began to suffer as a result of the rising prosperity of the neighbouring towns of Vence and Cagnes. The village sank into somnolent oblivion, from which it was rescued after 1918 by a sudden influx of artists who were attracted here more than to almost any other Provençal village. Signac, Soutine, Modigliani, Bonnard, Picasso, Léger, Braque, Rouault and Chagall were among the countless painters who brought fame to the village in the course of the nineteen-twenties. The artistic celebrity of the place was finally sealed in the nineteen-sixties, when the gallery owners and art book publishers, Aimé and Marguerite Maeght, created in a park on the village's outskirts what was to become one of the most enlightened art foundations in Europe. As with so many other artist colonies, Saint-Paul's popularity was greatly enhanced by the presence here of an enlightened hotelier – in this case Paul Roux, or 'Roux the Magnificent' – who allowed extended credit to artists and accepted works of art in lieu of payment at his hotel and restaurant, *La Colombe d'Or.*

The medieval village itself, which is entered through an impressively machicolated double gateway, is now a place of sophisticated simplicity. Some of its streets are now paved with modern mosaics. A wealth of elegant stone palaces are fortunately still there to remind you of Saint-Paul's prosperity long before the arrival of artists and tourists. But the main expression of the original spirit of the village is the vast and magnificent church, a dignified mixture of Romanesque and Gothic.

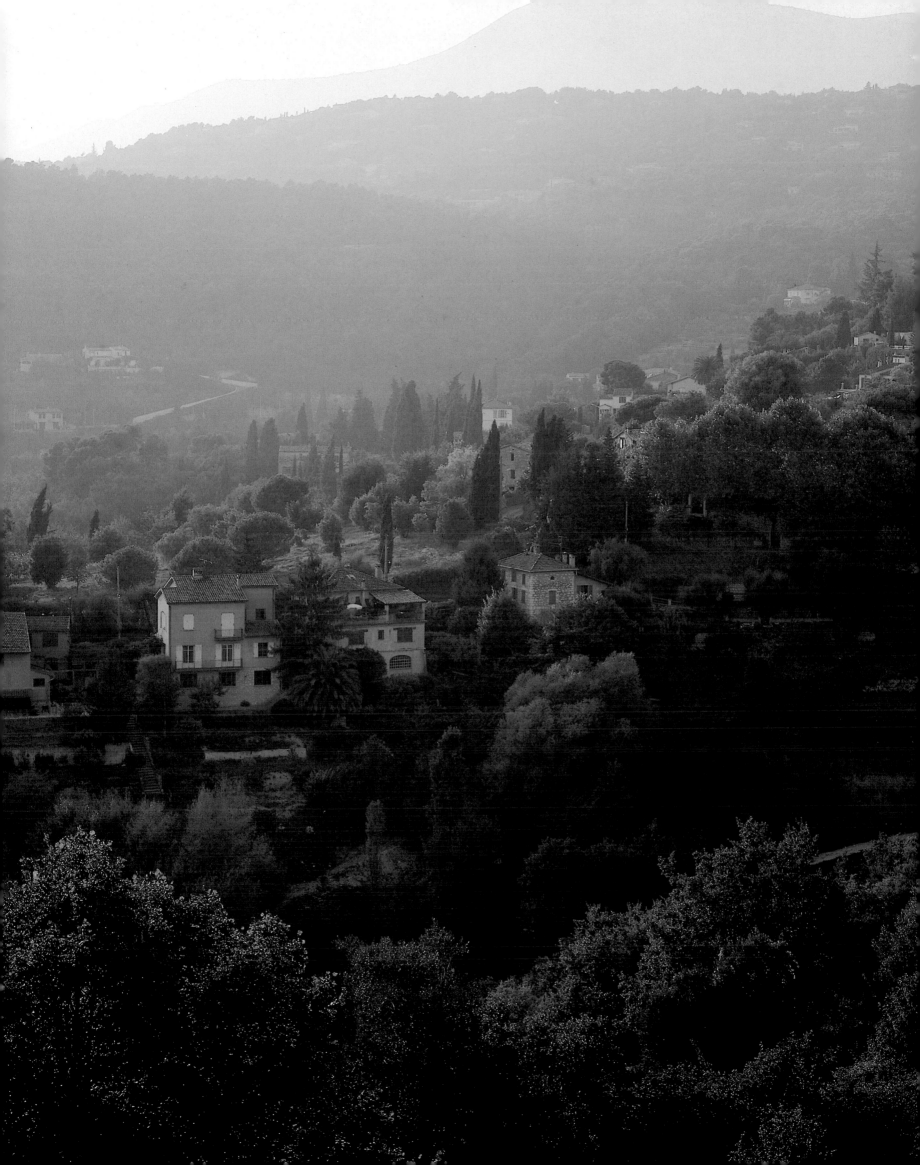

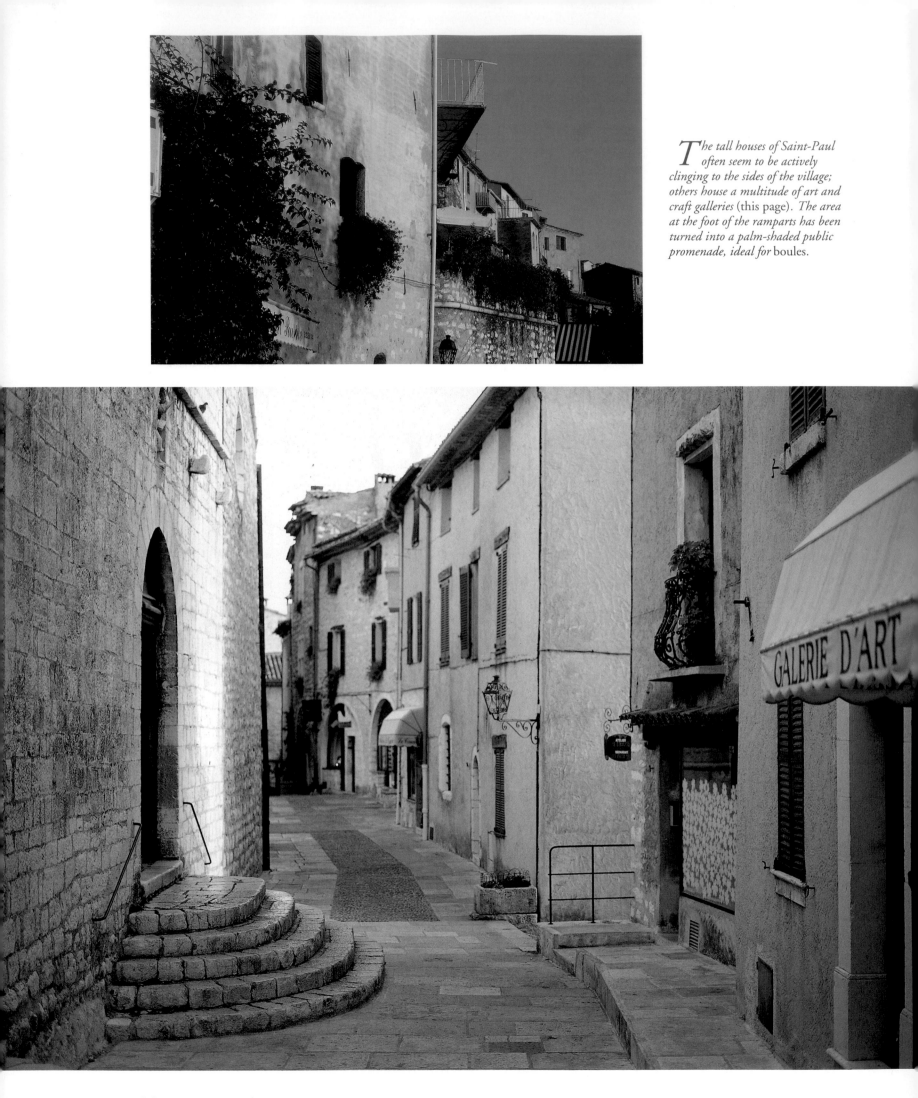

*T*he tall houses of Saint-Paul
often seem to be actively
clinging to the sides of the village;
others house a multitude of art and
craft galleries (this page). *The area
at the foot of the ramparts has been
turned into a palm-shaded public
promenade, ideal for boules.*

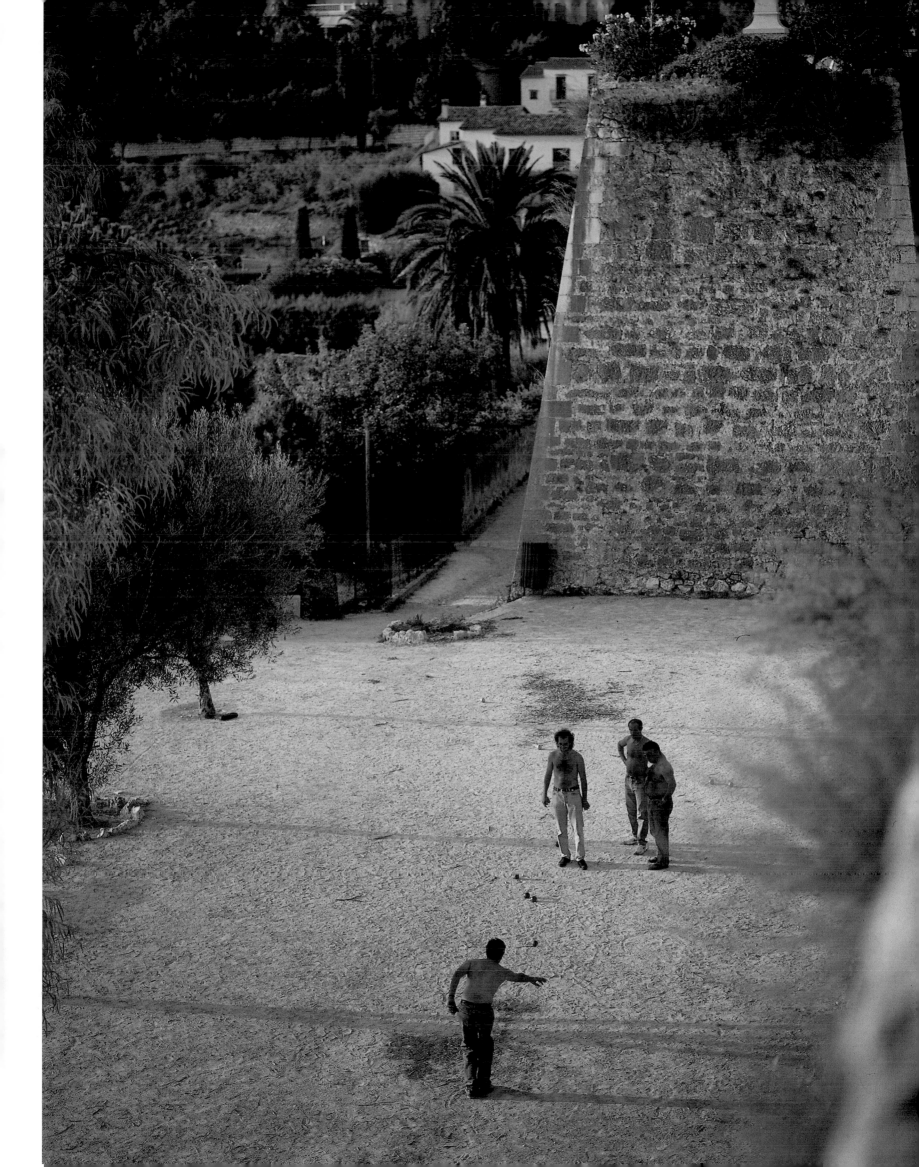

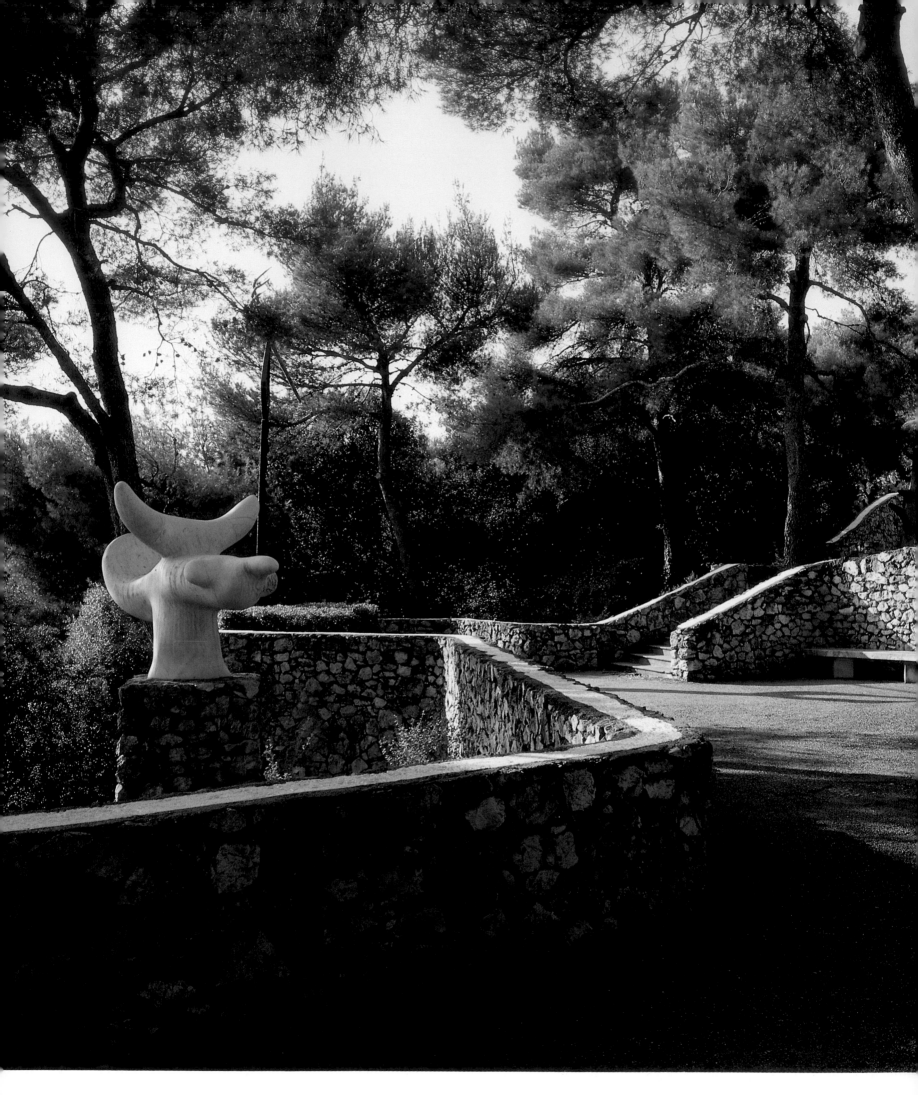

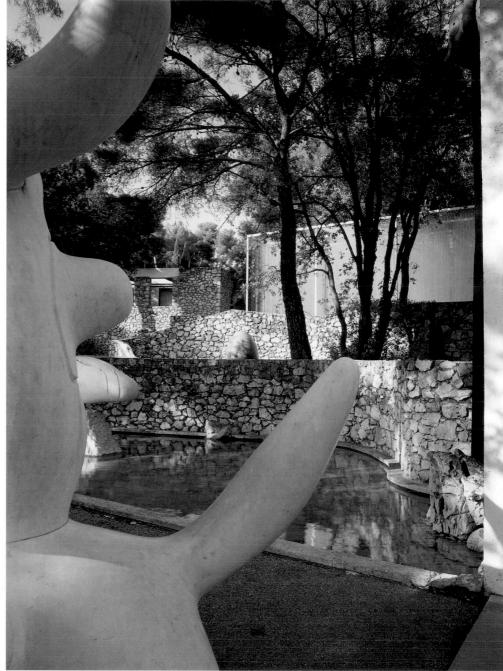

*J osep Luis Sert, who designed the remarkable
Fondation Maeght (above and left), believed
strongly not only in the breaking down of the barriers
between architecture and its landscape surroundings, but
also in the close collaboration of architects with painters,
sculptors and craftsmen. The exotic terraces of the park of
the Fondation confirm Saint-Paul's position as a major
international centre of modern art.*

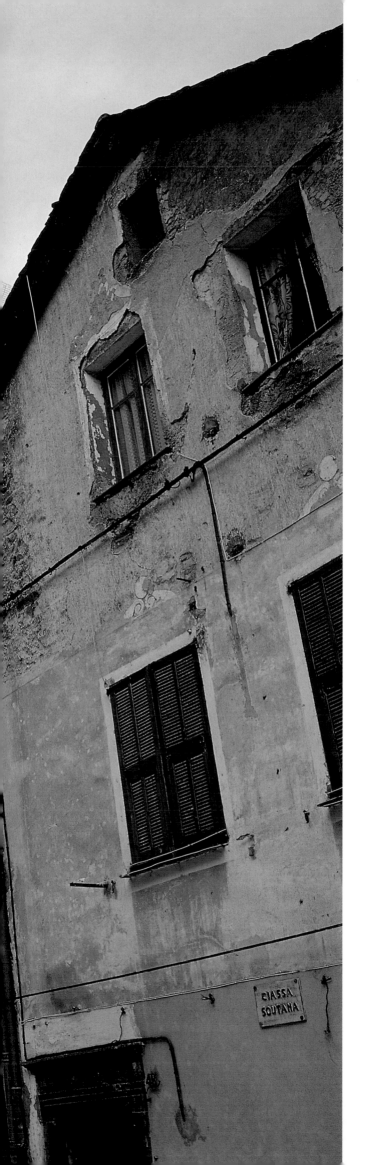

Saorge *ALPES-MARITIMES*

HIGH UP in a wild, mountainous landscape of olives, shrubs and aromatics, the crescent-shaped village of Saorge clings in apparent defiance of gravity to a near-vertical slope.

Though belonging to the Counts of Provence during the twelfth and thirteenth centuries, Saorge has been under Italian rule for much of its history, first under the Counts of Ventimiglia, and later the Dukes of Savoy, who turned it into a fortified village which was thought for many centuries to be impregnable. Its defensive walls were finally demolished in 1793 and since then the village has barely changed in appearance, and forms today an almost intact ensemble of fifteenth-to eighteenth-century buildings. Remarkably, there are no obvious signs either of tourism or of foreign settlers. Instead, the village retains the character of a quiet agricultural community.

Inevitably, given its history, Saorge is completely Italian in look, with soaring campaniles and tall houses tiered with balconies and plastered in pastel shades of blue and ochre. Cars are left at the village's northern extremity, from which stretches a narrow and cobbled main street, on either side of which are stepped and steeply falling alleys that disappear under dark arches. At the other end of Saorge is a path to a Baroque Franciscan church with wonderful views back to the village and down to the eleventh-century sanctuary of the Madonna del Poggio.

Tall, balconied buildings of Italianate appearance characterize much of the architecture in the heart of Saorge (left); *the grandest of the houses, however, are to be found immediately below the ramparts, including this elegantly curved Baroque example* (above).

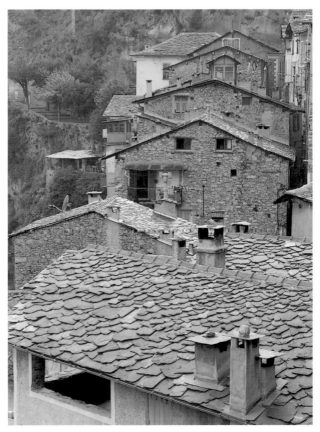

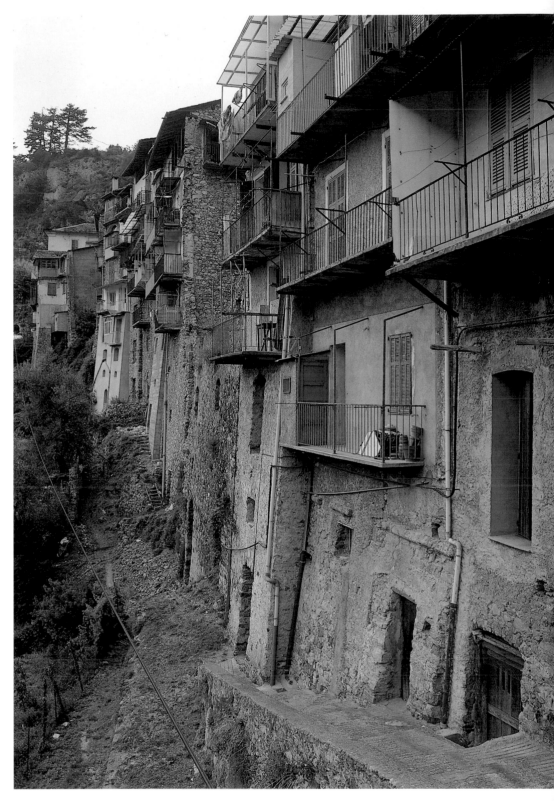

*C*hildren playing in a quiet Italianate square (left top) *and the presence of ordinary village shops* (opposite) *are salutary reminders that Provence has a life beyond the tourist centres. The houses at the edge of the inner village* (above) *were originally part of the sixteenth-century defensive system; the use of slate rather than clay tiles* (left) *is typical of the villages on the region's eastern borders.*

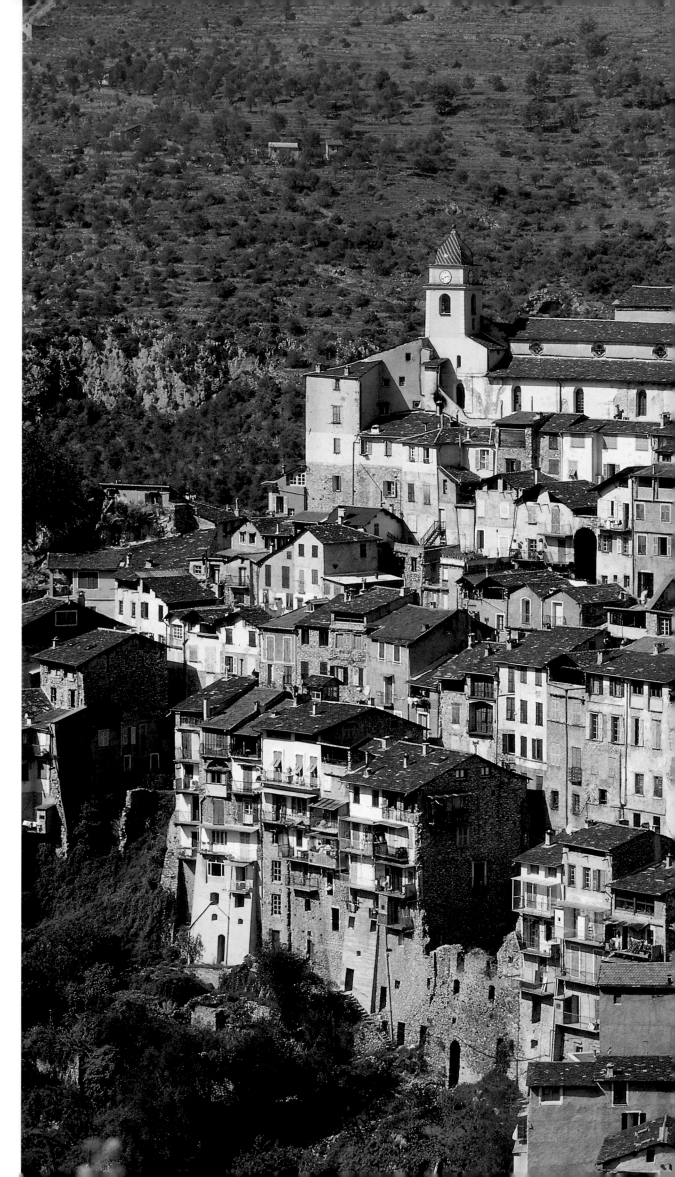

*I*solated among trees and shrubs on the western outskirts of Saorge is the beautiful eleventh-century sanctuary of the Madonna del Poggio (p.168), with a Lombard-style campanile articulated by blind arcading. The Franciscan church on the outskirts of the village (p.169) is a playful Baroque structure attached to a still functioning monastery; the terrace of the church also offers the finest view of Saorge (right), which appears as a harmonious crescent-shaped village with rows of houses curved along the contours of the landscape.

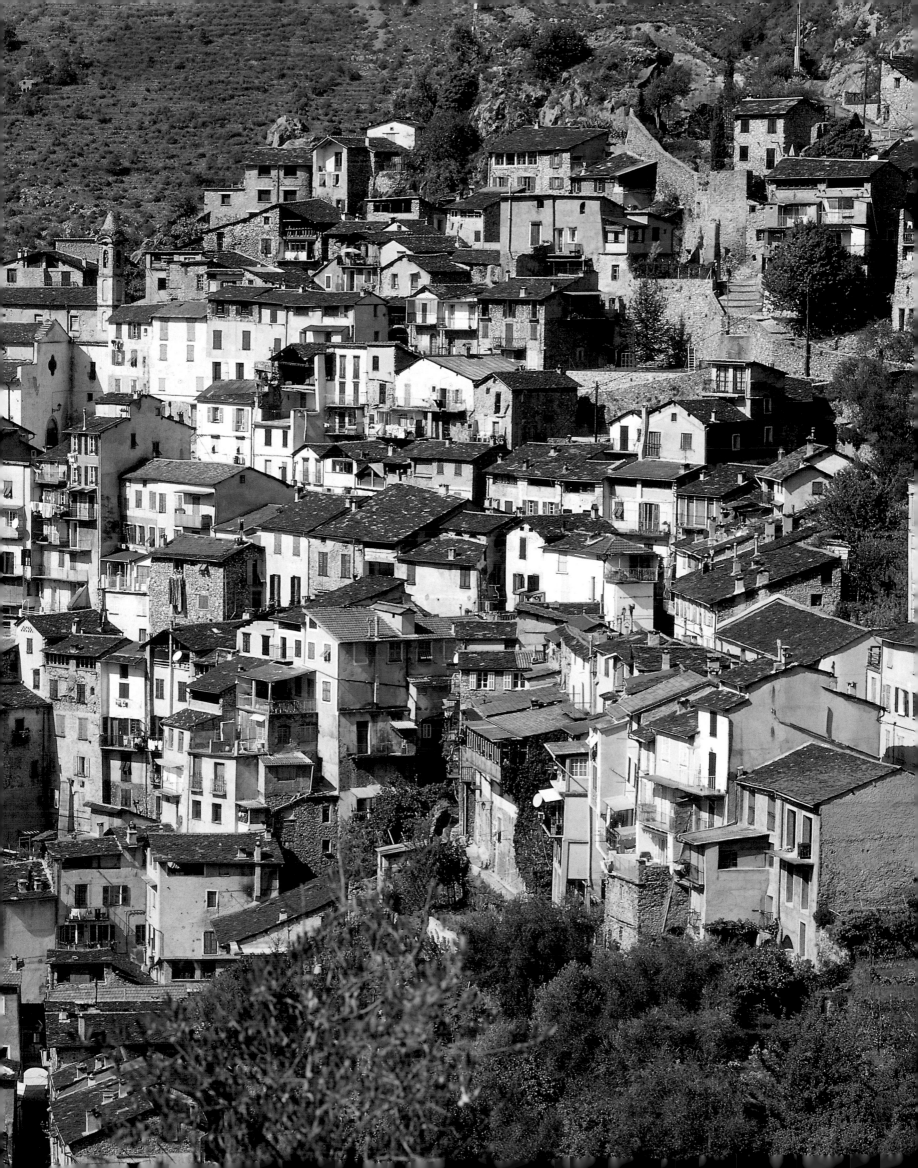

ALPES-DE-
HAUTE-
PROVENCE

Promoted today as 'the hidden Provence', the Alpes-de-Haute-Provence is one of the wildest and most haunting areas of the south of France and one which represents the complete antithesis to the towns and villages of the Provençal coast. To the novelist Jean Giono, the most famous writer native to the district, this was the one and true Provence. Bordered to the west by the sun-scorched Montagne de Lure, a bleaker and more inaccessible range than neighbouring Mont Ventoux, this region includes in its eastern sector such wholly Alpine communities as Entrevaux and Colmars, two of the best preserved fortified villages of France. It is dominated by the enormous Plateau de Valensole, which is brought to life in March and July respectively by the white blossom of almond trees and the vivid purple of great fields of lavender.

View of the Vaire valley from the road to Méailles (opposite).

Annot
ALPES-DE-HAUTE-PROVENCE

GUARDING the entrance to the rich, green mountain-valley of the Vaire, Annot is a village mingling Provençal and Alpine elements in a setting of meadows, pines, and distant lofty peaks. It was here that the earliest settlers to the area, the Ligurians, came around the fourth century B.C. to found the original settlement of Annot. In the early Middle Ages the village moved down to its present, gently sloping site besides the river Vaire.

Strategically situated near the great trade route of the Var valley, Annot is a village which has grown from an important fortified settlement into a thriving sum-mer resort and centre of the *charcuterie* industry. Its cheerful main street, marking the line of the original fortifications, is animated and coloured by cafés, restaurants and a flourishing market. Leading off from this, and in complete contrast to it, are the quiet, sombre alleys of an elongated old quarter composed mainly of sixteenth- and seventeenth-century houses. The predominance of Alpine grey stone is offset by elegant, decorative flourishes on the many fine lintels, as well as by occasional traces of *trompe-l'oeil* decoration, a legacy of nearby Italy. A picturesque climax is reached in the public wash-house, with its fine rustic stone columns.

Pillars marking the Stations of the Cross (above) line the path to the chapel of Notre-Dame-vers-la-Ville, which looks across fields to Annot; hidden within the wooded rocky slopes of the background are the fantastical rock formations known as the 'Grès'. A typical Provençal scene (opposite): sunlight filtering through the plane trees of Annot's lively main square stipples the faded façade of the Hôtel Grac, a family-run establishment of great charm, typical of the many small hostelries to be found in the villages of the region.

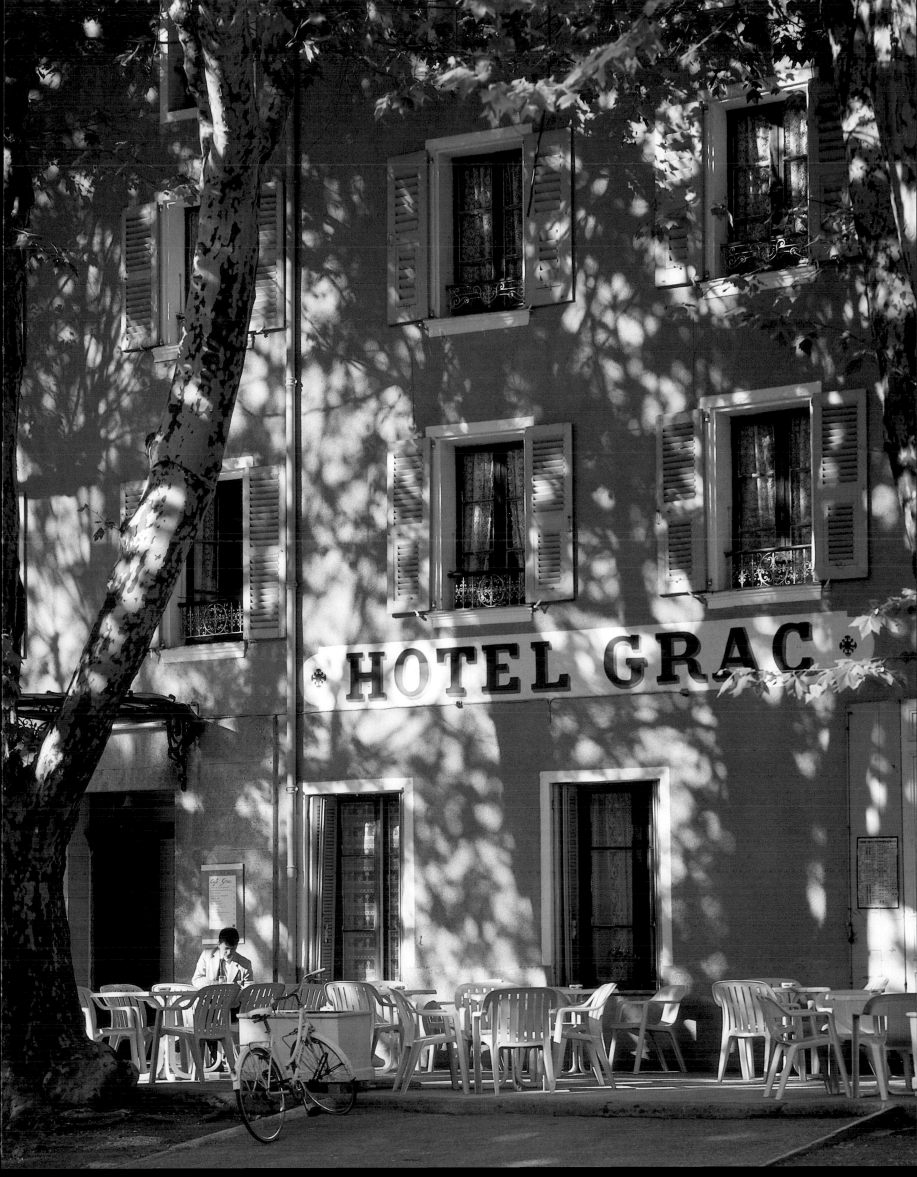

*T*he early medieval belfry of the church of Saint-Pons (right) rises above the quiet streets that lie behind Annot's main square, a distinct quartier *entered through* arches (opposite). *This arcade lines one of the finest secular buildings in the village (below), a seventeenth-century palace.*

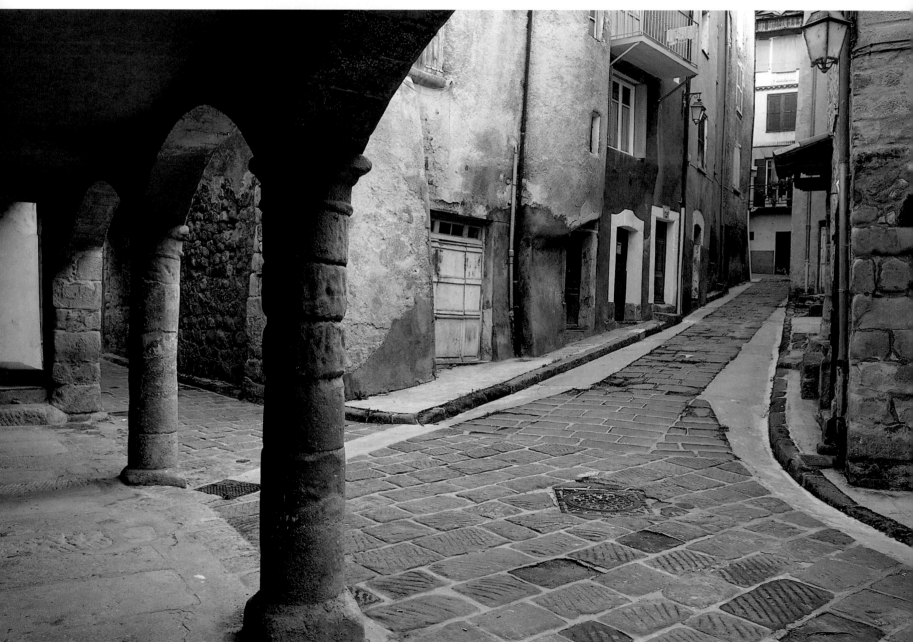

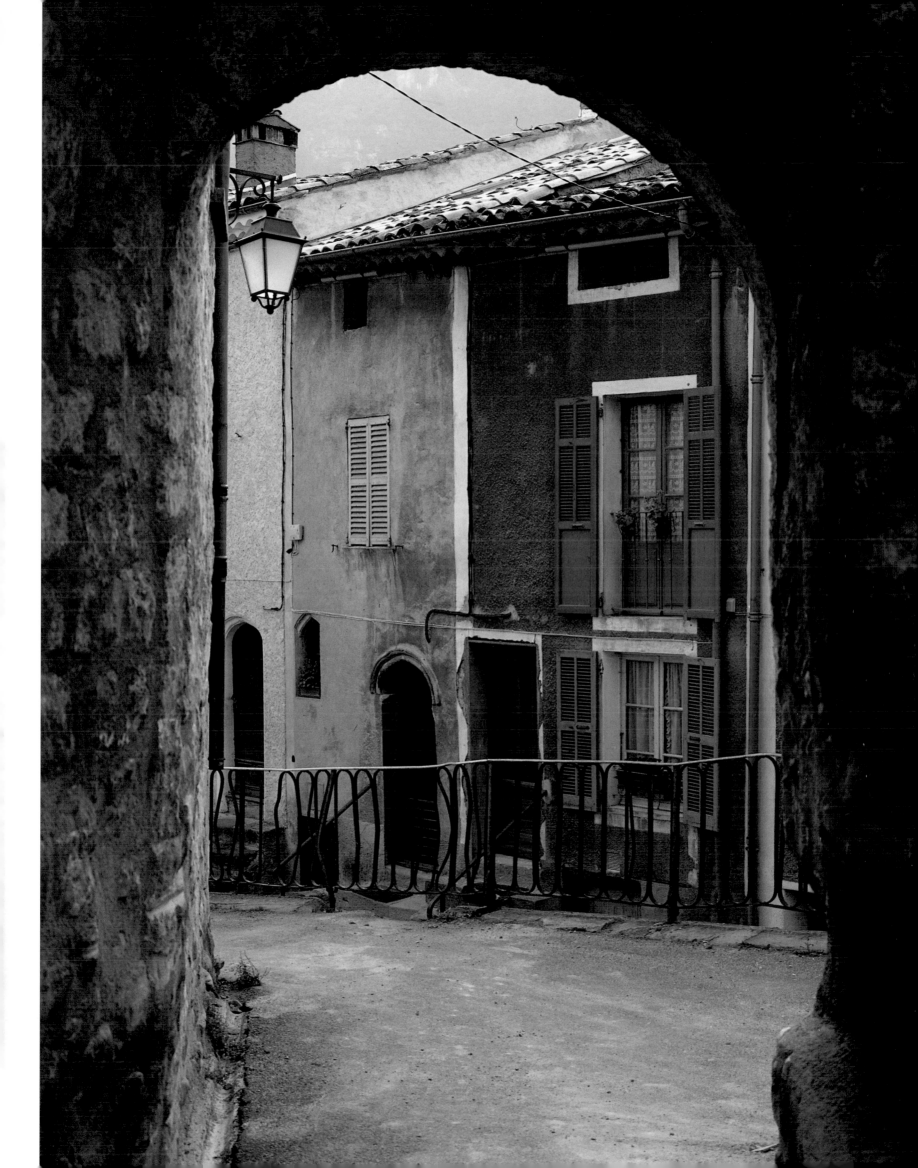

Colmars-les-Alpes
ALPES-DE-HAUTE-PROVENCE

*T*he village of Colmars lies suspended between its two seventeeth-century forts: the Fort de France (right) and, in the background, the grander Fort de Savoie, which is seen here (above) through the village's northern gate. The austere centre of Colmars (overleaf) is dominated by the tower of Saint-Martin rising in the background; the attractively stacked wood (p.181) underneath one of the arches of the fortifications hints at the severity of the winter climate.

FOUNDED by the Romans on a hill named 'Collo Martio' after the god of war, Colmars is a jewel of military architecture set by the torrential waters of the upper Verdon and surrounded by a circle of towering Alpine peaks.

Prospering right up to the nineteenth century as the centre of a flourishing textiles industry, the village of Colmars served also after 1388 as an important frontier town between France and Savoy. The original fortifications were entirely renewed by François I at the beginning of the sixteenth century, at the time of his conflict with the emperor Charles V. Their present look is due to further rebuilding after 1690, when the Duke of Savoy declared war on France. The new defensive system, incorporating elements of the old one, was carried out by the Director of Military Works in Provence, Niquet, who took his instructions from the great Vauban.

Two forts built by Niquet (one in ruins) stand on hills on either side of the intact ring of walls enclosing the village of Colmars. These walls are much restored, but beyond their towers and bastions lies a place of sombre beauty. Though a popular summer and winter resort, the inner village has retained a quiet dignity, with unadorned seventeenth- and eighteenth-century houses looking out over dark and empty streets. The use of slate rather than terracotta tiles gives Colmars an Alpine coldness, which is only partly balanced by such Provençal features as an elegant fountain whose soothing sounds echo throughout the village.

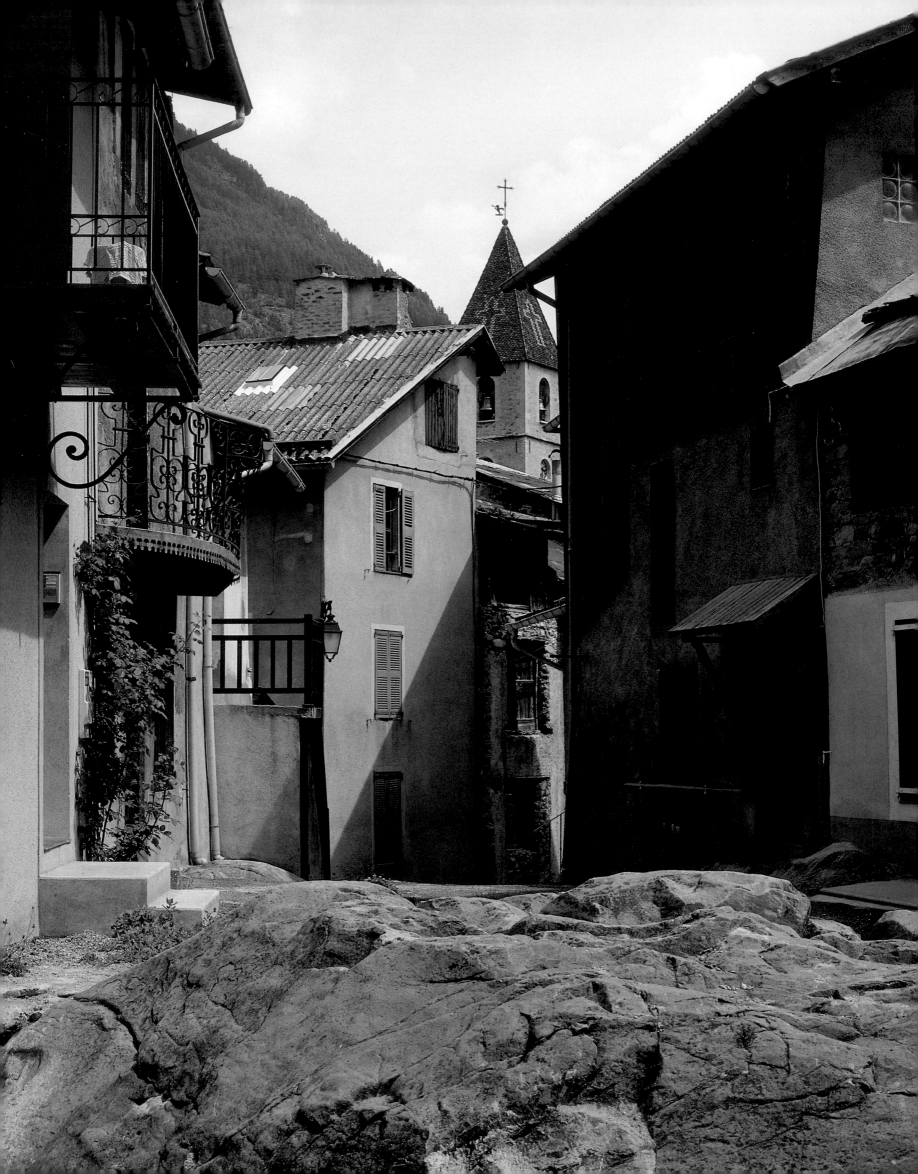

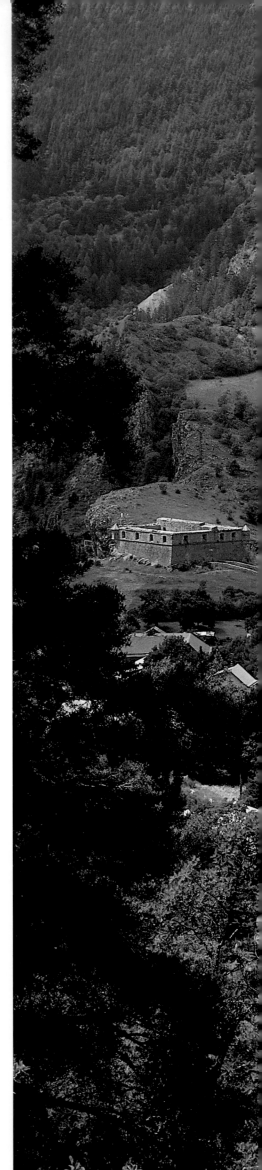

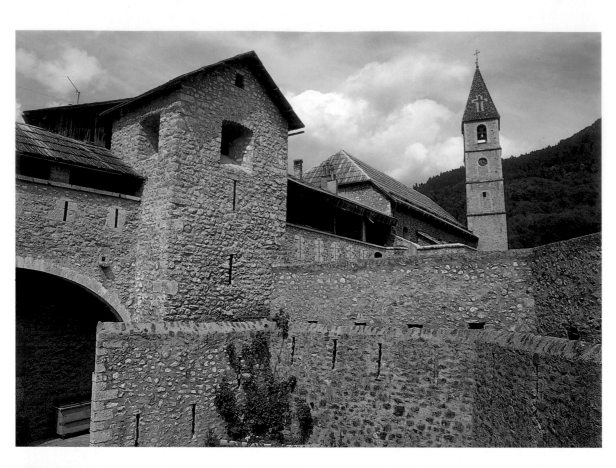

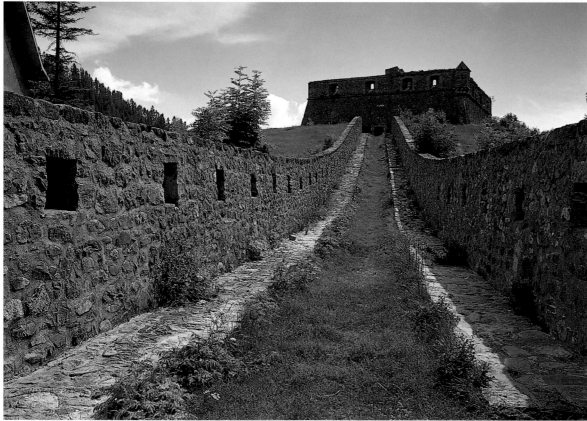

*T*he village's southern gate, or Porte de France
(top), *bears an old sundial and the coat of arms of*
François I; a fortified path leads from the gate up to the
Fort de France (above). *There are excellent views of the*
village (right) *from the Fort de Savoie; the Fort de*
France can be seen on the left.

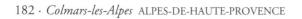

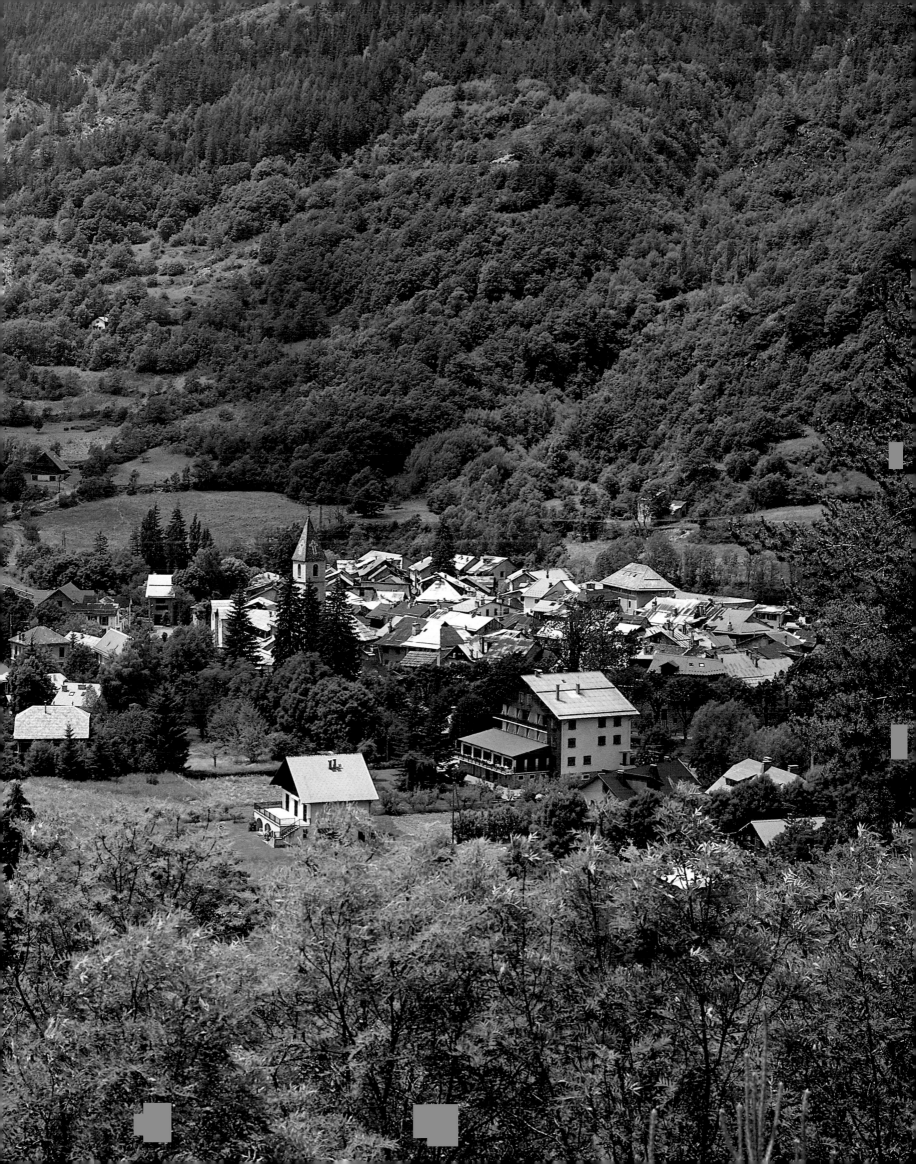

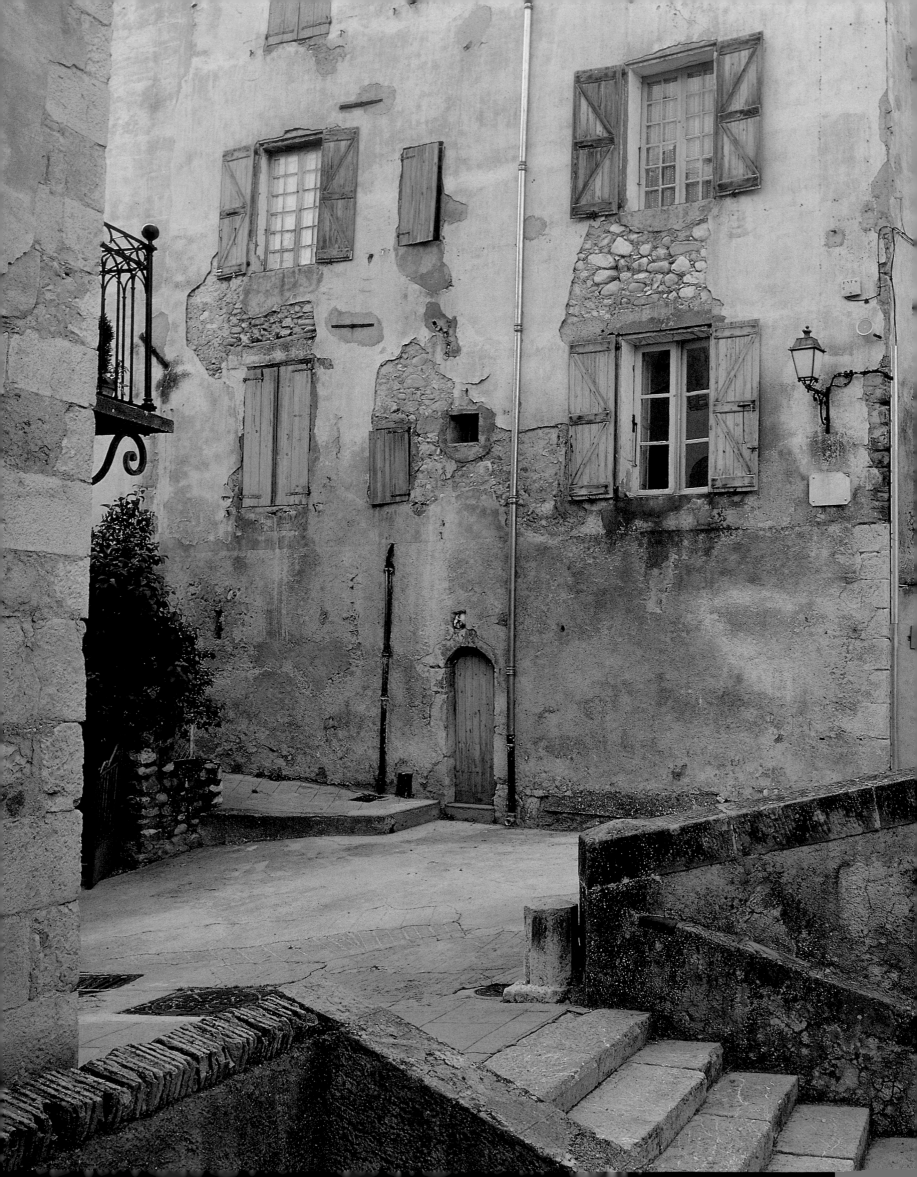

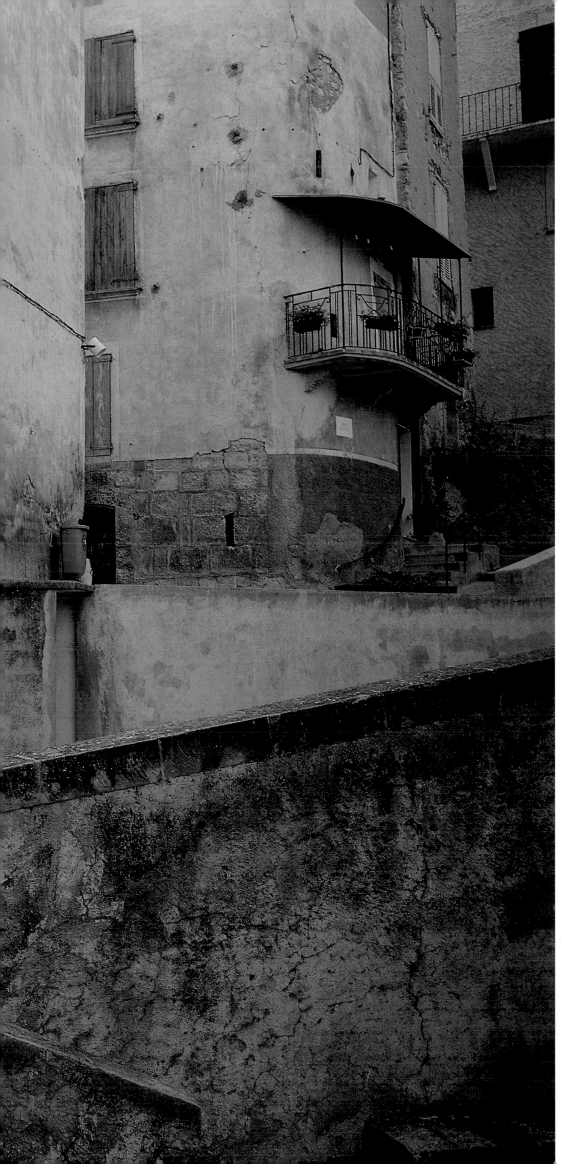

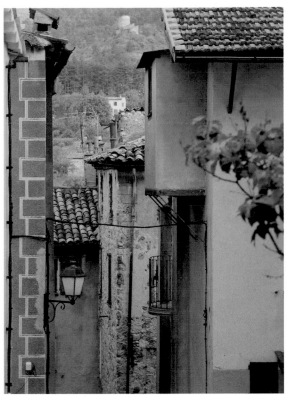

Entrevaux

ALPES-DE-HAUTE-PROVENCE

THRUST UP on a rock above the torrential river Var, and guarding an Alpine valley which once separated the kingdoms of France and Savoy, Entrevaux is an intact fortified village complete with moat, drawbridges and a magical, toy-town profile outlined against a green mountainous backcloth.

The origins of Entrevaux are in the Roman settlement and later bishopric of Glandèves, which was built on flat ground on the right bank of the river and enjoyed for several centuries the unusual status of being shared between France and Savoy. Repeated floodings and brigand attacks led in the late Middle Ages to the gradual abandonment of Glandèves and the creation on the opposite side of the river of the present village. The importance of the new settlement was greatly enhanced after 1694 when Louis XIV decided to turn Entrevaux into a key defensive position and to entrust the rebuilding of the ramparts to the great military engineer Vauban.

From the main Nice road a high one-arched bridge leads to an entrance gate flanked by rounded towers. The quiet, traffic-free streets inside are lined with stone buildings and seem to have changed little since the time of Vauban. The former cathedral, built in the seventeenth century, is attached to the northern ramparts. From the adjoining gate there is access to the ramparts and to a series of nine zigzag ramps (which took over fifty years to build) leading to an imposing citadel which commands remarkable views of the valley.

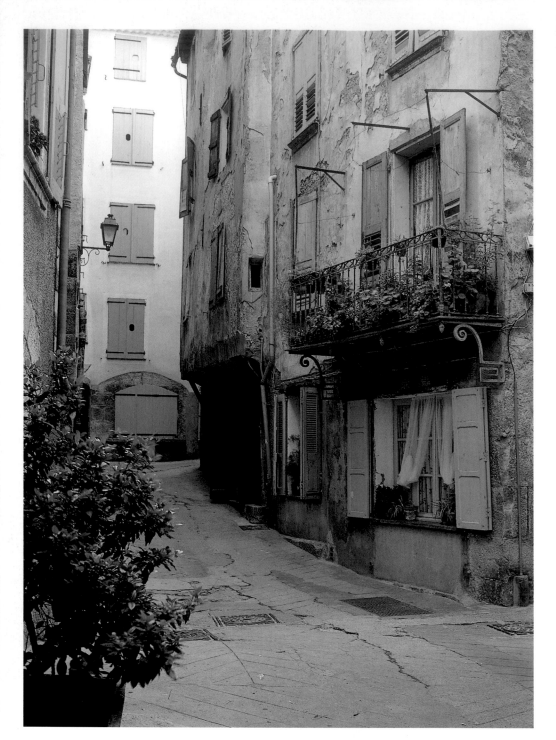

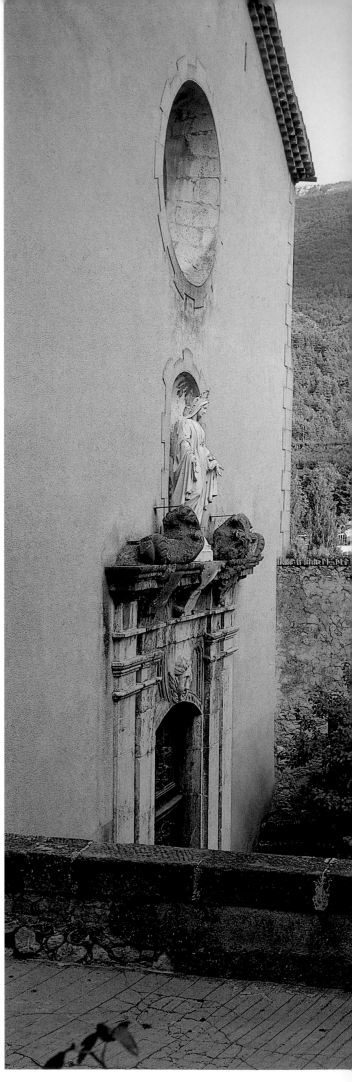

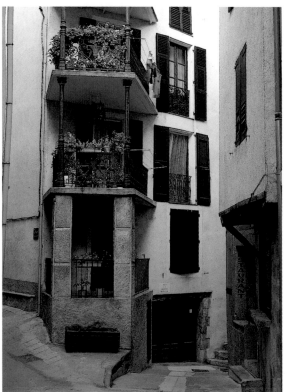

*T*he formal precision of Vauban's ramparts is reflected in the steep ramps and streets of Entrevaux itself (preceding pages, above *and* right). *The façade of the former cathedral church* (right) *is unusually severe for a structure of the Baroque era; the sole decoration is concentrated on the portal, crowned by a niche encasing a statue of the Virgin. The drama of the fortified village's setting* (overleaf) *is particularly apparent when viewed from the left bank of the river Var.*

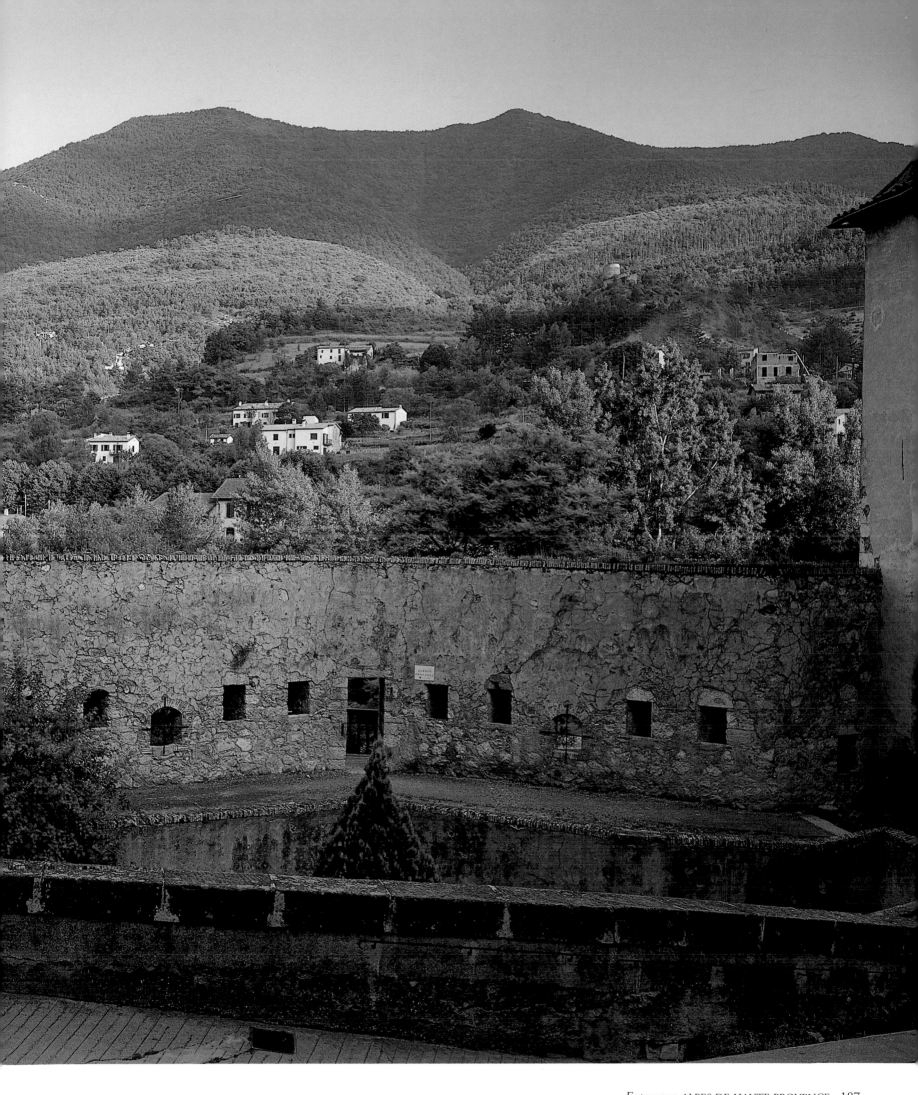

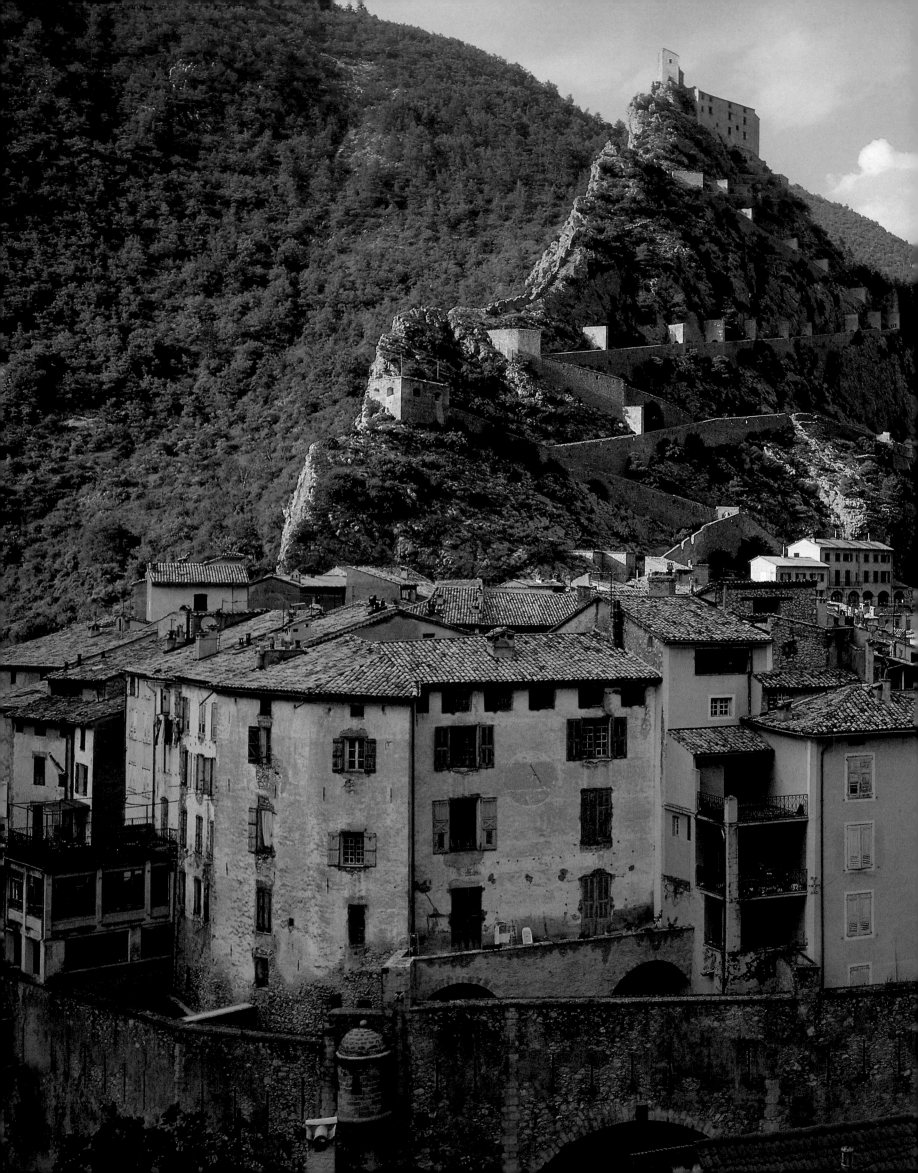

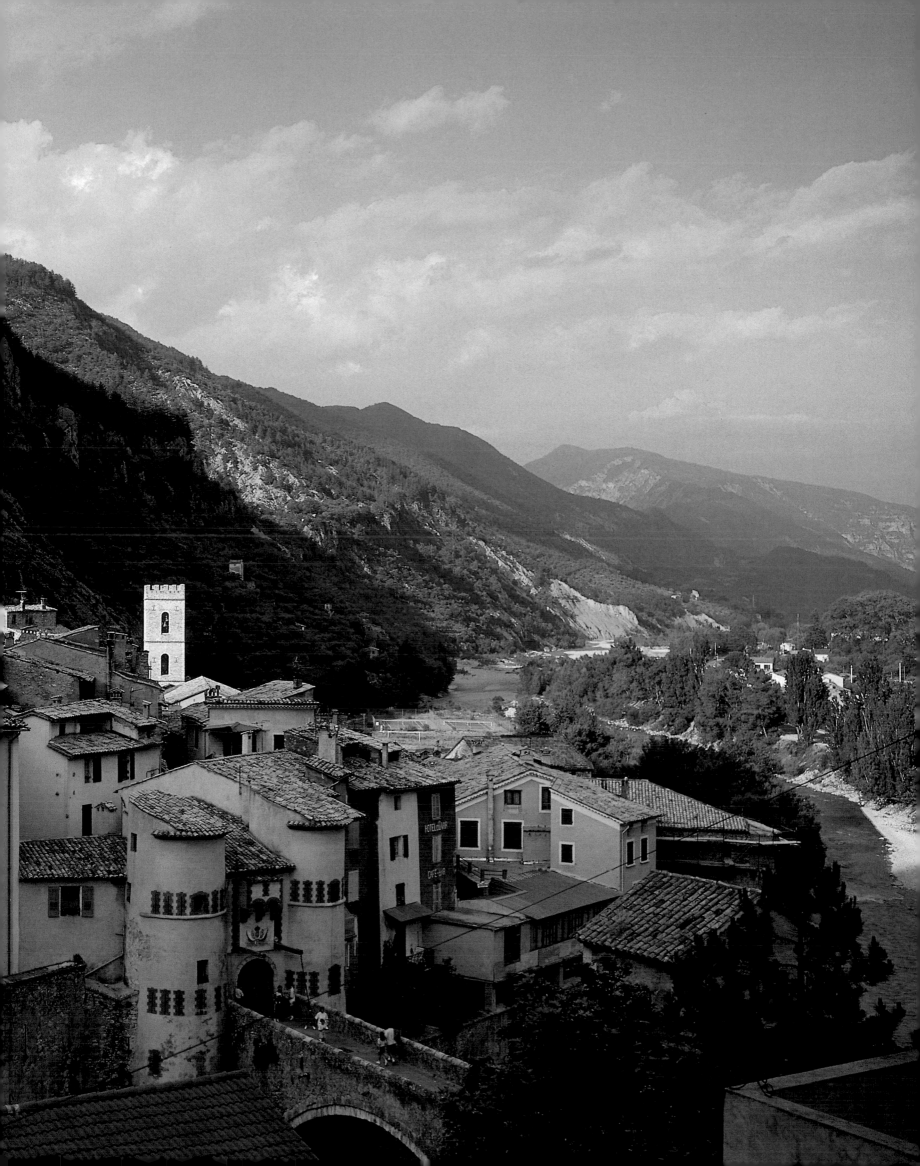

Lurs
ALPES-DE-HAUTE-PROVENCE

MOST OF the beautiful Provençal villages have spectacular views, but Lurs is special in enjoying a vast panorama on all sides from its exposed, ridge-top setting above the broad sweep of the Durance valley. A gentle, bucolic landscape of vines, olives and wheatfields rolls away to the south and west, while to the north and west are steep, pine-forested slopes, the fantastical rock formations of Les Mées, and gaunt peaks rising in the distance above the Durance and the great plateau of Valensole. The spectacular view to the west has earned the village the nickname of 'the balcony of the Durance'.

The village itself is a modest place barely evoking the important fortified settlement founded, according to tradition, by Charlemagne and later embellished by the Bishops of Sisteron. The Bishops retained Lurs as their favourite residence right up to the Revolution, after which the village went into a long decline. It was wholly in ruins by 1955, when it was visited by the novelist Jean Giono in the company of a group of graphic artists headed by the printer Maximilien Vox. A decision was made to restore the village and to give further life to it by instituting an annual international festival dedicated to printing and the graphic arts.

A belfry enclosing one of the oldest clocks in Provence marks the entrance to the scantly inhabited village where houses in bleached masonry stand out above deserted, sun-scorched alleys. On the village's northern outskirts is the so-called Promenade des Évêques, where the Stations of the Cross have been laid out along a scenic path which follows the edge of the ridge. From the chapel at the path's end can be seen the magnificent Romanesque priory of Ganagobie, some way to the north.

Seen from the Durance valley the village of Lurs appears as a scattered group of ruins projecting on a rocky spur above dense forest.

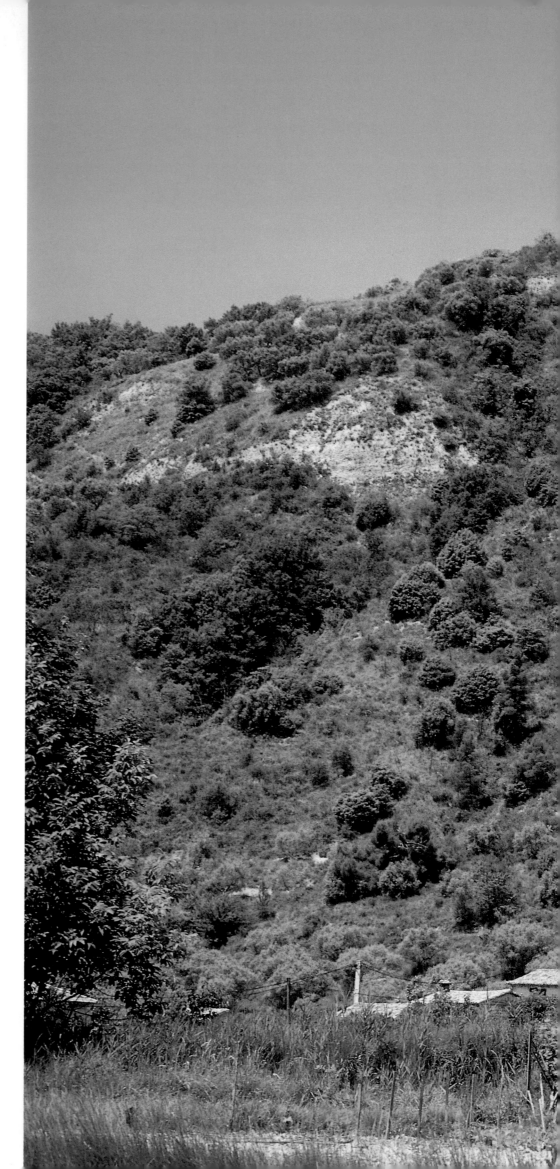

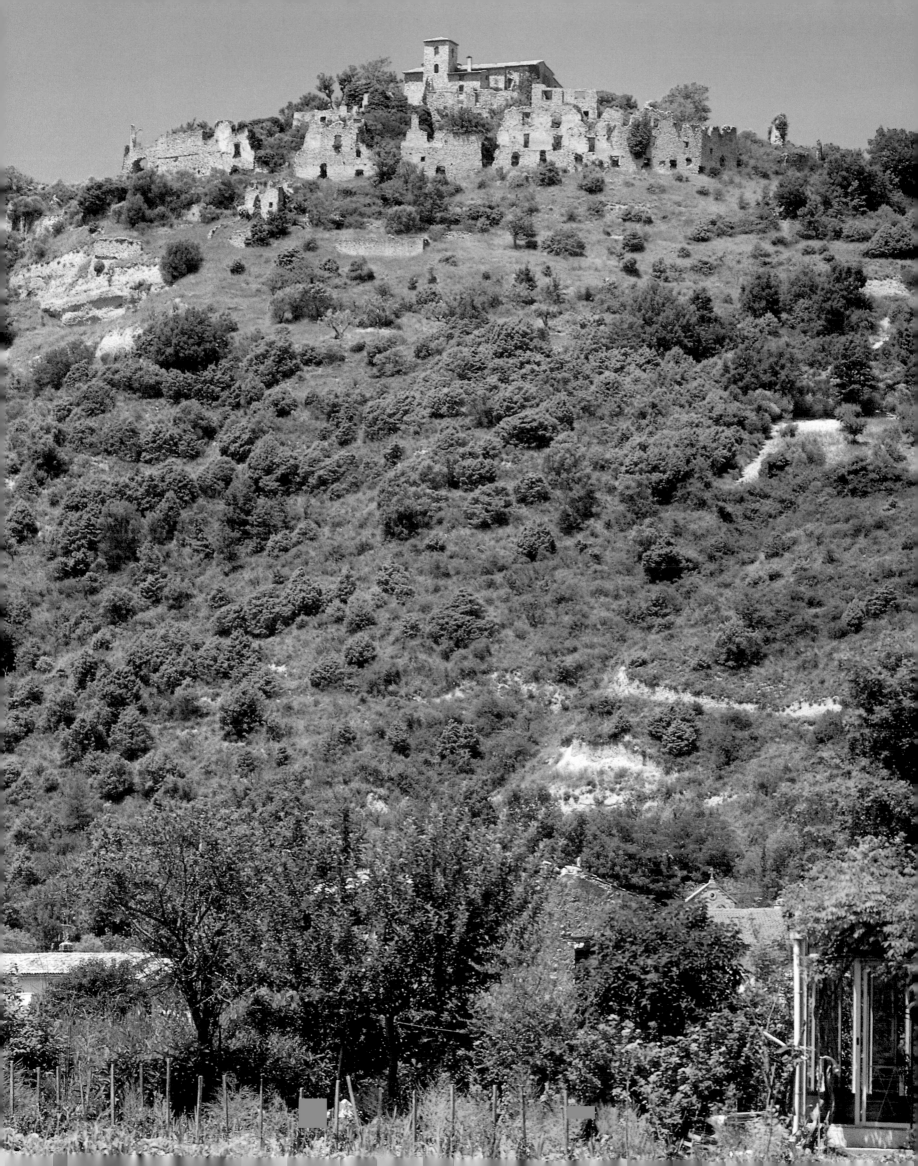

*M*any of the houses of Lurs (below, below left *and* opposite), *including several bearing coats of arms, have been entirely restored in recent years; the clock-tower* (left), *with its famous old clock, stands above the main entrance to the fortified section of the village.*

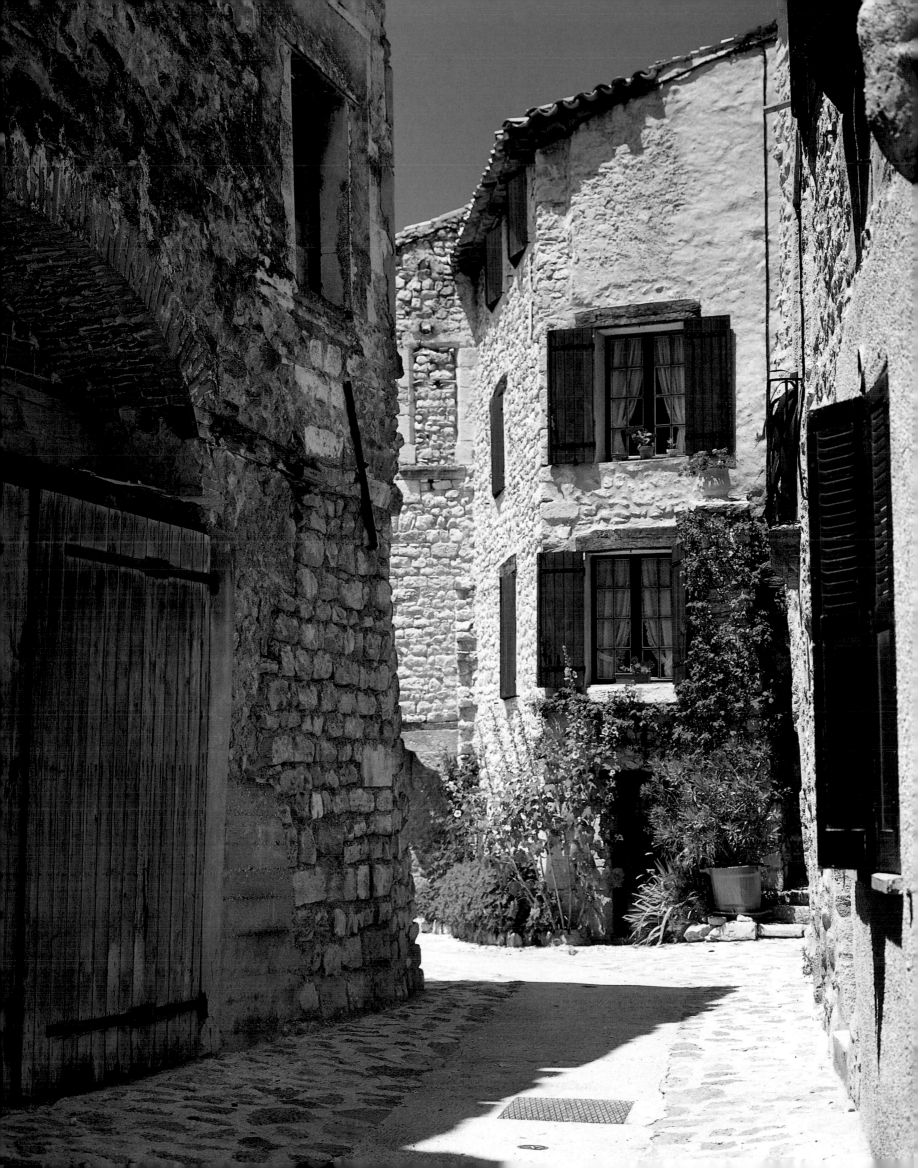

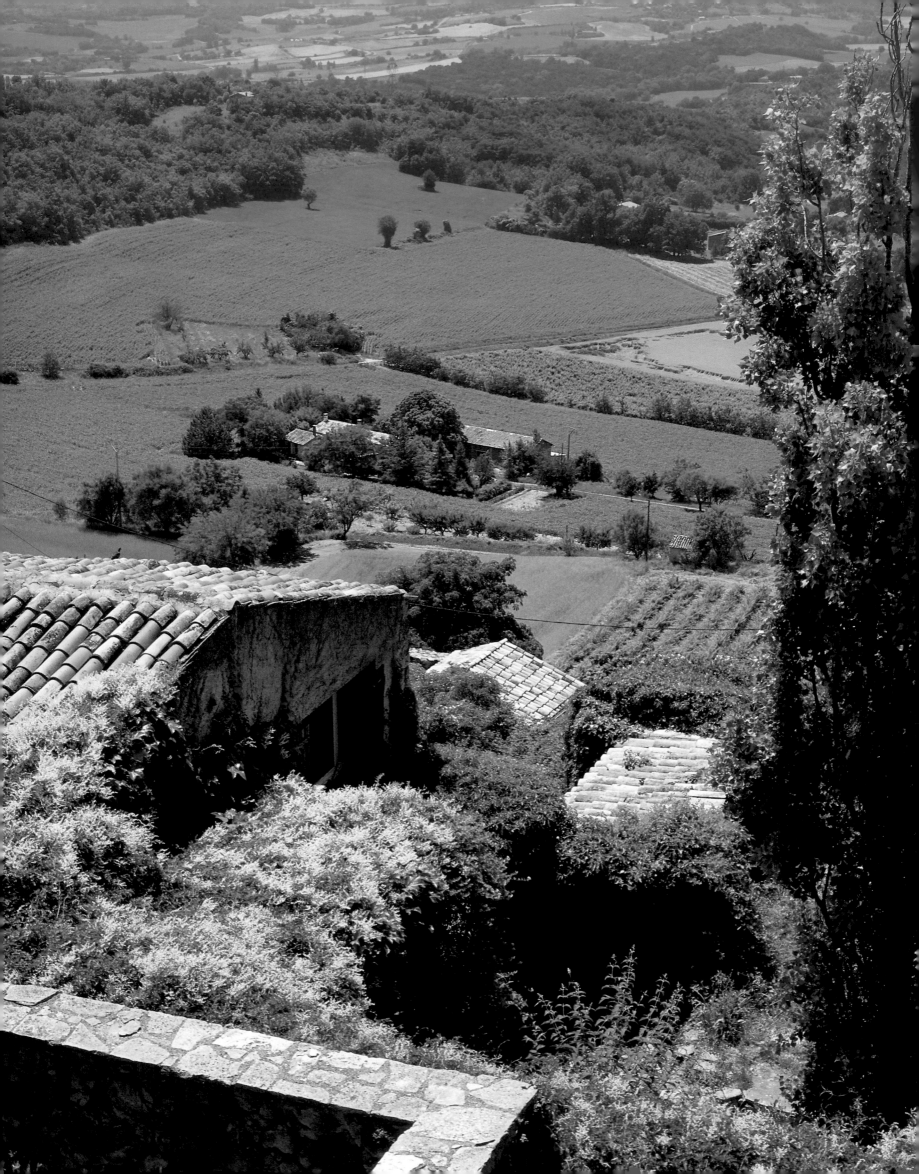

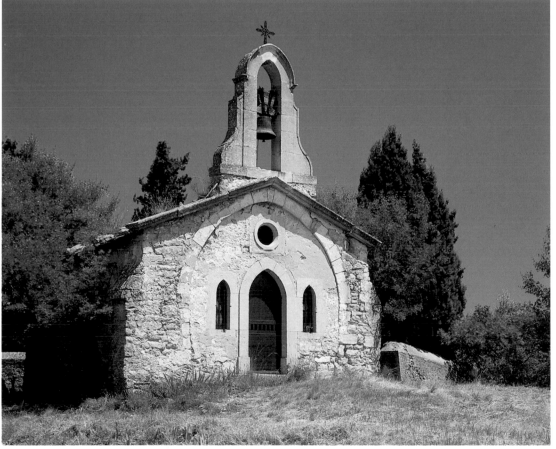

*T*he views over rolling, fertile fields to the north of the village (opposite) *towards the range of the Lubéron remind us that Provence is indeed a land of plenty. A line of fifteen nineteenth-century oratories* (above) *marks the so-called Promenade des Évêques; a delightful ridgeway path leads to the chapel of Notre-Dame-de-Vie, a simple fourteenth-century structure* (left).

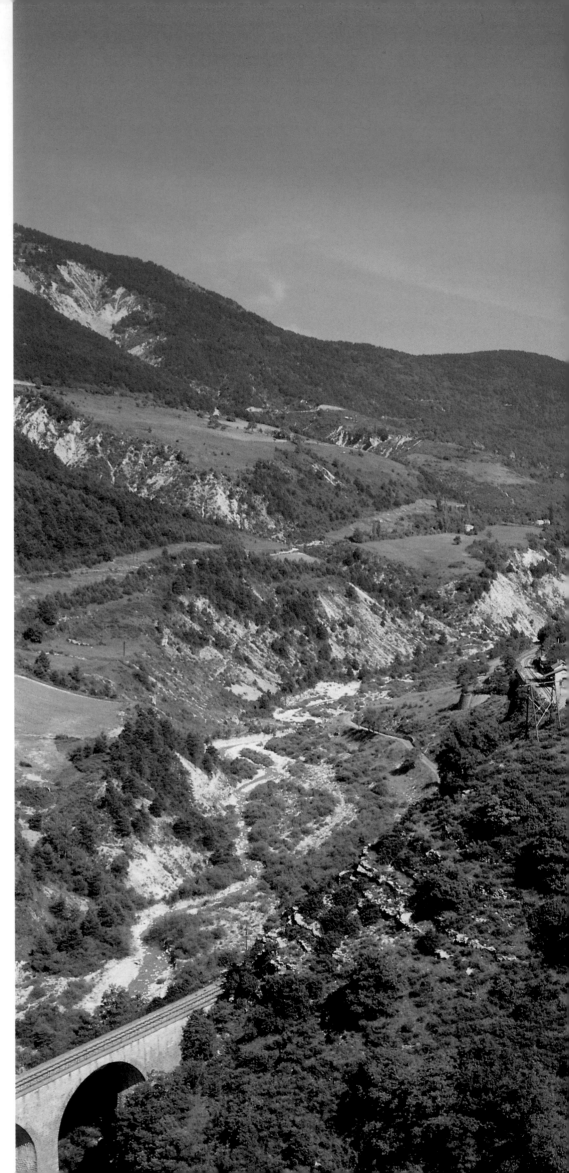

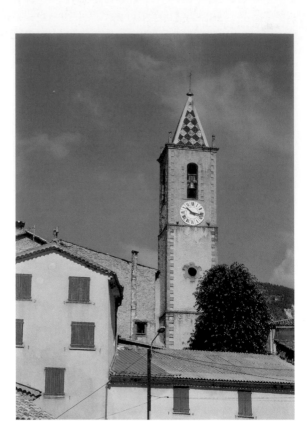

Méailles

ALPES-DE-HAUTE-PROVENCE

THE LANDSCAPE of walnut trees, chestnuts, pines and rock pinnacles which characterizes the Vaire valley near Annot gives way just before Méailles to a more open and dramatically Alpine terrain.

The tiny village of Méailles, reached by a perilous side road leading off the main valley route, stands above the valley at the edge of a small plateau abruptly terminated by a high cliff. The place itself is that great rarity in Provence – a village completely untouched by tourism. Though you might see the odd car with a Parisian licence plate, the few remaining inhabitants of this declining community are local farmers, living off the barely profitable adjoining pastures. The village streets disintegrate into rutted tracks, while many of the partly timbered and wholly Alpine houses function as farm buildings. The sole commercial establishment is a primitive café sheltering below the white belfry of a medieval church with a Romanesque nave and some grotesque, sculpted heads. The village wash-house, with its crude metal canopy, is still in use.

A view of Méailles and the Vaire valley (right) *from the vertiginous side road which climbs up to the village; the arches below the village are those of a late nineteenth-century railway line. The village is dominated by the Alpine-style campanile of its parish church* (above).

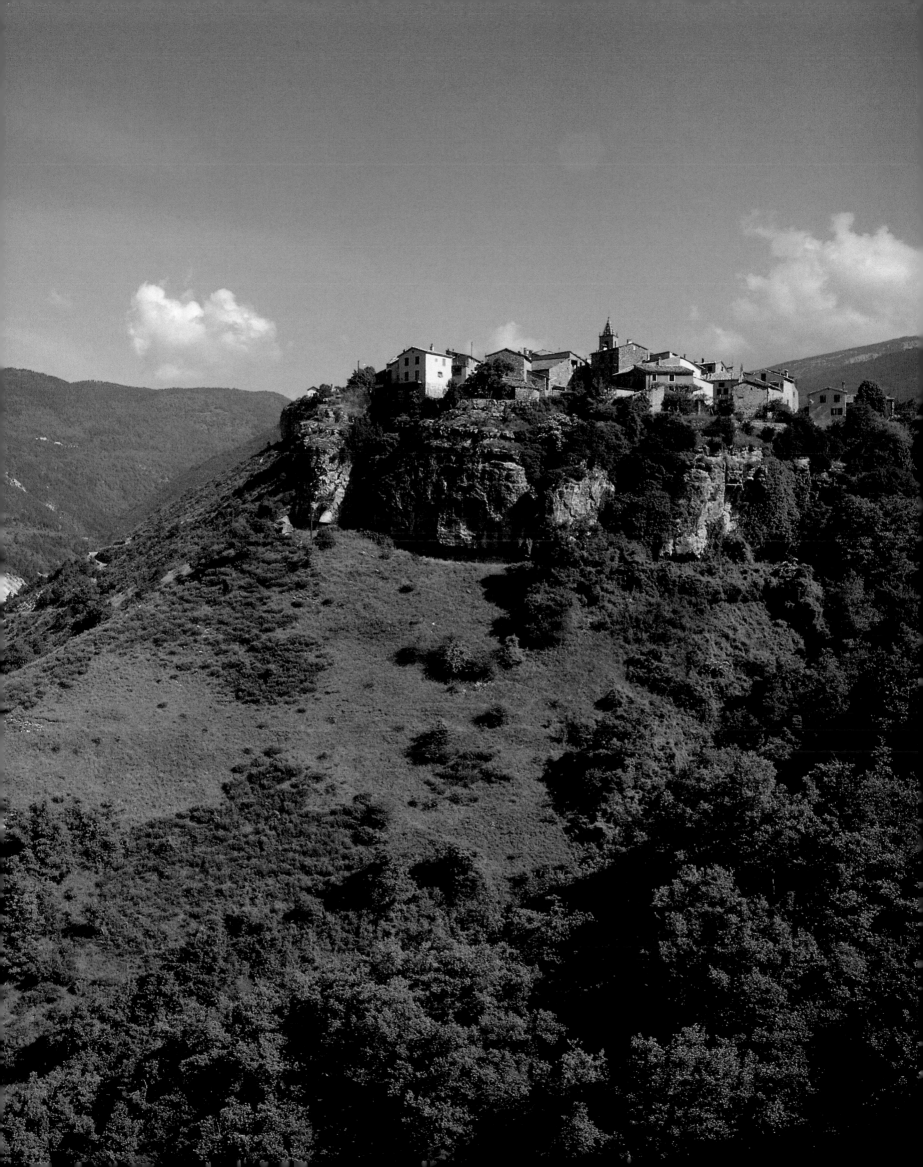

*T*raditional pitchforks and other implements, a battered wooden door, sturdy stone farm buildings and large stacks of logs for the winter (these pages): *all signs that Méailles is a traditional farming community just surviving under harsh conditions.*

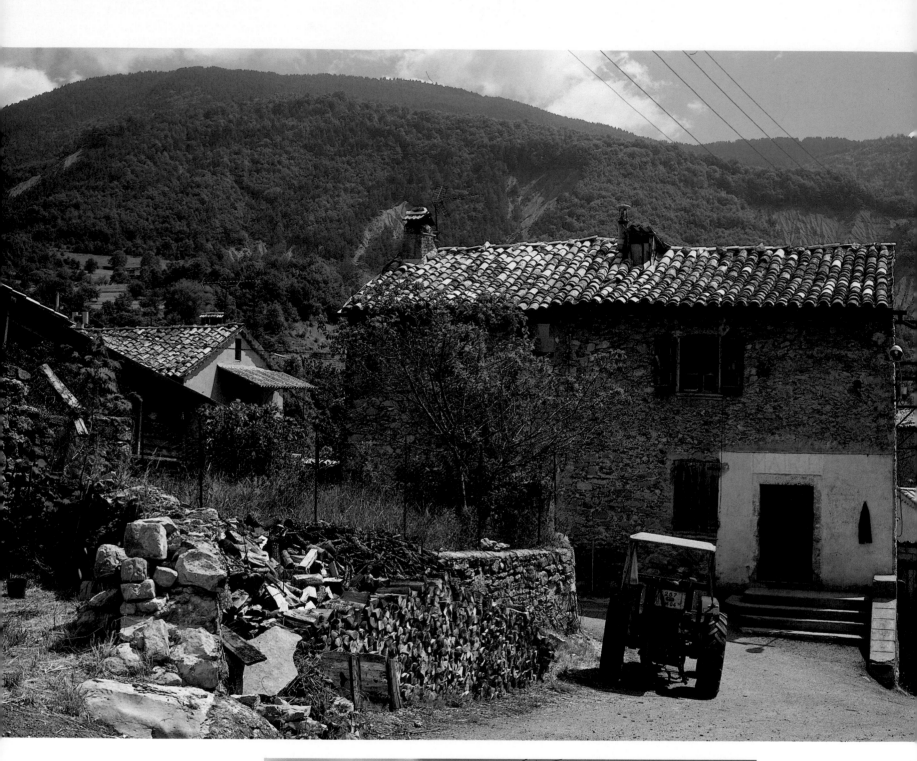

A tractor from Méailles' sole remaining farm (above); *the farmer* (opposite below left) *does not believe that his sons will continue farming there.*

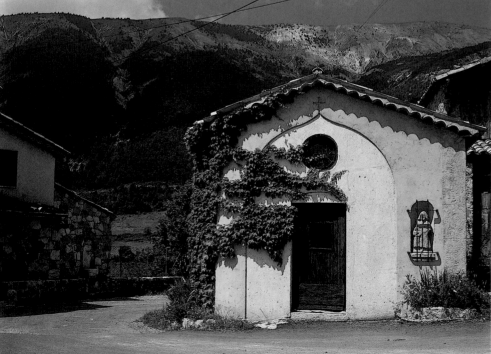

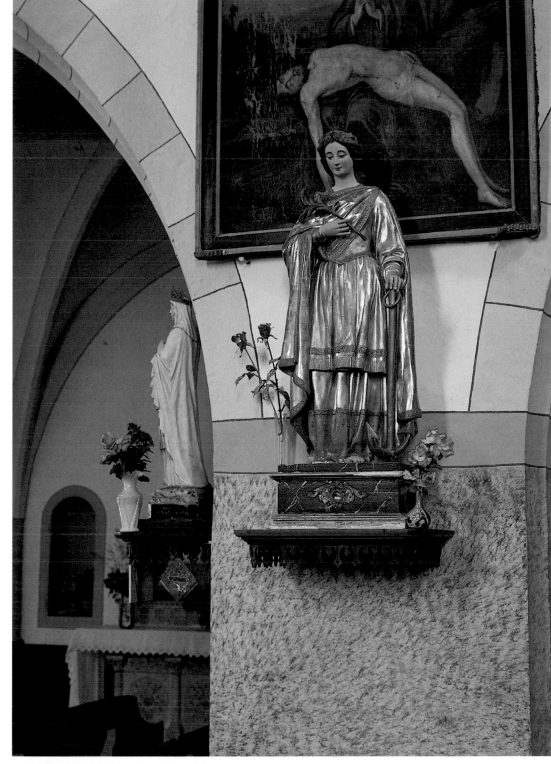

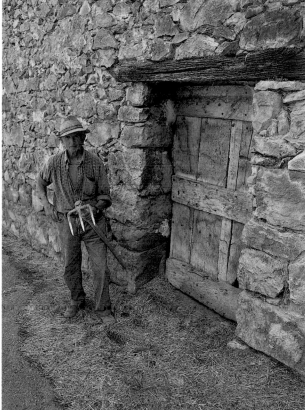

The restored interior of the medieval parish church (above) is as simple as its exterior (opposite below) and neighbouring bar (above left). The war memorial (left) is a poignant reminder of the extent to which this community was devastated in the First World War.

Riez ALPES-DE-HAUTE-PROVENCE

Archaeological excavations carried out in the nineteen-fifties at Riez revealed that the four Corinthian columns which stand isolated today in a meadow formed the façade of a temple of the first century B.C. The clock-tower which rises above the village (opposite) was originally part of the fourteenth-century fortifications of Riez; the church tower in the background is that of the former cathedral.

SITTING in a narrow valley at the verdant confluence of the rivers Auvestre and Colostre, Riez marks the site of an important Roman crossroads linking upper Provence with Aix and Fréjus.

A poignant survival of Riez's years as a Roman colony are four tall Corinthian columns, probably the remains of a temple dedicated to Apollo, which rise up among meadows on the outskirts of the village. Nearby, and in a similarly arcadian setting, is an isolated, much restored fifth-century baptistery testifying to Riez's importance during the early Christian period, when the place was established as a bishopric following a major Council held here in 439 under the renowned Archbishop Hilarius of Arles. The first Bishop of Riez was Saint Maxime, who founded both the baptistery and the adjoining cathedral, which was reduced over the centuries to a skeletal ruin.

As protection against attacks, Riez was rebuilt in the Middle Ages on top of the nearby hill named after Saint Maxime. This new settlement, of which there survives only a magnificently situated Romanesque chapel, was abandoned by the thirteenth century, when the inhabitants moved definitively back into the valley.

Riez remained a bishopric up to the Revolution, but was pillaged on several occasions and gradually reduced to the present modest community. However, in contrast to other former bishoprics such as Venasque, the Riez of today is a small place of considerable colour and animation. The tree-lined Place du Quinconce, marking the line of the original fortifications, provides a cheerful introduction to a lively artisan and agricultural centre, featuring medieval gates and a series of narrow shaded streets of numerous fine buildings of the fifteenth to eighteenth centuries.

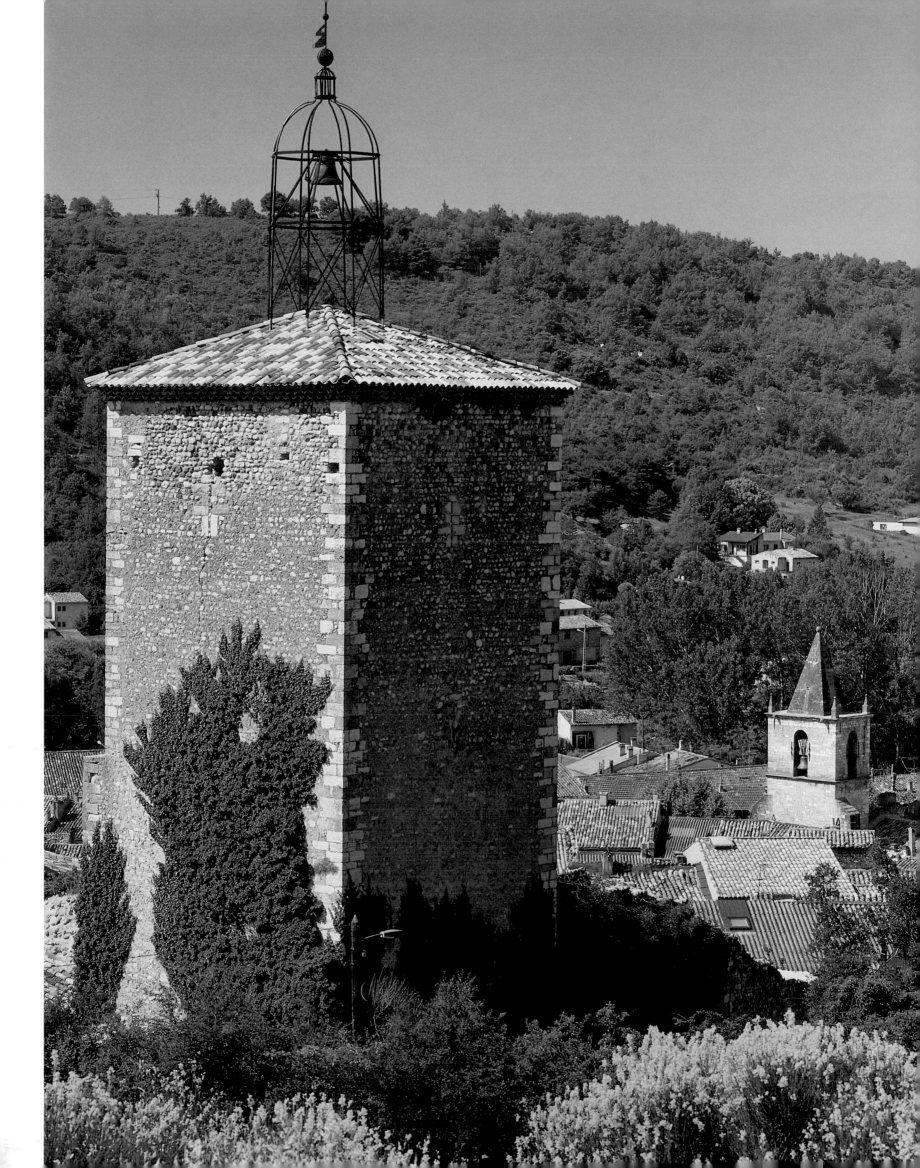

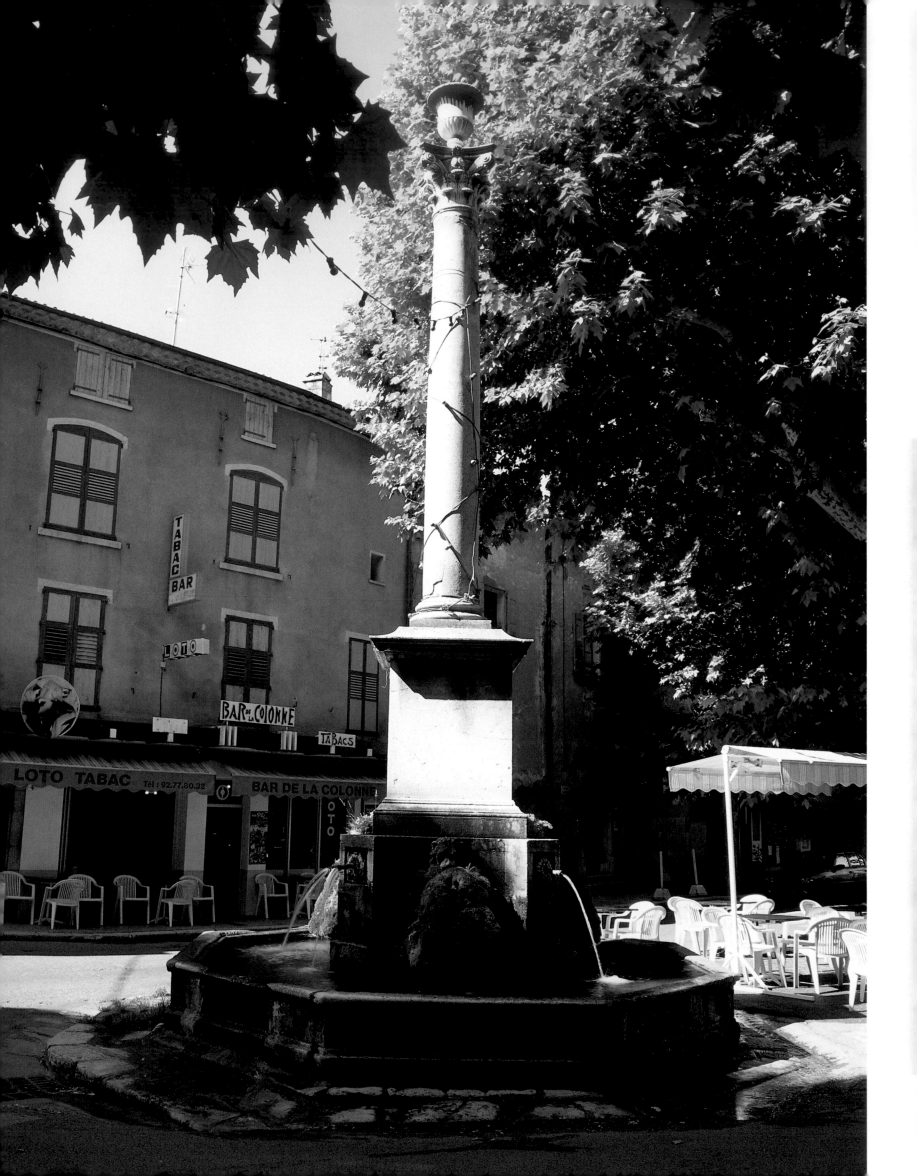

Behind the late fourteenth-century Porte Aiguière (below) *extends a charming small square adorned with an eighteenth-century fountain* (opposite), *whose column echoes those of the Roman temple on the outskirts of the village. A specialist honey shop* (right) *proclaims Riez as a centre of lavender growing.*

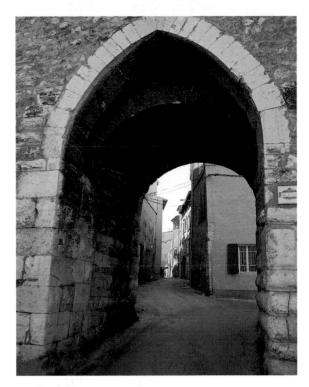

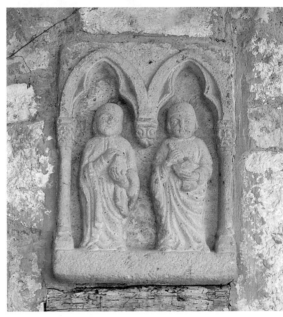

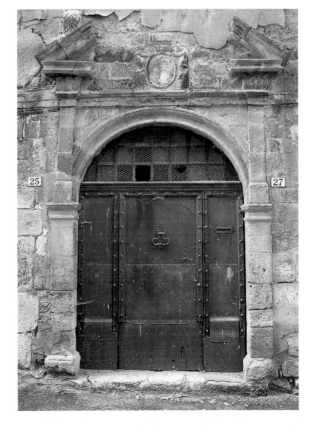

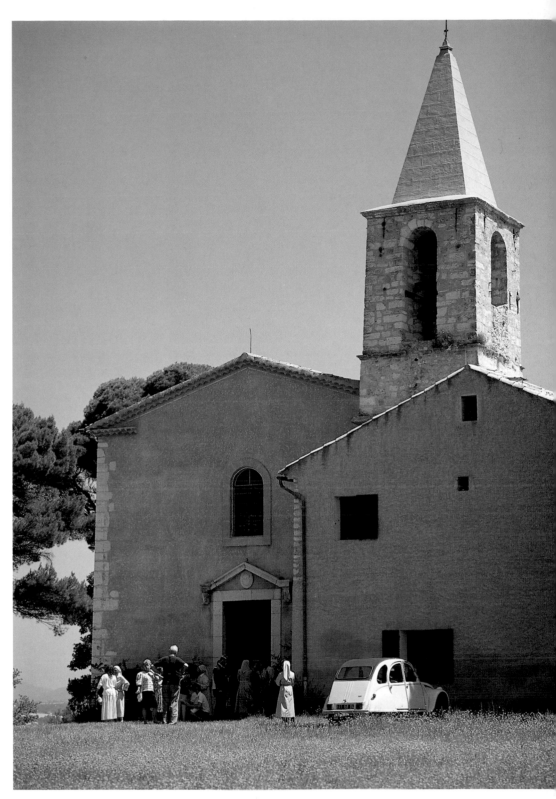

*T*he former cathedral of Riez (opposite) *was erected in the late fifteenth century; entirely rebuilt after the Revolution, it retains today only the medieval clock-tower from its original structure. A twin niche on the outside of the former cathedral displays crude carvings of Saints Maxime and Hilarius* (centre left). *An impressive seventeenth-century portal* (below left) *from one of the many fine houses of the village, seen here through a substantial gateway* (top left) *expressive of the place's importance. The isolated and heavily restored chapel of Saint-Maxime* (above), *high above the village, is a popular place for Sunday devotions.*

USEFUL INFORMATION

MAP · HOTELS AND RESTAURANTS
MARKET DAYS AND FESTIVALS

*R*iez, which holds regular lavender markets, is
often known as the lavender capital of Provence;
great expanses of purple (opposite) *cover the
surrounding plateau of Valensole, an area whose subtle
beauty was much praised by the writer Jean Giono.*

A fountain at Venasque, Vaucluse (above).

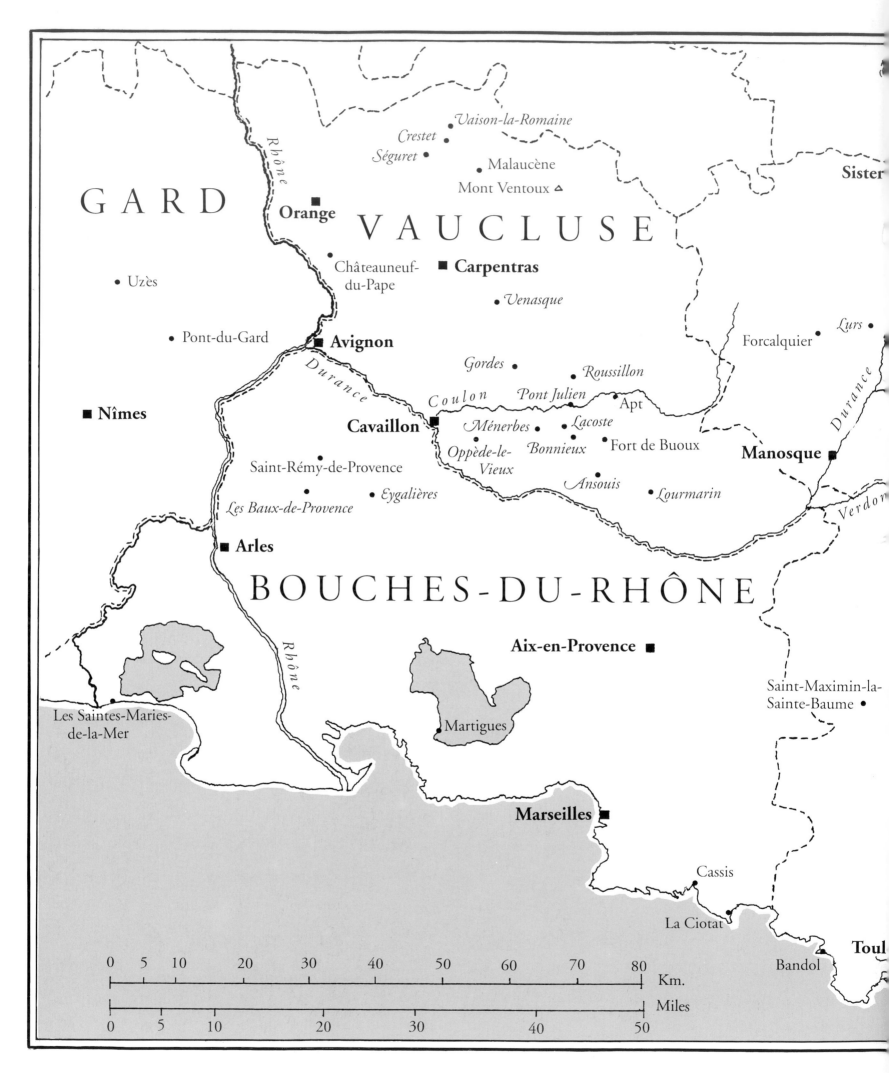

GARD

VAUCLUSE

Rhône

Vaison-la-Romaine

Crestet

Séguret

Malaucène

Mont Ventoux △

Sister

■ **Orange**

Châteauneuf-
du-Pape

■ **Carpentras**

• Uzès

Venasque

Lurs

• Pont-du-Gard

■ **Avignon**

Gordes

Roussillon

Forcalquier

Coulon

Pont Julien

Apt

Durance

Durance

■ **Nîmes**

Cavaillon

Ménerbes

Lacoste

Bonnieux

Fort de Buoux

Manosque ■

Saint-Rémy-de-Provence

*Oppède-le-
Vieux*

Ansouis

Lourmarin

Eygalières

Verdor

Les Baux-de-Provence

■ **Arles**

BOUCHES-DU-RHÔNE

Rhône

Aix-en-Provence ■

Saint-Maximin-la-
Sainte-Baume •

Les Saintes-Maries-
de-la-Mer

Martigues

Marseilles ■

Cassis

La Ciotat

Toul

Bandol

| 0 | 5 | 10 | 20 | 30 | 40 | 50 | 60 | 70 | 80 |

Km.

Miles

| 0 | 5 | 10 | 20 | 30 | 40 | 50 |

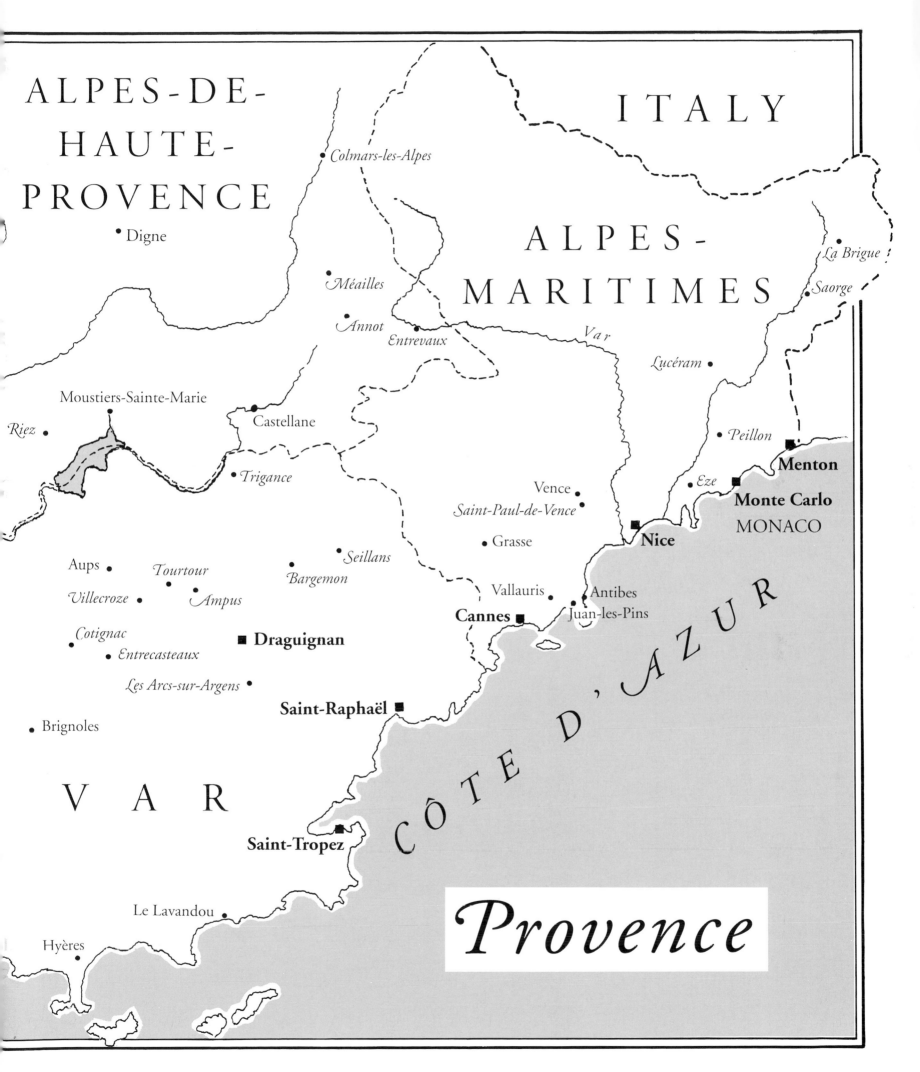

ALPES-DE-
HAUTE-
PROVENCE

ITALY

Colmars-les-Alpes

• Digne

ALPES-
MARITIMES

La Brigue

Méailles

Saorge

Annot

Entrevaux

Var

Lucéram •

Moustiers-Sainte-Marie •

• Castellane

Peillon •

Riez •

Trigance

Vence •

Eze •

Menton

Saint-Paul-de-Vence •

Monte Carlo

MONACO

• Grasse

■ **Nice**

Aups •

Seillans •

Tourtour •

Bargemon

Vallauris

Antibes •

Villecroze •

Ampus •

Draguignan

Juan-les-Pins

Cotignac •

■ **Cannes**

• *Entrecasteaux*

Les Arcs-sur-Argens •

Saint-Raphaël ■

• Brignoles

V A R

CÔTE D'AZUR

Saint-Tropez

Le Lavandou •

Provence

Hyères •

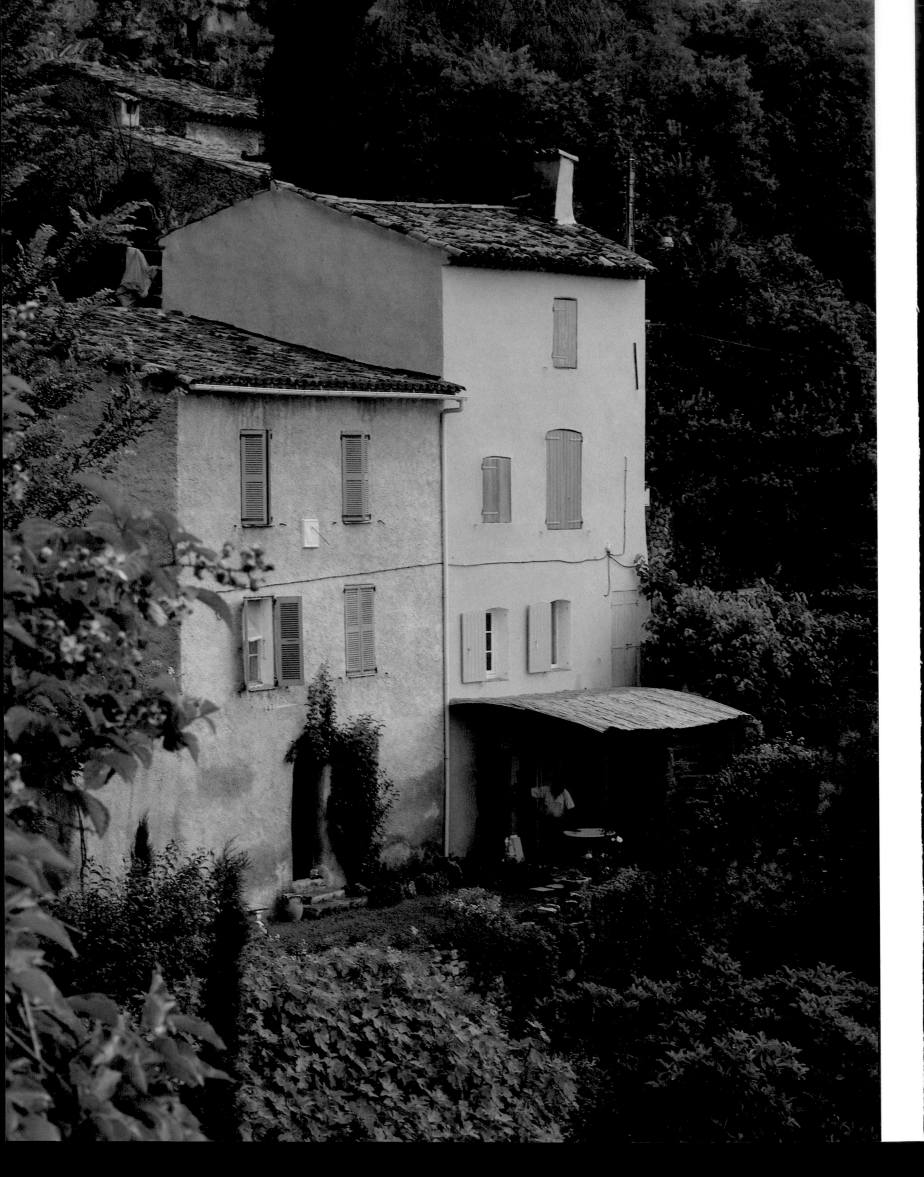

Useful Information

HOTELS AND RESTAURANTS · MARKET DAYS AND FESTIVALS

(PV = Protected Village; PBVF = Membership of the Les Plus Beaux Villages de France organization). While every effort has been made to ensure that the information given below is correct, the author and publisher cannot be held responsible for any inadvertent inaccuracies; the ratings for hotels, etc. are those given by the French Tourist Board.

VAUCLUSE AND BOUCHES-DU-RHÔNE

Ansouis
Pop. 612. PV

Festivals and Fêtes
Local fête, third Sunday in July; Cult of Saints Elzéar and Delphine, last Sunday in September.

Sights
CHÂTEAU
Daily, except Tuesdays, 14.45 – 17.45.
MUSÉE EXTRAORDINAIRE DE GEORGES MAZOYER
Daily, except Tuesdays, 14.00–18.00/19.00.

Bonnieux
Pop. 1385. PV

Festivals and Fêtes
Local fête, first Sunday after 22 August; 'Thursdays in Bonnieux' (concerts, plays, etc.), mid June – mid September.

Market
Saturdays, daily during the asparagus season (1 April – 31 May, 15 August – 15 September).

Sights
MUSÉE DE LA BOULANGERIE
Reconstructed bakery and items relating to history of bread. *Daily, 1 June – 30 September, 10.00 – 12.00 and 15.00 – 18.30, also Saturdays, Sundays and holidays, March – May, November – December*; opposite the museum is a bakery (Tomas) famous for its magnificent pastry known as a 'Louis-Philippe'.

Hotel-Restaurants
*** DE L'AIGUEBRUN. Fine, outlying property; tel: 90 74 04 14.

*CÉSAR. Central location, and good views; tel: 90 75 80 18.

Restaurants
AUBERGE DE LA LOUBE. Outside the hamlet of Buoux; heavy fare, but beautifully situated overlooking a wild mountain valley; tel: 90 72 26 31.

Information
7 Place Carnot (summer only); tel: 90 75 91 90.

Crestet
Pop. 326. PV

Festivals and Fêtes
Local fête, 30 June; pilgrimage to Notre-Dame du Peyron, Easter Monday.

Sights
Views of the Dentelles de Montmirail.

Gordes
Pop. 1607. PV; PBVF

Festivals and Fêtes
Local fête, third Sunday in September; wine festival ('Côtes-du-Ventoux'), 13–14 July; theatre and music festival, first fortnight in August.

Market
Tuesdays.

Sights
MUSÉE DIDACTIQUE VASARELY
Daily, except Tuesday, 10.00 – 12.00, 14.00 – 18.00.
VILLAGE DES BORIES
Primitive stone huts with reconstructed interiors. *Daily, 9.00 – sunset.*
ABBAYE DE SÉNANQUE
Cistercian abbey, with exhibition relating to

*H*ouses clustered under the tufa cliff at Cotignac, Var.

Sahara, and regular concerts of Gregorian chant. *Daily, 9.00 – 12.00/12.30 and 13.30/14.00 – 18.00/1900.*
LE MOULIN DES BOUILLONS and MUSÉE DU VITRAIL FRÉDÉRIQUE DURAN
Sixteenth-century olive mill with adjoining stained-glass museum. *Daily, April – October, 10.00 – 12.00, 15.00 – 19.00.*

Hotel-Restaurants
****LA BASTIDE DE GORDES. Tel: 90 72 12 12.
****LES BORIES. Situated in a tastefully converted group of *bories*, or stone huts;
tel: 90 72 00 51.
LA MAYANELLE. In old building in village centre;
tel: 90 72 00 28.

Information
Place du Château; tel: 90 72 02 75.

Lacoste
Pop. 309. PV

Festivals and Fêtes
Local fête, last Sunday in July, or first Sunday in August; concerts given by Deller Consort in August.

Sights
CHÂTEAU
Saturdays and Sundays throughout the year, guided tours 15 June – 15 July, 8.00 – 12.00.

Hotels
RELAIS DU PROCUREUR. A place of aristocratic pretensions, alongside village bakery;
tel: 90 75 82 28.
CAFÉ DE FRANCE. Old-fashioned and pleasantly run-down; tel: 90 75 82 25.

Restaurant
SIMIANE. Parisian-run, with gastronomic specialities named after the Marquis de Sade and his works; tel: 90 75 83 31.

Lourmarin
Pop. 858. PV; PBVF

Fêtes and Festivals
Local fête, first Sunday in August; antiques and handicrafts fair, mid July; dog show, beginning of August; Rencontres méditerranéennes Albert Camus (cultural festival), July and August; wine and local products trade fair, September.

Sights
CHÂTEAU
Guided tours daily, except Tuesdays, from November to March, 9.00/9.30 – 11.45 and 14.00 – 17.45/18.15.

Hotel-Restaurants
****LE MOULIN DE LOURMARIN. Central, with views towards château;
tel: 90 68 06 69.
***DE GUILLES. Outlying and peaceful;
tel: 90 68 30 55.

Restaurants
**LA FENIÈRE. Tel: 90 68 11 79.

Information
Avenue Philippe de Girard (summer only; tel: 90 68 10 77).

Ménerbes
Pop. 1027. PV:PBVF

Fêtes and Festivals
Local fête, 25 August.

Sights
Views to the north of the valley of the Coulon, the villages of Gordes and Roussillon (with its ochre cliffs), Mont Ventoux and the Vaucluse plateau; to the south, the range of the Lubéron.

Hotel-Restaurants
***HOSTELLERIE LE ROY SOLEIL. Tel: 90 72 25 61.

Oppède-le-Vieux
Pop. 1015. PV

Fêtes and Festivals
Local fête, 24 August.

Market
Thursdays.

Sights
Views of the Vaucluse plateau and the valley of the Coulon.

Hotel-Restaurants
MAS DES CAPELANS. Tel: 90 76 99 04.

Roussillon

Pop. 1313. PV; PBVF

Fêtes and Festivals

Local fête, last Sunday in July; ochre and colour festival, Ascension; international string quartet festival, June.

Market

Wednesdays.

Sights

Views of the Vaucluse plateau, Mont Ventoux and the valley of the Coulon; ochre cliffs of the Chaussée des Géants.

Hotel-Restaurants

***MAS DE GARRIGON. Quiet, isolated situation; tel: 90 05 63 22.
LES OCRES. Modern hotel on edge of village, no restaurant;
tel: 90 75 60 50.

Restaurants

DAVID. In centre of village, but with fine views over ochre cliffs;
tel: 90 05 60 13.

Information

Place de la Poste (open only during school holidays and weekends from Easter to end of October);
tel: 90 05 60 25.

Séguret

Pop. 714. PBVF

Fêtes and Festivals

Local fête, first Sunday in August; exhibition of cribs and crib figures, January and August; Provençal festival, end of August; 'Living Crib', Midnight Mass, Christmas.

Sights

View of the Dentelles de Montmirail; on clear days the Massif Central is visible to the far north.

Hotel-Restaurants

***AUBERGE DE CABASSE. Tel: 90 46 91 12.
***LA TABLE DU COMTAT. Fifteenth-century building in centre of village, famed for its Michelin-starred restaurant; tel: 90 46 91 49.

Vaison-la-Romaine

Pop. 5864, including new town

Fêtes and Festivals

Local fête, 15 August; Whitsun parade; theatre, music and dance festival, 10 July – 10 August; international choir festival (every three years, next due 1996), beginning of August.

Market

Tuesdays; Tuesday asparagus fair at end of February; Tuesday linden-blossom market in June and July.

Sights (old town)

Roman ruins of Quartiers de la Villasse and Puymin, 9.00 to sunset; Romanesque cathedral of Notre-Dame-de-Nazareth and chapel of Saint-Quenin;
MUSÉE ARCHÉOLOGIQUE THÉO DESPLANS *Daily, except Tuesdays, 10.00 – 12.00 and 14.00 – 17.00/18.00.*

Hotel-Restaurants

***LE BEFFROI. In sixteenth-century house at the centre of the upper town;
tel: 90 36 04 71.
**LE LOGIS DU CHATEAU LF. Quiet, isolated hotel above upper town;
tel: 90 36 09 98.

Information

Mairie 84210 (tel: 90 66 11 66).

Venasque

Pop. 656. PBVF

Fêtes and Festivals

Local fête, 15 August.

Market

Daily in May and June.

Sights

Medieval church of Notre-Dame and adjoining twelfth-century baptistery. *Daily, 9.00 – 12.00 and 15.00 – 18.00.* Views over woods and gorges.

Hotel-Restaurants

**LA GARRIGUE. Tel: 90 66 03 40.

Eygalières

Pop. 1427. PV

Fêtes and Festivals

Local fête, 9 August; Easter Tuesday, pilgrimage to chapel of Saint-Sixtus; Fires of Saint Jean (folkloric festival), nearest Saturday to Midsummer's Day; horse fair, 1 May.

Sights

Outlying chapel of Saint-Sixtus; sixteenth-century Penitents chapel, with archaeological remains and local art exhibitions; views from the church tower of the Caume, Alpilles and Durance; the canal of the Alpilles.

Hotel-Restaurants

****HOSTELLERIE DU MAS DE LA BRUNE. Outlying small hotel in excellently preserved sixteenth-century mansion, with charming grounds;
tel: 90 95 90 97.

Restaurants

L'AUBERGE PROVENÇALE. Centred around a large and beautiful courtyard, this establishment has been popularized by the South African novelist André Brink, who used it as a setting for *The Wall of the Plague* (1985); tel: 90 95 91 00.

Les Baux-de-Provence

Pop. 433. PV

Fêtes and Festivals

The Feast of the Shepherds, a famous Christmas Eve tradition dating back to medieval times and frequently associated in the past with paganism (it takes the form of a midnight mass combining much dancing with a recreation of the nativity).

Sights

THE CITADEL
Open from 9.00 to sunset.
MUSÉE DE L'ART MODERNE
Collection of works executed in Provence or Les Baux, situated in the sixteenth-century Hôtel des Porcelets. *Daily, Easter to end of October, 9.30 – 12.00 and 14.00 – 18.30.*
FONDATION LOUIS-JOU
The house and studio of the printer and engraver

Louis Jou (1882–1964), a beautiful sixteenth-century setting and a fine collection of modern and old master prints. *Daily from April to end of October, 10.00 – 13.00 and 14.00 – 19.00.*
MUSÉE ICONOGRAPHIQUE
Local history museum situated in sixteenth-century Hôtel de Manville; same opening hours as MUSÉE DE L'ART MODERNE.
MUSÉE ARCHÉOLOGIQUE ET LAPIDAIRE
Outstanding archaeological collections displayed in medieval Manoir de la Tour du Brau; same opening hours as above.
CATHÉDRALE D'IMAGES
A remarkable audio-visual show in the old subterranean bauxite quarries, where the surfaces of huge rooms and pillars are used as giant screens. *15 March to 30 September, 10.00 – 19.00; 1 October to 4 November, 11.00 – 18.00; closed Tuesdays in October.*

Hotel-Restaurants

****OUSTAU DE BAUMANIÈRES. Luxurious setting, one of the most famous and expensive restaurants in France;
tel: 90 54 33 07.
****CABRO D'OR. Same ownership as above but cheaper; tel: 90 54 33 21.
***BAUTEZAR ET MUSÉE. Small establishment in centre of the village;
tel: 90 54 32 09.
**REINE JEANNE. Also small and central;
tel: 90 97 32 06.

Information

Tel: 90 54 34 03.

VAR AND ALPES-MARITIMES

Ampus

Pop. 535. PV

Fêtes and Festivals

Local Fêtes, 15 August and first Sunday after 8 September.

Sights

Interesting Romanesque village church.

*T*he essential Provence: a hill-village in the Vaucluse, surrounded by olive groves and vineyards (opposite).

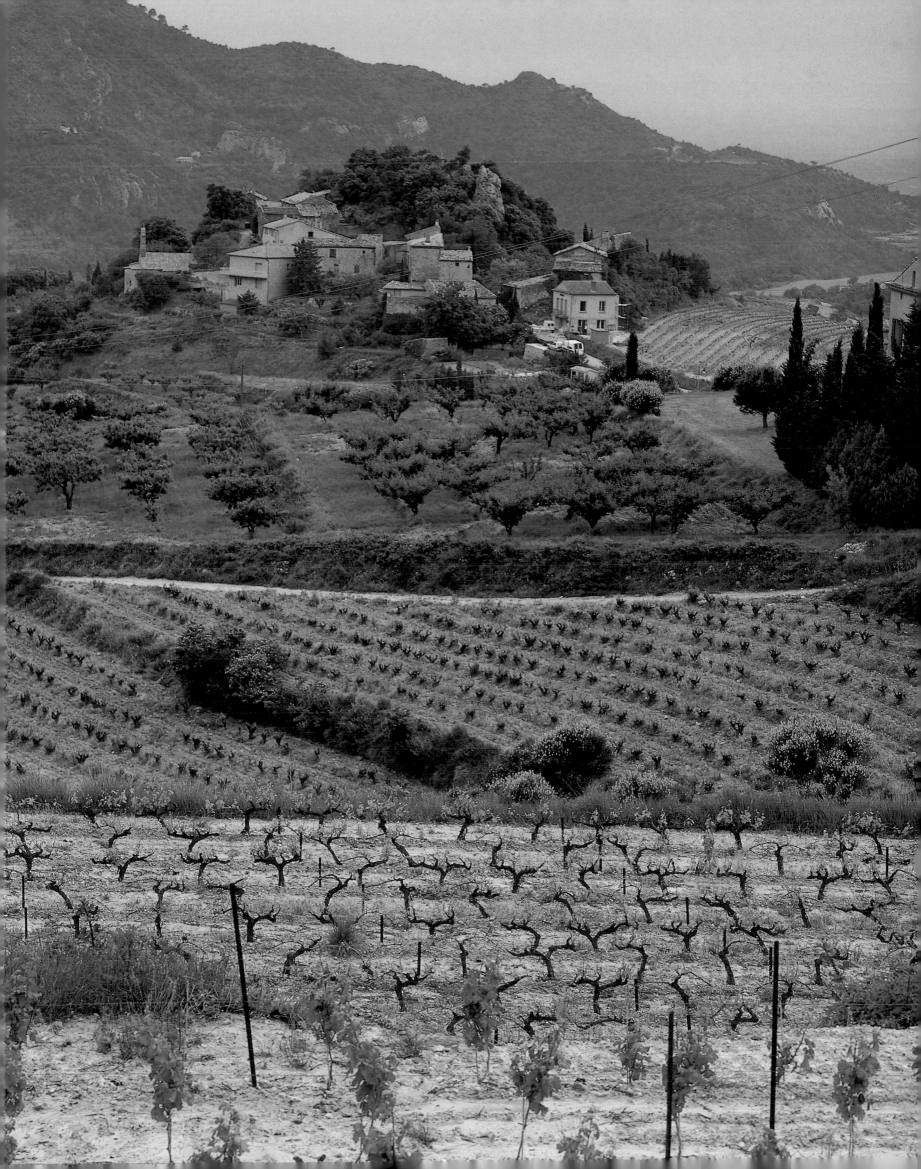

Bargemon

Pop. 1,110

Fêtes and Festivals

Local fête, first Sunday after 10 September; pilgrimage to chapel of Notre-Dame-de-la-Galine, 8 September; traditional Easter Monday procession at which for the only time in the year a small seventeenth-century statuette of the Virgin, carved in olive wood, is displayed.

Hotel-Restaurants

**L'Auberge des Arcades. Tel: 94 76 60 36.

Restaurants

Chez Pierrot. Intimate establishment in centre of village, specializing in traditional Provençal cuisine; tel: 94 76 62 19.
Maître Blanc. Similar to above; tel: 94 76 60 24.

Cotignac

Pop. 1628. PV

Festivals and Fêtes

Local fête, 8 August; open-air theatre productions in summer; pilgrimages to chapel of Notre-Dame-de-Grace.

Sights

Tufa cliffs and grottos; the village is famous for its wines, olive oil and honey.

Hotel-Restaurants

***Lou Calen. On central avenue; tel: 94 04 60 40.

Restaurants

Mas de Cotignac. Tel: 94 04 66 57.

Entrecasteaux

Pop. 527. PV

Festivals and Fêtes

Local fête, first Sunday in August; music festival in summer.

Sights

Château
Daily from April to September, 10.00 – 20.00; from October to March, 10.00 – 18.00.
Public gardens attributed to André Le Nôtre; designer carpets and olive oil.

Les Arcs-sur-Argens

Pop. 3786

Festivals and Fêtes

Local fête, 29 August.

Market

Thursdays.

Sights

Chapel of the former convent of La Celle-Roubaud
Nearby Romanesque chapel with fine furnishings and reliquary of Sainte Roseline. *Mid-September to late May, Wednesdays and Sundays, 14.30 – 17.00; early June to mid September, Wednesdays and Sundays, 15.30 – 18.30).* Frescoes and polyptych by Louis Bréa (1501) with sixteen compartments in main church.
Maison des vins des Côtes-de-Provence
Interesting, outlying wine museum. *Daily in summer, 9.00 – 19.00.*
Important vineyards surrounding the village.

Hotel-Restaurants

***Le Logis du Guetteur. Picturesquely sited within the castle; tel: 94 73 30 82.
*Charles. Tel: 94 73 32 02.

Seillans

Pop. 1609. PV; PBVF

Festivals and Fêtes

Local fête, first Sunday in July; pilgrimage to chapel of Notre-Dame-des-Selves, last weekend in July.

Sights

Notre-Dame-de-l'Ormeau
Outlying Romanesque chapel with outstanding late Gothic altarpiece of 1540. *Open every Sunday at 15.00.*

Hotel-Restaurants

***Les Deux Rocs. In eighteenth-century mansion in the centre of the village; tel: 94 76 87 32.
***France. Tel: 94 76 99 28.

Restaurants

L'Auberge Mestre Cornille. Tel: 94 76 87 31.

Tourtour

Pop. 384. PV; PBVF

Festivals and Fêtes
Local fête, 4 September; folklore festival, first
Sunday in August.

Hotel-Restaurants
****La Bastide de Tourtour. Beautifully
situated château-style hotel; tel; 94 70 57 30.
***L'Auberge Saint-Pierre. Rural-style
hotel; tel: 94 70 57 17.
***La Petite Auberge. Tel: 94 70 57 16.
***Hostellerie des Lavandes. Tel: 94 70 57 11.

Restaurants
Les Chênes Verts. One-star Michelin
establishment on road to Villecroze;
tel: 94 70 55 06.

Trigance

Pop. 122

Festivals and Fêtes
Local fête, 16 August; pilgrimage to Saint-Julien,
16 August.

Hotel-Restaurants
***Château de Trigance. Mock medieval
interior within real medieval castle;
tel: 94 76 91 18.
**Ma Petite Auberge. In village centre;
tel: 94 76 92 92.

Villecroze

Pop. 867

Festivals and Fêtes
Local fête, first Sunday after 8 August; September
concerts in parish church.

Sights
Grotto and cascades in public park (open in
summer only).

Hotel-Restaurants
**Les Esparrus. Tel: 94 70 66 99.
*Le Grand Hotel. In village centre;
tel: 94 70 78 82.

Restaurant
Marmite du Colombier. Tel: 94 70 67 57.

Èze

Pop. 2064. PV

Festivals and Fêtes
Local fête, 4–5 August; fête with Provençal mass,
15 August.

Sights
Exotic garden
*Daily, 1 June – 15 October, 8.00 – 20.00, and 16
October – 31 May, 9.00 – 17.30.*
Fragonard perfume factory
*Guided tours 15 March – 31 October, 8.30 – 18.30,
and 1 November – 15 March, 8.30 – 12.00 and 14.00
– 18.00.*
Chapelle des Pénitents Blancs. Fourteenth-
century chapel.

Hotel-Restaurants
****Château de la Chèvre d'Or. Luxuriously
converted medieval castle with famous
restaurant;
tel: 93 41 12 12.
****Cap Estel. The former villa of a prince,
situated on the coast below the village;
tel: 93 01 50 44.
**L'Auberge des Deux Corniches. In the
village;
tel: 93 41 24 64.
**Golf. Central location; tel: 93 41 18 50.

Restaurants
Le Grill du Château. Tel: 93 41 00 17.
Troubadour. Tel: 93 41 19 03.
Nid d'Aigle. Tel: 93 41 19 08.

Information
Mairie. Tel: 93 01 54 34.

La Brigue

Pop. 495

Festivals and Fêtes
Local fête, 15 August; pilgrimage to Notre-Dame-
des-Fontaines, 8 September.

Sights
Chapelle Notre-Dame-des-Fontaines
Containing one of the finest fifteenth-century
fresco cycles in Provence; the key for the chapel
can be had from the town hall or from any of the
village's hotels.

Hotel-Restaurants
**MIRVAL. Friendly and unpretentious;
tel: 93 04 63 71.
*L'AUBERGE SAINT-MARTIN. On village square;
tel: 93 04 62 17.
*FLEURS DES ALPES. On village square;
tel: 93 04 61 05.

Lucéram

Pop. 889

Festivals and Fêtes
Mardi Gras *carnaval* with distribution of polenta;
fête of Sainte Marguerite, 20 July; fête of Sainte
Rosalie (with procession of saint's image), 6
September; fête of Saint Hubert (with open-air
mass and blessing of dogs), 15 August; midnight
Christmas mass with procession of shepherds.

Sights
CHURCH OF SAINTE-MARGUERITE
Early Gothic, rebuilt 18th c. Has works by Jean
Canavesio and Louis Bréa and interesting
Renaissance silverware.

Hotel-Restaurants
*LA MÉDITERRANÉE. Simple village inn;
tel: 93 79 51 54.

Peillon

Pop. 1038. PV

Festivals and Fêtes
Local fête, first Sunday in August.

Sights
Chapelle des Pénitents Blancs has frescoes by
Jean Canavesio.

Hotel-Restaurants
***L'AUBERGE DE LA MADONE. Panoramic
situation; tel: 93 79 91 17.
*LA BRAISIÈRE. Tel: 93 79 91 06.

Saint-Paul-de-Vence

Pop. 2565

Festivals and Fêtes
Local fête, mid August; concerts of
contemporary music in Fondation Maeght, July
and August.

Sights
FONDATION MAEGHT
One of Europe's greatest centres of contemporary
art. *Daily, 1 July – 30 September, 10.00 – 19.00, and
1 October – 30 June, 10.00 – 12.30 and 14.30 –
18.00.*
Sixteenth-century ramparts; art and craft
galleries.

Hotel-Restaurants
****MAS D'ARTIGNY. Luxury modern version of
traditional Provençal mansion; tel: 93 32 84 54.
***LA COLOMBE D'OR. Excellent collection of
works by artists who have stayed there;
tel: 93 32 80 02.

Saorge

Pop. 323. PV

Festivals and Fêtes
Local fête, second Sunday in July.

Sights
Baroque Franciscan monastery (ring bell to enter,
men only); views over the Roya gorges.

ALPES-DE-HAUTE-PROVENCE

Annot

Pop. 1062

Festivals and Fêtes
Whitsun festivities in honour of Saint Fortunat.

Market
Tuesdays.

Sights
Odd rock shapes, caused by erosion, known as
the 'Grès d'Annot'.

Hotel-Restaurants
**GRAC. Old-fashioned, family-run hotel on
main square; tel: 92 83 20 02.
*DU PARC. Also on main square; tel: 92 83 20 02.

Information
Mairie. Tel: 92 83 22 09.

Colmars-les-Alpes

Pop. 314. PV

Festivals and Fêtes

Fête of Saint Jean (one of upper Provence's few surviving *bravades*, or festivals of military origin, involving seventeenth-century costumes and cannon fire), 24 June; torch-lit procession, 8 August; summer festival with fireworks, second week of August; market fair, 22 September.

Market

Tuesdays and Fridays.

Sights

Late medieval fortifications.

Hotel-Restaurants

LE CHAMOIS. Tel: 92 83 43 29.
VAUBAN. Tel: 92 83 40 49.

Information

Place Joseph-Girieud. Tel: 92 83 40 27.

Entrevaux

Pop. 698. PV

Festivals and Fêtes

Fête de la Saint-Jean, with picturesque procession, 24 June; local fête, 15 August; festival of early music in summer.

Sights

MUSÉE DE LA MOTOCYCLETTE
Enquire at local information office for access.
The interior of the old cathedral is an interesting mixture of Neoclassical and Baroque, with exceptionally fine altarpieces and paintings.

Hotel-Restaurants

VAUBAN. Modest, old-fashioned establishment, with parrot in dining-room who has been taught to whistle half the *Marseillaise*; tel: 93 05 42 40.

Lurs

Pop. 284. PV

Festivals and Fêtes

Local fête, last Sunday in July; pilgrimage to Notre-Dame-des-Anges, Whitsun Monday and 2

August; Rencontre internationale de Lure (graphic arts festival), last week of August.

Restaurants

LA BELLO VISTO. With spectacular views over Durance valley from dining room; tel: 92 79 95 09.

Information

Tel: 92 79 10 20.

Méailles

Pop. 80

Festivals and Fêtes

Fête de la Saint-Jacques, late July; procession to chapels of Saint-Jacques-le-Majeur and Saint-Jacques-le-Mineur on last Sunday of July.

Sights

Views along the river Vaire.

Riez

Pop. 1734

Festivals and Fêtes

Whitsun festivities; local fête, 15 August.

Market

Wednesdays and Saturdays (truffle market between November and March).

Sights

MUSÉE D'HISTOIRE NATURELLE DE PROVENCE
Extensive natural history collections displayed in basement of former bishops' palace. *Daily, except Tuesdays, 10.00 – 12.00 and 15.00 – 18.30.*
BAPTISTERY
Important early Christian monument housing small archaeological museum; to visit, ask at information office.
Views from the terrace of the Chapelle Saint-Maxime over the Plateau de Valensole, the Préalpes de Castellane, the hills of the Haut-Var, the Lubéron and the Montagne de Lure.

Hotel-Restaurants

CARINA. Tel: 92 77 85 43.
DES ALPES. Tel: 92 77 80 03.
CIGALOU. Tel: 92 77 75 60.

Information

Place des Quinconces. Tel: 92 74 51 81.

Select Bibliography

AGULHON, Maurice, *The Republic in the Village, The People of the Var from the French Revolution to the Second Republic*, Cambridge, 1982

ALIQUOT, Hervé, *The Alpilles*, Avignon, 1974

ALLEN, Percy, *Impressions of Provence*, London, 1910

BAILLY, Robert, *Dictionnaire des communes: Vaucluse*, Avignon, 1985

BARRUOL, G., *La Provence romane (2): La Haute Provence*, Paris, 1976

BENOÎT, F., *La Provence et le Comtat-Venaissin: Arts et traditions populaires*, Avignon, 1975

BERNARD, Yves, *Annuaire touristique et culturel du Var*, Aix-en-Provence, 1991

BLUME, Mary, *Côte d'Azur*, London, 1992

BORG, A., *Architectural Sculpture in Romanesque Provence*, Oxford, 1972

BRUNI, René, *Lubéron*, Aix-en-Provence, 1984

CHABOT, Jacques, *La Provence de Giono*, Aix-en-Provence, 1982

CHARDENON, Ludo, *In praise of Wild Herbs, Remedies and Recipes from Old Provence*, London, 1985

CLÉBERT, Jean-Paul, *La Provence de Mistral*, Aix-en-Provence, 1980

CLÉBERT, Jean-Paul, *Mémoire du Lubéron* (2 vols.), Paris, 1984

CLÉBERT, Jean-Paul, *Guide de la Provence mystérieuse*, Paris, 1986

COLLIER, R., *La Haute Provence monumentale et artistique*, Gap, 1987

COOK, T. A., *Old Provence*, London, 1905

DURANDY, D., *Mon pays. Villages et paysages de la Riviera* (2 vols.), Paris, 1918

DURRELL, Lawrence, *Caesar's Ghost*, London, 1989

FAUVILLE, H., *La Coste, Sade en Provence*, Aix-en-Provence, 1984

FLOWER, John, *Provence*, London, 1987

GIONO, Jean, *Provence*, Paris, 1957

GIONO, Jean, *Provence perdue*, Paris, 1967

GUINSBERG, S. and E., *The Perched Villages of the Alpes-Maritimes* (3 vols.), Aix-en-Provence, 1983

JACOBS, Michael, *A Guide to Provence*, Harmondsworth, 1988

JOUVEAU, R., *La cuisine provençale de tradition populaire*, Berne, 1962

MADOX FORD, Ford, *Provence. From Minstrels to the Machine*, London, 1935

MASSOT, J.- L., *Maisons rurales et vie paysanne en Provence*, Ivry, 1975

MÉDECIN, Jacques, *Cuisine Niçoise, Recipes from a Mediterranean Kitchen*, Harmondsworth, 1983

MEYNARD, Henri, *Lourmarin à la Belle Epoque*, Lourmarin, 1968

MISTRAL, F., *Memoirs of Mistral*, London, 1907

Monuments historiques de Provence-Alpes-Côte d'Azur, Marseille, 1986

PAGNOL, Marcel, *My Father's Glory* and *My Mother's Castle* (combined English-language edition), London, 1988

PAGNOL, Marcel, *The Time of Secrets* and *The Time of Love* (combined English-language edition), London, 1994

PAPON, Jean-Pierre, *Voyage littéraire de Provence* (4 vols.), Paris, 1777–86

POPE-HENNESSY, James, *Aspects of Provence*, London, 1952

REBOUL, J-B., *La cuisinière provençale*, Marseille, 1895

ROUQUETTE, J-M., *La Provence romane (2): La Provence rhodanienne*, Paris, 1974

THEVENON, L., *L'art du Moyen Age dans les Alpes Méridionales*, Nice, 1983

THEVENON, L., *La peinture au XVIIe siècle dans les Alpes-Maritimes*, Nice, 1985

THIRION, J., *Alpes romanes*, Paris, 1980

TORRE, Michel de la, *Alpes-Maritimes, Alpes-de-Haute-Provence, Bouches-du-Rhône, Var*, and *Vaucluse* (from the Nathan series, Guide de l'Art et de la Nature), Paris, 1985

VOVELLE, M., *De la cave au grenier*, Quebec, 1980

WYLIE, L., *Village in the Vaucluse*, Harvard, 1977

The view from a Provençal hill-village, across cultivated fields to mountains beyond (opposite).

Author's Acknowledgments

On my recent visits to Provence I have been wonderfully looked after by John and Christiane O'Keeffe at their house in Puyvert, on the outskirts of Lourmarin. John was also kind enough to drive me to most of the villages featured in this book, and made such enthusiastic comments about them that I dedicate my text to him. I must also thank Jules Bass, Jeannine Chadow, Paulette Falconnet, François Paliard, Richard Pinder, James, Kyran, Louise and Patrick O'Sullivan, and, as always, Jackie.

Photographer's Acknowledgments

Among the many kind people who helped me during my visits to Provence, I should like to thank especially Simon and Annette Freeman, Wolf and Shirley Rilla and my aunt Philippa, whose example as an intrepid traveller and great lover of Provence often sustained me during my expeditions and to whom the photographs in this book are dedicated.